Matisse on Art

Jack D. Flam

MATISSE
ON ART

A Dutton *Paperback*

E. P. Dutton *New York*

Frontispiece: *The Swan*. Illustration for *Poésies de Stéphane Mallarmé*. 1932. Etching.

This paperback edition of
MATISSE ON ART
First published 1978 by E. P. Dutton

First edition published 1973 by Phaidon Press Limited
All rights reserved.

Printed in the United States of America

For information contact: E. P. Dutton, 2 Park Avenue, New York, N.Y. 10016.

The originals of Texts 2, 3, 11, 12, 14, 15, 17, 19, 24, 26,
27, 28, 29, 31, 32, 33, 36, 38, 43 and 44 by Matisse are
© S.P.A.D.E.M., Paris, and are translated with permission.
The illustrations are also © S.P.A.D.E.M., with the exception
of 45 and 49.

Library of Congress Catalog Card Number: 77-93098

ISBN: 0-525-47490-0

Contents

To Max and Rose Flam

Preface

The purpose of this book is to present the collected writings on art of Henri Matisse (1869–1954). Although Matisse is recognized as one of the most important artists of the twentieth century and is the subject of one of the largest literatures in modern art, and although he made public statements about his art for nearly half a century, his writings have been given little attention. Only one very limited collection has appeared, in German, and there has been as yet no collection in French or in English (see the Bibliography, below).* As a result, many of Matisse's most important writings have never, or have only partially, and sometimes misleadingly, been reprinted, or have appeared only in inadequate or fragmentary translations. Further, many of the writings have been virtually inaccessible, and in some cases unknown, even to specialists in the field.

In a certain sense the writings of artists are as much a part of the artistic tradition as the body of works which form that tradition. This heritage, especially in France, has long been a part of the 'artistic culture' which constitutes the basic intellectual milieu of the artist. It is hoped that the publication of these texts, by enabling students of modern art and the general public to become familiar with the thought of Henri Matisse, will promote a broader appreciation and understanding of this most important modern master.

In the course of writing this book, I have benefited from the kind co-operation of many institutions and individuals.

I should like particularly to thank the staff of the following museums: the Baltimore Museum of Art; the Philadelphia Museum of Art; The Barnes Foundation, Merion, Pennsylvania: The Museum of Modern Art, New York; the Musée du Petit Palais and the Musée National d'Art Moderne, Paris; the Musée Matisse in Le Cateau; the Musée Matisse in Nice-Cimiez, especially Mme Oudibert.

I should also like to thank the staffs of the following libraries: The Architecture and Fine Arts Library of the University of Florida, especially Miss Anna Weaver; Miss Julia Sabine, Art Librarian, Newark Public Library, Newark, New Jersey; the Art Department of the New York Public Library; the staff of the Museum of Modern Art Library, New York, especially Mrs. Evelyn Semler, for many kindnesses; in Paris, the Bibliothèque Nationale, the Library and Archives of the École des Beaux-Arts, the Bibliothèque Historique de la Ville de Paris, the Bibliothèque d'Art et d'Archéologie (Fondation Doucet), the Library of the Musée National d'Art Moderne and that of the Musée National d'Histoire Naturelle.

I should also like to thank Miss Amy Tamburri for her great assistance with the early phases of research; Professor Len Kesl for many kindnesses; Miss Hilary Adams, Mme Susan Morgenstern, Mr. John Neff, Mr. Pierre Schneider, Mr. Henry Clifford, and Mlle Danièle Giraudy for generously sharing their resources with me; Mr. Jack Cowart for kindly

*After this book had been sent to press a French edition of Matisse's writings appeared: Dominique Fourcade, ed., *Henri Matisse, écrits et propos sur l'art.* Paris: Hermann, 1972.

sharing his knowledge of École des Beaux-Arts entrance procedures and Matisse's early training.

I should also like to express my thanks to my colleague Professor John L. Ward, with whom I have shared many hours of fruitful and enjoyable discussion, and to Professor William G. Wagner, Director of the Bureau of Research, College of Architecture and Fine Arts, University of Florida, for a grant which greatly helped to facilitate the completion of the manuscript.

To Professor Eugene E. Grissom, Chairman of the Art Department, University of Florida, I should like to offer my warmest thanks for his constant understanding, co-operation, encouragement, and friendship; and I should also like to thank Dr. Laurie Schneider Adams for her timely and important assistance with many of the translations.

Finally, I should like to acknowledge my deep gratitude to Miss Bonnie S. Burnham for her dedicated and invaluable assistance with all phases of the preparation of this book.

Biographical Note[1]

Henri-Emile Benoît Matisse was born at Le Cateau (Nord) on 31 December 1869. After attending the Lycée in St. Quentin, he spent a year in Paris preparing for his law exams, which he passed in August 1888. At this time it seems that Matisse was not particularly interested in art or painting, and while in Paris did not even visit the Louvre. After an attack of appendicitis in 1890, he began to copy colour prints with a box of paints given to him to while away the time of his convalescence. He seems to have obtained his first ideas on painting from a popular, rather dry treatise by Goupil. He began to become intensely interested in art, and finally decided to go to the École Quentin-Latour where he could further his studies; abandoning law, he went on to Paris in 1892, where he worked briefly under Bouguereau and Ferrier. After failing the entrance examination to the École des Beaux-Arts, he succeeded in entering the atelier of Gustave Moreau, where he remained for the next five years. Among the other students then at Moreau's studio were Rouault, Evenpoël, Camoin, Manguin, and Linaret. At this time, Matisse also began a series of copies at the Louvre and in 1896, he exhibited at the Salon de la Société Nationale des Beaux-Arts, and two paintings of his were purchased, one by the State. In the summer of 1896, he travelled to Brittany and painted outdoors with Emile Wéry. In 1897, he completed *La desserte* (Figure 5), which was exhibited at the Salon de la Nationale of that year. Although the work was in a relatively conservative Impressionistic style, it met with disapproval from the conservatives of the Academy who were still fighting the battle against Impressionism. That summer, at Belle-Île, he made the acquaintance of John Russell who introduced him to the work of the Impressionists and Van Gogh. In January 1898, Matisse married and, upon the advice of Pissarro, honeymooned in London where he studied especially the paintings of Turner. This was followed by a trip to Corsica and to the south of France where he mainly painted landscapes direct from nature, and occasionally some interiors, such as the *Chambre à Ajaccio*. Early in 1899 Matisse returned to Paris, exhibited for the last time at the Salon de la Nationale, and finally left the École des Beaux-Arts, where Cormon had replaced Gustave Moreau who had died in 1898. In the same year, he bought from Ambroise Vollard, Cézanne's *Trois Baigneuses* (Figure 9), which he could ill afford but which he kept until 1936, despite his severe financial problems at the turn of the century. This painting was to have a tremendous and far-reaching influence on his thought and work. That same year Matisse also acquired a bust by Rodin and a painting by Gauguin, *Head of a Boy*, in exchange for one of his own canvases, and a drawing by Van Gogh. At this time Matisse also began to study sculpture at night.

In 1900 Matisse, in dire straits, took a job painting decorations in the Grand-Palais for the Exposition Universelle of 1900, an experience to which later he would frequently refer. The early years of the century were dark ones for Matisse, marked by extreme poverty and illness, because of which he was obliged to be separated from his two sons, who were sent to live with relatives. In 1903, he exhibited two paintings at the Salon d'Automne, and in June 1904, had his first one-man show at Vollard's gallery, the catalogue preface to which was written by

Roger Marx.[2] The Summer of 1904 was spent at St. Tropez working with Signac and Cross in the neo-Impressionist manner.

In 1905, Matisse exhibited *Luxe, calme et volupté* (Figure **13**) at the Salon des Indépendants. This painting was in many ways the culmination of his neo-Impressionist experiment. In 1905, Matisse also exhibited in the central room of the 'Fauve Gallery' of the Salon d'Automne. This year was marked by the start of a buying public for his works; it was the year of the first purchase by the Steins (Gertrude, Leo, Michael, and Sarah), and of support from Marcel Sembat. The summer of 1905 Matisse spent at Collioure, where Derain came to join him. In the same summer, he became friendly with Maillol and visited the collection of Gauguin's South Sea pictures which were in the custody of Daniel Monfreid, a friend of Maillol. That autumn saw the exhibition of two of Matisse's most important Fauve works, namely *La femme au chapeau* and *Portrait à la raie verte* (Figure **16**); in October 1905, while the uproar over the *Femme au chapeau* was still raging, Matisse began the *Bonheur de vivre* (Figure **17**), later retitled *Joie de Vivre* by Albert Barnes. The painting was completed before the Salon des Indépendants which opened on 20 March 1906, and, because of its size and brilliance of colour, it created a furore. This animosity was felt not only among critics and academic painters but even extended to Paul Signac, who was at that time the vice-president of the Indépendants, and who resented Matisse's disavowal of neo-Impressionism. Because of its subject, composition, manner of rendering, and especially the blending of a variety of styles, the *Bonheur de vivre* was to be one of Matisse's major early works, 'a magnificent act of courage, a prime monument in the history of modern painting. . . .'[3] This was also the year of Matisse's second one-man show at the Galerie Druet, and of his trip to Biskra, and the subsequent *Nu Bleu* of 1907 (Figure **18**). In 1907 Matisse withdrew from his Fauve milieu, and that summer travelled to Italy where he especially admired Giotto and the Sienese primitives.

Early in 1908, at the suggestion of Sarah Stein and Hans Purrmann, Matisse began a painting class in his studio at the Couvent des Oiseaux, 56 rue de Sèvres.[4] The school was a success, and as enrolment increased Matisse moved the school to the Couvent du Sacré Cœur, 33 boulevard des Invalides, where he also took up residence. The school closed in 1911. The year 1908 was particularly important for Matisse's reputation since it marked his first shows outside of France; the first Matisse canvas exhibited abroad was at the New Gallery, London, in January; later that year, he exhibited in the United States at Stieglitz's '291' Gallery, showed in Russia at the Golden Fleece Salon in Moscow, and in Berlin, at the Cassirer Gallery. From a later (1910) exhibition at the '291' Gallery came the first acquisition of Matisse's works for a museum, three drawings purchased by Mrs. George Blumenthal, wife of the director of the Metropolitan Museum, New York. At the end of 1908, Matisse published 'Notes of a Painter', his first, and surely his most influential theoretical statement.

In 1909 Matisse signed his first contract with the Bernheim-Jeune Gallery and took a house at Issy-les-Moulineaux, where he would later paint many of his major works. In 1910 he had a large retrospective at the Bernheim-Jeune Gallery, and at the Salon d'Automne exhibited two large paintings, *La danse* and *La musique* (Figures **21**, **22**) which had been commissioned in the previous year by the Russian collector Shchukin. He also travelled to Munich to visit the exhibition of Islamic art, which made a deep and lasting impression on him, and wintered in Andalusia. He returned to France early the next year, and worked at Issy-les-Moulineaux until summer, when he travelled to Collioure again. In 1911 he began to develop a complex and extremely rich vocabulary of space and form. In the autumn, at the invitation of his patron, Sergei Shchukin, he went to Moscow, where he studied icons, and was evidently quite impressed with the foreignness of Russia.[5] Early in the winter of 1911, Matisse

left for Tangier, from whence he returned in the spring of 1912. That March his first sculpture exhibition opened at the '291' Gallery in New York. Matisse left for Morocco again before the end of the year, and met Camoin, Marquet, and James Morrice in Tangier, returning to Paris in mid-April for the exhibition of his Moroccan paintings, sculpture, and drawings at Bernheim-Jeune, and spending the summer at Issy-les-Moulineaux. In 1913 Matisse exhibited thirteen paintings, three drawings, and a large sculpture at the Armory Show in New York, Chicago, and Boston, and was introduced to the American public by an interview in the *New York Times*.[6] In the autumn of 1913, he once again took a studio on the quai St. Michel in Paris, where he had previously lived from 1899 to 1908. Matisse's retrospective exhibition at the Gurlitt Gallery, Berlin, opened in July 1914 and closed at the outbreak of the First World War. That September he met Marquet and Juan Gris at Collioure, and returned to Paris at the end of October.

In 1915 he exhibited at the Montross Gallery in New York, and in 1916, spent the winter at Nice in the Hôtel Beau-Rivage. This was the period of his most austere and ambitious works. He returned to Issy-les-Moulineaux in late spring of 1917, was at Issy that summer and worked in Paris in the autumn. Early in December he visited Marseilles and wintered again at Nice at the Hôtel Beau-Rivage. On 31 December 1917, he visited Renoir for the first time, at Cagnes.

In 1917, Matisse also renewed his contract with Bernheim-Jeune, on terms which were much better than those of his earlier contract. In 1918, he showed some of his paintings to Renoir, to whom he now paid frequent visits, and also visited Bonnard at Antibes. He had an exhibition with Picasso at the Paul Guillaume Gallery and spent the spring and early summer at the Villa des Alliés at Nice. He returned to Paris in September, but later in the autumn came back to Nice and took rooms in the Hôtel de la Méditerranée on the Promenade des Anglais. This was the real beginning of his so-called Nice period, marked by a return to small studies done out of doors directly from nature. In the spring of 1919, Matisse had another exhibition at Bernheim-Jeune, and his first one-man show in London at the Leicester Galleries. In that year Diaghilev suggested that Matisse design the decor and costumes for the ballet *Le Chant du Rossignol*, the choreography for which was by Massine and the music by Stravinsky; in 1920, *Rossignol* was performed at the Paris Opéra by the Ballets Russes. During the summer, Matisse painted at Etretat and had an exhibition of his Etretat and Nice paintings, with some early works, including his first and second paintings (painted in 1890), at Bernheim-Jeune. In 1921, by now almost universally considered one of the most important living painters, Matisse was invited to exhibit at the Carnegie International Exhibition in Pittsburgh. He had spent the summer painting at Etretat, and the autumn in an apartment on the Place Charles-Félix, in the old part of Nice. In 1923 the two major Russian collections of Matisse's works, those of Shchukin and Morosov, which had been confiscated during the Revolution, were combined in the Museum of Modern Western Art in Moscow. In 1924 Matisse exhibited in New York at the Brummer Galleries, and had a large retrospective exhibition organized by Leo Swane in Copenhagen, which then toured Scandinavia. Matisse visited Italy again in 1925 and in July of that year was made a Chevalier of the Legion of Honour. In 1927, Matisse exhibited at the Valentine Gallery in New York, an exhibition arranged by his son, Pierre, and was awarded first prize at the Carnegie International Exhibition for his *Compotier et fleurs*, 1924, a relatively conservative choice by the Carnegie jury. For years Matisse had dreamed of travelling to the South Seas, and in March 1930, at a moment of crisis in his life and art, he began his journey by way of New York and San Francisco. While in Tahiti, he did no painting. Instead, as he wrote to Escholier, 'I lived there three months,

absorbed in my surroundings, with no other ideas than the newness of all I saw, overwhelmed, unconsciously storing up many things.'[7] Matisse's return from Tahiti was not through the United States, but directly to Marseilles via Suez. In the autumn of 1930, he was invited to serve on the jury of the 1930 Carnegie International Exhibition, and after this, returned to New York, where he visited the homes of many collectors of his paintings. In the meantime, Dr. Albert C. Barnes, the important American collector, who had invited him to visit the Barnes Foundation in Merion, Pennsylvania, proposed a commission for a mural decoration for the Foundation, on the subject of the dance. Matisse returned to France, but returned to Merion in late December to plan for the commission, which he began later in an abandoned film studio in Nice. In November 1931 the Museum of Modern Art gave Matisse his first large American one-man show in New York. This show had been preceded by an important show in Berlin at the Thannhauser Gallery in the late winter of 1930, and by a large show which opened at the Georges Petit Galleries in Paris in 1931, composed in the main of pictures from the Nice period, 1918–30.

Thus the years 1930–1 brought to fruition many of Matisse's personal ambitions and solidified his already growing international reputation. In 1931 *Cahiers d'Art* published a special number on Matisse as did the French journal *Les Chroniques du Jour*. In 1932 Matisse completed the Barnes Mural, only to find that the wall space had been measured incorrectly; he then began a second version, which was eventually installed in 1933 to the satisfaction of both Barnes and Matisse. In October of 1932, the Skira edition of *Poésies de Stéphane Mallarmé*, Matisse's first illustrated book, was published. In 1935 Matisse signed a contract with Paul Rosenberg, and also was commissioned by George Macy of New York to illustrate an edition of James Joyce's *Ulysses*. In 1937 Massine asked Matisse to design sets and costumes for *Rouge et Noir*, a ballet with music by Shostakovitch and choreography by Massine. His painting at this period had begun to take on a new vigour and boldness. In 1938 Matisse moved to Cimiez, to the former Hôtel Régina, overlooking Nice, where he designed set and costumes for the ballet *Rouge et Noir* which was produced in the following year by the Ballets Russes de Monte Carlo.

In 1940, after the fall of Paris, Matisse secured a Brazilian visa and passage for Rio de Janeiro, but he changed his mind. As he said in a letter from Nice to Pierre Matisse in New York, 'When I saw everything in such a mess I had them reimburse my ticket. It seemed to me as if I would be deserting. If everyone who has any value leaves France, what remains of France?'[8] Despite the wartime shortages, Matisse managed to work, although not at full capacity. As he put it to Pierre Matisse, 'I have to invent and that takes great effort for which I must have something in reserve. Perhaps I would be better off somewhere else, freer, less weighed down.'[9] In any event, Matisse stayed in France throughout the war.

In March 1941, Matisse was operated on for an intestinal occlusion at Lyons, and he returned to Nice in May. The operation and ensuing illness left him seriously affected; damage to the muscular wall of one side of the abdomen caused him permanent weakness so that he was able to hold himself erect only for limited periods of time. While he was convalescing, he began to work once again, painting and drawing in bed. At this time he also worked on illustrations for the Fabiani edition of Montherlant's *Pasiphaë* and the Skira edition of *Florilège des Amours de Ronsard*. In 1943, Matisse moved to the Villa 'Le Rêve', at Vence and, still in less than the best of health, started work on the cut and pasted paper compositions for *Jazz*. In the early summer of 1945 he went to Paris, where, for the first time since 1940, he had a retrospective exhibition of thirty-seven paintings at the Salon d'Automne. The same year, an exhibition of paintings by Picasso and Matisse was given at the Victoria and

Albert Museum in London, and an exhibition of Matisse's drawings was shown by the Pierre Matisse Gallery in New York.

In 1947 Matisse was elevated to the rank of Commander of the Legion of Honour, and in the spring of 1948 a large and important retrospective exhibition was given at the Philadelphia Museum of Art. In this year Matisse began his work on the designs for the Chapel of the Rosary at Vence; this project, which originally grew out of a stained-glass window design, was to occupy most of his efforts for the next two years (Figure **45**). In 1949, Matisse had important shows of his large recent works at the Pierre Matisse Gallery in New York, and at the Musée d'Art Moderne in Paris. In December 1949, the cornerstone of the Chapel at Vence was laid, and in 1950 the maquettes for the Vence Chapel were shown in an exhibition at the Maison de la Pensée Française in Paris, and a retrospective exhibition was organized at the Galerie des Ponchettes in Nice. Also in 1950, Matisse was awarded the first prize for painting at the Venice Biennale.

In 1951, two very important exhibitions of Matisse's work were organized, one at the National Museum in Tokyo, and the other at the Museum of Modern Art in New York, afterwards shown in Cleveland, Chicago, and San Francisco. To coincide with the American exhibitions, Alfred H. Barr published *Matisse: his Art and his Public*, still the most important work on the artist. On 25 June 1951, the Chapel of the Rosary of the Dominican Nuns of Vence was consecrated, and in 1952, the Musée Henri Matisse was inaugurated at Le Cateau. In 1953 Matisse had a large exhibition of works in cut and pasted paper at the Berggruen Gallery in Paris. In the 1950s Matisse's late cut-outs were creating as much of a stir in the art world as had his Fauve paintings half a century earlier.

Henri Matisse died on 3 November 1954. He is buried on the hilltop of the cemetery at Cimiez, in a plot of ground offered by the city of Nice.

Introduction

Painter, sculptor, draughtsman, graphic artist, book illustrator—and even, toward the end of a career that spanned over half a century, architect—Henri Matisse managed in all these fields of endeavour to produce some of the most original and significant works of one of the most revolutionary periods in European art. But above all, as he himself insisted, he was a painter,[1] and the greatest richness and complexity of his thought were expressed in his paintings and in their later extension, compositions in cut and pasted paper.[2] The creation of pictorial space on a flat surface by means of line and colour, the pure process of painting, adherence to the basic means of expression, these were the means through which Henri Matisse reformulated the nature of painting and defined new parameters of structure and expression.

In his earliest public statement about his art, he stated this outlook with the disarming simplicity and straightforwardness that truly great practitioners of an art sometimes possess, a simplicity that almost amounts to a personal mysticism: 'When difficulties stopped me in my work, I said to myself, "I have colours, a canvas, and I must express myself with purity, even though I do it in the briefest manner by putting down, for instance, four or five spots of colour or by drawing four or five lines which have a plastic expression".'[3] This statement, in one sense so abbreviated as to seem obvious, is yet truly a summation of much of the thought behind Matisse's painting, for it expresses the two most powerful factors from which his art grew: an absolute belief in his own powers, and an absolute belief in painting itself. It is no exaggeration to say that Matisse conceived of himself as the high priest of a religion, and that despite any doubts that came up along the way, the basic and unassailable assumptions of his life lay in his refusal, one might say his inability, to doubt either his faith or his calling.

Such a man might be expected to maintain a close silence on his art, to consider verbalization about painting at best, futile, at worst, wasteful. And when he sat down in 1908, at the age of thirty-nine, to write his first public statement about his art, he evidently could not himself escape that feeling: 'A painter who addresses the public not in order to present his works but to reveal some of his ideas on the art of painting, exposes himself to several dangers. . . . I am fully aware that a painter's best spokesman is his work.'[4] Thirty-four years later, at the age of seventy-three, he would tell a radio interviewer that his advice to young painters was: 'First of all you must cut off your tongue because your decision takes away from you the right to express yourself with anything but your brush.'[5] And the first sentence of *Jazz*, one of the most ambitious projects of his later career, contains the same thought: 'He who wants to dedicate himself to painting should start by cutting out his tongue.'

Yet of the three major French painters of the first half of this century—Matisse, Picasso, and Braque—Matisse was not only the earliest, but also the most persistent and perhaps most conscientious theorist,[6] and was the only one of the three who for a time seriously taught painting. It seems, then, that Matisse had a good deal of the pedagogue about him, and that, lacking the *enfant terrible* stance of Picasso or the conscious mysticism of Braque, when he felt impelled to discuss his art, he went about it in the direct, orderly, and reasonable way in

which he approached his painting and his life—the same manner that had, earlier, led his fellow students to call him 'the professor'.[7] Matisse's statements on art cover almost the entire span of his career as a mature artist, and their content and frequency seem to form a counterpoint to the works themselves. In them one can see reflected the evolution of his art, for in most cases exploration of new means is followed rather than preceded by a written statement; the writings are in this sense reflective rather than exploratory, synthetic rather than analytic. The painter speaks of results rather than of ambitions.[8]

Chronologically, Matisse's writings divide themselves into two distinct groups: those before 1929, and those after. The period before 1929 is remarkable for the rarity of either statements or interviews, while from 1929 on, and especially after 1940, Matisse frequently expressed himself on his art and career. During the first period, Matisse's statements do not in fact go much beyond the ideas contained in 'Notes of a Painter', while after 1929, having begun anew an intense exploration and re-evaluation of his pictorial means, Matisse seems to have felt a very real need to discuss his work. 'Notes of a Painter' (1908) came out of Matisse's successful attempt to synthesize his own perceptions with the pictorial structures of the masters; an attempt, as will be seen, 'to re-do Cézanne after nature'. It is a summation and defence of the realizations that came to him after eighteen years of painting, and anticipates the austere and synthetic works of the next decade. In order better to place it and other of Matisse's writings within the context of his painting, it would be well to review briefly some aspects of his career as a painter.

The Development of Matisse's Painting

Matisse's mature paintings may be grouped into the following five periods: Fauve period, 1900–1908; Experimental period, 1908–1917; Nice period, 1917–1929; period of Renewed Simplicity, 1929–1940; period of Reduction to Essentials, 1940–1954.

Matisse's works before 1897 (see Figures 1–4), are essentially those of an apprentice or student painter. They include several copies after the old masters at the Louvre, a series of still-lifes very much in the tradition of Chardin, and interiors in the manner of the little Dutch Masters. The palette of these paintings is for the most part muted, on occasion almost drab. It was not until 1897 that Matisse, inspired by the Impressionists, began to brighten his palette by using dabs of pure colour, a method of working that he elaborated variously for the next two years (see Figures 5, 6). In 1899, he began to work in two seemingly different manners, both of which were to contribute to the later Fauve paintings. Typical examples of these manners are *La malade* (Figure 7) and *Buffet et table* (Figure 8). The former is painted in broad brush strokes, in fairly high colour, which, while exaggerated in various areas of the painting (for example, the greens in the shadows of the tablecloth, the reds and greens in the face of the women in bed, and the colours of the wall), is not the pure free colour of the Fauve period, which goes beyond mere exaggeration and has its own life. While in *La malade* the brushwork anticipates that of the Fauve period, being relatively brusque, the paint put down somewhat roughly, the colour of the Fauve period is anticipated in *Buffet et table*, which is painted in a somewhat Impressionistic technique and in high colour. Thus neither has the complete consort of Fauve colour and brushwork, and even in *Buffet et table* the colour is laid on against a series of open white spaces which prevent its taking on the density and compactness of the Fauve paintings.

In 1900 Matisse began to work in what might be called his proto-Fauve style. The paintings include a series of standing male and female figures (Figure **10**), composed of heavily brushed areas with sharp colour and value contrasts, though the colour is not in itself as bright as in the Fauve period, and the value contrasts are for the most part modified at the contours.

The development of Matisse's painting followed this pattern, for the most part, to around 1904. Although there are variations in the detail in which he rendered his objects, the paintings till then were still usually heavily brushed, emphasizing large flat areas of paint, as in *Notre-Dame: fin d'après-midi*, 1902 (Figure **11**). The difference between this and other paintings of this time, such as *La guitariste* of 1903 (Figure **15**), is largely a matter of detail; the vision behind them is essentially the same. In 1904, Matisse began to assimilate more thoroughly the lessons of Cézanne, as is evident in such paintings as *Nature morte au purro, I* (Figure **12**) and in the important transitional period of 1904–5 Matisse began to develop a much brighter palette as may be seen in *Nature morte au purro, II*, 1904–05. This neo-Impressionist phase of Matisse's paintings is best seen in his *Luxe, calme et volupté*, 1904–5 (Figure **13**). With this painting, Matisse began a series of works with a new subject, the imagined pastoral, and a new method, working from a constructed or imagined scene. Throughout most of his life, especially in the years of his early development, Matisse did not work from imagination, but from life: from actual landscapes, models in the studio, or from interiors and still-lifes. In *Luxe, calme et volupté* and its related studies, Matisse began to work toward an ensemble in which, though the individual parts are studied from models, the totality is imagined. The final painting combines vibrant colour, which is virtually Fauve in spirit, with a pastoral subject matter that seems to be based on Cézanne's Bathers. The intensity of the colour, however, is still somewhat modified by the ubiquitous presence of the white ground of the canvas showing between strokes.

This is also true of the even more overtly Fauve *Fenêtre ouverte, Collioure* (Figure **14**) of the summer of 1905, in which the passage which describes the scene through the window is broken up into many little strokes, suggesting the rhythm of the growing plants and of the rocking boat in contrast to the solid architecture of the room. This area of the painting also shows a good deal of the canvas, and has the effect of seeming looser in its visual texture, more nervous in its linearity, and less intense in colour because of this separation of colour areas by the white ground. Even in *La femme au chapeau*, which was the scandal of the 1905 Salon d'Automne and combines bright colour with density of surface handling, many areas of the painting are tempered by the addition of white to the pigment so that there is a certain chalkiness in some of the colour. *La raie verte* (Figure **16**) which was painted in the autumn of 1905, is perhaps a more cogent statement of both form and colour than was the *Femme au chapeau*, and is definitely more synthetic. In this painting, instead of the somewhat splotchy modelling of the face of the *Femme au chapeau*, the forms are simplified into a series of planes based on relatively complementary colours. Thus the blue of the hair plays against the red-orange of the left central background as a complementary; against the yellowish side of the face it operates as a blue violet, and near-complementary; the green strip down the face, in relation to the reds in the background and the dress, simultaneously sets up a by-play of red against green and at the same time becomes a spatial indicator: the brighter green of the face jumps forward from the duller green of the right-hand background. On the whole the painting is perceived as a series of large flat colour areas, which are broken by abrupt shifts in plane, so that the painting is simultaneously three-dimensional and quite flat.

In many ways, the culmination of this aspect of Matisse's style is the magnificent *Bonheur de vivre* (Figure **17**), a continuation of his imagined subject matter in an extremely complex

compositional format. Matisse made several studies for this painting, which was not only one of his major pictorial statements up to that time, but which, because of its large size, brilliant colour, and spatial complexity was to become one of his most influential paintings. In 1907, Matisse began to coalesce and to solidify many aspects of his paintings. The *Nu bleu* (Figure **18**) is a good example of his desire to combine strong two-dimensional pattern and strong three-dimensional modelling into a single ensemble, and there are overtones here, as in *Nature morte bleue* of 1907, which show his wish to realize greater solidity of form, probably inspired by re-study of Cézanne following the large Cézanne retrospective of 1907.

Early in 1907, Matisse also began a series of large decorative panels (such as *Le Luxe, I*) which follow the general direction of the *Bonheur de vivre*, but are more restrained in colour, sharper in value contrast, and more direct and cogent in their spatial construction. In 1908, Matisse brought the Fauve period to a close with a series of large flat decorative compositions, such as *Joueurs de boules* (Figure **19**), and Harmony in Blue, repainted as *Harmonie rouge* (Figure **20**).

Harmonie rouge, with its translation of the total ensemble into a kind of ecstatic arabesque, marks the beginning of a new, Experimental period in the art of Matisse. It is one of a series of monumental compositions with which Matisse redefined the direction of his own painting, and to a certain degree, that of European painting, as a whole. This in itself is an interesting paradox, for while Matisse's most immediate effect upon European painting came directly out of the high Fauve period paintings (roughly 1905–1908), the period from 1908 to 1917 is perhaps the richest single period in his art, both in terms of the ideas and problems that it presented, which he would use in his later development, and of the ultimate influence that Matisse would have upon succeeding painters. The study of some major works from this time will clarify these statements.

Matisse's earlier paintings had been for the most part concerned with the lyricism of pure colour, and relied upon an essentially nineteenth-century vision. The paintings which follow *Le Luxe* in the tradition of imagined spaces, such as *Joueurs de boules*, *La danse* (Figure **21**), and *La musique* (Figure **22**), and the paintings which come out of the 'realistic' tradition of observed interiors and intimate scenes, still-lifes and interiors, such as *Harmonie rouge*, provide good background for the synthetic aspect of Matisse's painting in the later Experimental period. The Experimental period might be divided into two parts, the earlier of which (1908–10) is characterized by a certain fluidity and preference for organic form, the later (1911–17) by a preference for rectangularity and strong geometrical substructure, possibly as a result of Matisse's exposure to Cubism.

Harmonie rouge is one of Matisse's first attempts to investigate the possibilities, on a large scale, of a space which is at once descriptive of tangible objects and at the same time pictorially intangible, or flat. Precisely what is meant here can be seen by comparing this painting with *La desserte* of 1897 (Figure **5**). The subject matter is essentially the same—a woman at a table which has similar objects on it. *Harmonie rouge* is a later restatement of *La desserte*, translated into Matisse's new vision. Although both these paintings were painted from what might be called the experience of natural perceptual phenomena, *Harmonie rouge* restructures these phenomena in such a fashion that the viewer sees a resynthesis of plastic objects in an essentially non-plastic, symbolic space. The painting represents two areas, that inside a room and that seen through a window. As the space of the painting is perceived by the viewer, however, it is essentially flat, since the green seen through the window and the reds inside the room balance each other out and tend to lie on the same plane in space. By colour Matisse unites almost the entire painting on a single plane, but by very subtle juxtapositions such as overlapping,

rhythmic placement of objects over the surface of the painting, and the use of contours to define separation of areas where there is no colour separation (as in the table top), he creates a space which has strong plastic overtones. Thus the painted space is perceived simultaneously as being flat and also three-dimensional. The three-dimensionality of the painting, however, is not constant, as it was in *La desserte* where the construction of space was codified into a system of perspective. In *Harmonie rouge*, the table cloth is at once in front of, and on the same plane as the wall, and the window is pictorially both behind and on the same plane as the table and the wall. Even such a heavily overlapped object as the chair next to the woman tends to operate most actively as a shape rather than as an object in space. The flattening out of the elements in this painting, the reduction of tangible objects to an intangible space, and the simplicity of the rendering of individual objects, all mark this painting as a distinct departure from Matisse's Fauve works. The metaphorical implications of this kind of space, the simultaneous presentation of the world as perceived and as conceived, also lay the groundwork for the symbolic overtones of Matisse's later works—the balance between objects and 'signs'.

A similar flattening of space is to be observed in many of the works of 1909 to 1910, notably *La danse* (Figure 21), *Nature morte à 'la danse'* and *La conversation* of 1909, and *La musique* of 1910 (Figure 22).

In *La famille du peintre*, 1911 (Figure 23), Matisse builds upon the new space and imagery of *Harmonie rouge*, but organizes his space in a different fashion. Although the painting is full of varied floral motifs, and is essentially a very richly ornamented and decorative painting, the painter treats the intangible space that was seen in *Harmonie rouge* in an even more complex fashion. Here, instead of the essentially frontal and straightforward presentation of objects, and the simple silhouette rendering of the figure, there is a complex relationship between the personages represented; the space depicted in the interior of the room is deeper, and the drawing is more complex in terms of the repertory of poses and of viewpoints. While in *Harmonie rouge* there is essentially no viewpoint (the objects are presented hieratically), in *La famille du peintre* there is a constant by-play between passages of perspective and passages of non- or even anti-perspective. By rendering almost everything in the painting in a flattened manner and by playing the perspective of the draught-board with its slanting pattern and strong insistence on drawn perspective, against the flatness of the painting, Matisse constructs a complex and contradictory space. The draught-board seems to be a pivotal part of the structure of this painting. Because of its strong black and white pattern and its perspectival rendering and because it is surrounded by the very bright reds of the boys' clothes, it operates as a focal area of tension. While Matisse uses a colour shift and three-dimensional drawing to heighten the plastic effect of the draught-board, he does not construct a space around it which is plastic enough to contain it, and the contradiction produces a strong tension. This kind of spatial contradiction was to become one of the bases of Matisse's pictorial structure.

A similar structuring, but in a much more sombre key is to be found in *La fenêtre bleue*, 1911 (Figure 24). The painting, a view through a window, is given a certain uniformity of space and density by the pervasive blue hue, and the isolation of the objects against the rigid geometrical substructure lends it a certain severity and serenity. Even more important is the ambiguity of the rendering of semi-plastic objects in an ambiguous space. This aspect culminates in the pincushion and the green vase on the left of the painting. Although they are in the same area as, and are thereby read as being with, the objects on the table, they are in fact not on the table, but 'on the wall'. The objects, if one were to read them literally, thus perform an impossible action: they defy gravity and float in space. In fact, of course, the viewer does not

read the objects as floating, but because of the dense and poetic space, accepts the ambiguity of the placement and relative plasticity of objects in the same way that the reduction of the trees into circular forms and of the cloud into an ellipse, is accepted; the same way that the space outside the window and inside the window is accepted as paradoxically united on the same plane. This kind of ideogrammic rather than logical space is carried out in a large series of works from 1911 onwards, most especially in *Grande nature morte aux aubergines*, *L'atelier du peintre*, *Fleurs et céramique*, the so-called Moroccan triptych, and *Le riffain*, in which there is a similar tension between the description of space through colour and the description of space through drawing, which results in an intangible space. Sometimes the spatial ambiguity is produced by drawing, as in the *Madame Matisse* of 1913 (Figure 26), in which objects such as the scarf are made to appear and disappear and to change from areas into lines; at other times the ambiguity is the result of painting: areas of the same colour are made to define different areas in depth, and in so doing tend to make ambiguous the spaces or areas which they describe —as in the grey area around the head of *Madame Matisse*. This handling of space is overtly Cézannesque in its play of line against area, and in the delicate brushwork, as may be seen in the similar treatment of space in the *Femme au tabouret* of 1913–14. One of the culminations of this handling of symbolic space is the well-known *Portrait de Mademoiselle Yvonne Landsberg* of 1914, in which lines radiate from the figure in a manner which is not descriptive at all, but purely expressive.

From early in 1914 to the end of 1917, Matisse's work took on a decidedly architectonic quality. This is apparent in *Le bocal aux poissons rouges*, of early 1914, in a series of still-lifes, and even in a series of figures studies and portraits, such as the *Tête rose et bleue*, *L'italienne*, *Sarah Stein*, and *Greta Prozor*. This sense of broad architectonics, tense and rarified space, and an icon-like severity, reaches its culmination in 1916 in such austere compositions as *L'atelier du quai Saint-Michel* (Figure 29), *L'artiste et son modèle* (Figure 28), and especially the *Leçon de piano* (Figure 27). One of the last of these severe period paintings, which just begins to indicate Matisse's move toward more three-dimensional space, is *Intérieur au violon* (Figure 31), painted in Nice during the winter of 1917–18.

The year 1917 was the beginning of Matisse's so-called Nice Period, which was to last until about 1930. The Nice period is marked for the most part by an overall sense of relaxation. The paintings become much smaller in size and less architectonic than those of 1916–17, they are softer in colour, and much more loosely painted. A good example of this change may be seen by comparing *L'artiste et son modèle* of 1916 (Figure 28), with *L'artiste et son modèle* of 1919 (Figure 30), in which the space is much more tangible, and the drawing more consistent in terms of the relationship of the spectator to the total pictorial space. This tendency is also seen in *Interieur à Nice* of 1921 (Figure 32) in which Matisse again begins to indulge in optical devices, such as the transparency of the curtains through which the view through the window can be seen. In these works, as well as in the numerous still lifes and odalisques of this period, the space is much more tangible than in the preceding period, the colour more relaxed, and the overall space and imagery decidedly less synthetic, even in such highly decorative canvases as the *Jeunes filles au paravent mauresque* (Figure 35) or such contemplative and serene works as *Femme et poissons rouges*. Although the subject matter (interiors, figures, and still lifes) remains fairly similar to that of the paintings of the Experimental period, the construction is quite different.

Around 1929, Matisse began to broaden his forms once again, and the scale of the paintings often increased in correspondence with the broadened forms (as in *Femme au turban* 1929–30 [Figure 33]), and more architectonic compositions, as in *Jeune fille en jaune*, 1929–31 (Figure

34), in which the familiar device of the French window is used to carry out the architectonic framework from which the figure of the girl is, as it were, suspended in the space of the painting.

From the time that Matisse received the commission for the Mural at the Barnes Foundation in 1930 until around 1933, he concerned himself mostly with large murals and graphic works (see Frontispiece) and did not do much easel painting. When eventually he returned to the steady production of easel painting in 1934, the experience of the large murals was evident in the works that followed, for there was a tendency toward a renewed simplicity, partly the outgrowth of the simplicity that was needed to cover the large walls of the Barnes Foundation (Figure 36) and also a reaction against the optical effects and detail of the Nice period works. In the Barnes Foundation Murals, Matisse had gone back to the theme of the dance, and to imagined rather than an observed subject matter. In his easel painting, he returned to painting from life, but began to simplify from life as he had simplified in the construction of the imagined imagery of the Barnes Murals. In paintings such as *Le rêve* of 1935, or the famous *Nu rose* (Figure 38), this process is once again apparent. This simplification is marked by a new sense of drawing in relation to painting. Whereas in the Nice period, as in the periods before, the drawing and painting were integral to each other (that is, the forms were painted and drawn simultaneously), in the paintings of the late 1930s the drawing very often acts in counterpoint to the large areas of colour, as in *Tête ochre* or *Grande robe bleue, fond noir* (Figure 39) of 1937, *Le jardin d'hiver* of 1937-8, or the Overmantel Decoration done for Nelson Rockefeller. These large works and others, such as *La musique* of 1939, signal a permanent return to large simplified areas of space, with very bright colour. Space in these works is less tangible than in those of the Nice period, the scale of the paintings is larger, and the cadences grander. In 1941, with the war around him, Matisse retired again to the south, and began his large cut *gouaches découpées*. His works of this period are even more simplified and the space even less tangible than in the paintings of the late thirties (see Figures 40-44). If in his late paintings, such as *Grand intérieur rouge* (Figure 44), he reduced the objects of the real world to signs and presented them in a rarified, intangible space, in many of the late cut-outs he arrived at imagery which seems to have no existence in space, which exists as pure idea, as in the grandly metaphorical *L'escargot* of 1953 (Figure 48).

When Matisse's painting is viewed retrospectively, it is seen to have a development that alternates between polarities of tangible and intangible space, three- and two-dimensionality, description and synthesis. During each of the major turning points in his art, the crisis involved a reformulation of pictorial space. From 1900 to 1908 he explored and built upon the pictorial means of the nineteenth century, basing his imagery on his sensations and feelings after nature. During the Experimental period he explored various means of achieving highly synthetic equivalents for those sensations and arrived at dynamic and original conceptions of pictorial space. By 1918, exhausted by the demands of his austere new formulations,[9] and perhaps needful of returning to more tangible means, Matisse backed away from the path that he had been following and returned to the cautious, empirical paintings of the Nice period. Instead of sustaining the symbolic abstract equivalences for light and space that he had explored between 1908 and 1917, he returned to analysis. In effect, he had backed away from the creation of imagery in which the sensations of light and space simultaneously are constituted by colour energy, and for a decade settled for the description of light and space through colour.

Around 1930 he began to advance again, working inductively from analysis toward synthesis. By 1940, the path was clear, and despite difficulties, he was finally able in the late paintings and

cut-outs to achieve that ultimate synthesis of light and space through colour to which he had first addressed himself some forty years earlier.

Matisse's key writings relate to these pivotal points in his career, and to his changing concerns. 'Notes of a Painter' coincides exactly with the transition into the Experimental period, sums up many of the concerns of his early career, and outlines the course that he would follow for the next decade. Thus it is a prime document in the painter's conception of his own recent work, as well as a summation and evaluation of many of the ideas that he had passed through en route. But although the years between 'Notes of a Painter' and the 1929 'Statement to Tériade' are some of the most important of his career, he wrote nothing and gave only a few interviews which merely repeated or elaborated on the ideas in 'Notes of a Painter', or which were essentially autobiographical. It is quite likely that he felt unwilling to theorize until he had arrived at a reformulation of his imagery.

The three statements to Tériade (Texts 8, 10, 13) reflect Matisse's concern, around 1930, with more synthetic imagery. Having spent over a decade seduced by the charms of southern light, and committed to a descriptive rather than a synthetic vision, Matisse was evidently impatient with his own progress, and seems to have felt that he had stood still or even retreated since the bold and daring works of 1916–17. Thus in these statements to Tériade, as well as in 'On Modernism and Tradition' of 1935 (Text 12), Matisse emphasizes the liberation of Fauve colour, the clarification of his visual sensibility, and the 'purification' of the means of expression: 'When the means of expression have become so refined, so attenuated that their power of expression wears thin, it is necessary to return to the essential principles which made human language. . . . This is the starting point of Fauvism: the courage to return to the purity of the means.' His statement refers as much to his recent painting, in which he had returned to pure colour and broad simplified forms, as to his original Fauve experience.

Though after 1929 Matisse seems to have become more willing to discuss his art, he still for the most part spoke in fairly concrete terms. Not until the 1939 'Notes of a Painter on his Drawing' does he begin seriously to elaborate on the symbolic quality of his forms. While in 'Notes of a Painter' he had discussed the process of how he arrived at his forms, in many of these later statements, he discusses the result: the creation of plastic signs. This idea, which runs throughout the late writings, has its equivalent in Matisse's paintings of the period, in which he had been reducing his objects into signs which, taken together, would form an ensemble in which the objects functioned like actors in a play or pieces on a chess-board, images that Matisse himself used repeatedly. Throughout the 1940s Matisse also developed the theme of keeping one's instincts fresh through contact with nature and avoiding clichés. In his later years there is a strong emphasis on synthesis from remembered experience rather than direct contact with a specific motif. These ideas also follow the development of his increasingly abstract imagery. Yet, curiously, they are quite consistent with his similar remarks in 'Notes of a Painter' about the value of working both from nature and from imagination.

In fact, Matisse's theoretical writings, even though they span almost half a century, have a remarkable consistency, possibly because his earliest writings date from a period of relative maturity. The major themes in his writings have to do with expression and with the relationship of art to what might be called 'sensations before nature'. Matisse's painting is based upon a condensation of fleeting sensations, recorded in the drawings, into a permanent image on canvas. Thus, although throughout his writings he constantly stresses expression and freshness of conception, the dependence of the artist upon nature is also emphasized. Matisse's intuition is informed, as it were, by deep self-appraisal and by contemplation of natural forms; he at all times tries to avoid formulae. These concerns are to be found in his earliest published state-

ments, such as the 1907 interview with Apollinaire and 'Notes of a Painter', and persist in statements made almost half a century later. His writings reflect his conviction that art is a form of projection of self through imagery, a form of meditation or contemplation which acts as a private religion. The artist develops his art by developing himself.

Later in life when he felt compelled to advise young artists, as in the 'Letter to Henry Clifford', Matisse mentioned, as he had forty years earlier in his school, the importance of the study of nature, technical proficiency, discipline, and the development of one's sensibilities. In this, as in so many other aspects of his career, he demonstrates the extreme importance to his later career of his early training: the forces and influences to which he was subject in the early part of his career, the same factors that he synthesised in 'Notes of a Painter', were to make themselves felt throughout his life.

The Historical Context

When at the turn of the century, in Paris, Matisse arrived at his first maturity as a painter, he was subject to more diverse influences and cross-currents than perhaps had existed simultaneously in a single place in the whole history of European painting. These influences were not only crucial to his early development but were also to have a lasting effect upon his whole career and were probably an important determinant of the polarity of imagery that marked his career as a painter, and which is reflected in his writings.

The basic matrix of his early development, the popular art of the time—that which one lived and breathed—was a curious composite of academic 'poetic realism' such as may be seen in the paintings of Bouguereau, and such *fin de siècle* phenomena as Art Nouveau. If the official Academic style represented the last degenerate phases of neo-Classicism and Realism brought to their ultimate degradation, what Ortega y Gasset has called 'a maximum aberration in the history of taste',[10] Art Nouveau, with its emphasis on decorative symbolism, may likewise be seen as a somewhat degenerate form of the Symbolist tendencies of the last third of the nineteenth century. These two styles present an interesting dichotomy, offering on the one hand imagery which is almost photographic in its rendering ('copy nature stupidly'), and on the other, imagery which is highly synthetic. In other words, Academicism and Art Nouveau represented polarities of imagery not unlike those polarities which were, transfigured, to run through the art of Matisse; the one three-dimensional, descriptive, realistic; the other two-dimensional, synthetic and symbolic. It must be realized that while neither Academic painting nor Art Nouveau necessarily had a direct or conscious influence upon the development of Matisse's later imagery, they both represented attitudes, habits of mind—even more important, vocabularies of form—which made up the essential visual milieu out of which Matisse grew and which he himself was later to redefine.

In opposition to such popular imagery, an important part of the culture of painting in France in the first years of the century was the, by then, 'tradition' of the *avant-garde*, the most important currents of which were Impressionism and post-Impressionism. Matisse, like any painter then working in Paris, was subjected to a series of reactions and counter-reactions against the traditions of this *avant-garde* as well as the traditions of the Academy and of the street as embodied in the official style and in Art Nouveau; all were to stay with him through the rest of his life. Perhaps more than any other major painter, Matisse represented not only a continuation but a constant reformulation of these currents which may, for the sake of convenience, be divided into two major groups: those in which the subject and motif were

real (actually derived from nature), and the technique improvised; and those in which the subject and motif were synthetic (not derived directly from nature), and the technique pre-determined. To the former category belong the Impressionists, Van Gogh, and Cézanne; to the latter the Academics, Seurat, Gauguin, the Nabis and Symbolists. In almost all cases, the main flow of tradition with which Matisse moved was that which dealt with direct sensations from nature and a technique improvised to correspond to those sensations, that is the tradition of the Impressionists and Cézanne. At the same time, the various traditions of syntheticism also had an enormous effect upon him. It was the balancing of these traditions, modified and informed by his own enormous will and intellect, that enabled Matisse to achieve his pre-eminent position.

Academic Painting

Matisse's experience of Academic painting had a curious effect upon his career: it was a tradition for which he expressed an active and long-lived contempt, yet his whole career was affected by what he learned and kept from it. Although he was repelled by the narrow-minded and moribund teaching that he had encountered there, and in his later years wrote and spoke out against it with passion, certain aspects of his École des Beaux-Arts background stayed with him all his life and had far-reaching effects on his thought. Despite Matisse's contempt for the École des Beaux-Arts, however, he was as powerless completely to do away with its influence on him as is a child to avoid the influence of a despised parent. In some part, at least, it seems that this was due to his late start as a painter.

As we have said, when Matisse arrived in Paris to study art in the winter of 1891–2, his previous training had consisted of drawing courses at the École Quentin-Latour (primarily a tapestry and textile design school) and his own efforts with one of Goupil's popular treatises on how to paint.[11] This book by Goupil, as might be expected, seems to have had some fairly direct influence on his early technique.[12] Further, the book, which is essentially a popularized compendium of nineteenth-century Academic practice, probably had some effect upon Matisse's early conception of what painting was, and some of the attitudes in it find specific echoes in Matisse's own later writings. At the very beginning of the book, Goupil discusses 'Initiative and Progress', saying 'How does one arrive at success? . . . Success is often only a long patience!!!'[13] The term 'a long patience' not only describes Matisse's later advice to younger artists,[14] but also describes his early career, during which he constantly forced himself to proceed slowly and thoroughly, even when frustrated by the system at the École des Beaux-Arts.

It is difficult to say for sure just what the twenty-year-old Matisse, recently taken by the desire to paint, would have found meaningful in Goupil. But there are themes that persisted in his thought which, though commonplace, he must have encountered there for the first time. 'Before one can create and compose pictures, it is indispensable to learn to copy', writes Goupil.[15] 'He who can copy can create', Matisse was to write in 'Notes of a Painter'. Goupil's emphasis upon copying the works of the old masters must also have affected Matisse's early ideas on painting. Goupil urges copying both nature and the works of the masters, and quotes Delacroix to the effect that one should make the study a pleasure: 'One therefore retains the memory of fine works by means of labour which is not at all accompanied by the fatigue and inquietude of the mind of the inventor who has had the anguish of the original work.'[16] That this feeling stuck with Matisse may be witnessed by his 1942 remark to Gaston Diehl that 'too

many of the young painters have thought it well to neglect the study of the masters; that alone, however, permits one to take account of the possibilities of expression of colour and drawing.'[17] Goupil also suggests the use of photographs as models, a procedure that Matisse used, especially around 1900,[18] although once again the practice is so general as to make it impossible to attribute it directly to the influence of Goupil.

Certain aspects of Matisse's later teaching also seem to be related to phrases from Goupil which, while not particularly original, may have stayed with Matisse. Goupil, in his discussion of working from the model advises: 'The painter who wants to make a picture should begin first of all by fixing his idea on the canvas. It is through drawing that one sets the general composition and gives to each thing in particular the form that it should have.[19] Although quite simple, such advice forms a leitmotif in Matisse's writings. To be sure, a good deal of Goupil's advice is quite general, even simplistic. Although it would be absurd to think that Matisse actually followed it all his life, it is evident that such an outlook, based on methodical study of nature, was part of the foundation of the attitude to painting on which he would later build.

Matisse's early training in Paris followed the same lines as his introduction to painting in Saint-Quentin and Goupil's book; he relied upon the standard approaches and the traditional methods. His experience at the Académie Julian, a private school taught by professors from the École des Beaux-Arts, and in the atelier of Bouguereau and Ferrier disgusted him by the quality of the teaching and made quite an impression for he would repeatedly refer to it in later life as a symbol of all that was wrong with the Academic system.[20]

In 1942, he told a radio interviewer: 'Undoubtedly the instruction given at the Beaux-Arts . . . is deadly for young artists',[21] and yet, despite his reaction to the Beaux-Arts teaching, which included that of the hated Bouguereau, Matisse in 1948 was to write urging the patient study of nature in words that bear a striking similarity to Bouguereau's ideas on the training of the artist.[22] And in 1892, when Matisse failed the entrance examination to the École des Beaux-Arts, he decided, instead of working as an independent, to draw in the glass-enclosed Court of the 'Cours Yvon',[23] where he attracted the attention of Gustave Moreau, who accepted him as a student in his atelier.[24] In Moreau's studio Matisse at last found a sympathetic atmosphere. Although Moreau was almost totally oblivious of the 'modern' advanced works of such painters as Van Gogh, Gauguin, and Cézanne, he was a very liberal teacher with catholic tastes and a good sense of his students' individual personalities. Though Moreau seems to have given Matisse little direct criticism of his work, he supported him enthusiastically and gave him a 'liberal education' in painting for which Matisse later felt a real sense of gratitude.[25] Further, even though Matisse's works of this period (mostly interiors, still-lifes, and figure studies in a somewhat dark tonality) have little in common with the sumptuous fantasy of Moreau's paintings he doubtless absorbed some of Moreau's ideas about imagination, and these would later appear in his own writings. Such thoughts as 'Colours must be thought, dreamed, imagined',[26] or 'I believe neither in what I see nor in what I touch, I believe only in what I feel. My brain and my reason appear to be ephemeral and of doubtful reality. Subjective emotion alone seems to me to be eternal and unquestionably certain',[27] have strong analogies with some of Matisse's own statements in 'Notes of a Painter': 'I am unable to distinguish between the feeling I have about life and my way of translating it.'

At this time Matisse was still proceeding very slowly, working on small unimaginative canvases, perfecting his technique and doing copies of paintings in the Louvre, mostly Baroque and Rococo works, many of the French school, in which he gave himself the opportunity to study the structure and composition of such masters as Poussin, Philippe de Champagne, Watteau, Fragonard, Boucher, and especially Chardin.[28]

Matisse's ambitions at this time also seem to have been somewhat ordinary. In the spring of 1896 he exhibited four works at the Salon de la Société Nationale des Beaux-Arts, and sold two of them.[29] He was also elected an Associate Member of the Société, a considerable honour which gave him the privilege of exhibiting several works each year without having to submit them to the Salon jury, and which also increased his chances of selling both to collectors and to the State. That summer, when he went to Brittany and painted out-of-doors, he still kept his somewhat muted palette and saw and composed in terms of value tones rather than colour, and both his subject matter and method of working, massing darks and lights, striving after the general effect seen in terms of chiaroscuro rather than colour, are very much in the tradition of the Academic landscape study (see Figure 4).[30] It was not until 1897 that Matisse, inspired by the Impressionists, began to break away from the Academic tradition and to reach toward a new vision. But even after spending the entire year of 1898-9 working mostly out of doors and in the Impressionist manner, when he returned to Paris in February 1899 it was to the atelier of the late Gustave Moreau. Although part of the reason behind his return to student status surely had to do simply with needing to work from the model, it is evident that at this period he still considered himself a student.[31]

In 1900, when Matisse at last truly became an independent painter, he had spent a full decade more or less under the influence of traditional methods of training, and had been exhibiting in the conservative salons. (Not until the spring of 1901 did he exhibit at the Salon des Indépendants, his first overt step in the direction of the *avant-garde*.) From his Academic training he obtained a great respect for the necessity of technical proficiency and a belief in the study of nature as a means of arriving at truth. This provided him with firm roots in the traditions of the nineteenth century and doubtless contributed to the streak of conservatism that ran through his later thought. At the same time it also gave him the confidence and proficiency which would serve as a source of liberation from the very tradition which had nurtured him.

Decorative Art

Matisse had a profound and abiding interest in decoration and decorative art. Throughout his life he expressed this interest in his constant use of decorative objects (rugs, tapestries, screens, vases, etc.) as motifs for his paintings and drawings, and by his interest in large decorative paintings, such as the Shchukin *La danse* and *La musique*, the Barnes Murals and the late cut-outs. The aesthetic of decoration was also expressed in his writings, especially 'Notes of a Painter'.

When in October 1892, Matisse enrolled for an evening course at the École des Arts Décoratifs, he may have reflected an early interest in the decorative arts, which often tended during the 1890s to be allied to the Fine Arts.[32] When the convalescent Matisse was introduced to painting in 1890, it was by the director of a textile factory who occupied the next bed,[33] and his first formal training was at the École Quentin-Latour, under what he himself characterized as 'draftsmen who designed textiles'.[34] It seems therefore likely that he may early have come to know and take an interest in a book like Henry Havard's *La décoration*.[35] Some of the ideas in this book have indeed sufficient parallel to parts of Matisse's 'Notes of a Painter' to warrant mention. Havard discusses general similarities and differences between painters and sculptors and decorators, noting that there is a separation between them, even though 'all the arts seek Beauty'.[36] He then goes on to discuss some of the differences between artists (e.g. history painters, etc.) and decorative artists. He notes that while artists can depict violent

movement, decorators should avoid it, that while painters can depict sadness, horror, disgust, and pain, decorative artists should not: 'The duty of the decorator . . . is not to provoke sentiments of fear or enthusiasm, but simply to adorn, and embellish. He should interest the spectator, but never move him.'[37] The decorative artist, Havard goes on to say, should avoid subjects which provoke an intense emotion, and should be careful not to create an illusion, not to imitate nature too closely.[38] These thoughts not only seem germane to Matisse's painting around 1908, but have an equivalent in 'Notes of a Painter' where Matisse states his desire for 'an art of balance, of purity and serenity, devoid of troubling or depressing subject matter . . . a soothing, calming influence on the mind . . .'—a statement of his belief in painting as a decorative, purely visual, as opposed to narrative art. Havard speaks similarly of decoration: 'The role of decoration . . . is uniquely to charm the eyes. That is why the decorator so often has recourse to fabulous representations to express abstractions . . . not being contained within the limits of reality he can give free rein to his fantasy, and with the aid of these gracious fictions produce exquisite creations.'[39] Havard's comments seem not only to relate to some of the ideas in 'Notes of a Painter', but also to Matisse's paintings of that period. Speaking of the use of modern subjects it is noted that the artist 'should carefully avoid giving these objects too real an aspect, which would certainly attenuate their emblematic value'.[40] Most of Matisse's works of this period avoid this 'too real aspect' by generalized rendering of costume (which perhaps carries over even into the odalisques of the Nice period), and by using nude figures—thus avoiding a sense of specific time and place—even in such topical works as the *Joueurs de boules* of 1908 (Figure **19**). In keeping with the aesthetic of decoration, Havard insists that the decorator should make his form quite legible: 'He should underline the principal features, to accentuate their character',[41] which is quite in line with Matisse's insistence upon reducing things to their 'essentials'. Havard also notes that the painter should represent only the durable: 'All violent actions whose transitory character is too accentuated, are ill-suited to decorations which are fixed for a relative eternity on the place which has been given to them',[42] a sentiment that has direct parallels in 'Notes of a Painter'. Thus it seems that the aesthetics of decorative painting had their part in Matisse's formulation of his own ideas on painting and in his paintings themselves.

In addition, Matisse was quite obviously influenced by certain aspects of Art Nouveau decoration, which comprised an important aspect of the visual environment at the turn of the century. S. Tschudi Madsen has noted that the 'principal ornamental characteristic of Art Nouveau is the asymmetrically undulating line terminating in a whip-like, energy-laden movement',[43] a description which might well characterize some of the impulse behind the arabesques in Matisse's painting from 1905 onward. As Trapp has remarked, a good deal of the impulse behind Matisse's early sinuous arabesques, such as that of *Bonheur de vivre*, seems to come out of the milieu of Art Nouveau, and also to be connected with paintings such as Derain's *L'Age d'Or* of 1905, or Long's *Pan* of 1899, both of which represent bacchanals in a landscape.[44] Trapp further goes on to point out the similarity between several of Matisse's large interiors such as *Harmonie rouge* of 1909 (Figure **20**) and *Grande nature morte aux aubergines* of 1911, with various Art Nouveau interiors.[45] Matisse not only adopted the superficial look of Art Nouveau, but he seems to have well understood its symbolic character. Madsen has noted:

> If we penetrate still deeper into the nature of Art Nouveau ornamentation, we shall find that at times it may constitute a feature of the object which is endeavouring to express something. This may both apply to its function as an artifact and be a purely aesthetic

element. We are here approaching the significance of Art Nouveau decoration as a symbolic factor. In this respect its most important aspect is its ability to emphasize the structure of form and, next, to fuse the object and its ornament into an organic entity: the aim is unity and synthesis. . . . The budding, growing ornamentation thus reflects essential elements of Art Nouveau—the very force and creative ability of the style.[46]

Matisse's early arabesque, that seen in the *Bonheur de vivre* (Figure **17**), seems to come directly out of the immediate milieu of Art Nouveau; indeed his use of the arabesque seems throughout his career to have had a distinctly metaphorical or symbolic character. During the most synthetic moments of the development of his style, as in the period from 1905 to 1917, and from 1930 onwards, Matisse made great use of the symbolic arabesque, to express growth or 'becoming'. During the less synthetic moments of his stylistic development, as in the period before 1905 and during the Nice period from 1917 to 1929, he made less use of it. Thus the arabesque seems to have had a direct correspondence in Matisse's art to his most synthetic style, and may be seen as an important by-product of his experience with and understanding of Art Nouveau.

Impressionism

If when Matisse worked in his most synthetic mode he seems to have relied upon his essentially Art Nouveau-inspired arabesque, when he worked in a more naturalistic or descriptive style, he seems instead to have gone back to the tradition of Impressionism.

As Meyer Schapiro has shown, many aspects of Matisse's style, including his subject matter, seem to derive from Impressionism. Schapiro points out that 'the flatness of the field or decomposition into surface patterns, the inconsistent, indefinite space, the deformed contours, the peculiarly fragmentary piecing of things at the edges of the picture, the diagonal viewpoint, the bright, arbitrary color of objects, unlike their known local color, constitute within the abstract style of Matisse an Impressionist matrix.'[47]

Impressionism represented for Matisse his first and most vivid awareness of the analysis of light and the creation of the effect of light through pure colour. As he himself stated, before his awareness of Impressionism he transposed in the transparent tones of the Louvre;[48] the dark, old master palette which he had used was determined both by his experience in the Louvre and by the palette of the Academic painters. Even his first ambitious Impressionist composition, *La desserte* of 1897 (Figure **5**) is indeed a very conservative brand of Impressionism. The colour is brushed on in somewhat broad strokes, more in the manner of early Manet than Monet or Renoir, and the breaking up of colour within local colour areas, even in the white of the tablecloth, is not nearly so dynamic as that of the Impressionists. *La desserte* in retrospect seems more of an Academy piece with an Impressionist inflection than an Impressionist picture. Matisse's first really Impressionistic paintings date from the summer of 1897, when he brightened his palette and began to conceive of his pictures in terms of colour sensations rather than masses of light and shadow. In 1897 he also met Pissarro, who encouraged him to work in an Impressionist manner, and even advised him to study Turner in London as Pissarro himself and Monet had done in 1870—advice which Matisse did in fact follow in January 1898. When Matisse left Paris for the South shortly after his return from London, he was already committed to a new vision and a new method. He set out consciously to seek out vivid optical sensations and to record them directly. The canvases executed during that year in

Corsica and near Toulouse are mostly small landscape sketches concerned with the general impressions of the landscape, but conceived in terms of colour rather than values (see Figure 6). While in a certain sense they are as much landscape *études* as were the pictures executed at Belle-Île in 1896, the intention is entirely different, effects of chiaroscuro being sacrificed for vividness of colour and a certain surface tension. By the end of 1899, in *Nature morte à contre-jour* and *Buffet et table* (Figure 8), in which form is actually dissolved by light and the components of areas of local colour are analysed and described, though exaggeratedly, he had achieved a kind of personal Impressionism.

Matisse, however, tended constantly to see form as integral rather than as dissolved by light, and as a result did not long stay with orthodox Impressionism. At the same time, the influence of Impressionism upon his succeeding works is marked by liberation of colour and by a certain delectation in the rendering of light and light effects. In 1904–5, during his neo-Impressionist or Divisionist phase, he managed to merge some of the technique and vision that he had learned from his Impressionist studies with a greater synthesis of form and a structural ordering of colour. This experiment was also short-lived, but had a pronounced effect upon his following works, especially those of the high Fauve period (1905–6), after which he moved constantly away from Impressionism to other concerns. He began to seek a greater solidity and structure in his pictures, and moreover a greater synthesis of his vision itself. This is clearly reflected in 'Notes of a Painter' where he writes: 'Often when I start to work I become aware of fresh and superficial sensations. . . . A few years ago I might have been satisfied with the result . . . I would have recorded fugitive and momentary sensations which would not completely define my feelings, which I would barely recognize the next day.' He goes on to characterize the Impressionists, saying, 'The word "impressionism" perfectly characterizes their style, for they register fleeting impressions.'[49] Matisse, seeking at this time more enduring images, based on a 'condensation of sensations', turned away from Impressionism somewhat as Cézanne had done a generation before him, and in search of similar ends. For Matisse, who wrote of his inability 'to distinguish between the feeling I have about life and my way of translating it', truth was to be found in the confrontation between the individual personality and nature, not in nature itself. He expressed his understanding of this when he said, 'A Cézanne is a moment of the artist while a Sisley is a moment of nature.'[50] Matisse's ambitions lay in the direction of Cézanne rather than of Impressionism.

It is significant, however, that when during the Nice period he began to return to direct observation of nature, his Impressionist experiences of some twenty years earlier had a profound effect upon him.[51] The paintings of the Nice period are good evidence of this. For one thing, unlike those of the Experimental period, they have much of the casualness of objects seen at a glance. As Schapiro says of painters after Monet, 'They discover their pictures in looking around at objects, and execute swift sketches which have the immediacy of a glance. Sensibility operates instantaneously, in the very act of seeing.'[52] This is seen in many of Matisse's paintings of the Nice period, which dwell upon the fleeting effects of light and texture (see Figures 31–33), and which often have truncated compositions. Matisse's consciousness of the Impressionist tradition before him may be seen especially in the Etretat series executed in 1920, in which he painted the Needle and the Elephant rocks on Etretat beach, a theme especially dear to Monet. Even Matisse's return in the early 1920s to paintings done out-of-doors is part of a conscious return to nature via Impressionism, as is his return to tonalities of yellow and violet, which give a distinct sense of atmosphere and of light and shadow. It was not until the transition into the more austere works toward the end of the Nice period, that he finally moved away from a distinctly Impressionist attitude.

The Impressionist experience, however, was deeply rooted in Matisse's mentality, and when he designed the stained-glass windows for the Chapel at Vence, the colour scheme of green, violet, yellow and blue with which he broke up the light coming through the glass and the fragmentation of the forms of the windows into little sections, is an indirect but positive echo of Impressionism. Thus it may be seen that Impressionist doctrine not only affected Matisse in his formative years, but remained throughout his life a force in his paintings and writings.

Cézanne

Cézanne's influence upon Matisse is extremely rich and varied, and most important. No other outside influence seems to have been so strong, yet no other influence was more thoroughly assimilated. Despite Kurt Badt's contention that Cézanne had no heir or successor, it seems that Matisse (even more than the Cubists) represents the continuation of the tradition of Cézanne.[53]

The influence of Cézanne upon Matisse is seen alike in motifs, techniques, and attitudes. Throughout the earlier part of his career, Matisse made significant use of compositional motifs taken from Cézanne, as in his *St. Tropez: la baie* of 1904 which closely resembles, among others, Cézanne's *L'Estaque: la baie*.[54] Although Matisse's brushwork is broader, his colour brighter, and his form less solid, the painting expresses his desire to treat in his own way some of Cézanne's actual motifs and compositional devices.

This may also be seen in *Carmelina* of 1903 which shares with Cézanne's *Portrait de Chocquet* 1879–82[55] a similar compositional format (placing the figure firmly in the middle of a series of rectilinear forms which echo the format of the painting itself), and an opportunity to use Cézannesque modelling. Although the colour scheme in *Carmelina* does not have as complicated a break-down of local colour areas as does the Cézanne portrait, the sense of form and of the total pictorial space is very similar, and *Carmelina* has in common with the Cézanne portrait a sense of simultaneous solidity of form and two-dimensional design.

Nature morte au purro, I of 1904 (Figure 12) is also an excellent example of Matisse's Cézannesque handling of form during this early period in which Matisse developed a certain sense of clear colour, of solidity and austerity. After the height of the Fauve period, in order to solidify his forms, he returned again to Cézanne, as may be seen in such paintings as the Barnes *Nature morte bleue* of 1907 and, in a less obvious way, *Nu bleu* (Figure 18) of the same year.

In 1911, one of the most crucial years of Matisse's development, he began once again to resynthesise his forms after Cézanne. *La fenêtre bleue* of 1911 (Figure 24) seems quite obviously to be based upon Cézanne's *Le vase bleu* (Figure 25) which had been given as part of the Camondo legacy to the Jeu de Paume in 1911. The two paintings have much in common besides their blue tonality. The dense and poetic handling of space in *Fenêtre bleue* is extremely Cézannesque, especially in terms of the modelling and the interaction between painting and drawing. Furthermore, both paintings share a similar compositional device of centring objects in relation to a frame-with-a-frame: the window in the Matisse and the window frame in the Cézanne. Both paintings also have a tendency to make vertical divisions of form in which various objects are centred in relation to other objects in a series of changing near-symmetrical relationships. This multiple centring of objects gives each painting its sense of simultaneous repose and dynamism.

Even during the Nice period, Matisse tended to refer back to certain Cézannesque devices, although toward different ends. *Les joueurs de dames* of 1923, for example, is quite obviously

based upon the early Cézanne *Overture de Tannhauser*, in which the patterning of the wall behind the piano also expresses a visual embodiment of the music.

Another adaptation by Matisse from Cézanne, one which had an extraordinary longevity in the formulation and reformulation of his pictorial means, was the study of the figure imagery of his own Cézanne, *Trois baigneuses* (Figure 9), which he had bought in 1899. Its influence may be seen in both the subject matter and certain aspects of pose in both *Luxe, calme and volupté* of 1904-5 (Figure 13) and the *Bonheur de vivre* of 1905-6 (Figure 17).[56] Further, the Cézanne *Trois baigneuses* seems to have been one of the major impulses behind Matisse's use of imagined idyllic and pastoral subject matter. The adaptation of specific motifs from the painting may be seen in Matisse's *Baigneuse* of 1909, in the four reliefs of *Le dos* (1909-30), and in the Barnes Murals of 1931-3.[57]

Matisse's return to his own Cézanne around 1930 seems significant. This reconception and simplification of form at the end of the Nice period reflects some of his feeling towards Cézanne, who seems to have represented for him an ultimate synthesis and condensation, as opposed to the much more immediate and fleeting effects which could be created with a version of Impressionist vision. Within Matisse's hierarchy of visual contexts, that of Cézanne gave him the greatest structural awareness and feeling for synthesis, a realization of the enduring quality behind objects. Thus at certain crucial moments in his career he seems not only to have turned to Cézannesque motifs, but also to a certain Cézannesque technique, as in *L'atelier du quai Saint-Michel* (Figure 29), in which the fluidity of the forms, the dynamism of the plastic space, the constantly shifting planes, and the uncanny sense of simultaneous two- and three-dimensionality are all part of the legacy of the Master of Aix-en-Provence.

There are also distinct parallels between Matisse's thought and that of Cézanne, many of which are pointed out in the notes to the texts, below.[58] In general terms Matisse shares with Cézanne a sense of research with regard to arriving at a fully 'realized' canvas. This sense of study and research which runs throughout Matisse's writings has a definite precedent in Cézanne.[59] Like many other aspects of Matisse's painting it had its roots in nineteenth-century empiricism in a way that quite differentiates it from Cubism.

Cubism

Although Picasso was not far off when he said that he and Matisse represented the North and the South poles, they both had a common point of departure in Cézanne.[60] For each of them Cézanne amounted to something like a talisman, a paragon, and a definition of modernity; but each interpreted and synthesized Cézanne to a different end. While Picasso took from Cézanne the outward structure of his late paintings and brought it to a conclusion beyond anything that Cézanne had conceived, Matisse saw in Cézanne a method of perception rather than of construction. For while Picasso was committed to the *avant-garde*, Matisse always balanced his daring with a good measure of caution. 'Matisse possessed, as the counterpoint of his recurrent boldness, an almost equally persistent streak of caution. It was a part of his strength; he never moved until the way ahead was clear.'[61] While Matisse mistrusted modernism for its own sake, Picasso espoused it, and while Matisse considered his paintings to be researches, probing into a difficult and elusive reality, Picasso was ever ready to impose his own truth: 'To search means nothing in painting. To *find* is the thing.'[62]

At the turn of the century the arts in general were involved in seeking a new workable balance between the objective and subjective, what Shattuck refers to as the 'self-reflexive'

element of modern art;[63] both Matisse and the Cubists, strongly tied to Cézanne and to an essentially Bergsonian outlook, reflect this.[64] The Cubists, no less than Matisse, were involved in the problem of reaching a truth underlying visual experience, and their early professed aims bear a certain similarity to those of Matisse.[65] The pictorial means they arrived at, however, differed, and by 1911 any similarity between their goals had become barely recognizable. For while in 1908 both were involved with depicting a kind of Bergsonian knowledge of the objects they painted—in which accumulated memory and experience become the basis for the knowledge of objects—the Cubists tended to move increasingly toward an art of deduction,[66] whereas Matisse maintained, with only a few exceptions, an art of induction. Thus while the legibility of objects in Cubist paintings between 1908 and 1911 was becoming increasingly more difficult, the representation of objects in Matisse's paintings remained clear. While Matisse stayed with an inductive, empirical method, based on direct visual sensations and an attempt to avoid pre-knowledge of objects (a legacy of nineteenth-century empiricism, the Impressionists, and Cézanne), the Cubists arrived at an art of deduction, in which the process of deduction depends on inventing forms from pre-existing ideas.[67] Within this context the physical work of art could contain concrete fragments of unsynthesised reality (undisguised collage elements) which became part of the new reality of the work of art by participating in an ensemble which was composed of fragments of pre-existing ideas, rendered in a predetermined fashion.

In other words, the Cubists and Matisse, starting initially from similar assumptions about painting, worked toward divergent ends, both by intention and in terms of the pictorial means employed. The Cubists throughout the Analytic phase constructed in terms of a limited fairly tangible relief space, whereas Matisse's pictorial space at this time is much less tangible. In Matisse, space is not described so much as it is suggested; in an Analytic Cubist painting the limits of the pictorial space are fairly well described even though the objects which fill it are not. Further, whereas the Cubists constructed in terms of geometry, Matisse constructed in terms of the arabesque, and while the Cubists used colour to describe form in space, Matisse used it to constitute space itself. The Cubists in this early phase relied upon the modelling of form with dark and light in order to construct a sculptural space, whereas Matisse constructed space in terms of colour and thereby arrived at a pictorial space which has less plastic actuality.

Within these contexts, the problems of the description of objects were different. Whereas Matisse invented forms which were synthetic equivalents of objects, the Cubists invented new objects. This may be seen in a painting such as Picasso's *Ma Jolie* of 1911, in which, although the forms suggest a woman with a guitar, what is actually described in the painting is a combination of brush-strokes, lines, and planes in a limited but internally fluid space, which is activated or animated by fragments of figurative imagery. The subject is represented as a gathering of energies rather than as a discrete form. In order to maintain the legibility of the objects being described in such a painting, the painter resorts to clichés to describe parts of the subject involved. Throughout the Analytic Cubist painting of this period, the forms used to describe eyes, hands, ears, pieces of rope, fragments of musical instruments, etc., are self-conscious clichés (pre-existing ideas) which are easily legible. This cliché aspect of Analytic Cubism maintains the legibility of the total image of the painting. In Matisse's paintings of this period (Figures 19–24) the overall imagery is extremely clear, but the details of many of the forms are so synthetic that they would be meaningless outside the context of the painting. Whereas the rendering of a hand in an Analytic Cubist painting may be identifiable outside the context of the painting, many of Matisse's forms in this period, although they are very

clear within the context of the painting, are almost completely illegible as discrete objects outside that context. Thus the Cubist painting not only constructs a distinct plastic space, it also constructs an internal temporal environment. Because the painting is perceived as an accumulation of details, and because of the relatively difficult legibility of many forms, the painting not only articulates its own temporal environment, but also imposes that sense of time upon the consciousness of the viewer, since, like words on a printed page, the Analytic Cubist painting cannot be taken in at a glance. A Matisse painting, on the other hand, involves a simultaneous presentation of its spatial totality. While the Cubist painting is composed of a series of occurrences or interactions of form which happen in time, with something like a causal relationship between them, a Matisse painting is literally read as a condensation of sensations into a total image which suggests past and future time, but which is unequivocally depicted in terms of the 'present'. Thus while Matisse's paintings almost never have any internal sense of cause and effect, they almost always have a strong suggestion of before and after. Just as an Analytic Cubist painting constructs a plastic actuality, so it constructs a temporal actuality; whereas in the contemporary paintings of Matisse time is no more actual than space.

Although it is quite likely that the flowering of Cubism around 1911 may have given Matisse an added impetus and boldness in his own formulations at that time,[68] he remained constant to an inductive method based on actual vision. Although he occasionally deviated from this,[69] even his most austere and geometric works, such as the *Leçon de piano* of 1916 (Figure 27) are an organic part of his imagery and have little to do with Cubism. Around 1918, when he seems to have exhausted his involvement or belief in synthetic imagery, he returned to empirical descriptive painting, the legacy of the nineteenth century. When he returned to synthetic imagery after 1929, he first worked in terms of reformulating his earlier imagery (as in the Barnes Murals), and then once again from life. And even, toward the end of his life, when he began to work in his most abstract style, his method remained largely inductive, as may be seen in his description (Text 42, below) of the evolution of *L'escargot* (Figure 48).

This attitude persists also in his later pedagogical position (Texts 33, 35, 43, below), and in his attitude toward non-figurative art (Texts 34, 42, below), which he saw as 'abstractions based on abstractions'. For Matisse art was always more or less directly based on visual observation, even in his last, magnificently metaphorical works. 'My destination is always the same but I work out a different route to get there', he wrote in 1908, and the words turned out to have a truth far beyond what he could then have imagined.

It is in this sense that Matisse also presents one of the most striking paradoxes in all modern art. His reliance upon actual sensation from nature and his mistrust of purely synthetic means of expression seem to be almost anti-modern, especially in contrast to the theoretical bases of the Cubists and other schools independent of direct, empirical observation. Yet his flexibility and acuity of awareness allowed him to transcend the object by realizing form and space in terms of pure colour. As Gowing has pointed out, 'In the end, when the developments of the first half of the twentieth century were complete, it was apparent that while for his contemporaries representation of one kind or another and the basic reference to form had outlasted the luminous substance of painting, with Matisse the reverse had happened. Light had outlasted representation. . . . No one else was travelling the same way. Matisse had developed a self-protective, conservative attitude.'[70]

Matisse's imagery depended upon the sensations of light energy upon the eye and mind of the artist. In this adherence to purely visual phenomena, he remained perhaps the only major painter of his period to construct space in a purely visual way, with light energy articulated by colour.[71] In this sense, Matisse, like Cézanne, stands apart from the schools and systems

that were contemporary with him. While for the Cubists, especially Picasso, the history of art was like a vast encyclopaedia of forms which, through modification, could be reinvented into new forms or recombined into new entities, for Matisse the history of art served mainly as an impetus to new modes of vision. Thus while many influences can be seen at work in his paintings, they never possess the conscious eclecticism of Picasso or Braque. Instead Matisse drew from the past what he needed to organize and put into context his own sensations before nature, and therefore, unlike Picasso, who created a whole new language of forms and shapes—of new characters, as it were, in the world of painted imagery—Matisse arrived at a new formulation of pictorial space itself. It was precisely the openness of his attitude and his extreme flexibility which allowed him constantly to revitalize himself from the same sources and to create a notion of pictorial space which, because of its empirical, totally pictorial nature, can be seen as no less than the discovery of a new reality for painting.

It is this, above all, that has made Matisse so important to painting today.

The Texts

In the following collection, Matisse's writings have been arranged chronologically; each selection is preceded by a critical introduction, and each is annotated in order to explain certain points, identify persons and circumstances not generally known, and to call attention to significant parallels in other statements by Matisse and others.

A word should be said about the use of the term 'writings' since the present volume is both more and less than a collection of Matisse's complete writings. The term is here meant to denote the body of Matisse's significant statements on art regardless of the manner of presentation. These are of three types: statements written by the artist, statements transcribed by someone else, and interviews. The present collection includes all of Matisse's own significant writings, and most of the transcribed statements and interviews. The final criterion for the selection has been to represent as fully and deeply as possible Matisse's thoughts on art. Almost all the texts presented here have either been published during Matisse's lifetime or were approved by him before his death. Taken together, then, they represent his formulation of the principles and ideas behind his art, as well as his observations on his career, on the various art movements of importance which occurred during his lifetime, and on some problems of the arts in general.

Within this context, the artist's general correspondence has been of only limited interest since most of his letters to friends and relatives are concerned with daily affairs and problems of the sort that make up any man's life. When these letters do discuss artistic problems, they are often confined to a brief mention or discussion of the problems inherent in single works, and although such letters are interesting from a documentary point of view their general interest is limited. Further, those letters which do address themselves to general problems and attitudes usually repeat or echo public statements. Because of this, and because most of the available letters have recently been or soon will be published—see the Bibliography—the present collection does not include Matisse's general correspondence. The available letters have, however, been carefully examined and are quoted from where they seem relevant to the specific texts and ideas here presented.

Such diverse writers as George Moore and Vladimir Nabokov have argued that translations should sound like translations. In the following, I have tried to preserve the original sense by

following, whenever possible, the phrasing and sense of wording of the originals. In many instances gallicisms have been retained in order to preserve some of the vividness although occasionally I have transposed person or tense to conform to more natural English usage.

Apart from the few cases where a text was originally published in English and the original French manuscripts has not been obtainable, all the texts except Texts 1 and 21 have been retranslated expressly for this volume and all translations are my own.

The Texts

I

Apollinaire's Interview, 1907[1]

In December of 1907 the poet and critic Guillaume Apollinaire published an essay which contains four quotations by Matisse. While the general style is lyrical ('When I came to you, Matisse, the crowd had looked at you and as it laughed at you, you smiled'), Matisse's own statements are marked by the calm sobriety which was to characterize most of his theoretical writings and his interviews.[2] For the most part Matisse's statements are on a personal level. He says very little about his specific theories of art, but does speak of his general method of conception, which he equates with self-discovery, as when he relates how he found his artistic personality by looking over his earliest works, and how he made an effort to develop it by relying on 'intuition' and by returning always to 'fundamentals'. This emphasis upon fundamentals is of particular interest, for it is a point that Matisse was to return to again and again. At this time, Matisse was also somewhat defensive about his reliance upon the art of others, most notably Cézanne, and both courage and a certain defensiveness may be noted in his statement that he never avoided the influence of others. This conception of the development of his own art in relation to other artists and nature is Matisse's first public statement, here only implicit, of his belief that the act of creation is a synthesis of the individual's relationship to the art that has come before him and his own confrontation with nature.

APPOLLINAIRE'S INTERVIEW

I have worked . . . to enrich my knowledge by satisfying the diverse curiosities of my mind, striving to ascertain the different thoughts of ancient and modern masters of plastic art. And this study was also material because I tried at the same time to understand their technique.

Then . . . I found myself or my artistic personality by looking over my earliest works. They rarely deceive. There I found something that was always the same and which at first glance I thought to be monotonous repetition. It was the mark of my personality which appeared the same no matter what different states of mind I happened to have passed through.

I made an effort to develop this personality by counting above all on my intuition and by returning again and again to fundamentals. When difficulties stopped me in my work I said to myself: 'I have colors, a canvas, and I must express myself with purity, even though I do it in the briefest manner by putting down, for instance, four or five spots of color or by drawing four or five lines which have a plastic expression.'

I have never avoided the influence of others, I would have considered this a cowardice and a lack of sincerity toward myself. I believe that the personality of the artist develops and asserts itself through the struggles it has to go through when pitted against other personalities. If the fight is fatal and the personality succumbs, it means that this was bound to be its fate.

2

Notes of a Painter, 1908[1]

'Notes of a painter', Matisse's earliest theoretical statement, and one of the most important and influential artists' statements of the century, was written at a time when he was involved in controversial ideas about painting and seems to have been opposed especially to certain aspects of contemporary Cubism.[2] This essay is an attempt by Matisse to state the basic tenets of his art and by implication to clear himself of some of the criticism levelled against him.[3]

The presentation of ideas in 'Notes of a Painter' is quite methodical, and seems to reflect Matisse's legal training. He begins the essay with a disclaimer, saying that the painter who addresses the public with words exposes himself to the danger of being literary, but notes that other painters have written about their work, thereby associating himself directly with his contemporaries and indirectly with such illustrious names as Leonardo, Ingres and Delacroix, who also wrote extensively.

The ideas that Matisse discusses are relevant not only to his painting of around 1908, but are for the most part germane to his pictorial thought until his death. It should be remembered that when Matisse wrote this he was no longer a young man; in 1908 he was already thirty-nine years old, and although he had not by far exhausted the range of his stylistic development, much of his basic theoretical outlook was already formed. Matisse's theory was, with certain modifications, generally valid over a long period of time and for a great number of stylistic changes. This has to do with a basic outlook expressed in 'Notes of a Painter', where he notes that his fundamental thoughts have not changed, but instead have evolved and that his modes of expression have followed his thoughts; it also has to do with the general nature of the ideas expressed: Matisse's essay is more philosophic than technical.

One of the basic ideas of 'Notes of a Painter', and of Matisse's whole theory of art, is his professed goal of 'expression', which is inseparable from the painter's pictorial means. The

emphasis here is on the creation of intuitive symbolism through perceptual experience. As Gauss has said of this expressionistic viewpoint of art, 'This intuition is a consciousness of life which is of the nature of a religious attitude. They [expressionists] make no distinction between their consciousness of life and their manner of expressing it. The work of art is thus a sample of the feeling it expresses. It is only the rendition of that feeling in concrete form. The work of art is therefore a symbol in a special sense.'[4]

This emphasis on intuition also has much in common with the writings of Bergson (1859–1941) and of Croce (1866–1952), whose ideas were current at the time. (Croce's *Aesthetics* was published in 1902, Bergson's *Creative Evolution* in 1907.) The broad concepts of Bergsonism were especially in the air at the time, much as Einstein's theory of relativity, or, much later, Sartre's Existentialism would be. Not only were these ideas current among artists and writers; they also found their way, condensed, into the popular press (in the same way as Matisse's own ideas later, somewhat garbled, were to find their way into the *New York Times Magazine* in 1913).[5] There are indeed similarities between certain aspects of Matisse's thought and Croce's.[6]

Bergsonian Intuition also offers a striking parallel with Matisse's theory. Based on reciprocal action between past and future, space and time, Intuition, by the 'sympathetic communication which it establishes between us and the rest of the living, by the expansion of our consciousness which it brings about, introduces us into life's own domain, which is reciprocal interpenetration, endlessly continued creation.'[7] Matisse placed great importance on the possibility of expanded consciousness through 'sympathetic communication' and 'reciprocal interpenetration'. So much so, that it may be described as his method. It was from precisely such a flow of time: 'this succession of moments which constitutes the superficial existence of beings and things . . . and which is continually modifying and transforming them', that Matisse wanted to evolve forms which would express the 'more essential character' of things, so that he might 'give to reality a more lasting interpretation'.

Matisse, conceiving of existence as flux, and perceiving happening in a fashion similar to Bergson's *durée*, wanted intuitively to evolve forms that would express the elusive 'present' even as it was being eroded by the mutual interpenetration of past and future. The goal of the process is to arrive at an absolute which, paradoxically, has only relative validity: that is, for a given situation. Thus Matisse, who could say that he would not repaint any picture in the same way, follows a process which is remarkably close to that outlined by Bergson in *Introduction to Metaphysics*:[8]

> It follows that an absolute can be reached only by an *intuition*, whereas the rest [of our knowledge] arises out of analysis. We here call intuition the *sympathy* by which one transports oneself to the interior of an object in order to coincide with its unique and therefore ineffable quality.

For Matisse the goal of this process, was 'that state of condensation of sensations which constitutes a picture'. This single idea, which is as important to the art of Matisse as that of *réalisation* was to the art of Cézanne,[9] also has affinities with Bergson:[10]

> Now the image has at least this advantage, that it keeps us in the concrete. No image can replace the intuition of duration, but many diverse images, borrowed from very different orders of things, may, by the convergence of their action, direct the consciousness to the precise point where there is an intuition to be seized.

This of course is also close to Matisse's idea of taking different routes to arrive at the same place (*réalisation* through *condensation*), and possibly explains why Matisse was not a painter

of a small number of 'masterpieces', but of numerous realizations of condensed and frozen duration, of multiple absolutes. It is in this special sense that Matisse's paintings become symbols; they are like a cinematographic record of the intuited perceptions of the duration of his lifetime; only their field of action is limited by the painter's subject matter.[11]

By abandoning the literal representation of objects and of movement, and by avoiding anecdotal subject matter, Matisse hoped to achieve 'a higher ideal of grandeur and beauty' and to raise decorative painting to the level of philosophy. Matisse clarifies this idea with the well-known statement, 'What I dream of is an art of balance, of purity and serenity devoid of troubling or depressing subject matter . . . a soothing, calming influence on the mind, something like a good armchair which provides relaxation from physical fatigue.' It is important to realize that this statement is more an explanation, and perhaps defence, of Matisse's limited range of subject matter than an expression of simple-minded optimism. Unfortunately the phrase, 'something like a good armchair', which has been quoted so often, tends to give the impression that Matisse desired from painting merely a means of relaxation or of entertainment—in short that his ideals were somewhat superficial.[12] Matisse, however, does not advocate an art of superficial decoration or entertainment, but states his belief in art as a medium for the elevation of the spirit above and beyond, yet rooted in the experience of, everyday life. In other words, the transfiguration of experience into a state of what might in the past have been called 'the sublime'. This is borne out by Matisse's statement that there are no new truths besides the discoveries within the formal configuration of a single painting. Truth is as intuitive and relative a process as is individual perception, and 'rules have no existence outside of individuals'.

Matisse's reliance on nature, so evident in his paintings, is very strongly stated in 'Notes of a Painter'. He emphasizes honesty and sincerity of perception in relation to the final image, to the degree that the painter should feel that he has painted only what he has seen: 'And even when he departs from nature, he must do it with the conviction that it is only to interpret her more fully.' Within Matisse's theoretical framework, nature is the ultimate source of art, and the work of art is a synthesis of imagery perceived in nature and translated, by an act of belief in the artist's own perceptions, into the final image. The act of painting is an act of belief, a synthesis (or 'condensation') of sensations into perceptions, and of perceptions into significant form.

Although Matisse dwells at great length on the general process of the creation of art through the temperament of the painter and by contact with nature, he discusses only to a limited degree the actual formal nature of paintings themselves. Indeed he says virtually nothing about the creation of space in painting, about drawing and line, or about the relationship between the nature of painting and drawing. In the main, 'Notes of a Painter' is concerned with subject matter and its function, and the relation of this to the artist himself. The only formal element that he discusses in specific terms is colour.

The discussion of colour is for the most part in terms of expression. Like Matisse's drawing, which is based upon an aesthetic of condensation of meaning through essential lines, colour is considered to be a reduction to essentials, the finding of an equivalence.[13] Matisse's search for colour equivalence points to his desire not to reproduce direct optical sensation but rather to transfigure it, thus finding a configuration of form which, while it does not imitate nature, is an equivalence of the painter's perception of nature; all of which is accomplished through instinct rather than by the application of a set theory. This synthetic balancing of tones and hues is part of a conception in which the picture is not fragmented, but in which, right from the beginning, the painting is conceived as a total image rather than a conglomeration of vignettes.

Consonant with this idea of total conception is Matisse's idea of clarity, the clarity which he so admired in Cézanne's paintings. Just as Cézanne's painting was woven into the fabric of Matisse's pictorial thought—so Cézanne's theories had also been absorbed and synthesized.

The main concerns of 'Notes of a Painter' then, are those of expression, synthesis from nature, clarity and colour. In this essay Matisse states his faith in art as personal expression, his conception of which is not 'imaginative' or literary, but based instead upon the intuitive synthesis of sensations from nature. The artist, working toward an ideal that he intuitively understands, is a person of extremely fine perceptions who is able to translate these perceptions into tangible form. The most important aspect of painting is not the imitation of nature, but the transfiguration of perceptions into an enduring image. This more lasting interpretation was to be achieved by balancing the total structure of the picture rather than by dwelling upon specific emotion: the drama of Matisse's painting, he implies, is to be found in form rather than specifically in subject matter. It is a drama of happening, not of events. The realization of a painting is achieved through synthesis of nature and the organization of visual ideas in a clear and lucid fashion. The process of painting has an almost religious significance because it involves a restructuring of time and space, a penetration into Reality itself.

NOTES OF A PAINTER

A painter who addresses the public not just in order to present his works, but to reveal some of his ideas on the art of painting, exposes himself to several dangers.

In the first place, knowing that many people like to think of painting as an appendage of literature and therefore want it to express not general ideas suited to pictorial means, but specifically literary ideas, I fear that one will look with astonishment upon the painter who ventures to invade the domain of the literary man. As a matter of fact, I am fully aware that a painter's best spokesman is his work.[14]

However, such painters as Signac, Desvallières, Denis, Blanche, Guérin and Bernard have written on such matters and been well received by various periodicals.[15] Personally, I shall simply try to state my feelings and aspirations as a painter without worrying about the writing.

But now I forsee the danger of appearing to contradict myself. I feel very strongly the tie between my earlier and my recent works, but I do not think exactly the way I thought yesterday. Or rather, my basic idea has not changed, but my thought has evolved, and my modes of expression have followed my thoughts. I do not repudiate any of my paintings but there is not one of them that I would not redo differently, if I had it to redo. My destination is always the same but I work out a different route to get there.

Finally, if I mention the name of this or that artist it will be to point out how our manners differ, and it may seem that I am belittling his work. Thus I risk being accused of injustice towards painters whose aims and results I best understand, or whose accomplishments I most appreciate, whereas I will have used them as examples, not to establish my superiority over them, but to show more clearly, through what they have done, what I am attempting to do.[16]

What I am after, above all, is expression. Sometimes it has been conceded that I have a certain technical ability but that all the same my ambition is limited, and does not go beyond the purely visual satisfaction such as can be obtained from looking at a picture.[17] But the thought of a painter must not be considered as separate from his pictorial means,

for the thought is worth no more than its expression by the means, which must be more complete (and by complete I do not mean complicated) the deeper is his thought. I am unable to distinguish between the feeling I have about life and my way of translating it.[18]

Expression, for me, does not reside in passions glowing in a human face or manifested by violent movement. The entire arrangement of my picture is expressive: the place occupied by the figures, the empty spaces around them, the proportions, everything has its share. Composition is the art of arranging in a decorative manner the diverse elements at the painter's command to express his feelings. In a picture every part will be visible and will play its appointed role, whether it be principal or secondary. Everything that is not useful in the picture is, it follows, harmful. A work of art must be harmonious in its entirety: any superfluous detail would replace some other essential detail in the mind of the spectator.

Composition, the aim of which should be expression, is modified according to the surface to be covered. If I take a sheet of paper of a given size, my drawing will have a necessary relationship to its format. I would not repeat this drawing on another sheet of different proportions, for example, rectangular instead of square. Nor should I be satisfied with a mere enlargement, had I to transfer the drawing to a sheet the same shape, but ten times larger. A drawing must have an expansive force which gives life to the things around it. An artist who wants to transpose a composition from one canvas to another larger one must conceive it anew in order to preserve its expression; he must alter its character and not just square it up onto the larger canvas.[19]

Both harmonies and dissonances of colour can produce agreeable effects. Often when I start to work I record fresh and superficial sensations during the first session. A few years ago I was sometimes satisfied with the result. But today if I were satisfied with this, now that I think I can see further, my picture would have a vagueness in it: I should have recorded the fugitive sensations of a moment which could not completely define my feelings and which I should barely recognize the next day.[20]

I want to reach that state of condensation of sensations which makes a painting. I might be satisfied with a work done at one sitting, but I would soon tire of it; therefore, I prefer to rework it so that later I may recognize it as representative of my state of mind.[21] There was a time when I never left my paintings hanging on the wall because they reminded me of moments of over-excitement and I did not like to see them again when I was calm. Nowadays I try to put serenity into my pictures and re-work them as long as I have not succeeded.

Suppose I want to paint a woman's body: first of all I imbue it with grace and charm, but I know that I must give something more. I will condense the meaning of this body by seeking its essential lines. The charm will be less apparent at first glance, but it must eventually emerge from the new image which will have a broader meaning, one more fully human. The charm will be less striking since it will not be the sole quality of the painting, but it will not exist less for its being contained within the general conception of the figure.[22]

Charm, lightness, freshness—such fleeting sensations. I have a canvas on which the colours are still fresh and I begin to work on it again. The tone will no doubt become duller. I will replace my original tone with one of greater density, an improvement, but less seductive to the eye.

The Impressionist painters, especially Monet and Sisley, had delicate sensations, quite close to each other: as a result their canvases all look alike. The word 'impressionism' perfectly characterizes their style, for they register fleeting impressions. It is not an appropriate designation for certain more recent painters who avoid the first impression,

and consider it almost dishonest. A rapid rendering of a landscape represents only one moment of its existence [*durée*]. I prefer, by insisting upon its essential character, to risk losing charm in order to obtain greater stability.

Underlying this succession of moments which constitutes the superficial existence of beings and things, and which is continually modifying and transforming them, one can search for a truer, more essential character, which the artist will seize so that he may give to reality a more lasting interpretation. When we go into the seventeenth- and eighteenth-century sculpture rooms in the Louvre and look, for example, at a Puget, we can see that the expression is forced and exaggerated to the point of being disquieting. It is quite a different matter if we go to the Luxembourg; the attitude in which the sculptors catch their models is always the one in which the development of the members and tensions of the muscles will be shown to greatest advantage. And yet movement thus understood corresponds to nothing in nature: when we capture it by surprise in a snapshot, the resulting image reminds us of nothing that we have seen.[23] Movement seized while it is going on is meaningful to us only if we do not isolate the present sensation either from that which precedes it or that which follows it.

There are two ways of expressing things; one is to show them crudely, the other is to evoke them through art. By removing oneself from the literal *representation* of movement one attains greater beauty and grandeur. Look at an Egyptian statue: it looks rigid to us, yet we sense in it the image of a body capable of movement and which, despite its rigidity, is animated. The Greeks too are calm: a man hurling a discus will be caught at the moment in which he gathers his strength, or at least, if he is shown in the most strained and precarious position implied by his action, the sculptor will have epitomized and condensed it so that equilibrium is re-established, thereby suggesting the idea of duration. Movement is in itself unstable and is not suited to something durable like a statue, unless the artist is aware of the entire action of which he represents only a moment.[24]

I must precisely define the character of the object or of the body that I wish to paint. To do so, I study my method very closely: If I put a black dot on a sheet of white paper, the dot will be visible no matter how far away I hold it: it is a clear notation. But beside this dot I place another one, and then a third, and already there is confusion. In order for the first dot to maintain its value I must enlarge it as I put other marks on the paper.

If upon a white canvas I set down some sensations of blue, of green, of red, each new stroke diminishes the importance of the preceding ones. Suppose I have to paint an interior: I have before me a cupboard; it gives me a sensation of vivid red, and I put down a red which satisfies me. A relation is established between this red and the white of the canvas. Let me put a green near the red, and make the floor yellow; and again there will be relationships between the green or yellow and the white of the canvas which will satisfy me. But these different tones mutually weaken one another. It is necessary that the various marks I use be balanced so that they do not destroy each other. To do this I must organize my ideas; the relationship between the tones must be such that it will sustain and not destroy them. A new combination of colours will succeed the first and render the totality of my representation. I am forced to transpose until finally my picture may seem completely changed when, after successive modifications, the red has succeeded the green as the dominant colour. I cannot copy nature in a servile way; I am forced to interpret nature and submit it to the spirit of the picture. From the relationship I have found in all the tones there must result a living harmony of colours, a harmony analogous to that of a musical composition.[25]

For me all is in the conception. I must therefore have a clear vision of the whole from the beginning. I could mention a great sculptor[26] who gives us some admirable pieces: but for him a composition is merely a grouping of fragments, which results in a confusion

of expression. Look instead at one of Cézanne's pictures: all is so well arranged that no matter at what distance you stand or how many figures are represented you will always be able to distinguish each figure clearly and to know which limb belongs to which body. If there is order and clarity in the picture, it means that from the outset this same order and clarity existed in the mind of the painter, or that the painter was conscious of their necessity. Limbs may cross and intertwine, but in the eyes of the spectator they will nevertheless remain attached to and help to articulate the right body: all confusion has disappeared.

The chief function of colour should be to serve expression as well as possible. I put down my tones without a preconceived plan. If at first, and perhaps without my having been conscious of it, one tone has particularly seduced or caught me, more often than not once the picture is finished I will notice that I have respected this tone while I progressively altered and transformed all the others. The expressive aspect of colours imposes itself on me in a purely instinctive way. To paint an autumn landscape I will not try to remember what colours suit this season, I will be inspired only by the sensation that the season arouses in me: the icy purity of the sour blue sky will express the season just as well as the nuances of foliage. My sensation itself may vary, the autumn may be soft and warm like a continuation of summer, or quite cool with a cold sky and lemon-yellow trees that give a chilly impression and already announce winter.

My choice of colours does not rest on any scientific theory; it is based on observation, on sensitivity, on felt experiences.[27] Inspired by certain pages of Delacroix, an artist like Signac is preoccupied with complementary colours, and the theoretical knowledge of them will lead him to use a certain tone in a certain place. But I simply try to put down colours which render my sensation. There is an impelling proportion of tones that may lead me to change the shape of a figure or to transform my composition. Until I have achieved this proportion in all the parts of the composition I strive towards it and keep on working. Then a moment comes when all the parts have found their definite relationships, and from then on it would be impossible for me to add a stroke to my picture without having to repaint it entirely.

In reality, I think that the very theory of complementary colours is not absolute. In studying the paintings of artists whose knowledge of colours depends upon instinct and feeling, and on a constant analogy with their sensations, one could define certain laws of colour and so broaden the limits of colour theory as it now defined.

What interests me most is neither still life nor landscape, but the human figure. It is that which best permits me to express my almost religious awe towards life. I do not insist upon all the details of the face, on setting them down one-by-one with anatomical exactitude. If I have an Italian model who at first appearance suggests nothing but a purely animal existence, I nevertheless discover his essential qualities, I penetrate amid the lines of the face those which suggest the deep gravity which persists in every human being. A work of art must carry within itself its complete significance and impose that upon the beholder even before he recognizes the subject matter. When I see the Giotto frescoes at Padua I do not trouble myself to recognize which scene of the life of Christ I have before me, but I immediately understand the sentiment which emerges from it, for it is in the lines, the composition, the colour. The title will only serve to confirm my impression.[28]

What I dream of is an art of balance, of purity and serenity, devoid of troubling or depressing subject matter, an art which could be for every mental worker, for the businessman as well as the man of letters, for example, a soothing, calming influence on the mind, something like a good armchair which provides relaxation from physical fatigue.

Often a discussion arises as to the value of different processes, and their relationship

to different temperaments. A distinction is made between painters who work directly from nature and those who work purely from imagination. Personally, I think neither of these methods must be preferred to the exclusion of the other. Both may be used in turn by the same individual, either because he needs contact with objects in order to receive sensations that will excite his creative faculty, or his sensations are already organized. In either case he will be able to arrive at that totality which constitutes a picture. In any event I think that one can judge the vitality and power of an artist who, after having received impressions directly from the spectacle of nature, is able to organize his sensations to continue his work in the same frame of mind on different days, and to develop these sensations; this power proves he is sufficiently master of himself to subject himself to discipline.[29]

The simplest means are those which best enable an artist to express himself. If he fears the banal he cannot avoid it by appearing strange, or going in for bizarre drawing and eccentric colour. His means of expression must derive almost of necessity from his temperament. He must have the humility of mind to believe that he has painted only what he has seen. I like Chardin's way of expressing it: 'I apply colour until there is a resemblance.' Or Cézanne's: 'I want to secure a likeness', or Rodin's: 'Copy nature!' Leonardo said: 'He who can copy can create.' Those who work in a preconceived style, deliberately turning their backs on nature, miss the truth. An artist must recognize, when he is reasoning, that his picture is an artifice; but when he is painting, he should feel that he has copied nature. And even when he departs from nature, he must do it with the conviction that it is only to interpret her more fully.[30]

Some may say that other views on painting were expected from a painter, and that I have only come out with platitudes. To this I shall reply that there are no new truths. The role of the artist, like that of the scholar, consists of seizing current truths often repeated to him, but which will take on new meaning for him and which he will make his own when he has grasped their deepest significance. If aviators had to explain to us the research which led to their leaving earth and rising in the air, they would merely confirm very elementary principles of physics neglected by less successful inventors.

An artist always profits from information about himself, and I am glad to have learned what is my weak point. M. Péladan in the *Revue Hébdomadaire* reproaches a certain number of painters, amongst whom I think I should place myself, for calling themselves 'Fauves', and yet dressing like everyone else, so that they are no more noticeable than the floor-walkers in a department store.[31] Does genius count for so little? If it were only a question of myself that would set M. Péladan's mind at ease, tomorrow I would call myself Sar and dress like a necromancer.[32]

In the same article this excellent writer claims that I do not paint honestly, and I would be justifiably angry if he had not qualified his statement by saying, 'I mean honestly with respect to the ideal and the rules.'[33] The trouble is that he does not mention where these rules are. I am willing to have them exist, but were it possible to learn them what sublime artists we would have!

Rules have no existence outside of individuals: otherwise a good professor would be as great a genius as Racine. Any one of us is capable of repeating fine maxims, but few can also penetrate their meaning. I am ready to admit that from a study of the works of Raphael or Titian a more complete set of rules can be drawn than from the works of Manet or Renoir, but the rules followed by Manet and Renoir were those which suited their temperaments and I prefer the most minor of their paintings to all the work of those who are content to imitate the *Venus of Urbino* or the *Madonna of the Goldfinch*. These latter are of no value to anyone, for whether we want to or not, we belong to our time and we share in its opinions, its feelings, even its delusions. All artists bear the imprint of their time, but the great artists are those in whom this is most profoundly

marked. Our epoch for instance is better represented by Courbet than by Flandrin, by Rodin better than by Frémiet. Whether we like it or not, however insistently we call ourselves exiles, between our period and ourselves an indissoluble bond is established, and M. Péladan himself cannot escape it. The aestheticians of the future may perhaps use his books as evidence if they get it in their heads to prove that no one of our time understood anything about the art of Leonardo da Vinci.

3

Statement on Photography, 1908[1]

In 1908 Alfred Stieglitz's magazine *Camera Work* solicited views on photography from several painters. Although Matisse's statement may seem at first to relate directly to an aesthetic of photography ('documentary' as opposed to 'contrived' or 'studio'), it is really concerned with Matisse's views about penetrating nature, since he sees photography primarily as yet another way of approaching the study of nature.[2] In this, as in many other instances, nature may be equated with 'external reality'.

STATEMENT ON PHOTOGRAPHY

Photography can provide the most precious documents existing and no one can contest its value from that point of view. If it is practised by a man of taste, the photograph will have an appearance of art. But I believe that it is not of any importance in what style they have been produced; photographs will always be impressive because they show us nature, and all artists will find in them a world of sensations. The photographer must therefore intervene as little as possible, so as not to cause photography to lose the objective charm which it naturally possesses, notwithstanding its defects. By trying to add to it he may give the result the appearance of an echo of a different process. Photography should register and give us documents.[3]

4

Sarah Stein's Notes, 1908[1]

Sarah Stein (Mrs. Michael Stein) was a close friend of Matisse and studied in his school, which she helped to organize during 1908. She took careful notes on Matisse's advice to the class and to individuals within the class. These notes were first published by Alfred H. Barr, and are reprinted here as edited by him.

The programme of study at Matisse's school was quite traditional, consisting of drawing and painting from plaster casts and from the model, still-life, and modelling clay. At the height of his interest in the school, Matisse came every Saturday to give criticism, the usual practice of professors when he had himself been a student. The emphasis was on 'adhering to nature and trying to portray it with exactness. In the beginning you must subject yourself totally to her influence. . . . You must be able to walk firmly on the ground before you start walking a tight-rope!'[2] In the approach to the model, there are also some striking analogies with Academic drawing practice of the 1890s.[3] Yet Matisse's teaching also was tempered by his own breadth of understanding, and was not moribund.

Matisse's advice to his students seems to have three basic aspects: advice on how to perceive nature more fully, advice on how to go about constructing a picture, and general advice about the purpose of the work of art, especially in relation to nature. In helping his students to perceive more fully what was presented to their eyes, Matisse used both analytic and synthetic methods. A good deal of his advice has to do with the analysis of form; for example he speaks of an Antique head as a ball. In some cases, as in his discussion of the analysis of the model, he takes a functional approach: 'Remember the foot is a bridge, the pelvis fits into the thighs to form an amphora.' He stresses not only visual analysis but also what might be called emphatic analysis, as when he advises the student to assume the pose of the model himself, for the key of the movement is where the strain comes. He is very much concerned with the poetry of the vision of his students; they must have true sensitivity to see the resemblance of a calf to a beautiful vase form. Matisse evidently was concerned with imbuing his students with a poetry of vision comparable to his own.

Matisse's advice on the construction of paintings is very similar to his own methods of construction; as in his own paintings, he stresses the importance of order, of colour and of unity. This unity, he advises, should be above all a unity of colour: 'Construct by relations of colour; close and distant—equivalents of the relations that you see upon the model.' This idea of 'equivalence', which is so important to Matisse's own paintings, he also stresses for students: 'You are representing the model, or any other subject, not copying it; there can be no colour relations between it and your picture; it is the relation between the colours in your picture which are the equivalent of the relation between the colours in your model that must be considered.'

In terms of the general aesthetic outlook that he tried to communicate to his students, Matisse's comments are very revealing. He notes, for example, that while in the Antique, fullness of form results in unity and repose of the spirit, in the moderns we often find a passionate

expression and realization of certain parts at the expense of others; hence, a lack of unity, consequent weakness, and a troubling of the spirit. This is not very far from the outlook expressed in 'Notes of a Painter'. He remarks also that the great periods of art concern themselves with the essentials of form while decadent periods dwell on small detail (a prejudice no doubt stemming from his implicit criticism of nineteenth-century Academic French painting), and also advises his students to let the model awaken ideas and not simply to agree with a preconceived theory or effect. As has been seen in 'Notes of a Painter', Matisse was at this time himself very much concerned with avoiding formulas.

Matisse's advice to his students is remarkably close to his own aims, and within the context of those aims his advice seems extremely sound. It is general enough to give the student sufficient leeway to follow his own personality, and is in fact specifically aimed at not feeding the student preconceived theories and ideas, a pedagogical attitude he may well have derived from Gustave Moreau.

SARAH STEIN'S NOTES

DRAWING

Study of Greek and Roman sculpture

The antique, above all, will help you to realize the fullness of form. I see this torso as a single form first. Without this, none of your divisions, however characteristic, count. In the antique, all the parts have been equally considered. The result is unity, and repose of the spirit.

In the moderns, we often find a passionate expression and realization of certain parts at the expense of others; hence, a lack of unity, consequent weakness, and a troubling of the spirit.

This helmet, which has its movement, covers these locks of hair, which have their movement. Both were of equal importance to the artist and are perfectly realized. See it also as a decorative motive, an ornament—the scrolls of the shoulders covered by the circle of the head.

In the antique, the head is a ball upon which the features are delineated. These eyebrows are like the wings of a butterfly preparing for flight.

Study of the model

Remember that a foot is a bridge. Consider these feet in the ensemble. When the model has very slender legs they must show by their strength of construction that they can support the body. You never doubt that the tiny legs of a sparrow can support *its* body. This straight leg goes through the torso and meets the shoulder as it were at a right angle. The other leg, on which the model is also standing, curves out and down like a flying buttress of a cathedral, and does similar work. It is an academy rule that the shoulder of the leg upon which the body mainly is resting is always lower than the other.[4]

Arms are like rolls of clay, but the forearms are also like cords, for they can be twisted. These folded hands are lying there quietly like the hoop-handle of a basket that has been gradually lowered upon its body to a place of rest.

This pelvis fits into the thighs and suggests an amphora. Fit your parts into one another and build up your figure as a carpenter does a house. Everything must be constructed—built up of parts that make a unit: a tree like a human body, a human body like a

cathedral.[5] To one's work one must bring knowledge, much contemplation of the model or other subject, and the imagination to enrich what one sees. Close your eyes and hold the vision, and then do the work with your own sensibility. If it be a model assume the pose of the model yourself; where the strain comes is the key of the movement.

You must not see the parts so prosaically that the resemblance of this calf to a beautiful vase-form, one line covering the other as it were, does not impress you. Nor should the fullness and olive-like quality of this extended upper arm escape you. I do not say that you should not exaggerate, but I do say that your exaggeration should be in accordance with the character of the model—not a meaningless exaggeration which only carries you away from the particular expression that you are seeking to establish.[6]

See from the first your proportions, and do not lose them. But proportions according to correct measurement are after all but very little unless confirmed by sentiment, and expressive of the particular physical character of the model. When the model is young, make your model young. Note the essential characteristics of the model carefully; they must exist in the complete work, otherwise you have lost your concept on the way.

The mechanics of construction is the establishment of the oppositions which create the equilibrium of the directions. It was in the decadent periods of art that the artist's chief interest lay in developing the small forms and details. In all great periods the essentials of form, the big masses and their relations, occupied him above all other considerations—as in the antique. He did not elaborate until that was established. Not that the antique does not show the sensibility of the artist which we sometimes attribute only to the moderns; it is there, but it is better controlled.

All things have their decided physical character—for instance a square and a rectangle. But an undecided, indefinite form can express neither one. Therefore exaggerate according to the definite character for expression. You may consider this Negro model as a cathedral, built up of parts which form a solid, noble, towering construction—and as a lobster, because of the shell-like, tense muscular parts which fit so accurately and evidently into one another, with joints only large enough to hold their bones. But from time to time it is very necessary for you to remember that he is a Negro and not lose him and yourself in your construction.

We have agreed that forearms, like cords, can be twisted. In this case much of the character of the pose is due to these forearms being tied tight in a knot, as it were, not loosely interlaced. Notice how high upon the chest they lie; this adds to the determination and nervous strength of the pose. Don't hesitate to make his head round, and let it outline itself against the background. It is round as a ball, and black.

One must always search for the desire of the line, where it wishes to enter or where to die away. Also always be sure of its source; this must be done from the model.[7] To feel a central line in the direction of the general movement of the body and build about that is a great aid. Depressions and contours may hurt the volume. If an egg be conceived as a form, a nick will not hurt it; but if as a contour, it certainly will suffer. In the same way an arm is always first of all a round form, whatever its shades of particular character.

Draw your large masses first. The lines between abdomen and thigh may have to be exaggerated to give decision to the form in an upright pose. The openings may be serviceable as correctives. Remember, a line cannot exist alone; it always brings a companion along. Do remember that one line does nothing; it is only in relation to another that it creates a volume. And do make the two together.

Give the round form of the parts, as in sculpture. Look for their volume and fullness. Their contours must do this. In speaking of a melon one uses both hands to express it by a gesture, and so both lines defining a form must determine it. Drawing is like an expressive gesture, but it has the advantage of permanency. A drawing is a sculpture, but it has the advantage that it can be viewed closely enough for one to detect suggestions

of form that must be much more definitely expressed in a sculpture which must carry from a distance.[8]

One must never forget the constructive lines, axes of shoulders and pelvis; nor of legs, arms, neck, and head. This building up of the form gives its essential expression. Particular characteristics may always heighten the effect, but the construction must exist first.

No lines can go wild; every line must have its function. This one carries the torso up to the arm; note how it does it. All the lines must close around a center; otherwise your drawing cannot exist as a unit, for these fleeing lines carry the attention away— they do not arrest it.

With the circle of brows, shoulders, pelvis and feet one can almost entirely construct one's drawing, certainly indicate its character.

It is important to include the whole of the model in your drawing, to decide upon the place for the top of the head and base of the feet, and make your work remain within these limits. The value of this experience in the further study of composition is quite evident.

Do remember that a curved line is more easily and securely established in its character by contrast with the straight one which so often accompanies it. The same may be said of the straight line. If you see all forms round they soon lose all character. The lines must play in harmony and return, as in music. You may flourish about and embroider, but you must return to your theme in order to establish the unity essential to a work of art.[9]

This foot resting upon the model stand makes a line as sharp and straight as a cut. Give this feature its importance. That slightly drooping bulge of flesh is just a trifle that may be added, but the line alone counts in the character of the pose. Remember that the foot encircles the lower leg and do not make it a silhouette, even in drawing the profile. The leg fits into the body at the ankle[?],[10] and the heel comes up around the ankle.

Ingres said, 'Never in drawing the head omit the ear.' If I do not insist upon this I do remind you that the ear adds enormously to the character of the head, and that it is very important to express it carefully and fully, not to suggest it with a dab.[11]

A shaded drawing requires shading in the background to prevent its looking like a silhouette cut out and pasted on white paper.

SCULPTURE

The joints, like wrists, ankles, knees and elbows must show that they can support the limbs—especially when the limbs are supporting the body. And in cases of poses resting upon a special limb, arm or leg, the joint is better when exaggerated than underexpressed. Above all, one must be careful not to cut the limb at the joints, but to have the joints an inherent part of the limb. The neck must be heavy enough to support the head (in the case of a Negro statue where the head was large and the neck slender and the chin was resting upon the hands, which gave additional support to the head).

The model must not be made to agree with a preconceived theory or effect. It must impress you, awaken in you an emotion, which in turn you seek to express. You must forget all your theories, all your ideas before the subject. What part of these is really your own will be expressed in your expression of the emotion awakened in you by the subject.

It can only help you to realize before beginning that this model, for instance, had a large pelvis sloping up to rather narrow shoulders and down through the full thighs to the lower legs—suggesting an egg-like form beautiful in volume. The hair of the model describes a protecting curve and gives a repetition that is a completion.[12]

Your imagination is thus stimulated to help the plastic conception of the model before you begin. This leg, but for the accident of the curve of the calf, would describe a longer, slenderer ovoid form; and this latter form must be insisted upon, as in the antiques, to aid the unity of the figure.

Put in no holes that hurt the ensemble, as between thumb and fingers lying at the side. Express by masses in relation to one another, and large sweeps of line in interrelation. One must determine the characteristic form of the different parts of the body and the direction of the contours which will give this form. In a man standing erect all the parts must go in a direction to aid that sensation. The legs work up into the torso, which clasps down over them. It must have a spinal column. One can divide one's work by opposing lines (axes) which gives the direction of the parts and thus build up the body in a manner that at once suggests its general character and movement.[13]

In addition to the sensations one derives from a drawing, a sculpture must invite us to handle it as an object; just so the sculptor must feel, in making it, the particular demands for volume and mass. The smaller the bit of sculpture, the more the essentials of form must exist.

PAINTING

When painting, first look long and well at your model or subject, and decide on your general color scheme. This must prevail. In painting a landscape you choose it for certain beauties—spots of color, suggestions of composition. Close your eyes and visualize the picture; then go to work, always keeping these characteristics the important features of the picture. And you must at once indicate all that you would have in the complete work. All must be considered in interrelation during the process—nothing can be added.

One must stop from time to time to consider the subject (model, landscape, etc.) in its ensemble. What you are aiming for, above all, is unity.

Order above all, in color. Put three or four touches of color that you have understood, upon the canvas; add another, if you can—if you can't set this canvas aside and begin again.

Construct by relations of color, close and distant—equivalents of the relations that you see upon the model.

You are representing the model, or any other subject, not copying it; and there can be no color relations between it and your picture; it is the relation between the colors in your picture which are the equivalent of the relation between the colors in your model that must be considered.

I have always sought to copy the model; often very important considerations have prevented my doing so. In my studies I decided upon a background color and a general color for the model. Naturally these were tempered by demands of atmosphere, harmony of the background and model, and unity in the sculptural quality of the model.

Nature excites the imagination to representation. But one must add to this the spirit of the landscape in order to help its pictorial quality. Your composition should indicate the more or less entire character of these trees, even though the exact number you have chosen would not accurately express the landscape.

Still life

In still life, painting consists in translating the relations of the objects of the subject by an understanding of the different qualities of colors and their interrelations.

When the eyes become tired and the rapports seem all wrong, just look at an object. 'But this brass is yellow!' Frankly put a yellow ochre, for instance on a light spot, and start out from there freshly again to reconcile the various parts.

To copy the objects in a still life is nothing; one must render the emotion they awaken in him. The emotion of the ensemble, the interrelation of the objects, the specific character of every object—modified by its relation to the others—all interlaced like a cord or a serpent.

The tear-like quality of this slender, fat-bellied vase—the generous volume of this

copper—must touch you. A still life is as difficult as an antique and the proportions of the various parts as important as the proportions of the head or the hands, for instance, of the antique.

CRITICISM (remarks addressed to individual students)

This manner of yours is a system, a thing of the hand, not of the spirit. Your figure seems bounded by wires. Surely Monet, who called all but the people who worked in dots and commas wire-draughtsmen, would not approve of you—and this time he would be right.

In this instance the dark young Italian model against a steel-gray muslin background suggests in your palette rose against blue. Choose two points: for instance, the darkest and lightest spot of the subject—in this case the model's black hair and the yellow straw of the stool. Consider every additional stroke in addition to these.

This black skirt and white underskirt find their equivalent—in your scheme—in ultramarine blue with dark cobalt violet (as black), and emerald green and white. Now the model is a pearly, opalescent color all over. I should take vermilion and white for this lower thigh, and for this calf—cooler but the same tone—garance and white. For this prominence of the back of the forearm, cool but very bright, white tinged with emerald green, which you do not see as any particular color now that it is placed.

Your black skirt and red blouse, on the model stand, become an emerald green (pure) and vermilion—not because green is the complementary of red, but because it is sufficiently far away from red to give the required rapport. The hair must also be emerald green, but this green appears quite different from the former.

You must make your color follow the form as your drawing does—therefore your vermilion and white in this light should turn to garance and white in this cooler shadow. For this leg is round, not broken as by a corner.

Thick paint does not give light; you must have the proper color-combination. For instance, do not attempt to strengthen your forms with high lights. It is better to make the background in the proper relation to support them. You need red to make your blue and yellow count. But put it where it helps, not hurts—in the background, perhaps.

In this sketch, commencing with the clash of the black hair, although your entire figure is in gradation from it, you must close your harmony with another chord—say the line of this foot.

There are many ways of painting. You seem to be falling between two stools, one considering color as warm and cool, the other, seeking light through the opposition of colors. Had you not better employ the former method alone? Then your blue background will require a warmer shadow; and this warm, black head against it, a warmer tone than this dark blue you have chosen. Your model stand will take a warmer lighter tone; it looks like pinkish, creamy silk in relation to the greenish wallpaper.

Cézanne used blue to make his yellow tell, but he used it with the discrimination, as he did in all other cases, that no one else has shown.

The Neo-Impressionists took different centers of light—for instance, a yellow and a green—put blue around the yellow, red around the green, and graded the blue into the red through purple, etc.

I express variety of illumination through an understanding of the differences in the values of colors, alone and in relation. In this still life, an understanding of cadmium green and white, emerald green and white, and garance and white, give three different tones which construct the various planes of the table—front, top, and the wall back of it. There is no shadow under this high light; this vase remains in the light, but the high light and the light beneath it must be in the proper color relation.

5

Estienne: *Interview with Matisse, 1909*[1]

In April 1909 Charles Estienne published an interview with Matisse as part of a newspaper series on modern art. This interview is of particular interest because it reflects some of Matisse's immediate concerns at the time, as well as his stature ('leader of a school'), that led him to speak of modern painting partly in terms of 'we'. Although Matisse dwells upon the general synthetic aspect of modern painting in these terms, he changes to the first person singular when he begins to elaborate the subtle but distinct definition of his own attitude.

Most of this elaboration parallels 'Notes of a Painter', with only a few minor changes in wording. The passages that he repeats are significant, however, in that they seem to sum up the core of his theory at the time: the condensation of sensations which constitutes a painting. This restatement of the ideas in 'Notes of a Painter', less than four months after its publication, gave Matisse the opportunity, in addressing himself to a larger if less sophisticated audience, to underline the most essential aspects of his theory. And also to side-step the image of a painting being like a good armchair, a phrase which he here omits from his repetition of that passage from 'Notes of a Painter'.

INTERVIEW WITH MATISSE

It is with all impartiality that we institute here several interviews on the plastic arts and their current development, and more directly on painting, for it is in this domain of art that experiments seem the most daring and the most debatable.

A new spirit has begun to flow through all the arts during the past twenty years. We have had Symbolism, after Naturalism, for poetry and literature; we have lately heard talk of 'music of the future' and this music has become, I believe, that of today; the revolutionary ferment is now in painting.

We are not setting out to state our preferences here. We admit and quite understand that these new tendencies are provoking a resounding censure. Above all, what we are investigating, for the edification of the public, are the arguments, the motives, the vital explanations.

To ask about these, we went to M. Henri-Matisse, who is considered, one cannot ignore it, the leader of a school, and whose works are among those which have aroused the harshest criticism.

M. Henri-Matisse answered us with a readiness that well indicates that the motives he gives us are his customary ones. Hence, he did not express them by random conversation, as one might imagine. This painter, of whom it is too easily said that he mocks the world, has a thoughtful and curious conception of his art, which he has already stated, at the inducement of M. Georges Desvallières, in the *Grand Revue* following the last Salon d'Automne.

'I related in *Notes of a Painter*', he said to me, 'several of my ideas; but what I am going to say to you will be more formal and more complete.'

First of all, M. Matisse harbours no resentment toward the public for its incomprehension: never, according to him, is the artist entirely understood by the majority; nor even by the mean. Is he even by his peers? Formidable question! The poet like the musician, the sculptor like the painter, must undergo this almost total impossibility. But the quality of the work of art operates little by little, without the knowledge of men, and this influence obliges them one day to attest the truth.[2]

'We are leaving the Realist movement,' said M. Henri-Matisse. 'It has amassed the raw materials. They are there. We must now begin the enormous job of organization.

'What did the Realists do, and the Impressionists? They copied nature. All their art has its roots in truth, in exactitude of representation. It is a completely objective art, an art of unfeeling—one might say of recording for the pleasure of it. And yet, what complications are behind this apparent simplicity! Impressionist painting—and I know, having come from there—teems with *contradictory sensations*, it is a state of agitation.

'We want something else. We work toward serenity through simplification of ideas and of form. The ensemble is our only ideal. Details lessen the purity of the lines and harm the emotional intensity; we reject them.

'It is a question of learning—and perhaps relearning—a linear script; then, probably after us, will come the literature.'

(The reader should understand the word literature to mean a mode of pictorial illustration.)

'The painter no longer has to preoccupy himself with details,' continues M. Henri-Matisse. 'The photograph is there to render the multitude of details a hundred times better and more quickly. Plastic form will present emotion as directly as possible and by the simplest means.

'The object of painting is no longer narrative description, since that is in books.

'We have a higher conception of it.

'By it, the artist expresses his interior visions.

'I take from nature what I need, an expression sufficiently eloquent to suggest my thoughts. I painstakingly combine all effects, balancing them in rendering and in colour, and I don't attain this condensation, to which everything contributes, even the size of the canvas, at the first shot. It is a long process of reflection and amalgamation. Suppose I want to paint a woman's body: first of all I mirror her form in my mind, I imbue it with grace and charm; then I must give something more. I will condense the meaning of this body by seeking its essential lines. The charm will be less apparent at first glance, but it must eventually emerge from the new image which will have a broader meaning, one more fully human. The charm will be less striking since it will no longer be the sole quality of the painting, but it will not exist less for its being contained within the general conception of the figure.'[3]

That is formal, and this is no less so:

'A picture is a slow elaboration. A first sitting notes down fresh, superficial sensations. A few years ago I was sometimes satisfied with the result. But today if I were satisfied with this now that I think I can see further, my picture would have a vagueness in it, I should have recorded rapid, momentary sensations which cannot completely define my feelings, and which I should barely recognize the next day. I want to reach that state of condensation which makes a painting. I might be satisfied with a work done at one sitting, but I would quickly tire of it; therefore, I prefer to rework it so that later I may recognize it as representative of my state of mind. There was a time when I never left my paintings hanging on the wall because they reminded me of moments of over-excitement and I did not like to see them when I had again become calm.

Nowadays I try to put serenity into my pictures and re-work them as long as I have not succeeded.'[4]

Here Matisse sounds like Puvis de Chavannes; for him painting is an appeal to reflection, to serenity. It should be restful, and this feeling should be reached by the simplest possible means; three colours for a large panel of the dance: azure for the sky; pink for the figures; green for the hill where the Muses dance.[5]

And how does he compose? I believe I understood it by an example he gave me:

'I have to decorate a staircase. It has three floors. I imagine a visitor coming in from the outside. There is the first floor. One must summon up energy, give a feeling of lightness. My first panel represents the dance, that whirling round on top of the hill. On the second floor one is now within the house; in its silence I see a scene of music with engrossed participants; finally, the third floor is completely calm and I paint a scene of repose: some people reclining on the grass, chatting or daydreaming. I shall obtain this by the simplest and most reduced means; those which permit the painter pertinently to express all of his interior vision.[6]

'What I dream of is an art of balance, of purity and serenity, devoid of troubling or depressing subject matter, an art which could be for every mental worker, for the businessman as well as the man of letters, for example, a soothing, calming influence on the mind, something which provides relaxation from fatigues and toil.'[7]

This conception is logical and acceptable. To interpret this, the artist goes back beyond the Renaissance to the image-makers of the Middle Ages, ingenuous as well as ingenious, and farther in the past, to Hindu and Persian art. Is he on the right path, or does he err? Too many contingencies assail us on all sides to allow us these certainties. The testimony of time, of the works, will outweigh our present speculations.

6

Clara T. MacChesney: *A Talk with Matisse,* 1912[1]

The stir which greeted the New York Armory Show of modern art (17 February to 15 March 1913) is by now legendary. Matisse, who was well represented (by thirteen paintings, three drawings and a sculpture), was vehemently attacked by the conservatives. The *New York Times*, 23 February 1913, for example, said of him: 'We may as well say in the first place that his pictures are ugly, that they are coarse, that they are narrow, that to us they are revolting in their inhumanity'. And when the show moved to the Art Institute of Chicago, the art students at the Institute held a protest meeting and burned in effigy Matisse's *Nu blue* (Figure **18**).

A week before the New York show closed, the *New York Times Magazine* published the following interview with Matisse, by the journalist Clara T. MacChesney. The actual interview appears to have taken place during the summer of 1912. Despite the (often amusing) inaccuracies and confusions in MacChesney's reportage, her awkward translations from French,

and her evident ignorance of art, the statements by Matisse appear to be authentic and fairly accurate. This interview is of enormous interest, as it reveals Matisse quite consciously addressing a lay audience (indeed an ignorant and antagonistic lay audience); and it also provides a description of Matisse's working arrangements at this time.

Matisse was never an *enfant terrible*; he was always very serious about his art and anxious to be understood. Thus he is not daunted by the obtuseness of his interviewer, and states quite directly, if somewhat simply, the aims and problems of his art. It is interesting to note his stress on technical competence (the answer to the tired old question of 'but can he draw?') and on his extensive preparation and training as an artist.

A TALK WITH MATISSE

In speaking of the different post-Impressionists, it is always Matisse's name which heads the list. At first it was a name which to many suggested the most violent extremes in art; it was spoken of with bated breath, and even horror, or with the most uproarious ridicule. But time has converted many, even of our most conservative critics and art lovers, to his point of view. One says: 'He is a recluse in revolt, a red radical, whose aim is not to overturn pomps, but to escape from them. He discards traditions, and seeks the elemental,' and 'he paints as a child might have painted in the dawn of art, seeing only the essentials in form and color.'

Five of his canvases were placed before me by a Paris dealer last Summer,[2] and arranged in chronological order. The first was an ordinary still life, painted in an ordinary manner. The next two were landscapes, broader and looser in treatment, higher in key, showing decidedly the influence of the Impressionists. The last two I studied long and seriously, but I failed absolutely to discover what they expressed—still-life, landscapes, or portraits.

Thus it was with keen interest that I sought this much-ridiculed man, whose work is the common topic of many heated arguments today. After an hour's train ride and walk on a hot June day, I found M. Matisse in a suburb southwest of Paris.[3] His home, the ordinary French villa, or country house, two-storied, set in a large and simple garden and inclosed [*sic*] by the usual high wall. A ring at the gate brought the gardener, who led me to the studio, built at one side, among trees, leading up to which were beds of flaming flowers. The studio, a good-sized square structure, was painted white, within and without, and had immense windows, (both in the roof and at the side,) thus giving a sense of out-of-doors and great heat.

A large and simple workroom it was, its walls and easels covered with his large, brilliant, and extraordinary canvases. M. Matisse himself was a great surprise, for I found not a long-haired, slovenly dressed, eccentric man, as I had imagined, but a fresh, healthy, robust blond gentleman, who looked even more German than French, and whose simple and unaffected cordiality put me directly at my ease. Two dogs lay at our feet, and, as I recall that hour, my main recollection is of a glare of light, stifling heat, principally caused by the immense glass windows, open doors, showing glimpses of flowers beyond, as brilliant and bright-hued as the walls within; and a white-bloused man chasing away the flies which buzzed around us as I questioned him.

'I began at the Ecole des Beaux-Arts. When I opened my studio, years after, for some time I painted just like any one else. But things didn't go at all, and I was very unhappy. Then, little by little, I began to paint as I felt. One cannot do successful work which

has much feeling unless one sees the subject very simply, and one must do this in order to express one's self as clearly as possible.'

Striving to understand, and failing to admire, a huge, gaudy-hued canvas facing me, I asked: 'Do you recognize harmony of color?'

Almost with indignation he replied: 'I certainly do think of harmony of color, and of composition, too. Drawing is for me the art of being able to express myself with line. When an artist or student draws a nude figure with painstaking care, the result is drawing, and not emotion. A true artist cannot see color which is not harmonious. Otherwise it is a *moyen*, or recipe. An artist should express his feeling with the harmony or idea or color which he possesses naturally. He should not copy the walls, or objects on a table, but he should, above all, express a vision of color, the harmony of which corresponds to his feeling. And, above all, one must be honest with one's self.'

'But just what is your theory on art?' I persisted.

'Well, take that table, for example,' pointing to one near by, on which stood a jar of nasturtiums.[4] 'I do not literally paint that table, but the emotion it produces upon me.'

After a pause full of intense thought on my part, I asked: 'But if one hasn't always emotion. What then?'

'Do not paint,' he quickly answered. 'When I came in here to work this morning I had no emotion, so I took a horseback ride. When I returned I felt like painting, and had all the emotion I wanted.'

'What was your art training?' I asked.

'I studied in the schools mornings, and I copied at the Louvre in the afternoons. This for ten years.'

'What did you copy?' I asked curiously.

'I made a careful copy of *La Chasse* ("The Hunt") by Carraccio [*sic*], which was bought by the Government for the Hotel de Ville, at Grenoble; and *Narcisse*, by Poussin, which was also bought for the provinces. Chardin's large still-life of fish I worked at for six years and a half, and then left it unfinished. In some cases I gave my emotional impressions, or personal translations, of the pictures, and these', he said sadly, 'the French Government did not care to buy. It only wants a photographic copy.

'No, I never use pastels or water colors, and I only make studies from models, not to use in a picture—*mais pour me nourrir*—to strengthen my knowledge; and I never work from a previous sketch or study, but from memory. I now draw with feeling, and not anatomically. I know how to draw correctly, having studied form for so long.

'I always use a preliminary canvas the same size for a sketch as for a finished picture, and I always begin with color. With large canvases this is more fatiguing, but more logical. I may have the same sentiment I obtained in the first, but this lacks solidity, and decorative sense. I never retouch a sketch: I take a new canvas the same size, as I may change the composition somewhat. But I always strive to give the same feeling, while carrying it on further. A picture should, for me, always be decorative. While working I never try to think, only to feel.'

As he talked he pointed to two canvases of equal size. The sketch hung on the wall at my left, and the finished canvas was on an easel before me. They represented nude figures in action, boldly, flatly, and simply laid in in broad sweeps of vivid local color, and I saw very little difference between the two.

'Do you teach?' I asked.

'Yes, I have a class of sixty pupils, and I make them draw accurately, as a student always should do at the beginning. I do not encourage them to work as I do now.'[5]

Yet I had heard he was not always successful in this respect.

'I like to model as much as to paint—I have no preference. If the search is the same

when I tire of some medium, then I turn to the other—and I often make *pour me nourrir*; a copy of an anatomical figure in clay.'

'Tell me,' I said, pointing to an extraordinary lumpy clay study of a nude woman with limbs of fearful length, 'why—?'

He picked up a small Javanese statue with a head all out of proportion to the body. 'Is not that beautiful?'

'No,' I said boldly. 'I see no beauty when there is lack of proportion. To my mind no sculpture has ever equaled that of the Greeks, unless it be Michael Angelo's.'

'But there you are, back to the classic, the formal,' he said triumphantly. 'We of to-day are trying to express ourselves to-day—now—the twentieth century—and not to copy what the Greeks saw and felt in art over two thousand years ago. The Greek sculptors always followed a set, fixed form, and never showed any sentiment. The very early Greeks and the *primitifs* only worked from the basis of emotion, but this grew cold, and disappeared in the following centuries. It makes no difference what are the proportions, if there is feeling. And if the sculptor who modeled this makes me think only of a dwarf, then he has failed to express the beauty which should overpower all lack of proportion, and this is only done through or by means of his emotions.'

Yet I gazed unconvinced at the little figure of a dwarf from Java, for I failed to see anything of beauty.

'Above all,' he said, struggling with the fly problem, 'the great thing is to express one's self.'

I thought of a celebrated canvas Matisse once produced of blue tomatoes. 'Why blue?' he was asked. 'Because I see them that way, and I cannot help it if no one else does,' he replied.

'Besnard's work? It is full of feeling, but *sans naïveté*. Monet is very big. Cézanne seeks more the classic. Rafäelli I do not like at all.[6] Goya, A. Dürer, Rembrandt, Corot, Manet are my favorite masters.'

'Yes, I often go to the Louvre,' he replied, in answer to my question, asked rather perfunctorily.

'Whose work do I study the most? Chardin's,' he answered, to my great surprise.

'Why?' I asked curiously, for there is not a trace of that great man's manner in Matisse's work.

'I go there to study his technique.'

Audible silence.

His palette, lying near by, was a large one, and so chaotic and disorderly were the vivid colors on it, that a close resemblance could be traced to some of his pictures.

'I never mix much,' he said. 'I use small brushes and never more than twelve colors.'

'Black?'

'Yes, I use it to cool the blue.'

I pondered on this statement a few moments before asking him if he had traveled much.

'No, I've only made a trip or two to Germany, and lately to Tangiers in Morocco, and I've never been to America.'

'No; I seldom paint portraits, and if I do only in a decorative manner. I can see them in no other way.'

The few hanging on the wall were forceful, boldly, simply executed, and evidently done in stress of great emotion. An eye, in one canvas, was placed on the right cheek, and in another one-half of the face was drawn so unpleasantly to one side as to suggest a paralytic stroke.

One's ideas of the man and of his work are entirely opposed to each other: the latter

abnormal to the last degree, and the man an ordinary, healthy individual, such as one meets by the dozen every day. On this point Matisse showed some emotion.

'Oh, do tell the American people that I am a normal man; that I am a devoted husband and father, that I have three fine children, that I go to the theatre, ride horseback, have a comfortable home, a fine garden that I love, flowers, etc., just like any man.'

As if to bear out this description of himself, he showed me the salon in his perfectly normal house, to see a normal copy which he had made at the Louvre, and he bade me good-bye and invited me to call again like a perfectly normal gentleman.

As I walked down to the station in the blazing sun in the throes of a brain-storm from all I had seen and heard, Augustus John's opinion of Matisse stood out clear in my mind: 'He has a big idea, but he cannot yet express it.'

M. Matisse sells his canvases as fast as he can paint them, but, if the report is true, speculators buy the majority. He certainly has the courage of his convictions; his work is constructive, and not destructive; he has many followers, who, unlike him, are not expressing themselves, but are imitating him. One critic maintains that his work acts like a sedative to a tired brain, or as an easy chair to a weary toiler home from his day's work.[7] But I am positive that I should not dare when weary, to sit for long in front of his 'Cathedrals at Rouen'.[8]

A facetious American asked: 'Are these ruins?' for none of the pillars were perpendicular, but standing or falling at all angles to the horizon. She asked the reason of this apparent intemperance of the pillars and walls and was told: 'Oh, we do not see as you do; we are perfectly free, and are bound by no rules, and we see as we please!'

7

Interview with Jacques Guenne, 1925[1]

In 1925 Jacques Guenne published an interview with Matisse which was also incorporated into his essay on Matisse in *Portraits d'artistes*. The greater part of this interview consists of autobiographical reminiscences by Matisse which are mainly concerned with his formative years. These reminiscences not only shed light upon Matisse's attitude to his early training— a quarter of a century later—but also show his obsession with discipline and reliance on sensations after nature. Furthermore, this interview contains one of Matisse's most striking observations about the significance and influence of Cézanne upon his own work. Coming at a time in Matisse's career when he himself was going through a crisis in his art, a transition from the somewhat loose style of the Nice period to the more austere compositions of the 1930s, it is interesting to see Matisse's renewed concern with Cézanne.

INTERVIEW WITH JACQUES GUENNE

It was at Clamart,[2] where Matisse usually spends several months, that I met him.

'I was a lawyer's clerk at Saint-Quentin,' he said, 'but even then other people's quarrels interested me much less than painting. One of my acquaintances, a friend of Bouguereau,[3] advised me to come to Paris and take lessons from a painter who had acquired such great notoriety at the Ecole des Beaux-Arts. I used to go to the atelier of Bouguereau. The master taught relief in twenty lessons, the art of giving the human body noble academic bearing and the best way to scumble the depths. He contemplated my easel. "You need to learn perspective", he said. "Erasure should be done with a good clean rag, or better yet, with a piece of amadou. You should seek advice from an older student."[4]

'Another time, he reproached me more crossly for "not knowing how to draw". Tired of faithfully reproducing the contours of plaster casts, I went to Gabriel Ferrier[5] who taught from live models. I did my utmost to depict the emotion that the sight of the female body gave me. The model had a pretty hand. I first painted the hand. How stupefied and indignant the professor was! Painting the hand before the model's face! "But my poor friend," he cried, "you will never finish your canvas by the end of the week." Having barely sketched in the torso, he considered indeed that I would never have time to "do the feet". And one should be ready to "do the feet" by Saturday, the day when the professor came around to correct us. I abandoned that studio.[6] Sometimes I went to Lille. I admired the works of Goya in the Museum.[7] I wanted to do something like that. It seemed to me that Goya had understood life well. Nevertheless I went back to the Ecole des Beaux-Arts.

'I had been advised to go to the "Antiques" where Gustave Moreau was teaching.[8] "All you have to do," I was told, "is to rise when the professor walks by in order to be accepted as one of his students." This time I had been better advised. What a charming master he was! He, at least, was capable of enthusiasm and even of being carried away. One day he would affirm his admiration for Raphael, another, for Veronese. One morning he arrived proclaiming that there was no greater master than Chardin. Moreau knew how to distinguish and how to show us who were the greatest painters, whereas Bouguereau invited us to admire Giulio Romano.[9]

'From that time dates my first still life,[10] you see it there, which I have preciously saved. I used to visit the Louvre. But Moreau told us: "Don't be content with going to the museum, go out into the streets." In effect it's there that I learned to draw. I went to the Petit Casino with Marquet who was my co-disciple.[11] We were trying to draw the silhouettes of passers-by, to discipline our line. We were forcing ourselves to discover quickly what was characteristic in a gesture, in an attitude. Didn't Delacroix say: "One should be able to draw a man falling from the sixth floor"?'[12]

Did you go to Impressionist shows?

'No, I only knew their works when the Caillebotte collection opened.'[13]

Was Gustave Moreau aware of your efforts?

'Certainly. He told me: "You are going to simplify painting".'

Would that he had simplified his own!

'It was then that I made a copy of Chardin's *La Raie*.[14] Soon I joined a painter named Véry[15] and I left for Brittany with him. I then had only bistres and earth colours on my palette, whereas Véry had an Impressionist palette. Like him, I began to work from nature. And soon I was seduced by the brilliance of pure colour. I returned from my trip with a passion for rainbow colours whereas Véry returned to Paris with a love for bitumen! Naturally colleagues and collectors marvelled at his new style.

'Then I did a *Desserte*.[16] And already I was not transposing any longer in the transparent tones of the Louvre.'

And what did Gustave Moreau think of that canvas?

'Moreau showed the same indulgence toward me as toward Marquet and Rouault. To the professors who discovered what was already revolutionary in this attempt, he responded: "Let it be, his decanters are solidly on the table and I could hang my hat on their stoppers. That's what is essential." I exhibited this work at the Nationale.[17] It was the time when the public was generally terrified of germs. One had never seen so many cases of typhoid. The public found germs at the bottom of my decanters![18] However, I had been raised to the level of Associate. What a fine civil service career opened before me! I deserve no praise, I assure you, for not having followed it. To tell the truth, it's my modest condition which I have to thank for my success. In effect, painting, even academic, was a poor provider at that time. I was going to be forced to take up another profession. I decided to take a year off,[19] avoid all hindrances, and paint the way I wanted to. I worked only for myself. I was saved. Soon the love of materials for their own sake came to me like a revelation. I felt a passion for colour developing within me.

'At that moment the big Mohammedan exhibition was mounted.[20] And with what pleasure I also discovered Japanese woodcuts! What a lesson in purity, harmony, I received! To tell the truth, these woodcuts were mediocre reproductions and yet I did not experience the same emotion when I saw the originals. Those no longer brought with them the newness of a revelation.[21]

'Slowly I discovered the secret of my art. It consists of a meditation on nature, on the expression of a dream which is always inspired by reality. With more involvement and regularity, I learned to push each study in a certain direction. Little by little the notion that painting is a means of expression asserted itself, and that one can express the same thing in several ways. 'Exactitude is not truth', Delacroix liked to say. Notice that the classics went on re-doing the same painting and always differently. After a certain time, Cézanne always painted the same canvas of the *Baigneuses*. Although the master of Aix ceaselessly redid the same painting, don't we come upon a new Cézanne with the greatest curiosity? Apropos of this, I am very surprised that anyone can wonder whether the lesson of the painter of the *Maison du pendu* and the *Joueurs de cartes* is good or bad. If you only knew the moral strength, the encouragement that his remarkable example gave me all my life![22] In moments of doubt, when I was still searching for myself, frightened sometimes by my discoveries, I thought: "If Cézanne is right, I am right"; because I knew that Cézanne had made no mistake. There are, you see, constructional laws in the work of Cézanne which are useful to a young painter. He had, among his great virtues, this merit of wanting the tones to be forces in a painting, giving the highest mission to his painting.

'We shouldn't be surprised that Cézanne hesitated so long and so constantly. For my part, each time I stand before my canvas, it seems that I am painting for the first time. There were so many possibilities in Cézanne that, more than anyone else, he had to organize his brain. Cézanne, you see, is a sort of god of painting. Dangerous, his influence? So what? Too bad for those without the strength to survive it. Not to be strong enough to withstand an influence without weakening is proof of impotence. I will repeat what I once said to Guillaume Apollinaire: *For my part, I have never avoided the influence of others, I would have considered it cowardice and lack of sincerity toward myself.* I believe that the artist's personality affirms itself by the struggle he has survived. One would have to be very foolish not to notice the direction in which others work. I am amazed that some people can be so lacking in anxiety as to imagine that they have grasped the truth of their art on the first try. I have accepted influences but I think I have always known how to dominate them.'

Matisse turned toward the wall where his latest works were hanging. And since I indicated two of them which differed only by the means of expression and the lighting:

'Yes,' he told me, 'I copy nature and I make myself even put the time of day in the painting. This one was painted in the morning, that one at the end of the afternoon; one with a model, the other without. I often told my students when I had a school: The ideal would be to have a studio with three floors. One would do a first study after the model on the first floor. From the second, one would come down more rarely. On the third, one would have learned to do without the model.'

Can you tell me what reasons led you to open the school and then to close it?

'I thought it would be good for young artists to avoid the road I travelled myself. I thus took the initiative of opening a school in a convent on the rue de Sèvres, which I then moved near the Sacré Cœur, in a building where the Lycée Buffon now stands.[23] Many students appeared. I forced myself to correct each one, taking into account the spirit in which his efforts were conceived. I especially took pains to inculcate in them a sense of tradition. Needless to say, many of my students were disappointed to see that a master with a reputation for being revolutionary could have repeated the words of Courbet to them: *I have simply wished to assert the reasoned and independent feeling of my own individuality within a total knowledge of tradition.*[24]

'The effort I made to penetrate the thinking of each one tired me out. I reached the point where I thought a student was heading in the wrong direction and he told me (revenge of my masters), "That's the way I think." The saddest part was that they could not conceive that I was depressed to see them "doing Matisse". Then I understood that I had to choose between being a painter and a teacher. I soon closed my school.'

When you started out what were the material conditions of life for a painter?

'We didn't have enough to buy a beer. Marquet lived in such misery that one day I was obliged to reclaim the twenty francs which a collector owed him because he needed the money so badly. I was personally obliged to work with Marquet on the decoration of the ceiling of the Grand-Palais.[25] Marquet did not have enough money to buy colours, especially the cadmiums which were expensive. Consequently he painted in greys and perhaps this economic condition favoured his style. At one point I thought of setting up a company of collectors run for my profit, like Van Gogh had proposed. One of my cousins agreed to be party to it on the condition that I do two "views" of his property. Hunger was threatening us. And we looked at what others were doing and decided to do the same in order to please the public. We couldn't. So much the better for us! The collectors said: "We've got our eye on you", which meant that, in a few years, they would take the risk of paying a hundred francs for one of our paintings.'

Didn't you know the shop of Père Tanguy?[26]

'That shop in front of which people used to meet to make fun of Cézanne and Van Gogh? No! But I knew old Druet,[27] then a wine merchant on the place de l'Alma. Rodin ate there and made Druet take photos. Then Druet installed himself on the rue Matignon where he sold the neo-Impressionists. He had a genius for making collectors enthusiastic, and thus performed a great service for painters. Ambroise Vollard[28] did a bigger favour in taking the initiative in having canvases photographed.[29] This had considerable importance because without it others surely would have "finished" all the Cézannes, like they used to add trees to all the Corots. Berthe Weill also helped painters a lot. "Bring me a canvas," she wrote us sometimes, "I have a buyer." And in fact it sometimes happened that a buyer introduced by her offered us twenty francs for a canvas, which was an honourable fee at the time.[30]

'For my part, I have never regretted this poverty. I was very embarrassed when my canvases began to get big prices. I saw myself condemned to a future of nothing but masterpieces!'

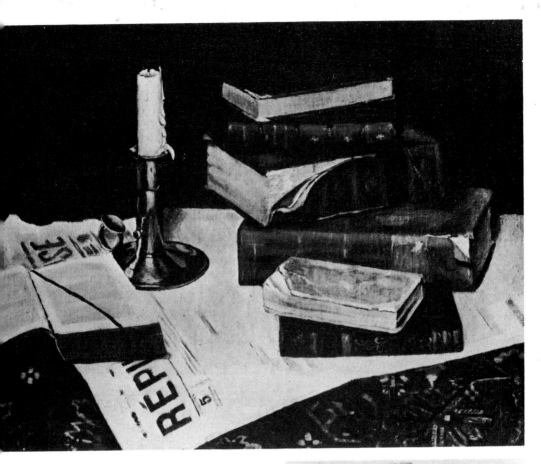

1 *Nature morte aux livres* 1890.

2 *Life study* 1891.

3 *Nature morte après de Heem* 1893.

4 *Rochers: Belle-Île* 1896.

5 *La desserte* 1897.

6 *Olivier* 1898.

7 *La malade* 1899.

8 *Buffet et table* 1899.

9 Cézanne: *Trois baigneuses*
1879–82.

10 *Nu debout* 1900.

11 *Notre-Dame: fin d'après-midi* 1902.

14 *Fenêtre ouverte, Collioure* 1905.

16 *Portrait à la raie verte* 1905.

◀ 15 *La guitariste* 1903.

17 *Bonheur de vivre* 1905.

18 *Nu bleu* 1907.

19 *Les joueurs de boules* 1908.

20 *Harmonie rouge*
1908–9.

21 *La danse* 1909.

22 *La musique* 1910.

23 *La famille du peintre* 1911.

24 *La fenêtre bleue* 1911.

25 Cézanne: *Le vase bleu* 1883–87.

8

Statements to Tériade, 1929–30[1]
[On Fauvism and Expression through Colour; On Travel]

In 1929, before Matisse's Tahitian voyage, and again in 1930, a few months after it, Matisse's friend the critic Tériade recorded some statements by the artist. These two statements also formed the basis for a later statement to Tériade, 'Matisse Speaks' (Text 39, below).

In the first statement, Matisse explains the difference between neo-Impressionism and Fauvism, noting that the former is an essentially mechanical method of painting, and that the theoretical aspect of such painters as Seurat did not, in the last analysis, count nearly so much as the human value, a line of thought quite in keeping with his earlier dictum that rules have no meaning outside of individuals. It is significant that Matisse recalls the artistic and moral victory which Fauvism represented to him, since it suggests the new crisis Matisse felt in his art at this time, which is reflected in such works as *Figure decorative sur fond ornemental* of 1927, *Femme au turban* of 1929 (Figure **33**), and *Le dos, IV* (Figure **37**) of 1929–30, all of which indicate his desire to achieve a renewed simplicity in his works. The parallel between this 1929 crisis and the earlier Fauve crisis is striking; both have to do with a calculated aesthetic and social risk (cf. the interview with Jacques Guenne, Text **7** above), and both are concerned with moving from observation of actual light and detail to construction with colour 'without differentiation of texture'. This statement also shows Matisse's retrospective state of mind at the time, his lack of interest in contemporary movements and his preoccupation with finding a fresh way to move. In 1929, no less than in 1905, Matisse was indeed going once again—from the ordered interiors of the Nice period (kept by country aunts)—back into the jungle.

The statement made after Matisse came back from his trip to Tahiti shows just how profound was the unrest which moved him to make the voyage in the first place, and some of the effects which his travels had on him. One of the most interesting aspects of this statement is Matisse's discussion of the tensions which provoked him to work, and their absence in Tahiti and presence in New York. This desire to regain equilibrium in the face of tension seems to have been one of the most important psychological impulses behind his art.

STATEMENTS TO TERIADE [On Fauvism and Expression through Colour]

[Matisse, about to leave Paris, speaks to Tériade:] 'I went to bed a little late last night. Let's speak to the point, because we have scarcely an hour. I am leaving right away for Nice. Paris tires me in winter—the noises, the movement, the events and fashions that one has to follow. When you are young, of course, it's all very good. You have to begin by

entering the fray, adventuring in the bush.[2] But for me now, silence and isolation are useful. Only superficial painters need fear them. As for the movements and exhibitions, I have almost nothing to learn from them, and I don't want to let my thought stray from my work in progress. Look, during these few days that I spent in Paris, I went to see the boat show the first day, and the second also, and every day since. Even today, I don't want to leave Paris without having given it a last glance. I adore boating. Look at the calluses I have on my hands.' And Matisse showed us his bronzed palms which bore the only sign of the sun in the grey room.

'How do you feel about the Fauve movement judged from the distance of today?' This question, asked a little bluntly, resounded too profoundly in Matisse for him to be able to answer it immediately, directly. Thus he began by going back to the sources, to the neo-Impressionist period where his true work as a painter became evident, and I was given an admirable lesson on colour, on the means by which the coloured surface of the painting was divided according to Divisionist theories, on the reconstruction of white light, Chevreul's colour wheel, diffusion, the breaking up of shadow by light, etc. This brought the painter to speak of himself and of his situation at that time.

'I showed Signac and Cross my first picture done according to these principles. The latter, noting that I had achieved contrasts as strong as the dominants, told me: "That's good, but you won't stay with it long".[3] Quite so.

'Neo-Impressionism, or rather that part called Divisionism, was the first systematization of the means of Impressionism; but a purely physical systematization; an often mechanical means corresponding only to a physical emotion. The breaking up of colour led to the breaking up of form, of contour. Result: a jumpy surface. There is only a retinal sensation, but it destroys the calm of the surface and of the contour. Objects are differentiated only by the luminosity given them. Everything is treated in the same way. Ultimately, there is only a tactile vitality comparable to the "vibrato" of the violin or voice. As Seurat's canvases become greyer with time, they lose whatever formulary aspect there was in the grouping of the colours and retain only their true values, those human values in painting which are today more profound than ever.[4]

'I didn't stay on this course but started painting in planes, seeking the quality of the picture by an accord of all the flat colours. I tried to replace the "vibrato" by a more expressive and more direct accord, an accord whose simplicity and honesty would have given me quieter surfaces.

'Fauvism overthrew the tyranny of Divisionism. One can't live in a house too well kept, a house kept by country aunts.[5] One has to go off into the jungle to find simpler ways which won't stifle the spirit. The influence of Gauguin and Van Gogh were felt then, too. Here are the ideas of that time: Construction by coloured surfaces. Search for intensity of colour, subject matter being unimportant. Reaction against the diffusion of local tone in light. Light is not suppressed, but is expressed by a harmony of intensely coloured surfaces. My picture, *La musique* [Figure 22] was done with a fine blue for the sky, the bluest of blues (the surface was coloured to saturation, that is to the point where the blue, the idea of absolute blue, was entirely evident), green for the trees and violent vermilion for the figures. With those three colours I had my luminous harmony, and also purity of colour tone. To be noted: the colour was proportioned to the form. Form was modified, according to the reaction of the adjacent areas of colour. For expression comes from the coloured surface which the spectator perceives as a whole.'

And Matisse continues: 'The painter releases his emotion by painting; but not without his conception having passed through a certain analytic state. The analysis happens within the painter. When the synthesis is immediate, it is schematic, without density, and the expression suffers.

'Fauvism did not content itself with the physical arrangement of the picture, as did

Divisionism. It was thus the first effort towards an expressive synthesis. Compare El Greco and Velasquez.[6] With Velasquez, emotion is solely physical. It goes no further. Without the sensory pleasure, there is obviously nothing. But you can ask of painting a deeper feeling which touches the mind as well as the senses. On the other hand, purely intellectual painting is non-existent. You cannot even say that it goes no further, for it does not even begin. It remains locked up in the intention of the painter and is never realized.'

What was the state of mind at the time of Fauvism?

'The state of mind was the defence of the painters against the Salons and the official painters. Nowadays, on the other hand, the Indépendants are the masters. To exist, you have to put on an "Indépendant" arm band. That is the current madness of the moderns. One wants it; it isn't anymore. If more or less literary endeavours were born at that moment in painting, they were all confined to the literary coteries. The literary coteries were not aware of each other. There was no confusion between them. One didn't try to succeed through politics.[7] Sincerity was in favour.'

Have we arrived at a new pictorial ideal?

'Some new means have been arrived at, or rather the means have been renewed. The retina tires of the same means. It demands surprises. For myself, since it is always necessary to advance and to seek new possibilities, I nowadays want a certain formal perfection, and I work by concentrating my means to give my painting this quality, which is perhaps external, but which is necessary at a given moment, of a well-executed, finished object. But this doesn't mean that it isn't necessary to mess up some canvas when you are young, that one shouldn't start at the beginning. The problems of a young man are very different, much more serious, and form the very basis of his work, before its components are fixed.

'At the time of the Fauves, what created the strict organization of our works was that the quantity of colour was its quality. It had to be right from all points of view. That is what was timely then. The people who saw painting from the outside were made uneasy by the schematic state of certain details. Hands, for example, Renoir painted progressively according to his feeling, sensation by sensation. We ourselves were preoccupied with the measure of the plastic ensemble, with its rhythm, with the unity of its movement. Thus we were accused of not knowing how to paint a hand or how to draw any other detail. Nothing could be more false. It was simply that the state of our pictorial problem did not permit us to go all the way to the perfection of details.

'The only thing that one should ask of a painter is to express his intentions clearly. His thought will profit from this. As for those who, preoccupied with the precious aspect of their works, begin with perfection, the spirit of the École [des Beaux-Arts] and of the Prix-de-Rome is with them. Without going so far as to encourage certain painters for whom the language no longer exists, I think that the young who will have something to say and who will go beyond the means along the way, will say it anyway.'

Does your choice of Odalisques have any particular reasons behind it?

'I do Odalisques in order to do nudes. But how does one do the nude without it being artificial? And then, because I know that they exist. I was in Morocco. I have seen them. Rembrandt did Biblical subjects with real Turkish materials from the bazaar, and his emotion was there. Tissot did the Life of Christ with all the documents possible, and even went to Jerusalem. But his work is false and has no life of its own.[8]

And the window?[9]

'My purpose is to render my emotion. This state of soul is created by the objects which surround me and which react in me: from the horizon to myself, myself included. For very often I put myself in the picture, and I am aware of what exists behind me. I express as naturally the space and the objects which are situated there as if I had only the sea and

the sky in front of me; that is to say, the simplest thing in the world. This is to make it understood that the unity realized in my picture, however complex it may be, is not difficult for me to obtain, because it comes to me naturally. I think only of rendering my emotion. Very often, the difficulty for an artist is that he doesn't realize the quality of his emotion and that his reason leads this emotion astray. He should use his reason only for control.'

[On Travel]

[Tériade has asked Matisse about the value that travel has for the painter.] 'If I may,' Matisse says, 'I should like to answer by an example taken from my work, which will put these questions into a tangible context.

'In my Nice studio, before my departure for Tahiti, I had worked several months on a painting without finishing it.[10] During my trip, even while strongly impressed by what I was seeing every day, I often thought of the work I had left unfinished. I might even say that I thought of it constantly. Returning to Nice for a month this summer, I went back to the painting and worked on it every day. Then I left again for America. And during the crossing I realized what I had to do—that is, the weakness in the construction of my painting and its possible resolution. I am anxious to go back to it today.

'This proves perhaps that my work is the binary of the life of my brain. Perhaps it is also the *idée fixe* of a foolish old world traveller who upon his return looks for a tobacco pouch he had mislaid before leaving.

'When you have worked for a long time in the same milieu, it is useful at a given moment to stop the usual mental routine and take a voyage which will let parts of the mind rest while other parts have free rein—especially those parts repressed by the will. This stopping permits a withdrawal and consequently an examination of the past. You begin again with more certainty when the preoccupation of the first part of the trip, not having been destroyed by the numerous impressions of the new world you are plunged into, takes possession of the mind again.

'The mind of a man who is still developing can be intoxicated by places like Tahiti because his pleasures are confused (that is to say that when he has felt the voluptuous roundness of a Tahitian woman, he imagines that the sky is clearer). But when a man is formed, organized, with an ordered brain, he no longer makes these confusions and better knows the source of his euphoria, his expansion.

'Consequently, he doesn't risk interrupting the course of his own development. It is thus for the painter. A voyage made at the time when the mind is already formed has a usefulness different from that of a voyage made by a young man[11]—if you will grant that the artist can attain his complete development only on the soil where he is born.[12]

'This is clearly applicable to artists for whom imagination plays an important role. As for the realists, if you take the word "realism" in its narrow, objective sense, they can express themselves anywhere as long as their interior life does not change.

'Having worked forty years in European light and space, I always dreamed of other proportions which might be found in the other hemisphere. I was always conscious of another space in which the objects of my reveries evolved. I was seeking something other than real space. Whence my curiosity for the other hemisphere, or a place where things could happen differently. (I might add, moreover, that I did not find it in Oceania.)

'In art, what is most important is the relationship between things. The attempts to possess the light and space in which I lived gave me the desire to see myself with a different space and light which would allow me to grasp more profoundly the space and light in which I do live—if only to become more conscious of them.

'That is why, when I was in Tahiti, I collected my thoughts to produce visions of Provence, in order to contrast them strongly with those of the Oceanic landscape.'

Matisse concluded: 'Most painters require direct contact with objects in order to feel that they exist, and they can only reproduce them under strictly physical conditions. They look for an exterior light to illuminate them internally. Whereas the artist or the poet possesses an interior light which transforms objects to make a new world of them— sensitive, organized, a living world which is in itself an infallible sign of the Divinity, a reflection of Divinity.

'That is how you can explain the role of the reality created by art as opposed to objective reality—by its non-material essence.'

Here are some remarks by Matisse about Tahiti:[13]

'Nature there is sumptuous, but not exalting, a familiar apartment-like sumptuousness, practically without surprises. You don't have an immediate reaction which makes you need to unwind by working.

'The light is lovely, but on a small scale, on trees which are not large and seem rather like house plants.

'I realized there that I had no pictorial reaction whatsoever, and that there was nothing to do but languish in the thick, cool shadows of the island mountains, or else at the "Lotus", the "Lido", or the "Lafayette", fashionable night-clubs no doubt open so that the Europeans will lose neither their inspiration nor the Dionysian habits of the Métropole.

'You are struck there by this ambiance which consists of doing nothing. Laziness is stronger than everything else. That is what lies behind the amiable amorality in the customs of the islanders, an amorality which becomes quite demoralizing after a short time. The Tahitians are like children. They have no sense of anything being prohibited, nor any notion of good and evil. Steal a bicycle? What for? Where would you go with it? Eventually, after riding around, it would have to be put back where it came from. Take the next fellow's wife? Nothing wrong with that. And if you are white, it's an honour for the family and its future descendants.

'The Tahitian girls retain their wild and uncultivated nature despite the delicate Parisian styles they wear. They go to a bar, they drink cocktails, and their only reading material is the seasonal catalogues from the Paris department stores.

'It is also true that everything there comes from far away, and very late. *L'Intran* [*sigeant*] you read three months late. The newsreels at films are often four years behind the times. Thus this past summer I was able to admire the sumptuous reception of Amanoullah by the King of England, which, if it wasn't a burning current event, was at least ironically irreverent.'

And Gauguin?

'Gauguin left as a rebel. That's what kept him in this ambiance which liquifies you, as is said there. His combative character, his sense of being crucified, preserved him from the general torpor. His wounded vanity kept him awake.

'There is no memory of him there. Except, on the part of the people who knew him, a regret that his paintings are so expensive nowadays. There is also a tiny "rue Gauguin" just next to the Oceanic Phosphates Company, but the director of this company had never noticed it.

'Then there is his son who lives in Punaauia. Everyone calls him Gauguin. He has his father's heavy eyelids and hooked nose. A superb man in his thirties with powerful arms. He spends his nights engaged in *pêches miraculeuses*. Peculiar sign: he speaks no French. This is quite exceptional in Tahiti. Contrary to his father, his gentle character makes him very popular.

'In imitation of Gauguin, other painters live there and paint the beauties of the island with a heavy hand. They are generally encouraged by the inhabitants who thus hope to

gain their turn. They all admire nature, but only at sunset: Sunset over Moorea. They
paint nothing but that all their lives.

'It's true that the evening there is magnificent. Before the flamboyant sunset, the sky is
blond, like honey. Then it turns blue with an infinite softness.

'On the other hand, at 6 o'clock in the morning, it is beautiful, too beautiful, ferociously
beautiful. Weather so brilliant, so bright that you would think it was already noon. Then, I
assure you, it is frightening. It is alarming to have the day begin with a dazzling sun
that will not change until sunset. It is as if the light would be immobilized forever. It is as
if life were frozen in a magnificent stance.

'Before I left, everyone said to me: "How lucky you are!" I answered: "I would love to
already be on my way back." Now I am!'

'The first time that I saw America,' Matisse says, 'I mean New York, at 7 o'clock in the
evening, this gold and black block in the night, reflected in the water, I was in complete
ecstacy. Someone near me on the boat said: *It's a spangled dress*, which helped me to arrive
at my own image. New York seemed to me like a gold nugget.[14]

'Later, on the Fifth Avenue sidewalk, I was truly electrified, and I thought: Is it really
worth the trouble to go so far (I was crossing America then to go to Tahiti) when I feel so
full of energy here.

'The proportions of the street and the height of the buildings give a sensation of space.
One breathes better there than in narrow old streets. One has an impression of amplitude
in which the order gives you a feeling of security. You can think very comfortably in a New
York street, which has become practically impossible in our Parisian muddle.

'Obviously, I am not speaking of the side-streets, but rather of that American spirit
which seems to be realized more and more freely in the heart of a city like New York.

'The skyscrapers are not at all what you would imagine from photographs. The sky
begins after the tenth storey, because the stonework is already eaten up by the light. The
light and its reflections take the materiality from the building. Seen from the street, the
skyscraper gives us the sensation of a gradation of tones from the base to the top. The
gradation of a tone which evaporates in the sky, taking on the softness of the celestial
matter with which it mixes, gives the passer-by a feeling of lightness which is completely
unexpected by the European visitor. This lightening, which corresponds to a feeling of
release, is quite beneficial in counterbalancing the overwhelming hyperactivity of the
city.

'The modern buildings, mostly white, are often traversed from base to top with great
brilliant aluminium mouldings which render the proportions comprehensible at a glance,
without distorting them, like a mirror of water. Thus we can associate this size with that
which is already familiar to us, and the skyscraper fits into our scheme of palpable
objects, with human proportions. This no doubt enlarges our space.

'At the Musée de Cluny, for example, you are confined by walls whose proportions were
necessary in the Middle Ages. In the Renaissance château, one already breathes more
freely. And so on. In the neighbourhood of a skyscraper there is a clear feeling of liberty
through the possession of a larger space.

'The space that I sought in Tahiti and did not find there, I found in New York.

'This is self-evident when you contemplate the city from the thirteenth or fourteenth
floor of the Plaza Hotel for example, where you see Central Park before you, and, on each
side, the skyscrapers of the grand avenues. It is a prodigious vision, but not inhuman like
that of the high Swiss mountains, for example.

'As for Broadway at night, which is so greatly praised, it has no lasting interest. The
Eiffel Tower illuminated is a much finer object. The Americans themselves admit
it.

'On the other hand, when one sees New York from the river at the end of the day, all these great buildings of different heights are coloured differently and present a ravishing spectacle in the Indian Summer sky. Until the end of November, there is a very pure, non-material light, a crystalline light, as opposed to the light of Oceania which is pulpy and mellow like that of the Touraine, and which seems to caress what it touches.

'It is an exceedingly pictorial light, like the light of the Italian primitives.'

Is there an American pictorial climate?

'Very much so, but one which has not been exploited yet. When the Americans have travelled sufficiently across the old world to perceive their own richness, they will be able to see their own country for what it is.

'And I am not only talking about the American physical climate, but the moral atmosphere itself. This tension, the constant dynamism, can be transformed, in the artist, into artistic activity by provoking a beneficial reaction in him.'

How did the Americans come to our modern painting?

'Americans are interested in modern painting because of its immediate translation of feeling. It is more direct than previous painting. The materials used lose less of their natural side. It has much more to do with lines and colours in movement than with reproduction of a given object or person. Through it, Americans communicate more freely amongst themselves. It is more in rapport with the activity of their spirit. It does not tie them to a kind of identification of the conditions of the material life of the objects represented.

'When they are tired, their minds are not confronted by a "void of action", but they confront modern paintings and find, on another level, their own activity.

'Thus they relax.

'That is what I said twenty-five years ago in *La Grande Revue: Painting should be a calming influence for the mind tired by the working day of the contemporary man.*

'One of the most striking things in America is the Barnes collection,[15] which is exhibited in a spirit very beneficial for the formation of American artists. There the old master paintings are put beside the modern ones, a Douanier Rousseau next to a Primitive, and this bringing together helps students understand a lot of things that the academies don't teach.

'This collection presents the paintings in complete frankness, which is not frequent in America. The Barnes Foundation will doubtless manage to destroy the artificial and disreputable presentation of the other collections, where the pictures are hard to see—displayed hypocritically in the mysterious light of a temple or cathedral. According to the current American aesthetic, this presentation seeks to introduce a certain supposedly favourable mystery between the spectator and the work, but it is in the end only a great misunderstanding.

'In any case, the vogue for modern painting in America is certainly a preparation for a flowering of American art.

'Moreover, in other domains, the expression of the American energy is making itself felt, as in the cinema or in architecture, where they have given up imitating the Loire châteaux, without regret. Although some supreme vestiges still remain, little pieces surviving on the twenty-sixth floor of a building in the form of a hat, or on Wall Street, the cornices which crown a building create disturbing black bars which are disquieting to the passers-by.

'It will probably be said that I am flattering the Americans, just as they said a few years ago that I had grown a beard to please the Russians.[16] But there is every evidence, for someone with some awareness, that the new buildings are more satisfying to the mind than the poor assemblages of our diverse styles which they constructed in the past. There are still some examples of that on Fifth Avenue. Thus it is easy to compare.

'The great quality of modern America is in not clinging to its acquisitions. Over there,

love of risk makes one destroy the results of the day with the hope that the next day will provide better.[17] America has the form and the spirit of a great range of experiences, which, for the artist, must be extremely agreeable.'

And the Carnegie prize?[18]

'The purpose of the Carnegie is to show in America what is happening in European painting, and that without a feeling of judgement, without preference to one tendency rather than another. But what is slightly troubling is that the jury is constituted of artists whose tendencies are so irremediably different that the result has no significance.

'The European part of the jury is composed of three members: a Frenchman (always chosen from amongst the painters with the most advanced ideas), an Englishman (always a member of the Royal Academy in London), and a third person picked from one of the other European countries. This year, it was an Austrian. It is noteworthy that this third member should be, for preference, without marked leanings, the "middling painter" par excellence, obviously to establish the desired equilibrium.

'This year the first prize was given to Picasso. The second to an American, Brook. The third to Dufresne.'

9

Courthion: *Meeting with Matisse,* 1931[1]

In this 1931 interview with Pierre Courthion, Matisse manages to make some significant points in spite of the apparent obtuseness of his interviewer. Fresh from his visit to Tahiti, he mentions the meditation which the South Seas aroused in him and the way in which he had used the time to store impressions for later work. This anticipates the method of working that he would develop more fully in the next decade, and is an experience to which he would frequently allude.

This interview also give good evidence of Matisse's awareness of the tradition in which he is working and his relationship to it.

MEETING WITH MATISSE

Matisse thinks slowly before speaking, and expresses himself with a striking precision. He has blue eyes, agate-coloured, curiously attentive behind his tortoise-shell glasses. Dressed in sports clothes, his greying hair brushed back carelessly, he is seated in front of me with his legs crossed but his back very straight. He surrounds himself only with things that are necessary to him, putting out of his way everything that could distract him. He has only one canvas on the wall, the one he is working on at present which is

held up by drawing pins. When I tell him his painting reminds me of that of Velasquez he stops me: 'When I saw his work in Madrid, to my eyes it was like ice! Velasquez isn't my painter: Goya, rather, or El Greco.'[2]

Matisse likes that which is ablaze. Nevertheless, I expand on my comparison and he accepts it, saying: 'Perhaps, but you must distinguish between *conception* and *result*. The conception of pure painting, in Velasquez' work, doesn't give a result that satisfies me.'

'Delacroix, then,' I said. 'Although you don't grant the same importance to the imagination, to the subject.'

'You see,' continued Matisse, 'we never realize sufficiently clearly that the old masters we admire would have produced very different works if they had lived in another century than their own. Delacroix in 1930 would not have been inspired by the same themes that occupied his mind in 1830.'

I reminded Matisse that in 1908 he wrote: 'What I dream of is an art of balance, of purity and serenity, devoid of troubling or depressing subject matter, an art which could be for every mental worker, for the businessman as well as the man of letters, for example, a soothing, calming influence, something like a good armchair which provides relaxation from physical fatigue.'[3]

'It's true there is Chardin,' I added, 'but apart from these few relationships none of which is really direct, you are really so individualistic a painter that you are "without a path".'

'It depends on what you mean by that. Do you mean without being influenced and without having any influence on the future?'

'By no means: I mean that, for someone who tries to associate you with a tradition or a master, apart from the Mediterranean aspect which is your "climate", and the French ethos, which has rubbed off on you, you are an exception, and a rare, a very rare artist.'

'I can't judge that. I don't know about that: but what's so astonishing about not understanding? There are so many things in art, beginning with art itself, that one doesn't understand. A painter doesn't see everything that he has put in his painting. It is other people who find these treasures in it, one by one, and the richer a painting is in surprises of this sort, in treasures, the greater its author. Each century seeks to nourish itself in works of art, and each century needs a particular kind of nourishment.'

We started talking about the South Seas Islands and Matisse told me about his recent trip, recalling Tahiti,[4] the small coral islands, the multi-coloured fish, the broad, flat tones of the countryside. While visiting these islands, Matisse observed; he did not work with a paintbrush in his hand. To open his eyes! I believe that is the secret of a man like Matisse.

Matisse has widespread knowledge on just about everything. He never seems to be at a loss. I talked to him about his copies, done at the Louvre when he was young, some of which he found in storage in the museum, where they had lain hidden for a long time, since his difficult years.

'I owe my knowledge of the Louvre to Gustave Moreau: one didn't go there any more. He took us there, and taught us to see and to question the old masters.'

'I saw your copies in your studio on boulevard Montparnasse. Can you tell me the order in which they were done?'

'I started with David De Heim's *La desserte*.[5] Then there was *La raie*,[6] that I tried to paint schematically—Cézanne was the last.'[7]

'Your copy of *La raie* is the first work in which one can recognize your own style. It is clearly Chardin as seen by Matisse. Your *Christ mort* after Philippe de Champaigne,[8] seemed duller to me.'

'That's not surprising. I first had made a free copy of it; then, in the hope of a sale, I repainted it differently. I also made copies of *Baldassare Castiglione*,[9] and of *La tempête* by Ruysdael.'

Statement to Tériade, 1933[1] [On Creativity]

In 1933 Matisse again made a statement to Tériade. Once again he professes his faith in the study of nature and in the enrichment of the self in order to achieve expression. He repeats, more clearly, his earlier statement (Text 3, above) that photography may be used to study nature.

STATEMENT TO TÉRIADE [On Creativity]

Photography has greatly disturbed the imagination, because one has seen things devoid of feeling. When I wanted to get rid of all influences which prevented me from seeing nature from my own personal view, I copied photographs.[2]

We are encumbered by the sensibilities of the artists who have preceded us. Photography can rid us of previous imaginations. Photography has very clearly determined the distinction between painting as a translation of feelings, and descriptive painting. Descriptive painting has become useless.

The things that are acquired consciously permit us to express ourselves unconsciously with a certain richness.

On the other hand, the unconscious enrichment of the artist is accomplished by all he sees and translates pictorially without thinking about it.

An acacia on Vésubie,[3] its movement, its svelte grace, led me perhaps to conceive the body of a dancing woman.

I never think, when looking at one of my canvases, of the sources of emotion which were able to motivate a certain face, object or movement I see there.

The reverie of a man who has travelled is richer than that of a man who has never travelled. The daydreams of a cultivated mind and the daydreams of an uncultivated one have nothing in common but a certain state of passivity.

One gets into a state of creativity by conscious work. To prepare one's work is first to nourish one's feelings by studies which have a certain analogy with the picture, and it is through this that the choice of elements can be made. It is these studies which permit the painter to free his unconscious mind.

The harmony of all the elements of the picture which have a part in the unity of feeling encouraged by working, imposes a spontaneous translation on the mind. It is this which one can call the spontaneous translation of feeling, which comes not from a simple thing but from a complex thing, and which is simplified by the purification of the subject and of the mind of whoever translated it.

One does not put one's house in order by getting rid of what one does not have, because that only creates a void, and a void is neither order nor purity.

I I

Letters to Alexandre Romm, 1934[1]

In 1934 Matisse wrote several letters to the Soviet art critic Alexandre Romm, who was writing a book on him,[2] and who had solicited information directly from the artist. Matisse's answers to Romm were the considered statements of an artist to his public, rather than personal letters, as is attested to by the content of the letters themselves and by Matisse's statement (20 June 1935) to the Director of the Museum of Modern Western Art in Moscow: 'I have not written on painting since the War, as I did before in the *Grande Revue*, except to Mr. Romm'.[3]

The letters are devoted mostly to discussion of Matisse's most recent works, especially the Barnes Murals (Figure **36**) on which these letters remain his most important statements and formed the basis for several other statements,[4] and the *Danse* and *Musique* panels (Figures **21** and **22**) that he had done for Shchukin in 1909–10, and which had been confiscated by the State for the Museum of Modern Western Art in Moscow. Some of Matisse's stubbornness and precision may also be seen in these letters.

LETTERS TO ALEXANDRE ROMM

Sir, 19 January 1934
[The letter starts with topical matters and suggests illustrations for Romm's book.]
From these last years (1931–2 and 3), I am sending you the photo of an important work which I have just done for the Barnes Foundation (Philadelphia); it is a panel of 13 metres by 3·50 metres, placed above three entirely glazed doors six metres in height. The photo of the ensemble with the doors, made from different photographs assembled together, will give you an idea of it. The painting acts as a pediment to these three doors—like the elevated part of a cathedral porch—a pediment placed in shadow and yet required, in continuing the large mural surface broken by the three great luminous bays, to maintain itself in all its luminosity; consequently its plastic eloquence (a surface in shadow juxtaposed against a strongly lit bay without destroying the continuity of the surface) is the result of modern achievements regarding the properties of colour. Perspective, as you can see for yourself, reduces the painted part, since it is in reality 3·50 metres tall, while the doors are 6. I have added to these photos another of a view drawn by an architect, which gives the true proportions.

Apart from the fact that this work is the most important I have done these past three years, the subject too, analogous to one of my important works in Moscow (*La danse*), will convey to you an interesting relationship between these two works. These panels are painted in flat colours. The areas between the doors are continued in the decoration of the black surfaces and give a unity of surface from the floor to the top of the vault: 6 m + 3 m.50 = 9 m.50, which, together with the pendentives which press down on these black surfaces, gives the illusion of a monumental support for the vault.

The other colours: rose, blue, and the nudes of a uniform pearl grey, form the whole musical harmony of the work.

Their frank contrasts, their decided relationships, give an equivalent of the hardness of the stone, and of the sharpness of the ribs of the vault, and give the work a grand mural quality—a very important point since this panel is placed in the upper part of the large gallery of the Foundation, which is filled with easel paintings—it was logical clearly to differentiate my work of architectural painting.

I will indicate on the back of the photos the colours of the different sections. In spite of all these explanations, I think it will be impossible for you to get a clear enough idea of the work to be able to establish a close enough comparison with *La danse* in Moscow, for the points of view are totally different. The Moscow panel still proceeds from the rules governing an easel painting (that is to say, a work which can hang anywhere), which is because I was unable to imagine these panels in place, only knowing the staircase where they were to hang from having gone up it a few times without knowing that I would have paintings there—it was not then a question of decorating it.

The Merion panel was made especially for the place. In isolation I only consider it as an architectural fragment. It is really immovable, so much so that I forsee that these photos will be only of little interest to you in spite of my explanations.

You will find two or three photos representing two different versions of this same dance. That is because following an error in measurement of the two pendentives, which I had made 50 cm instead of 1 metre wide at the base, I had to start again when my first panel was finished after a year of work.[5] I enclose with my letter this first version. The second is not a simple copy of the first; for, because these different pendentives required me to compose with architectural masses more than twice the size, I had to change my composition. I even produced a work with a different spirit: the first is aggressive, the second Dionysiac; the colours, which are the same, are nonetheless changed; as the quantities being different, their quality also changes: the colours applied freely show that it is their quantitative relation that produces their quality.

Since I am talking to you in such detail about by work, I should tell you that I did another large work of sixty etchings to illustrate the *Poésies de Mallarmé*.[6]

[Matisse lists the etching reproductions enclosed.]

I close hoping that you will excuse all this writing if it doesn't interest you. I live here in solitude and when I have the occasion to pour forth, I cannot resist.

Please accept, Monsieur, with my thanks for all the trouble that you have gone to for me, my very best wishes.

Henri Matisse

P.S. I couldn't procure other reproductions of etchings—these ones are rather soiled, but the balance and the proportion in relation to the page are scrupulously exact, for these two elements are essential.

14 February 1934

Dear Mr. Romm,

You tell me in your letter of 3 February that my Merion panel is a logical follow-up of the Moscow *Danse*, but that you see there a distinct difference: the human element is less pronounced—and this induces me to answer you that the object of the two works was not the same; the problem was different.

In architectural painting, which is the case in Merion, it seems to me that the human element has to be tempered, if not excluded. I, who let myself always be guided by my instinct (so much so that it manages to overcome my reason), had to avoid it, for it led me away from my architectural problem each time it appeared on my canvas. The expression of this painting should be associated with the severity of a volume of whitewashed stone, and an equally white, bare vault. Further, the spectator should not be arrested by this

human character with which he would identify, and which by stopping him there would keep him apart from the great, harmonious, living and animated association of the architecture and the painting.

Didn't Raphael and Michelangelo, despite the abstraction resulting from all the richness of mind that they expended on their murals, weigh down their walls with the expression of this humanity, which constantly separates us from the ensemble, notably in the *Last Judgement*? This human sentiment is possible in a picture—a picture is like a book—its interest does not overwhelm the spectator who must go in front of it; the place it will hang is not fixed in advance. It can change places without essentially modifying its place. The painter, then, has more freedom to enrich it.

Architectural painting depends absolutely on the place that has to receive it, and which it animates with a new life. Once it is placed there, it cannot be separated. It must give the space enclosed by the architecture the atmosphere of a wide and beautiful glade filled with sunlight, which encloses the spectator in a feeling of release in its rich profusion. In this case, it is the spectator who becomes the human element of the work.

You also say: 'It seems to me that the Merion panels should produce an effect analogous to stained-glass windows in the semi-darkness of a nave.' Yes, with the difference that my wall is penetrated by light at the foot, while in the nave it comes from above. My painted surface is quite opaque, and does not give any illusion of the transparence of a stained-glass window; rather it reflects light.

I should like to add that the glazed arches are wider than the solid parts, but that my vertical plan still takes precedence over all else. I will even add that by the action of my lines and my painted surfaces, I have raised the arches of the vault, which were very oppressive and gave a crushing feeling.

You point out to me the difference between the Moscow *Danse* and the Merion panel (reminding you of the *Bonheur de vivre*) and you wonder if the different character of the colouring is not the cause.

On this subject, I should tell you that the first panel made for Merion (which because of an accident in measurement had to be redone) and the final one are painted with exactly the same colours, the same manner of painting and that, nonetheless, they have a different character. The first decoration is a warlike dance and has a little of the frenzy of the Moscow panel. The feeling alone turned the same constructive elements into a different expression, by proportioning them differently—as in music, the seven notes, more or less altered, and the same tones express by their different combinations—an extraordinary variety of expression. That is all.

You may, as you ask, make use of passages of this letter and of the preceding one if you consider it worthwhile. I hope to have expressed myself clearly enough for that.

I congratulate the directors of the Russian B.[eaux] A.[rts] on their excellent idea to have public momuments decorated by their painters; that is where the great problem is, at present.

Please accept my thanks for the great interest that you take in my work, and also the expression of my highest regard.

Henri Matisse

P.S. I looked with interest at the book of embroideries that you sent me. I had already seen this work in Moscow in the National Museum of Art formed by the brother of Serge Ivanovitch Stschoukine; the reproductions in this book are very well done.

A friend brought me from Moscow, several years ago, a colour reproduction of an *espagnole*,[7] in the Stschoukine collection. Could you tell me, if it is no trouble, whether there were other colour reproductions made of my works in Moscow?

17 March 1934

Dear Mr. Romm:

I said of a picture: its interest does not overwhelm the spectator who must go in front of it. It is an image. Like the book on the shelf of a bookcase, only showing the few words of its title, it needs, to give up its riches, the action of the reader who must take it up, open it, and shut himself away with it—similarly the picture enclosed in its frame and forming with other paintings an ensemble on the wall of an apartment or a museum, cannot be penetrated unless the attention of the viewer is concentrated especially on it. In both cases, to be appreciated, the object must be isolated from its milieu (contrary to architectural painting). It is this which made me write that the spectator must go 'in front of'; I should have written 'in search of' to be more precise.

[The letter concludes with topical matters.]

Henri Matisse

October 1934

Dear Sir,

[The letter begins with topical matters.]

Regarding the information that you asked me for on my manner of painting—intense study of the model and rapid execution of the picture afterwards; this is quite right, but again the method of work depends very much on temperament. Delacroix said that after making all the studies that one feels are needed for a picture, it was necessary to buckle down to it exclaiming: 'And now never mind about mistakes!' That is to say that it is necessary to let instinct speak. Regarding the transparency of colours, it is also a sort of instinct which guides your hand. When I undertook the Moscow *Danse* and *Musique*, I had decided to put colours on flat and without shading.[8] I knew that my musical harmony was represented by a green and a blue (representing the relation of the green pines to the blue sky of the Côte d'Azur) completed by a tone for the flesh of the figures. What seemed essential was the surface quantity of the colours. It seemed that these colours, applied by no matter what medium—fresco, gouache, watercolour, coloured material—would give the spirit of my composition. I was quite astonished, when I saw the decorations in Moscow, to see that I had, in applying my colours, played a little game with the brush in varying the thickness of the colour so that the white of the canvas acted more or less transparently and threw off a quite precious effect of moiré silk.

To use the transparency of colours, to avoid mixing them, which renders them dull, use glazes, etc. (this is your own phrase). This is governed by the same principle. You can superimpose one colour on another and employ it more or less thickly. Your taste and your instinct will tell you if the result is good. The two colours should act as one—the second should not have the look of a coloured varnish, in other words the colour modified by another should not look glassy. The painter who best used slightly thinned paint and glazes is Renoir—he painted with liquid: oil and turpentine (I suppose $\frac{2}{3}$ poppy seed oil and $\frac{1}{3}$ turpentine) quite fresh and not syrupy, oxidized by the air; for in this case the painting never dries; I knew of a Renoir of the Cagnes period, a figure of a woman representing a spring, which was still not dry twenty years after its execution.[9]

Since I am speaking of the Moscow decoration, let me tell you that in the panel of *Musique*, the owner had a little red painted on the second personage, a young flutist with crossed legs. He had a little red painted to hide the sex which was, however, indicated quite discreetly, it was there to finish the torso.[10] All that is needed is for a restorer to take a little liquid solvent like mineral spirits benzine, and rub this place a moment until the hidden lines appear.

12

On Modernism and Tradition, 1935[1]

Although Matisse had given some interviews between 1908 and 1935, his own published writing within that period consisted only of a relatively unimportant autobiographical note.[2] In May of 1935 Matisse contributed to a series of articles in *The Studio* in which artists and critics wrote on the art of the time. In this article, he reminisces about his early training, especially the time he spent copying in the Louvre, and about his relationship to his contemporaries. He notes that while most of the latter were interested in the Impressionists and post-Impressionists, he himself spent his time copying in the Louvre and submitting himself to the influence of such masters as Raphael, Poussin, and Chardin, because he wanted to see beyond the Impressionists' subtle gradations of tone: 'In short, I wanted to understand myself'. This emphasis upon the finding of oneself is a reiteration, here in autobiographical form, of Matisse's concept of painting as expression through the medium of the self.

Matisse in 1935 is just as concerned with his theory of the picture as a total harmony (not unlike a musical composition) in which the configuration of form and space carries the expression, as he was in 'Notes of a Painter' of 1908. His image of the chess-board is particularly revealing and sheds light on his choice of subject matter. The constant repetition of similar —and sometimes the same—objects and situations in his painting may be seen to have the constancy of a chess-board, while the different configurations of form in which the situations are embodied may be compared to the different moves which make the appearance of the board change during the course of play. As the intentions of the players remain constant, so it might be said that Matisse's intentions also remained constant, despite his changes in style.

The reasoning behind Matisse's synthesis of objects is succinctly stated here: significance is found not in copying nature but in the relation of the object to the artist's personality and to 'his power to arrange his sensations and emotions'.

Just as 'Notes of a Painter' showed Matisse's relationship to tradition, so here, he states that there has been no break in 'the continuity of artistic progress from the early to the present day painters'. Matisse obviously sees himself as part of a long and rich tradition in which 'only plastic form has a true value', and in which 'a large part of the beauty of a picture arises from the struggle which an artist wages with his limited medium',[3] what Roger Fry called 'The dual nature of painting, where we are forced to recognize at one and the same moment, a diversely coloured surface and a three-dimensional world. . . .'[4] This struggle with the limitations of the medium obsessed Matisse throughout his career.

In this essay Matisse once again discusses his continuity with the traditions of European painting, states his belief in painting as expression, and acknowledges his preference for bright, clear colour. Although he alludes to colour, line and subject matter, he once again avoids a specific discussion of space and the illusion of space and of the relationship between painting and drawing.

ON MODERNISM AND TRADITION

It is undeniable that, during the last fifty years, every artistic effort of importance has been made in Paris. Elsewhere, artists are content to follow where others have led, but in Paris there is the enterprise and the courage necessary to all creative work which has made this city an artistic centre.

When I first began to paint, we did not disagree with our superiors and advanced our opinions slowly and cautiously. The Impressionists were the acknowledged leaders and the post-Impressionists followed in their footsteps. I didn't. We young painters strolled down the rue Laffitte looking at the galleries in which their pictures were on view, and as we worked we thought of them. As for me, having left the Beaux-Arts, I spent my time in the Louvre copying and submitting myself to the influence of such undoubted masters as Raphael, Poussin, Chardin and the Flemish. I felt that the methods of the Impressionists were not for me. I wanted to see beyond their subtle gradations of tone and continual experiments. In short, I wanted to understand myself. Coming out of the Louvre, crossing the Pont des Arts, I saw other subjects for my art.

'Well, what *are* you looking for?' Gustave Moreau, my master, asked me, one day.

'Something that is not in the Louvre,' I answered, 'but is there', pointing to the barges on the Seine.

'And do you think that the masters of the Louvre didn't see that?' he replied. In point of fact what I saw at the Louvre did not affect me directly. There I felt as though I were in a library containing works of the past and I wanted to create something out of my own experience, so I began to work alone.[5]

It was then that I met a tall, thin young man, who has since put on quite a respectable amount of flesh; this was Derain.[6] We lived together for some time at Collioure, where we worked unremittingly, urged by the same incentive. The methods of painting employed by our elders were not adequate to the true representation of our sensations, so we had to seek new methods. And, after all, this urge is felt by every generation. At that time, it is true, there was more scope than there is to-day, and tradition was rather out of favour by reason of having been so long respected.

The simplification of form to its fundamental geometrical shapes, as interpreted by Seurat, was the great innovation of that day. This new technique made a great impression on me. Painting had at last been reduced to a scientific formula; it was the secession from the empiricism of the preceding eras. I was so much intrigued by this extraordinary method that I studied post-Impressionism, but actually I knew very well that achievement by these means was limited by too great adherence to strictly logical rules. Those around me knew of this feeling. Standing in front of a canvas that I had just finished, Cros [*sic*][7] said to me: 'You won't stay with us long.'

In the post-Impressionist picture, the subject is thrown into relief by a contrasting series of planes which always remains secondary. For me, the subject of a picture and its background have the same value, or, to put it more clearly, there is no principal feature, only the pattern is important. The picture is formed by the combination of surfaces, differently coloured, which results in the creation of an 'expression'. In the same way that in a musical harmony each note is a part of the whole, so I wished each colour to have a contributory value. A picture is the co-ordination of controlled rhythms, and it is thus that one can change a surface which appears red-green-blue-black for one which appears white-blue-red-green; it is the same picture, the same feeling presented differently, but the rhythms are changed. The difference between the two canvases is that of two aspects of a chess-board in the course of a game of chess.

The appearance of the board is continually changing in the course of play, but the intentions of the players who move the pawns remain constant.

I decided then to discard verisimilitude. It did not interest me to copy an object. Why should I paint the outside of an apple, however exactly? What possible interest could there by in copying an object which nature provides in unlimited quantities and which one can always conceive more beautiful? What is significant is the relation of the object to the artist, to his personality, and his power to arrange his sensations and emotions.

I have a great love for bright, clear, pure colour, and I am always surprised to see lovely colours unnecessarily muddied and dimmed.

A great modern attainment is to have found the secret of expression by colour, to which has been added, with what is called Fauvisme and the movements which have followed it, expression by design; contour, lines and their direction. In the main, tradition was carried forward by new mediums of expression and augmented as far as was possible in this direction.

It would be wrong to think that there has been a break in the continuity of artistic progress from the early to the present-day painters. In abandoning tradition the artist would have but a fleeting success, and his name would soon be forgotten.

To-day, it seems to me that we live in a period of fermentation, which promises to produce important and durable works. But, if I am not mistaken, only plastic form has a true value, and I have always believed that a large part of the beauty of a picture arises from the struggle which an artist wages with his limited medium.[8]

One last comment on the name of that school of painting known as 'Fauvisme', a word which was found so intriguing and which became the subject of many more or less apt witticisms. The phrase originated with the art critic Louis Vauxcelles who, on coming into one of the rooms of the Autumn Salon, where, among the canvases of that generation, a statue was on view executed by the sculptor Marque in the style of the Italian Renaissance, declared 'Look, Donatello among the beasts.' [9] This shows that one must not attach more than a relative importance to the qualifying characteristics which distinguish such and such a school, and which, in spite of their convenience, limit the life of a movement and militate against individual recognition.

13

Statements to Tériade, 1936[1]
[The Purity of the Means]

In 1936 Matisse made two short statements to Tériade, which are particularly relevant to his own development at this point. From around 1929 to about 1933, Matisse had been undergoing a revision of his own values, as evidenced in his work and in his statements. The first statement to Tériade is the boldest and the most straightforward appraisal of this change.

He is particularly concerned with a return to essentials, having felt perhaps that during the Nice period his paintings had become a little too complicated, relaxed, and low key, too much involved with the fleeting effects of nature, not synthetic enough. Thus he calls for 'beautiful

blues, reds, yellows—matter to stir the sensual depths in men. This is the starting point of Fauvism: the courage to return to the purity of the means.' Matisse here is obviously referring to the boldness of his own imagery in the mid 1930s. Thus he can state: 'In my last paintings I have united the acquisitions of the last twenty years to my essential core, to my very essence.' The twenty-year period he refers to is that between 1916 and 1936, and thus it seems that during the Nice period Matisse had indeed been regathering his forces, through the analysis of visual effects, in order to strike out even more boldly.

The second statement, which concerns relationships, anticipates Matisse's later exposition of his portrait painting method (Text 44, below), and bears witness to Matisse's consistency of method. It also provides a specific description of the fluid relationship Matisse maintained with his pictures while working on them.

STATEMENTS TO TÉRIADE [The Purity of the Means]

When the means of expression have become so refined, so attenuated that their power of expression wears thin, it is necessary to return to the essential principles which made human language. They are, after all, the principles which 'go back to the source', which relive, which give us life. Pictures which have become refinements, subtle gradations, dissolutions without energy, call for beautiful blues, reds, yellows—matter to stir the sensual depths in men.[2] This is the starting point of Fauvism: the courage to return to the purity of the means.

Our senses have an age of development which does not come from the immediate surroundings, but from a moment in civilization. We are born with the sensibility of a given period of civilization. And that counts far more than all we can learn about a period. The arts have a development which comes not only from the individual, but also from an accumulated strength, the civilization which precedes us. One can't do just anything. A talented artist cannot do just as he likes. If he used only his talents, he would not exist. We are not the masters of what we produce. It is imposed on us.

In my latest paintings, I have united the acquisitions of the last twenty years to my essential core, to my very essence.

The reaction of each stage is as important as the subject. For this reaction comes from me and not from the subject. It is from the basis of my interpretation that I continually react until my work comes into harmony with me. Like someone writing a sentence, rewrites it, makes new discoveries . . . At each stage, I reach a balance, a conclusion. At the next sitting, if I find a weakness in the whole, I find my way back into the picture by means of the weakness—I re-enter through the breach—and reconceive the whole. Thus everything becomes fluid again and as each element is only one of the component forces (as in an orchestration), the whole can be changed in appearance but the feeling still remains the same. A black could very well replace a blue, since basically the expression derives from the relationships.[3] One is not bound to a blue, to a green or to a red. You can change the relationships by modifying the quantity of the components without changing their nature. That is, the painting will still be composed of blue, yellow and green, in altered quantities. Or you can retain the relationships which form the expression of a picture, replacing a blue with a black, as in an orchestra a trumpet may be replaced by an oboe.[4]

. . . At the final stage the painter finds himself freed and his emotion exists complete in his work. He himself, in any case, is relieved of it.[5]

14

On Cézanne's 'Trois baigneuses', 1936[1]

In 1936 Matisse decided to give his Cézanne *Trois baigneuses* (Figure 9) to the Museum of the City of Paris at the Petit Palais. He had purchased the painting from Vollard in 1899, and had kept it through intense financial difficulties (see Text 18, below).[2] His letter to Raymond Escholier, Director of the Museum, is a moving testament to his regard for Cézanne.

ON CÉZANNE'S *TROIS BAIGNEUSES*

Nice, 10 November 1936

Yesterday I consigned to your shipper Cézanne's *Baigneuses*. I saw the picture carefully packed and it was supposed to leave that very evening for the Petit Palais.

Allow me to tell you that this picture is of the first importance in the work of Cézanne because it is a very solid, very complete realization of a composition that he carefully studied in several canvases, which, now in important collections, are only the studies that culminated in the present work.

In the thirty-seven years I have owned this canvas, I have come to know it quite well, I hope, though not entirely; it has sustained me morally in the critical moments of my venture as an artist; I have drawn from it my faith and my perseverance; for this reason, allow me to request that it be placed so that it may be seen to its best advantage. For this it needs both light and perspective. It is rich in colour and surface, and seen at a distance it is possible to appreciate the sweep of its lines and the exceptional sobriety of its relationships.

I know that I do not have to tell you this, but nevertheless I think it is my duty to do so; please accept these remarks as the excusable testimony of my admiration for this work which has grown increasingly greater ever since I have owned it.

Allow me to thank you for the care that you will give it, for I hand it over to you with complete confidence. . . .

Henri Matisse

15

Divagations, 1937[1]

In the late 1930s Matisse was moved to write two essays which are concerned primarily with drawing. 'Divagations' is the first of these. Although the early critical battles were past, political events had caused a new wave of reaction against much of modern painting, and Matisse's art was especially prone to criticism not only in Nazi Germany, where his art was considered 'decadent', but also in Russia where his art was criticized for its 'bourgeois aestheticism'. In addition, in the depth of the depression in America there was a tendency to distrust the opulence and aloofness of Matisse's painting from social events.[2] In this period Matisse was not only very much involved with drawing but was also quite aware of the appeal of his drawings even to persons who were not particularly enthusiastic about his painting.[3]

In 'Divagations', Matisse reflects at length on the inscription at the École Nationale des Beaux-Arts of a saying of Ingres which reads, 'Drawing is the probity of art'. He uses this quotation as a springboard for his own reflections upon drawing and the teaching of drawing; it also serves to vent his spleen against the Academicians, whom he felt misunderstood 'these facile words of Ingres, constantly repeated by pompous ignoramuses'. In reflecting upon the importance which Ingres and Leonardo (for both of whom Matisse had a great deal of respect) assigned to drawing, Matisse discusses the role of the artist as teacher.

Perhaps with some desire to justify the brevity of his own career as a teacher, Matisse regrets the sight of 'genuine artists devoting a portion of their efforts to the aid of those who cannot find their way alone!'[4] Finally, he comes back to an attitude which underlies all of his writings: 'He who really has something to say is driven to it by his emotion which induces him to carry out his work in relation to his own qualities.' Thus, while Matisse identifies himself with the 'classical tradition' of painters, he expresses the attitude that if rules are made they must be broken, that while intensive training and endless study are necessary to the development of the artist, the artist should proceed from his own instincts rather than by formulae. Matisse believed great art to be the product not of a didactic system, but of the contact between an individual sensibility and nature. Great art makes its own rules.

DIVAGATIONS

'Drawing is the probity of art.' Many years ago I used to find myself frequently standing perplexed before this statement, graven above the signature of Ingres on the marble of the little monument which is dedicated to him in the vestibule of the drawing class called the 'Cours Yvon' at the École Nationale des Beaux-Arts.

What exactly does this inscription mean? I readily agree that it is necessary first of all to draw, but what I do not understand is the word 'probity'. Can you hear words of this sort spoken by Corot, Delacroix, Van Gogh, Renoir or Cézanne? And yet I am not annoyed when Hokusai is called 'the old man mad about drawing'.

Are these facile words of Ingres, constantly repeated by pompous ignoramuses, to be linked with those contained in Leonardo da Vinci's manuscript recommending that lines of composition be sought in the cracks of old walls or indicating coarse tricks for giving expression to the likeness of young girls?[5]

I am of the opinion that Ingres and Leonardo, believing themselves obliged to teach their art, could only enter into communion with their pupils by giving them handy rules: either to hold them to their work through the patient execution of a literal drawing of the object to be represented (I think of the tailor who, having botched the cut and hang of his suit, tries to get out of the scrape by fastening it to the body of the customer by means of numerous alterations which bind his victim and paralyse his movements), or to remedy the poverty of their imagination through mechanical means of composition.

Similarly style, which is the result of the necessities of a given period and is determined by exigencies independent of the artist's will, cannot be taught.

Besides, I understood nothing of the drawing instruction given in this Cours Yvon, where, more than forty years ago, I was 'corrected' by Gérôme, Bouguereau, Joseph Blanc, Bonnat, Lenepveu, etc., exacting but imprecise teachers; nor, with the passage of time, has any of this instruction come back to me. But would I have understood any more had these masters been genuine? I don't believe so. I once had the good fortune to receive Rodin's advice on the subject of my drawings, which had been shown him by a friend. Yet the advice he gave in no wise suited me, and on this occasion Rodin merely showed his petty side.[6] He could not do otherwise. For the best of what the old masters possess, that which is their *raison d'être*, is beyond their grasp. Having no understanding of it, they cannot teach it.

An atelier of students reminds me of Bruegel's *Parable of the Blind* in which the teacher would be the first blind man who is leading the others.

Michel Bréal[7] used to say, 'A professor is a man who teaches what he doesn't know' (quoted by his son Auguste).

How distressing it is to see genuine artists devoting a portion of their efforts to the aid of those who cannot find their way alone. They merely succeed in whittling out so many white canes which will permit men whose activity might be better employed to grope their way until they have done a useless piece of work.

He who really has something to say is driven to it by the emotion which makes him carry out his work, in relation to his own qualities.

Renoir was consequently right when he said, 'The man who has turned his canvas to the wall for three months, and still cannot discover what is lacking in it has no need to go on painting.'

16

Montherlant: *Listening to Matisse*, 1938[1]

In 1938, the writer Henry de Montherlant published an interview with Matisse. Although this short piece is actually more of an essay than an interview and the reader is in fact listening more to Montherlant than to Matisse, it is reproduced here because of the insight that it gives into Matisse's attitude toward his immediate surroundings as the raw materials of his art.

LISTENING TO MATISSE

Each winter, for the last two years, I have often seen Henri Matisse in Nice. He had been asked to illustrate a limited edition of *La Rose de Sable*. After a long hesitation, he finally decided against it: 'It's a book in which everything has been said. There isn't room for anything in the margins.' He had a copy of *Atala* on the table, which he pointed to: 'That has no need to be completed either.' [2]

Who was it that said: 'I like women who have a past and men who have a future'? I like men who have a past and women who have a future. I like men who have lived a full life and accomplished much, and children who haven't as yet, but who are full of inspiration and promise. People of my own age are less interesting. I always feel as though I know more than they do. Barrès, who during his last agonizing five minutes of life must have been desolate at missing the pleasures of old age, spoke profoundly of the first signs of the twilight.[3] No one better understood Hugo's poems of old age, *Dieu, la fin de Satan*, unknown to the public.

Last winter, having caught influenza, Matisse thought he was going to die. It is important for a man, at least once in his life, to have believed he is about to die: parenthetically, this is one of the gifts war gives to man. I find it hard to believe that a creator of Matisse's calibre should have so early this 'Moment of Oversight', with which D'Annunzio reproaches Barrès (the word, by the way, is Goethe's, apropos of whom I know not; we know that D'Annunzio was light-fingered). But finally he took himself for lost, and such an idea is fruitful. While convalescing, he said several interesting things which pleased me, some of which I will relate here.

'I thought I was about to die. I was sure of it. It's not fair. I did all that I could not to get sick, but to no avail. No, it just isn't fair.'

'Didn't your work and your memories prevent you from suffering? It always seemed to me that the artist, when faced with death, should be secretly smiling like the man whose safe is being robbed and knows that it is empty. What is valuable is elsewhere.'

'Yes, but I should have liked to finish.'

'I should have liked to *finish*.' How well said! Constructed works. During the months I spent in Algiers, I could see from my window a tall block of flats being built. During the construction I wrote the eight hundred pages of *La Rose de Sable*. The house was taking form at the same time as my work. This parallel touched me. I said to myself: 'Yes, it's

just the same thing. This certainly is not mere chance.' And I remember having written fifteen years ago in *Olympiques*: 'If I die too soon, my work will have no roof.'

Matisse continued: 'I had formed in my mind a hierarchy of misfortunes, and I had found that the greatest misfortune for me would be to recover from my illness only to find that I had lost all will to work.'

His apartment contains a large aviary, full of birds both rare and common. The first time I saw him last winter, he led me immediately to the aviary and gave a long dissertation on the birds. He spoke so long I began to worry: I remembered Goethe showing his medals to tiresome visitors, because he didn't have anything else to say to them. But I soon began to understand Matisse's child-like passion for his birds. He spoke of each like a real expert; some of his ideas went a bit beyond the realm of science, as when he said that European birds are brighter and more intelligent than those of exotic countries.

'Sometimes when I bought one of these birds I found it really very expensive . . . but when I thought I was done for, I said to my wife, see how right I was to buy these birds for my enjoyment! You must always do what gives you pleasure.'

These were profound words, beyond their seeming ingenuousness. So much more profound than those idiots who say to you indignantly: 'So, you think that man is born for happiness?' These stupid Westerners! 'What have I done? I lived, I made myself happy,' wrote Galliéni to Lyautey (and I believe that Lyautey would have written the same thing).[4] You really have to be a stupid Westerner not to experience a certain *grandeur* before such men who are reaching old age and, *having accomplished their work*, say: 'And then, I made myself happy.' For there is also the greatness of wisdom which is none other than that of intelligence.

Sometimes Matisse and I don't agree. As when he tells me he suffers from criticism, but praise does not give him pleasure (I'm just the opposite); or that it is the truth of an artist that remains, not his legend; I don't see why posterity should be less frivolous than the contemporary world: the truth of the artist remains, but illuminated—and sometimes in the wrong light—by his legend. Or when he says that, like most of the artists I have met, he prefers working under uncomfortable conditions, and on works created with great difficulty, to work which 'escapes from you, when it has barely been expressed, like a bird which flies off forever as soon as the cage is open'. I, on the other hand, prefer those of my works that sprang into existence with an ease that was almost magic, because though I love my work, I prefer life to it, and the work that gave me trouble inspires a kind of grudge in me: it has taken too much time from my private life, which is more important to me. . . .[5]

Matisse often told me that the best thing the old masters have, their *raison d'être*, is beyond them, that they are not able to teach it and that they waste their time by trying. But they are able to teach, without meaning to, by informal conversation, about their work or their life.[6] And they can talk to their colleagues who practise a different art from theirs. Stendhal showed us Michelangelo going to the Coliseum to find inspiration for the Basilica of Saint Peter's: 'A theatre gives ideas for a church.' There is unity in creation, and the writer learns from the painter as the cupola of Saint Peter's perhaps learned from the pagan circus.

Notes of a Painter on his Drawing, 1939[1]

In 1939, Matisse was persuaded to write a defence of his drawing for an issue of *Le Point* devoted to him and his work.

In 'Notes of a painter on his Drawing', he once again makes reference to his own education, which he felt made him cognizant of the different means of expression inherent in colour and drawing, and discusses how he studied the old masters to find how they dealt with volume, line, contrasts and harmonies; and how he tried to synthesise his awareness of their work with his own observations from nature. Here he states quite explicitly his version of the method of classical training: to absorb the lessons of the masters and then having done so, to 'forget' those lessons in order to arrive at a means of personal expression.

Matisse's description of his own working method when drawing is very revealing; he not only describes his attitude toward the act of drawing, but also describes aspects of his attitude toward picture-making on the whole. In this essay Matisse also makes some important observations about the nature of his subject matter, and expresses views on space and line which were not found in his earlier writings. Discussing his interiors, he notes that his models are never to be conceived of as just 'dummies', and that while their expression is not always articulated by the portrayal of human attitudes, it is by the total ensemble of his picture, by the creation of what he calls 'plastic signs' [*signes plastiques*]. This sublimation of expression into the total ensemble of the painting is a clarification of the expression of similar values in 'Notes of a Painter', and an important aspect of Matisse's method.

In this essay Matisse also discusses the creation of space, noting that his final line drawings always have a luminous space, and that the objects which constitute them have positions in different planes in space: 'in perspective, *but in a perspective of sentiment*, in suggested perspective'. This notion of luminous space is a generalized equivalent of the ambiguous, intangible space that may also be seen in his painting, and is most important to an understanding of his work.

Matisse felt that the human side of painting is the result of a mysterious, expressive quality which, if the painter himself is possessed of a good sensibility, comes through in the final painting. Thus it need not be overtly stated in the subject matter; the painter should instead construct his painting according to what he perceives, and the force of this expression will be evident as a by-product of the painter's own depth of humanity; not as something apart from or only presented by form, but rather as feeling which is embodied into the very fibre of form itself: 'My plastic signs probably express their souls. . . .'

NOTES OF A PAINTER ON HIS DRAWING

My education taught me an awareness of the different means of expression inherent in colour and drawing. My classical education naturally led me to study the old masters, and to assimilate them as much as possible while considering such things as volume, the arabesque, value contrasts and harmony, and to relate my reflections to my work from nature; until the day when I took stock of myself and realized that for me it was necessary to forget the methods of the old masters, or rather to comprehend them in a completely personal manner. Isn't this the rule of all artists of classical training? Next came the recognition and influence of the arts of the Orient.

My line drawing is the purest and most direct translation of my emotion. The simplification of the medium allows that. At the same time, these drawings are more complete than they may appear to some people who confuse them with a sketch. They generate light; seen on a dull day or in indirect light they contain, in addition to the quality and sensitivity of line, light and value differences which quite clearly correspond to colour. These qualities are also evident to many in full light. They derive from the fact that the drawings are always preceded by studies made in a less rigorous medium than pure line, such as charcoal or stump drawing, which enables me to consider simultaneously the character of the model, the human expression, the quality of surrounding light, atmosphere and all that can only be expressed by drawing. And only when I feel drained by the effort, which may go on for several sessions, can I with a clear mind and without hesitation, give free rein to my pen. Then I feel clearly that my emotion is expressed in plastic writing. Once my emotive line has modelled the light of my white paper without destroying its precious whiteness, I can neither add nor take anything away. The page is written; no correction is possible. If it is not adequate, there is no alternative than to begin again, as if it were an acrobatic feat.[2] It contains, amalgamated according to my possibilities of synthesis, the different points of view that I could more or less assimilate by my preliminary study.[3]

The jewels or the arabesques never overwhelm my drawings from the model, because these jewels and arabesques form part of my orchestration.[4] Well placed, they suggest the form or the value accents necessary to the composition of the drawing. Here I recall a doctor who said to me: 'When one looks at your drawings, one is astonished to see how well you know anatomy.' For him, my drawings, in which movement was expressed by a logical rhythm of lines, suggested the play of muscles in action.

It is in order to liberate grace and character that I study so intently before making a pen drawing. I never impose violence on myself; to the contrary, I am like the dancer or tightrope walker who begins his day with several hours of different limbering exercises so that every part of his body obeys him, when in front of his public he wants to give expression to his emotions by a succession of slow or fast dance movements, or by an elegant pirouette.

(As regards perspective: my final line drawings always have their own luminous space, and the objects of which they are composed are on different planes; thus, in perspective, *but in a perspective of feeling*, in suggested perspective.)

I have never considered drawing as an exercise of particular dexterity, rather as principally a means of expressing intimate feelings and describing states of mind, but a means deliberately simplified so as to give simplicity and spontaneity to the expression which should speak without clumsiness, directly to the mind of the spectator.[5]

My models, human figures, are never just 'extras' in an interior. They are the principal theme in my work. I depend entirely on my model, whom I observe at liberty, and then I

decide on the pose which best suits *her nature*. When I take a new model, I intuit the pose that will best suit her from her un-selfconscious attitudes of repose, and then I become the slave of that pose. I often keep those girls several years, until my interest is exhausted. My plastic signs probably express their souls (a word I dislike), which interests me sub-consciously, or what else is there? Their forms are not always perfect, but they are always expressive. The emotional interest aroused in me by them does not appear particularly in the representation of their bodies, but often rather in the lines or the special values distributed over the whole canvas or paper, which form its complete orchestration, its architecture. But not everyone perceives this. It is perhaps sublimated sensual pleasure, which may not yet be perceived by everyone.

Someone called me:[6] 'This charmer who takes pleasure in charming monsters'. I never thought of my creations as charmed or charming monsters. I replied to someone who said I didn't see women as I represented them: 'If I met such women in the street, I should run away in terror.' Above all, I do not create a woman, *I make a picture.*

In spite of the absence of shadows or half-tones expressed by hatching, I do not renounce the play of values or modulations. I modulate with variations in the weight of line, and above all with the areas it delimits on the white paper. I modify the different parts of the white paper without touching them, but by their relationships. This can be clearly seen in the drawings of Rembrandt, Turner, and of colourists in general.[7]

To sum up, I work *without a theory*. I am conscious only of the forces I use, and I am driven on by an idea which I really only grasp as it grows with the picture. As Chardin used to say, 'I add (or I take away, because I scrape out a lot) until it looks right.'

Making a picture would seem as logical as building a house, if one worked on sound principles. One should not bother about the *human* side. Either one has it or one hasn't. If one has, it colours the work in spite of everything.

18

Carco: *Conversation with Matisse,* 1941[1]

Francis Carco's recollection of his conversation with Matisse is an interesting document for its attention to the small details of Matisse's working day and for the insights it offers into Matisse's sometimes sentimental recollection of the past. Like Montherlant's interview, Carco's essay suffers from a certain slanting of details and in parts there is obviously as much of Carco present as there is of Matisse.

CONVERSATION WITH MATISSE

In Nice in 1941, I ran into Matisse under the arcades of the Place Massena. As usual he was looking well. He looked completely at peace with himself that day. Everything about him exuded harmony and honesty. His neat appearance, the brightness of his look, the assurance of his features and an undefinable air of youth and serenity struck me immediately.

'Come see me,' he said, 'I've been working hard.'

That gave me enormous pleasure: it was so reassuring that at least one great artist refused to admit all was lost. Who else was thinking about painting then? He must have been the only one, and that seemed to be a good omen, because if each of us, in his own sphere, accomplished his allotted task, the machine could get going again and pull us out of the rut bad driving had put us in. The example, coming from such an exalted source, could only be the more inspiring. Matisse brought no vanity whatsoever to the situation. He had taken up his paint brushes again like others their pen, their tools, and with the help of his love for work, one could believe that the great miracle we had all been waiting for through the humiliating days before the Armistice, was finally coming to pass.

That was not the first time that the painter had, so to speak, forced this to come about. Thanks to this faith in work, Matisse, who once struggled to ensure his material needs, had ended up by being hired by the Jambon studio where, in spite of his glasses and beard, he worked like a labourer.[2] His seriousness and courtesy have always stood him well, in all sorts of situations. At Jambon's everyone called him 'doctor'. And later, in Montmartre, the 'belle Fernande' [3] was to write of him as 'the archetypal master'.

His parents were grain merchants in the north; he arrived in Paris as a young man to study pharmacy, adds Gertrude Stein. 'He had set himself to copy the Poussins in the Louvre and became a painter scarcely without bothering about the consent of his family, who nevertheless continued to give him a small monthly allowance. At first he had a little success. And he got married. . . . Then he had begun to come under the influence of Cézanne and then of Negro sculpture. From all this sprang the Matisse of the *Femme au chapeau*.' [4]

That painting is the portrait of Mme Matisse and I remember the curious impression it made on me. I had not yet developed a taste for modern art. The discussions that it provoked at Max Jacob's on the rue Ravignan between Guillaume Apollinaire and Picasso, or at Frédé's in the long boisterous nights of the 'Lapin Agile', had not yet convinced me.[5] Picasso never exhibited, on principle, and showed his works only to a small circle of the initiated few, so one had to be satisfied with the doctrinaire aphorisms which he tinged with humour to seduce his audience. Everything gravitated around these specifications. And I was wondering if Picasso, in spite of his amazing powers of persuasion, didn't enjoy mystifying us more than painting, when the famous *Femme au chapeau* taught me more in an instant than all these paradoxes.

At last I was able to appreciate what my friends meant by a 'portrait'. Nothing about it was physically human. One had the impression that the artist had been more concerned with his own personality than with that of the model. I didn't know Mme Matisse at all but, according to Gertrude Stein, who bought the work without understanding why 'it enraged everyone', she was a 'big woman with a long face and a big, obstinate, hanging mouth'.[6] Not a very flattering description, but I must agree that it corresponded pretty well to my own impression. However, this extraordinary work, whose lines might have been drawn on a wall in charcoal and yet were in balance with the cold tones which one would think had been applied with a stencil—this work had such a clear and deliberate air of premeditation that more than thirty years later I have not forgotten it.

'I painted this portrait at Issy-les-Moulineaux', Matisse told me. 'I went there in 1907 when I left the Couvent des Invalides. . . .' [7]

A few years later, a trip to Morocco decided the direction of his talent. The painter returned to Paris and settled there on the quai Saint-Michel, in his old lodgings where he had so many times in the past descended the stairs early in the morning to take the bus 'La Villette–Saint-Sulpice' to Jambon's to earn his and his family's livelihood at twenty-five sous an hour.

'It was hard work, but I had no choice. Jambon, who had obtained the commission for the decoration of the Trans-Siberian exposition at the Grand-Palais for the Expo, had taken us on, Marquet and myself, to paint the garlands. We worked bent double. We were all crimped up. What a job! I had never known more complete degradation. Among our companions, the sharp ones got themselves fired after two weeks so they could collect compensation money. There were café waiters, delivery boys, a whole team of "I-don't-give-a-damn" types whom the boss kept under his eye. Unfortunately the boss didn't like my looks. One day I was whistling and right away he called me: "Hey there doctor, my word, you're having a good time!" I was so disgusted that I retorted: "That's not what I'm here for!" Quick as a flash, that did it; I got my pay and the sack. I had to go and get signed on somewhere else.'

'But in the evening when you went home to the quai Saint-Michel, you had the consolation of admiring Cézanne's picture hanging in your studio?' [8]

'Of course', replied the painter, 'I could have sold it . . . but I stood fast.'

His face lit up with a smile.

'You must always stand fast, at all costs. . . .'

'Yes,' I said. 'When you can.'

'Whether you can or not, you hold on: that's the essential. When you're out of will power you call on stubbornness, that's the trick. For big things as well as small, that suffices, almost always. I used to be always late. One evening I went to meet Marquet . . . and I waited. I cooled my heels for more than twenty minutes: no Marquet! The next day naturally, as soon as I saw him, I stopped him. "What!" he replied. "I waited for you too, but after fifteen minutes I left." You know Marquet? He can't lie. Well, I told myself, since I always find a way to be late, I should one day be able to end up being on time!'

'Did you succeed?'

'And how! I even poison everyone's existence with it, because by wanting to correct this fault, which is basically a female one, I have fallen into the opposite extreme: I arrive, too early.'

What is striking about Matisse when one knows him slightly, is the extreme interest he shows, in conversation, about trivia as well as important matters. Under a nonchalant exterior, one feels his keenness to pierce the secret of things. Approximations don't attract him. The habit of reflection, of logic, of analysis, leads him to formulate each one of his thoughts or his impressions with all the clarity and rigour one could wish for.

Having taken up his invitation I was received in the big room on the left which he uses for a studio. Arranged in several rows, one above the other, a series of drawings executed after an initial study covered the walls. You could read there, as in an open book, the succession of states and abbreviations by which the study was transformed into an arabesque and passed from volume to line, with the most subtle and sparse of scripts.

'That's what I call the cinema of my sensibility,' he told me right away. 'When my study is done, or rather my point of departure is established, then I let my pen run where it wills. There are all the steps which, from the form to the rhythm, permit me to watch my own reactions. I enjoy that: I don't know where I am going. I rely on my subconscious self and the proof of this is that if I am disturbed during the process I can no longer find the thread of it again.'

After a while he said: 'Basically I enjoy everything: I am never bored.' Then inviting me with a nod: 'Come,' he added, 'You will see how I am organized.'

A second room, also on the left, had two cages full of birds. Bengalis, cardinals, Japanese warblers fluttered the bright colours of their feathers, which the long black tail feathers of the widow-birds made even more brilliant. Fetishes and negro masks gave the room an exotic look; but since it only served as an antechamber to a conservatory where philodendra from Tahiti spread their huge leaves, we crossed it fairly quickly and found ourselves in a sort of jungle, which an ingenious sprinkling system maintained in its green and tropical state. On a marble platform gourds and giant pumpkins composed, with Chinese statuettes, an ensemble of contrasts where the disproportion of the different elements permitted the artist to give free rein to his fantasy.

'Here we are in what I call my "farm",' Matisse informed me. 'I potter here several hours a day, for these plants are a frightful bother to keep up. You have no idea! But as I take care of them, I learn their types, their weight, their flexibility, and that helps me in my drawings.'

'In short, your return to the earth.'

'Yes, of course . . . why not?' [9] And looking at me over his glasses, he said: 'Do you understand now why I am never bored? For over fifty years I have not stopped working for an instant. From nine o'clock to noon, first sitting. I have lunch. Then I have a little nap and take up my brushes again at two in the afternoon until the evening. You won't believe me. On Sundays, I have to tell all sorts of tales to the models. I promise them that it's the last time I will ever beg them to come and pose on that day. Naturally I pay them double. Finally, when I sense that they are not convinced, I promise them a day off during the week. "But Monsieur Matisse," one of them answered me, "this has been going on for months and I have never had one afternoon off." Poor things! They don't understand. Nevertheless I can't sacrifice my Sundays for them merely because they have boyfriends. Put yourself in my place: when I was living in the Hôtel de la Mediterranée, the Battle of the Flowers[10] was almost a torture for me. All that music, the floats and the laughter on the Promenade! They were no longer with me, so I installed them by the window and painted them from behind. What could I do? I don't know how to improvise. In order for things to click I must recover the idea I had the previous day.'

We returned to the studio. Matisse was speaking of his work and, recounting the thousand little difficulties he was running up against, he paused at times to scrutinize me and see if I was taking in what he said, then he continued explaining his methods in his rather hollow voice and that took me back to the time when we both had lived in the Hôtel de la Mediterranée by the sea. We had occupied neighbouring rooms. One morning Matisse had come into my room.

'Well,' he had asked me in the same velvety voice as he approached the bed. 'What's wrong? Sick?'

I had the flu. Matisse took my pulse, and I understood from his serious air why his colleagues at Jambon's had called him the doctor.

'That's annoying,' he said. 'Yesterday I began a canvas at Cimiez and the car is waiting for me. But that's nothing. Just a minute.'

He left the room and returned with several of his works, a hammer and some nails. In an instant the nails were in the wall, the pictures hung. Matisse gathered the folds of his cape around his shoulders.

'I'm off!' he said. 'See you this evening. I'll come and see how you are. Stay in bed: don't do anything foolish. My paintings will keep you company.'

I reminded him of this incident.

'A good old hotel, I must say!' he murmured. 'And what lovely Italian ceilings! What

tiles! They were wrong to pull the building down. I stayed there four years for the pleasure of painting nudes and figures in an old rococo salon. Do you remember the way the light came through the shutters? It came from below like footlights. Everything was fake, absurd, terrific, delicious. . . .'

We sat down.

'I was saying' he continued, offering me a cigarette, 'that each day I need to recover my idea of the previous day. Even in the early days I was like that and I envied my comrades who could work anywhere. At Montmartre, Debray, the proprietor of the Moulin de la Galette,[11] used to invite all the painters to come and scribble at his place. Van Dongen[12] was prodigious. He ran around after the dancers and drew them at the same time. Naturally I took advantage of the invitation too, but all I managed to do was learn the tune of the farandole,[13] which everyone used to roar out as soon as the orchestra played it:

Let's pray to God for those who're nearly broke!
Let's pray to God for those who've not a bean!

'Do you remember it? And later this tune helped me when I began my painting of *La danse* which is in the Barnes Collection in New York.[14] I whistled it as I painted. I almost danced.' A youthful expression passed across his face. 'Those were good times!'

He must have read in my eyes that like him I had tasted the pleasures of those 'good old days' and that I had no occasion to regret them either, because he continued: 'I mean that we had painting in our blood then, that we would have fought for it. It's extraordinary, I was kicked out wherever I went and to use a model I was reduced to taking evening courses, in a Paris city school on the rue Etienne-Marcel. I slaved all day for my subsistence and was exhausted. My wife for her part had opened a little hat shop. But, however tired I was in the evening, nothing could have stopped me from getting to the rue Etienne-Marcel to work. One met strange fellows in that school. My neighbour, a sculptor, complained because he couldn't dig up a commission. Each evening he asked if we might not know a prominent man who had no statue in Paris. I looked with him: we boned up on a dictionary of famous men and finally discovered that Buffon[15] fell into this category. My sculptor, whom I took for an artist, leapt off to the Museum. He got round the Director who supported his request and got it accepted. Everything was going well. The fellow did a maquette, exhibited it at the Salon and, by way of thanking me for having helped him in his research, offered to take me on as an assistant. Sculpture has always fascinated me. So I said to myself, in all good faith, that if I used the maquette as inspiration, I could do something. Ah là là! The fellow thought I was going mad because, having listened to my suggestions, he said to me: "My dear fellow, out of the question! It's a matter of squaring the project up for enlargement. Otherwise I'll be out of pocket for it!" '

'Poor Buffon!'

'Yes. Rather. Luckily after a long search I also finished running to earth the Academy where Carrière corrected the work of students.[16] It was on the rue de Rennes in a courtyard where a blockmaker's is now. Jean Puy, Derain, Laprade, Chabaud all belonged to this Academy.[17] Chabaud, as he always used to, sweated away alone in his corner. The others used to show each other their sketches. Laprade's astounded everyone. "Be careful! there's the thaw!"[18] I said looking at one of them. Laprade never forgave me for it. And yet, that is what it was, joking apart. As for the scribbling of those who were inspired by the *patron*'s advice, that was really discouraging. You remember the remark Forain made in front of a canvas of children by Carrière: "Someone was smoking in that room!" I couldn't stop myself saying: "The stove is smoking. Open the windows!" [19] That wasn't really nasty. But once again I was kicked out. It was at that time that I became connected with Derain. He was on the eve of departure for Commercy to do his three years in the army and already he was painting magnificently. We had got to know each

other in the Louvre where his copies bewildered the patrols and visitors. Old Derain didn't get upset. When he came to join me at Collioure where I was spending the summer with my wife's family, he knew more about it than anyone. We worked together at Collioure, then exhibited the works which Vauxcelles baptized "the Fauves".'

'What a scandal!' Matisse rubbed his hands together. 'Frankly, it was admirable. The name Fauves was perfectly suited to our feelings. Then, in 1905, I spent several months in Saint-Tropez where as yet only Signac and old Pegurier,[20] who was born in the region, were living. Cross lived at Le Lavandou. The others came later. Renoir, however, had settled at Cagnes and Lebasque at Le Cannet.[21] An agreeable painter, Lebasque. Marquet joined him in the Midi.'

'But Marquet was much more your friend than his.'

'Yes, true, but he got along very well with Lebasque. He was the most pleasant of the group, and got along well with everyone. At Marseilles, he had entrées into the strangest circles. For example, in the Bouterie quarter, the girls used to shout out as soon as they saw him passing by: "There goes the *pintre*".' [22]

Matisse was off. He felt such pleasure in recounting these anecdotes that I would have been rude to interrupt him. Like all loners, who first by shyness and then by defiance, stick to a certain subject but suddenly abandon themselves to memories of their old escapades, he went on speaking of Marquet with such warmth that he forgot all about painting. He put such enthusiasm into his friendship for the '*pintre*' that you could feel how much he must have been captivated by him. They knew each other for a long time. They had worked, struggled and been successful together.

'At the time of the Expo, as they used to call the 1900 one, it was Marquet,' went on my interlocutor, 'who had the idea of finding a job which would allow us to live. We got a dozen addresses of decorators' studios out of the Bottin.[23] Marquet would apply for us to the boss. From street to street, we ended by being hired by Jambon, at the ends of the earth, near the Buttes-Chaumont. Marquet lived on the quai de la Tournelle and I on the quai Saint-Michel where we painted impressions of the Seine, each from our window.[24] I began by exhibiting at Vollard's who sold my first pictures to Olivier Sainsère. Then, one fine day, Vollard was convinced: for a thousand francs, he took five works from me among which were three large *dessertes* which were not too bad. Then, at the amusing little Mlle Weill's place, Huc of the *Dépêche de Toulouse* bought one of twenty of my works for a hundred francs on Albert Sarraut's account.[25] At that time Mme Odilon Redon was offering the works of her husband for absurdly low prices. Druet had a bistro on the Place de l'Alma. Shortly after, he set himself up in the rue Duphot, and, since the Independents were organizing their exhibitions in the City greenhouses, Signac and Luce went to eat at his place. Rodin, who worked at a mason's in the rue de l'Université, crossed the river with them. Druet, besides his bistro, was interested in photography. He had set up a lighting system that delighted Rodin. Finally Druet opened an art gallery on the rue Matignon, and the first exhibition of neo-Impressionists took place.

'Druet was a strange man. For fear that the artists would spend the money earned from the sale of their works too quickly, he gave it to them in small instalments which never exceeded two hundred and fifty francs. The photography business he had started made more money than the pictures and one had to wait for better days. Moline, who was a dealer on the rue Laffitte, had a neo-Impressionist show in his turn, but it had no success.'

Matisse nodded: 'Yes, those were the good old days, anyway!' he went on reflectively.

Perhaps he was remembering the long and splendid career in which, from the quai Saint-Michel to the Couvent des Invalides, then at Issy-les-Moulineaux, to Morocco, to l'Estaque, to Marseilles and from the Hôtel Beau-Rivage in Nice, to the Villa des Alliés, to the old Hôtel de la Mediterranée, to his apartment on the rue Charles-Félix, and the

one he now lives in at Cimiez, he had 'stood fast'. Frank Harris[26] (who had bravely fought for Oscar Wilde in London on his release from prison) had given him several rooms in the building on the rue Charles-Félix, and Matisse had hung the paintings of Cézanne and Gauguin there: the first, if we are to believe Gertrude Stein, bought with his wife's dowry and the second with her engagement ring.[27] Harris, who loved painting, parted with these rooms out of admiration for Matisse, of whom he spoke as the most extraordinary Frenchman he had ever known, and I couldn't tell if the epithet did not hide some bitterness, so different were the two men. Twenty years later, Harris settled at Cimiez.

'Is it to be near Matisse?' I had asked him with irony.

Harris just smiled, then, since he had no real reason to exist without a noble cause, gave me a reading from his play on Joan of Arc. And Maeterlinck,[28] who didn't like him very much, concluded: 'Naturally! Like all self-respecting Englishmen, he couldn't resist the pleasure of martyring her twice.'

Evening fell. 'You see,' murmured Matisse suddenly, 'when I think of the problems of the past, I wonder if they didn't stimulate in us the energy to conquer them. Life is short. Without problems, it would go by too quickly, and we would have made no progress. Thus' he said, putting a still-life under a good light, 'I needed three months to finish this work. Once I would have hesitated less.'

The painting is composed of a Persian vase and big shells from Oceania, arranged on a plane better defined by a simple opposition of tones than is clear at first glance.[29] In itself, each element was of little interest. It's their radiation, their harmony of values which gives this work its richness, its power of orchestration.

'Isn't everything in the values?'

I almost quoted him the classic remark of Fromentin:[30] 'A colour does not exist in itself since it is, as one knows, modified by the influence of a neighbouring colour. Its quality comes from its surroundings.' But Matisse got in ahead of me.

'Because one value on the right was out of place,' he said, 'everything got screwed up in my picture. Who would have thought it so important?'

This time I managed to get my quotation in, and I continued it, 'But "if from a Veronese, a Titian or a Rubens, you were to remove this perfect rapport of colour values, you would be left with no harmony in the colouring, no strength, delicacy, or rarity".'

The painter looked at me with approval. 'People have taken years', he grumbled, 'to realize just that. And yet it's right under your nose. When it's a matter of a friend's work, you see it right away: but in your own, you hesitate, stammer, because you can't reason any more: you have to feel.'

'You have to love.'

'Exactly! Basically it's as easy as pie. But we still don't have an overabundance of faculties to succeed where others fail.'

I suppressed the compliment which was on the tip of my tongue for fear that he would take it as trite flattery, since, even in the light of his works, Matisse has always been so straightforward that he avoids the particular for much wider issues. It's not that he's modest. He loves painting too much to make little of himself. He is also too much aware of his talent to be dazzled by words. This strength comes from his way of life, away from rascals and cheats. He knows his limitations. Derain too has this same strength which is so rare a quality in most painters. But Derain goes out a lot and becomes infatuated with all sorts of people. I have met him several times in society where, in spite of his finesse, he would let himself fall into an agreement for a portrait which he later had no desire to paint. His frank temperament, his friendly, generous nature would often put him in absurd situations if he didn't cut it all suddenly short and disappear from Paris.

'He's not a Fauve, he's a saint!' a Russian princess once remarked of him. Eight days later she rectified her statement, 'Or rather, an eel.'

And yet, when Zborowski died, Derain offered his widow several pictures in order to help her financially.[31] Madame Zborowska did not forget it. 'And do you know?' she confessed without false shame, 'he was the only one.'

A question that I had promised myself to ask Matisse in the course of our interview was now troubling me. I wanted to ask how he could live in such isolation and still maintain such prestige in the eyes of his colleagues and collectors. Work is not the only thing; emulation also enters significantly into the life of an artist. Picasso, whom one runs into in the most humble galleries where youths hang their pictures, could have served as a pretext. He has always carefully kept himself up to date with contemporary developments and, time-consuming as this may often be, it maintains, in one who practises it, an intellectual curiosity which is of great importance.

Clemenceau, from the time I held the modest position of art critic on *L'Homme Libre*, had had this same greed for learning.

'When you leave the paper,' he said, catching me one evening between two doors, 'do you go back to Montmartre?'

'Yes, Monsieur le Président.'

'And in Montmartre, who will you go and see?'

'Poets and painters.'

'Which painters?'

I mentioned Picasso, Valadon, Utrillo, Modigliani. The 'Tiger' wrote down their names in a notebook.

'And the poets?'

'Guillaume Apollinaire, Salmon, Max Jacob, Jean Pellerin.'

'And they are talented?'

'They are more than talented.'

'Ah!' snorted Clemenceau. 'Even if you are wrong, one must have faith. Never forget it!'

How to make Matisse realize that real youth consists in preserving this flame which still burned in the 'Tiger' at seventy-three years of age? Especially how to talk to him of Picasso? He would have told me that Picasso only haunted the galleries to improve all the prices. The old enmity which had only increased between them since Cubism might have disturbed the end of our conversation. In vain I told myself that with the passing of time and with his success Matisse probably no longer maintained the least bitterness toward his old rival; I was not at all sure of it. Gertrude Stein, who had introduced them to each other, affirms that they 'became friends but that they were also enemies'.[32]

Such incompatibility of temperament doesn't change easily. Besides it was not for me to get involved in the situation. And, though I wouldn't have minded hearing from Matisse himself what he thought of Picasso, or rather of this intellectual curiosity which he never ceases to manifest toward his art, I had no chance of finding out. The impression that I had just received in front of the still-life which cost him three months of thought and effort had plunged me into a deep perplexity. I wanted to tell its author that certain research sometimes goes too far, that it by-passes its object, and through it one ends up with 'an unknown masterpiece' about which Balzac reached his conclusions a long time ago.[33] But I restrained my desire.

Nevertheless, I told myself, the question is not without importance and if one but thinks about it, one might well wonder if artists don't go wrong in emphasizing difficulty alone. It is not a problem which will be solved by a handful of scholars. All art appeals first to the senses rather than to the soul. It is through the senses that art moves the masses just

as much as it seduces the elite, and when one sees Picasso start from abstraction to reach the same contradictions as Matisse—but by a diametrically opposite route—one is tempted to fear that they will no longer be followed. There are limits that must not be passed. Beyond their boundaries, there is no longer, in effect, painter, poet or composer, but an artist in the supreme sense of the word; the artist in the pure state, given over without defence to the vertigo of the summit, of the Absolute.

'You were going to say?' enquired Matisse, who noticed my agitation.

I had nothing to say: his canvas spoke for me.

19

On Transformations, 1942[1]

This excerpt from a letter from Matisse to his son Pierre, one of two published in *First Papers on Surrealism*, gives a nice insight into Matisse's attitude toward his finished work in relation to his personality. The work Matisse refers to is probably *Nature morte rouge au magnolia* (Figure 41) in which he had painted a green marble table red. (See Text 43, below.)

ON TRANSFORMATIONS

When I attain unity, whatever it is that I do not destroy of myself which is still of interest —I am told that it is transformed, sublimated—I am not absolutely certain. I do not find myself there immediately, the painting is not a mirror reflecting what I experienced while creating it, but a powerful object, strong and expressive, which is as novel for me as for anyone else. When I paint a green marble table and finally have to make it red—I am not entirely satisfied, I need several months to recognize that I created a new object just as good as what I was unable to do and which will be replaced by another of the same type when the original which I did not paint as it looked in nature will have disappeared— the eternal question of the objective and the subjective.

20

Matisse's Radio Interview: First Broadcast, 1942[1]

Early in 1942 Matisse gave two interviews broadcast over the radio, transcripts of which were sent to Pierre Matisse in New York in a letter dated 13 March 1942.[2] The first is general in scope, the second an attack on the French academic Beaux-Arts system in which Matisse suggested that the Prix de Rome be replaced by 'travelling scholarships' (not included here).

The first broadcast contains interesting answers to some fundamental questions, including an important statement of the function of the window motif in Matisse's works.

MATISSE'S RADIO INTERVIEW

As you know it is the painters who, by creating images, allow the objects and scenes of nature to be seen. Without them we could distinguish objects only by their different functions of utility or comfort. Each generation brings its new, characteristic representation.

Since the earliest times (from the cave artists to the modern painters), artists have enriched the common plastic vocabulary and each generation of man has seen through the eyes of the artists of the preceding generation.

Thus in my youth the colouring of chromos or the illustrations in popular books, which generally represented acceptable taste, was made against a bituminous background, because their creators were influenced by the painters of the preceding generation: notably those of the Romantic school.

Then the colouring of the chromos brightened and the colours of the Impressionist palette succeeded the harmonies of bistre.

Finally, after the rediscovery of the emotional and decorative properties of line and colour by modern artists, we have seen our department stores invaded by materials decorated in medleys of colour, without moderation, without meaning.

Then came the tonal scale of Marie Laurencin's palette, softly graduated, at the same time as the angular and linear decorations of the Cubist painters. These odd medleys of colour and these lines were very irritating to those who knew what was going on and to the artists who had to employ these different means for the development of their form.

Finally all the eccentricities of commercial art were accepted (an extraordinary thing); the public was very flexible and the salesman would take them in by saying, when showing the goods: 'This is modern'.

Today the exaggerations have quieted down, and the colours remain gay; nothing new asserts itself, however. This gaiety, which is a little relief for the pleasure of the eyes, is due to the vision of modern painters.

Why do you paint, M. Matisse?
Why, to translate my emotions, the feelings, and the reactions of my sensibility into colour and design, which neither the most perfect camera, even in colour, nor the cinema, can do.

From the point of view of entertainment and amusement the cinema has great advantages over painted pictures which each represent only a single view. In the cinema a simple landscape documentary contains many different landscapes. People who like seascapes, if their first consideration is not to find the spirit of the painter, can find complete satisfaction in front of the true representations of the calm or tragically rough sea which the cinema gives them, and someone who likes representations can have a collection of films representing views of the entire world, while a lover of paintings has but a few canvases, especially if they are of good quality.

As for portrait painters, they are outdone by good photographers, especially those who use anthropometry, who make complete likenesses. For a true lover who wants to keep the memory of one who has been the joy of his life will prefer a good photograph which will better aid his memory than the interpretation of the departed's face by an artist, even a celebrated artist.

What then of the artists? Of what use are they?
They are useful because they can augment colour and design through the richness of their imagination intensified by their emotion and their reflection on the beauties of nature, just as poets or musicians do.

Consequently we need only those painters who have the gift to translate their intimate feelings into colour and design.

I used to say to my young students: 'You want to be a painter? First of all you must cut out your tongue because your decision has taken away from you the right to express yourself with anything but your brush.'

To express yourself, how do you go about it?
A study in depth permits my mind to take possession of the subject of my contemplation and to identify myself with it in the ultimate execution of the canvas. The most elementary means suffice: some colours employed without mixing, other than with white or black, in order not to disturb their purity and their brilliance. It is only through their relationship that I express myself. As for drawing, I follow my inner feelings as closely as possible. Thus all the intellectual [*savante*] part of my work is secondary and very little evident.

When do you consider a work to be finished?
When it represents my emotion very precisely and when I feel that there is nothing more to be added. And once finished, the work stands on its own and the important thing is the next one which absorbs all my interest.

Do you forget your works?
Never. Although working every day for fifty years I have painted quite a few. Whenever someone speaks of one of my pictures, even an old one, in calling to mind some of its features, without being able to remember the year I did it, I see very precisely the state of mind I was in when I made it and all its colours, as well as its place in my total work.

Do you worry about the future of your works?
Since I am convinced that an artist can have no greater enemies than his bad paintings, I do not release a painting or a drawing until I have given it every possible effort; and if after that it still has life, I am happy as to the impression that it will make on the minds of those who see it.

Remember that the advantage that painting has over the theatre is that future generations may repair the injustice of the generation in which the painting first appeared, while in the theatre, if a play does not have immediate success it is buried for a very long time. The theatre, as Debussy said, doesn't allow glorious failures.

What do you remember of your teachers?
One only among them counts for me: Gustave Moreau who turned out, among numerous students, some real artists.

The great quality of Gustave Moreau was that he considered that the minds of young students were about to undergo continued development throughout their lives, and that he did not push them to satisfy the different scholastic tests which, even when artists have succeeded in the greatest competitions, leave them, around thirty, with warped minds, and an extremely limited sensibility and means; so that if they are not wealthy, they can only look for marriage to a well-to-do woman to help them follow their path in the world.

Where does the charm of your paintings of open windows come from?
Probably from the fact that for me the space is one unity from the horizon right to the interior of my work room, and that the boat which is going past exists in the same space as the familiar objects around me; and the wall with the window does not create two different worlds. This is, probably, where the charm of these windows, which have quite naturally interested me, comes from.

Why does Nice hold you?
Because in order to paint my pictures I need to remain for several days in the same state of mind, and I do not find this in any atmosphere but that of the Côte d'Azur.[3]

The northern lands, Paris in particular, once they have developed the mind of the artist through the intensity of their collective life and the richness of their museums, offer too unstable an atmosphere for work as I understand it.

Further, the richness and the silver clarity of the light of Nice, especially during the beautiful month of January, seems to me unique and indispensable to the mind of the plastic artist, especially if he is a painter.

21

Conversations with Aragon, 1943[1]
[On Signs]

In 1943 Matisse's friend, the poet and critic Louis Aragon, introduced the portfolio *Henri Matisse dessins: thèmes et variations* with an essay 'Matisse-en-France'. This lyrical essay makes constant reference to Matisse's thought, and contains many direct quotations. Because of Aragon's great feeling for Matisse and his work, he was able to convey a very good deal of the spirit of Matisse's actual manner of speech, and also to draw Matisse out on some very

important subjects. The following extract is one of Matisse's most revealing statements on the nature of the pictorial signs which he synthesized from his awareness of objects.

Matisse's discussion of how new plastic signs eventually become part of the common plastic language is an interesting parallel to his similar, but distinctly less articulate comments to Charles Estienne (Text 5, above) almost thirty-five years earlier. The very concept of plastic signs is interesting, since Matisse had arrived at this pictorial concept around 1908, but moved away from it during the Nice period. Beginning in the late 1930s, with the 'sign' aspect of his imagery becoming increasingly apparent as he began to abandon working directly from nature, Matisse seems to have developed a rather explicit theoretical basis for a feature of his art that he had already employed for almost three decades.

CONVERSATIONS WITH ARAGON [On Signs]

'*To imitate the Chinese . . .*' Matisse says. Here follows the painter's confession, which was not made all at once. I should like to retain the essence of it, I'm afraid of breaking its branches. If he admits that he laboured for long years in quest of a theme, or rather of a formula, a sign for each thing, this can be connected with that other admission, the most disturbing one: 'I have been working at my craft for a long time, and it's just as if up till now I had only been learning things, elaborating my means of expression.'

Once again, what amazing modesty, what scrupulous conscientiousness he shows: that immense lifelong labour, those fifty years of work were merely the preparation of his craft. What is he trying to do? Matisse continues:

'I have shown you, haven't I, the drawings I have been doing lately, learning to represent a tree, or trees? As if I'd never seen or drawn a tree. I can see one from my window. I have to learn, patiently, how the mass of the tree is made, then the tree itself, the trunk, the branches, the leaves. First the symmetrical way the branches are disposed on a single plane. Then the way they turn and cross in front of the trunk . . . Don't misunderstand me: I don't mean that, seeing the tree through my window, I work at copying it. The tree is also the sum total of its effects upon me. There's no question of my drawing a tree that I see. I have before me an object that affects my mind not only as a tree but also in relation to all sorts of other feelings . . . I shàn't get free of my emotion by copying the tree faithfully, or by drawing its leaves one by one *in the common language*, but only after identifying myself with it. I have to create an object which resembles the tree. The sign for the tree, and not the sign that other artists may have found for the tree: those painters, for instance, who learned to represent foliage by drawing 33, 33, 33, just as a doctor who's sounding you makes you repeat 99 . . . This is only the residuum of the expression of other artists. These others have invented their own sign . . . to reproduce that means reproducing something dead, the last stage of their own emotion . . .'

As he spoke to me I was thinking of Matisse's followers, of all those who imitate him clumsily or too cleverly, but who can see only his superficial gestures: they think they are starting from *his* signs, but they are in fact bound to fail because one can imitate a man's voice but not his emotion.

'. . . and the residuum of another's expression can never be related to one's own feeling. For instance: Claude Lorrain and Poussin have ways of their own of drawing the leaves of a tree, they have invented their own way of expressing those leaves. So cleverly that people say they have drawn their trees leaf by leaf. It's just a manner of speaking: in fact they may have represented fifty leaves out of a total two thousand. But the way they place the sign that represents a leaf multiplies the leaves in the spectator's mind so that he sees

two thousand of them . . . They had their personal language. Other people have learned that language since then, so that I have to find signs that are related to the quality of my own invention. These will be new plastic signs which in their turn will be absorbed into the common language, if what I say by their means has any importance for other people . . .'

And very quickly Matisse adds a truth, his own truth, which sums it all up:

'The importance of an artist is to be measured by the number of new signs he has introduced into the language of art . . .'

The Confession continued

It was after confiding this concept of signs that he made a remark which takes us a long way from the trees: 'It's just as if I were someone who is preparing to tackle large-scale composition.'

'I don't understand . . .'

Those blue eyes. Matisse stretches out his arms, holding his hands in a curious position with the wrists half bent and the fingers slightly turned in as though illustrating a foreshortened effect, which was to be the subject of his next sentence. 'Look, look . . . why do they say Delacroix never painted hands . . . that he only painted claws . . . like this? Because Delacroix composed his paintings on the grand scale. He had to finish off, at a certain place, the movement, the line, the curve, the arabesque that ran through his picture. He carried it to the end of his figure's arm and there he bent it over, he finished it off with a sign, don't you see? A sign! Always the same sign, the hand, made in the same way, not a particular hand but *his* hand, the claw . . . The painter who composes on the grand scale, carried away by the movement of his picture, cannot stop over details, paint each detail *as if it were a portrait*, portray a different hand each time . . .'

'You said that you were going to . . . that it's just as if you . . .'

'As if I were going to tackle large-scale composition: it's odd, isn't it? As if I had all my life ahead of me, or rather a whole other life . . . I don't know, but the quest for signs—I felt absolutely obliged to go on searching for signs in preparation for a new development in my life as painter . . . Perhaps after all I have an unconscious belief in a future life . . . some paradise where I shall paint frescoes . . .'

There's more laughter than ever in those blue eyes. On another occasion Matisse starts off once more from the Chinese artist with the transparent and delicate heart to consider signs. This time his own hand describes not the claws in a Delacroix but a Burmese hand . . . 'You know those Burmese statues with very long, flexible arms, rather like this . . . and ending in a hand that looks like a flower at the end of its stalk . . .' That's the Burnese sign-for-a-hand. The sign may have a religious, priestly, liturgical character or simply an artistic one. Each thing has its own sign. This marks the artist's progress in the knowledge and expression of the world, a saving of time, the briefest possible indication of the character of a thing. The sign. 'There are two sorts of artist,' Matisse says, 'some who on each occasion paint the portrait of a hand, a new hand each time, Corot for instance, and the others who paint the sign-for-a-hand, like Delacroix. With signs you can compose freely and ornamentally . . .'

Thereupon he returns to his own example, the mouth shaped like a 3. He draws the series of hieroglyphs based on a specific model, whose mouth has a slightly pouting lower lip, both lips being fleshy and pressed close together: I see the figure 3 gradually appearing under his hand as a profile of that mouth, although it is seen from the front. 'Why a 3 and not an 8? Because the mind can always imagine a line cutting the two parts of the 8 in the middle, whereas the 3 has to remain a whole . . .' On reflection, he adds: 'There's also the fact that I have grown used to seeing objects in a certain light, like all the painters of my time. So in the 3 of the mouth there's one part in shadow and the other, the part that disappears, is swallowed up by the light.'

22

Henri-Matisse at Home, 1944[1]

Marguette Bouvier's account of her visit to Matisse at Vence in October 1944 offers a candid glimpse of Matisse at home, when, weakened, he was forced to work in bed. The sense of his work room, the kinds of objects with which he surrounded himself, and especially his discussion of his student, offer interesting insights into Matisse's attitude toward his own art and also into his pedagogical outlook.

HENRI-MATISSE AT HOME

Vence . . . October 1944.

The pigeon caressed by Matisse flies from the foot of the bed to settle on the edge of the chair. It is a rare species, completely white; a cloud of powder makes a halo around it whenever it beats its wings.

Henri-Matisse has a passion for birds. He considers a birdcage as indispensable as a bed in a bedroom, and he collects hummingbirds, mirabilis, bengalis, and guittes or blue budgerigars. Congolese tapestries hang on the walls, panther skins, Persian rugs . . . Matisse and his legend reign over this unreal world.

Since 1918 the painter has lived in Nice. The evacuation measures before the American landings made it necessary for him to move to Vence. This was not an easy move because he brought his shells and Chinese porcelain, his *moucharaby*[2] and his marble tables and all the strange objects with which he loves to surround himself. Thus he reconstructed, in his villa Le Rêve, this Matisse-atmosphere which he needs in order to live.

How many times I have surprised him in bed, a sweater over his pyjamas, a board across his knees while he worked. He would be drawing, jotting illustration projects in the margins of Ronsard or Charles d'Orléans. In the room conceived for working while in bed, everything was easily reached without moving. Within arm's reach a revolving bookcase with dictionaries and classics. In the drawers an assortment of pencils, carefully arranged, erasers, paper and naturally the telephone on his bedside table. No one could be less bohemian than this artist who requires and studies his comforts like a *grand bourgeois.*

Matisse doesn't like to anticipate things. He has collected around his bed everything which pleases him. He has remade a world of his own taste in his bedroom.

Entering this room is a constant joy for me. Beyond the painter is the man, the man of a surprising intelligence and a dynamism which age has not touched.

On the wall facing him, under his eye, Matisse always hangs the paintings he is working on. Today there are seven paintings: a woman in a Russian blouse, a theme he has treated several times, still-lifes, and in the centre the portrait of a girl seated at a table between two bouquets of flowers.[3] As I was looking at this very red, very blue, very striking canvas, Matisse said to me: 'That's my little student who was the model.[4] Come tomorrow morn-

ing when I give her her lesson. We will go together to where she is working, you will meet her.'

The next day he was waiting for me, wearing light gloves and holding a cane. Matisse was already known for his elegance among his peers, when at the beginning of the century, unknown and rich mainly in hope, he bought his first car on credit.

We left together, scaling the rocky path side by side, and soon came to the girl. She looked like a child of sixteen, though she was nineteen. Her easel was set up in front of an olive tree with three trunks which she was drawing.

Matisse took some charcoal and immediately underlined with a heavy line the essential parts, the architecture of the tree:

'One can always exaggerate in the direction of truth,' he said.

The girl felt no shyness at being corrected by Matisse. The whole thing seemed simple to her. She said to him:

'That is difficult to express. There are two movements. What bothers me is that stump.'

'Why don't you eliminate it?'

The question was a trap but the girl took care not to fall in.

'Because that would upset the balance.'

'You see the empty spaces,' replied the master, 'they are very meaningful, it's they which will provide your balance.'

All of Matisse was in that conversation. In three minutes, with clarity and without a single superfluous word, he transmitted the essential principles of his drawing to his student; *to exaggerate the truth* and to study at length *the importance of voids*.

As we continued our walk, Matisse told me how this student came to him out of the blue.

'She lives near by, four kilometers from my villa. One fine day she decided to come to see me and arrived without ceremony at the house. My secretary wasn't in. She found her way in and without any preamble asked me:

' "I brought you some drawings, do you want to see them?"

' "What ... what ..." I was stunned by such audacity. "First of all who are you? Who sent you?"

' "No one, but I have some drawings to show you."

' "Whose drawings?"

' "My drawings."

' "But I am not interested. . . . Why didn't you telephone? Why didn't you have yourself announced?"

'She persisted with a child's pout:

' "Excuse me, sir, this will only take two minutes. You only have to tell me if they are bad or good." '

One can easily imagine the uneasiness of this little unknown girl, come to show her works to one of the greatest living painters, whom chance had given her as a neighbour.

' "But where after all are your famous drawings?"

' "On the road ... yes on the road, I left them in front of the gate in my cart."

'This kid had loaded two large framed pencil drawings, and carted them from home to ask my opinion.

'I let myself be moved, I examined them and said what I thought. She continued:

' "Do you think I could sell them? ... for how much?"

' "I have no idea. There you are going a little far. A minute ago it was only a matter of telling you what I thought of them. . . . Now you want a valuation."

'She was so insistent that I kept the drawings to show them. The next day I gave her an address where she sold several of them. Since, she has come to pose for me. Each day she works near my windows and I give her advice.'

He concluded:

'With her, it happened by itself. But you know, I accept no students . . . I made an exception for this child with the intention of leaving her to fate as soon as I had shown her the principles which can help her. For the moment I am going to put her on the double buckle diet.'

'Double buckle? What do you mean?'

'It's very simple, you'll understand in a moment. After dividing the paper up and down with a vertical line and crosswise with a horizontal line, she has to draw the lines of the tree in relation to these two fundamental directions.

'In other words, the branches of the tree composed of oblique lines must always be drawn in relation to these two principal directions.

'In a drawing representing an object or a tree, a line or a curve must not be just any line or any curve, they must be architecturally constructed so that the whole forms a stable combination.'[5]

A walk with Matisse is a real botany lesson.

He knows all sorts of things about the growth of fruit, the nature of the soil, which have nothing to do with painting. To say that he is interested in such diverse subjects reminds me that he plays no games. Matisse, at seventy-four years of age, has never touched a game of cards or chess or draughts. When, after too sustained an effort or during a convalescence, someone suggested that he play something for amusement, he refused, saying like Degas, 'And what if it bores me to distract myself?'

23

The Role and Modalities of Colour, 1945[1]

In 1945, Gaston Diehl published a series of quotations and reflections by Matisse noted in the course of 'recent conversations'. For the most part, these comments are general in nature. Allusion is made to Matisse's experience with the Japanese crêpe paper paintings, to the musical quality of colour, and to the Russian ballets of Bakst. As might be expected, Matisse makes a special note of the role of empathy in the creation of works of art and expresses his almost religious attitude toward artistic creation.

THE ROLE AND MODALITIES OF COLOUR

To say that colour has once again become expressive is to write its history. For a long time colour was only the complement of drawing. Raphael, Mantegna, or Dürer, like all Renaissance painters, constructed with drawing first and then added colour.

On the other hand, the Italian primitives and especially the Orientals, had made colour a means of expression. It was with some reason that Ingres was called an 'unknown Chinese in Paris', since he was the first to use bold colours, limiting them without distorting them.[2]

From Delacroix to Van Gogh and especially Gauguin, through the Impressionists, who cleared the way, and Cézanne, who gives a definitive impulse and introduces coloured volumes, one can follow this rehabilitation of the role of colour, and the restitution of its emotive power.

Colours have a beauty of their own which must be preserved, as one strives to preserve tonal quality in music. It is a question of organization and construction which is sensitive to maintaining this beautiful freshness of colour.

There was no lack of examples. We had not only painters, but also popular art and Japanese *crépons* which could be bought at the time.[3] Thus, Fauvism for me was proof of the means of expression: to place side by side, assembled in an expressive and structural way, a blue, a red, a green. It was the result of a necessity within me, not a voluntary attitude arrived at by deduction or reasoning; it was something that only painting can do.

What counts most with colours are relationships. Thanks to them and them alone a drawing can be intensely coloured without there being any need for actual colour.

No doubt there are a thousand different ways of working with colour. But when one composes with it, like a musician with harmonies, it is simply a question of emphasizing the differences.

Certainly music and colour have nothing in common, but they follow parallel paths. Seven notes, with slight modifications are all that is needed to write any score. Why wouldn't it be the same for plastic art?

Colour is never a question of quantity, but of choice.

At the beginning, the Russian Ballet, particularly *Scheherazade* by Bakst, overflowed with colour.[4] Profusion without moderation. One might have said that it was splashed about from a bucket. The result was gay because of the material itself, not as the result of any organization. However the ballets facilitated the employment of new means of expression through which they themselves greatly benefited.

An avalanche of colour has no force. Colour attains its full expression only when it is organized, when it corresponds to the emotional intensity of the artist.

With a drawing, even if it is done with only one line, an infinite number of nuances can be given to each part that the line encloses. Proportion plays a fundamental role.

It is not possible to separate drawing and colour. Since colour is never applied haphazardly, from the moment there are limits, and especially proportions, there is a division. It is here that the creativity and personality of the artist intervene.

Drawing also counts a great deal. It is the expression of one who possesses objects. When you understand an object thoroughly, you are able to encompass it with a contour that defines it entirely. Ingres said that the drawing is like a basket: you cannot remove a cane without making a hole.

Everything, even colour, can only be a creation. I first of all describe my feelings before arriving at the object. It is necessary then to recreate everything, the object as well as the colour.

When the means employed by painters are taken up by fashion and by big department stores, they immediately lose their significance. They no longer command any power over the mind. Their influence only modifies the appearance of things; only the nuances are changed.

Colour helps to express light, not the physical phenomenon, but the only light that really exists, that in the artist's brain.

Each age brings with it its own light, its particular feeling for space, as a definite need. Our civilization, even for those who have never been up in an aeroplane, has led to a new understanding of the sky, of the expanse of space. Today there is a demand for the total possession of this space.

Awakened and supported by the divine, all elements will find themselves in nature. Isn't the Creator himself nature?

Called forth and nourished by matter, recreated by the mind, colour can translate the essence of each thing and at the same time respond to the intensity of emotional shock. But drawing and colour are only a suggestion. By illusion, they must provoke a feeling of the property of things in the spectator, in so far as the artist can intuit this feeling, suggest it in his work and get it across to the viewer. An old Chinese proverb says: 'When you draw a tree, you must feel yourself gradually growing with it.'

Colour, above all, and perhaps even more than drawing, is a means of liberation.

Liberation is the freeing of conventions, old methods being pushed aside by the contributions of the new generation. As drawing and colour are means of expression, they are modified.

Hence the strangeness of new means of expression, because they refer to other matters than those which interested preceding generations.

Colour, then, is magnificence and eye-catching. Isn't it precisely the privilege of the artist to render precious, to ennoble the most humble subject?

24

Observations on Painting, 1945[1]

This essay, which is concerned with the development of young painters in relation to the past, stresses the importance of study of the masters for a young painter, and also the block that the past can sometimes be to the young artist.

Matisse suggests that the young painter can free himself from the spell of his immediate predecessors by seeking out kindred spirits and by finding new sources of inspiration in the work of other civilizations. This describes in part Matisse's own career. In formulating advice for young painters, he seems (as in his earlier statements) to generalize directly from his own experience. He repeats that great painting is a product of the synthesis between study of the past and study of nature. In this way the painter can acquire the perception and enthusiasm for hard work which will enable him, through that self-knowledge which seems to have been for Matisse the single most important requisite, to produce significant art.

OBSERVATIONS ON PAINTING

I can still hear old Pissarro exclaiming at the 'Indépendants', in front of a very fine still-life by Cézanne[2] representing a cut crystal water carafe in the style of Napoleon III, in a harmony of blue: 'It's like an Ingres'.

When my surprise passed, I found, and I still find, that he was right. Yet Cézanne spoke exclusively of Delacroix and of Poussin.[3]

Certain painters of my generation frequented the masters of the Louvre, to whom they were led by Gustave Moreau, before they became aware of the Impressionists. It was only later that they began to go to the rue Laffitte or even more important, to Durand-Ruel's to see the celebrated *View of Toledo* and the *Road to Calvary* by El Greco, as well as some Goya portraits and *David and Saul* by Rembrandt.

It is remarkable that Cézanne, like Gustave Moreau, spoke of the masters of the Louvre. At the time he was painting the portrait of Vollard, Cézanne spent his afternoons drawing at the Louvre. In the evenings, on his way home, he would pass through the rue Laffitte, and say to Vollard: 'I think that tomorrow's sitting will be a good one, for I'm pleased with what I did this afternoon in the Louvre.' These visits to the Louvre helped him to detach himself from his morning's work, for the artist always needs such a break in order to judge and to be in control of his work of the previous day.[4]

At Durand-Ruel's I saw two very beautiful still-lifes by Cézanne, biscuits and milk bottles and fruit in deep blue. My attention was drawn to them by old Durand to whom I was showing some still-lifes I had painted. 'Look at these Cézannes that I cannot sell' he said, 'you should rather paint interiors with figures like this one or that.'

Then as now the path of painting seemed completely blocked to the younger generations; the Impressionists attracted all the attention.

Van Gogh and Gauguin were ignored. A wall had to be knocked down in order to get through.

The different currents in modern painting remind me of Ingres and Delacroix who seemed so completely apart in their time, so much so that their disciples would have fought in their defence if they had so desired. Yet today it is easy to see the similarities between them.

Both expressed themselves through the *arabesque* and through *colour*. Ingres, because of his almost compartmentalized and distinct colour, was called 'a Chinese lost in Paris'.[5] They forged the same links in the chain. Today only nuances prevent us from confusing them with each other.

Later it will seem as if Gauguin and Van Gogh also lived at the same time: arabesques and colour. The influence of Gauguin seems to have been more direct than that of Van Gogh. Gauguin himself seems to come straight out of Ingres.

The young painter who cannot free himself from the influence of the preceding generation is bound to be swallowed up.

In order to protect himself from the spell of the work of his immediate predecessors whom he admires, he can search for new sources of inspiration in the production of diverse civilizations, according to his own affinities. Cézanne drew inspiration from Poussin. (To redo Poussin from nature.)

If he is sensitive, no painter can lose the contribution of the preceding generation because it is part of him, despite himself. Yet it is necessary for him to disengage himself in order to produce in his own turn something new and freshly inspired.

'Challenge the influential master,' said Cézanne.[6]

A young painter should realize that he does not have to invent everything, but that he should above all get things straight in his mind by reconciling the different points of view expressed in the beautiful works by which he is affected, and at the same time by directly questioning nature.

After he has become acquainted with his means of expression, the painter should ask himself, 'What do I want?' and proceed in his researches, both simple and complex, to try to find it.

If he can preserve his sincerity toward his deeper sentiment without trickery or without being too lenient with himself, his curiosity will not desert him and he will therefore have in his old age the same ardour for hard work and the necessity to learn that he had when young.

What could be better!

25

Interview with Degand, 1945[1]

Early in the summer of 1945 Matisse came north to Paris for the first time since 1940. At the 1945 Salon d'Automne he was honoured by a retrospective of thirty-seven works, most of them done during the War. Léon Degand took the occasion to interview Matisse in his studio on the boulevard Montparnasse, and the resulting text provides interesting insights into Matisse's thought on several matters. At the time of Degand's visit Matisse had on hand a series of 'work-in-progress' photographs of the *Léda* panel that he had recently finished,[2] and reference is made to them.

INTERVIEW WITH DEGAND

[Degand arrives at Matisse's boulevard Montparnasse studio and finds Matisse in bed. They discuss the Salon d'Automne. Degand then leads Matisse to discuss spontaneity.]

'Spontaneity is not what I am looking for. Thus *Le rêve* [Figure **40**] took me six months of work. The *Nature morte rouge au magnolia* [Figure **41**] also took six months . . . [He shows Degand photographs of the *Léda* panel.]

'Undoubtedly it is necessary to paint as one sings, without constraint. The acrobat executes his number with ease and an apparent facility. Let's not lose sight of the long preparatory work which permitted him to attain this result. It is the same with painting. The possession of the means should pass from the conscious to the unconscious through the work, and it is then that one is able to give the impression of spontaneity.

'Painting requires organization by very conscious, very concerted means, as in the other arts. Organization of forces—colours are forces—as in music, organization of tones. But let's not confuse painting and music. Their actions are only parallel. One wouldn't know how to translate Beethoven's symphonies into painting.

'I played the violin when I was young [that is, until he was fifty years old, his secretary says]. I wanted to acquire too rich a technique, and I killed my feeling. Now I prefer to listen to others.'

[The conversation returns to spontaneity.]

'I work from feeling. I have my conception in my head, and I want to realize it. I can, very often, reconceive it . . . [They return to the *Léda* photographs.] But I know where I want it to end up. The photos taken in the course of the execution of the work permit me to know if the last conception conforms more to the ideal than the preceding ones; whether I am advancing or regressing.'

[The interview starts.]

DEGAND Aren't you afraid this technique of research will destroy your inspiration?

MATISSE No, I have within me something to express, through plastic means. I work as long as that is still inside me.

DEGAND This apparent spontaneity which you manage to retain in your paintings in spite of this constant work, was taken for facility by certain artists. They tried to find a moral there.

MATISSE I am not obliged to put railings around me everywhere I pass. . . . At any rate, when one expresses a feeling, it is nothing as long as one has not found its perfect form.

DEGAND That demands a great consciousness of one's feeling.

MATISSE Above all, it demands sincerity. I want to keep myself always in a high state of sincerity; for it is impossible to deflect inspiration.

DEGAND This sincerity assumes lucidity as well?

MATISSE It is advisable first of all to acquire the habit of not lying, neither to others nor to yourself. That is where we have the drama of many artists today. They tell themselves: I am going to make concessions to the public and, when I have made enough money, I will work for myself. From that moment, they are lost. They behave like these women who propose to walk the streets until they have a sum of money, then marry. 'Virtue is like a match: it can only be used once', wrote Pagnol in *Marius*. It is the same for painters.

Watch out, then, for concessions. And don't let yourself be impressed when someone says to you: 'What a beautiful painting. And you have rubbed out part of it!' What counts is not the quantity of canvases that one has done, but the organization of one's brain, the order that one puts into the mind, in view of the achievement of what one has conceived.

[Degand and Matisse look again at the *Léda* photographs. At a given moment Matisse thought the work finished. Two days later, he modified it for the better. The feeling had not been exactly expressed by the architecture of the composition.]

MATISSE This feeling is independent of a change in colour. If a green is replaced by a red, the look of a painting can change, but not its feeling. Colours are forces, I said. They must be organized with a view to creating an expressive ensemble. The same as in orchestration; you give one part to an instrument which can also be assumed by another to reinforce the effect.

DEGAND Shouldn't one worry about excess of feeling?

MATISSE Feeling is self-contained. You don't say to yourself: Look, today I am going to manufacture some feeling. No, it is a matter of something more authentic, more profound. Feeling is an enemy only when one doesn't know how to express it. And it is necessary to express it entirely. If you don't want to go to the limit, you only get approximations. An artist is an explorer. He should begin by seeking himself, seeing himself act; then, not restraining himself, and above all, not being easily satisfied.

In no case should the client be an obstacle to the pursuit of this purpose. Also watch out for the influence of wives. The priest and the doctor should never marry, so as not to risk letting temporal considerations come before their professions; the same goes for the artist.

DEGAND To sum up, you advise a sort of religious celibacy.

MATISSE Yes. There is everything to fear from the woman who plagues you by warning you of dangers or the losses you may sustain. It is also indispensable for the artist to reduce his existence to the minimum. Maillol understood that. 'I can live on a pickled herring a day,' he said. Simplify life. Don't admit anything useless.

DEGAND I can admire this constant care to not let anything distract one's line of action, even the smallest details of life, this abhorrence of wasted time.

MATISSE In a car, one shouldn't go faster than five kilometres an hour. Otherwise you no longer have a sense of the trees. And for a long trip, rather the train than a car. When I

get into the train at Nice, I have all the leisure of thinking, of daydreaming, of being by myself until Paris.

DEGAND Will Matisse tell me what he thinks of our contemporaries? What artists will he name? I run up against complete refusal.

MATISSE Just because I don't agree with my neighbour doesn't mean that he's wrong. To each his own path.

DEGAND The ritual question: what projects?

MATISSE God knows. God guides my hand. Certainly he doesn't speak into my ear, but I trust in Him.

DEGAND For several years certain people, even some of the best, have been worrying that our period doesn't have a style of its own. They think they have discovered, in this claimed absence of style, a sign of decadence. What says one of the men who has had the most decisive influence on the style of his time?

MATISSE They can't see the style of their time. They make me think of the man who wanted to paint a mountain. The more he climbed, the less he saw it. One will see later, all the paintings of our period will have the same style. In spite of everything, Ingres and Delacroix are of the same period. The same for the eighteenth century. Style springs necessarily from the epoch. Undoubtedly there are styleless periods. But our period has a style that will be clearly marked. Liberty of artistic expression, which is the rule today, will not stop this. This freedom, granted, will only be valid if it is applied in the sense of a tradition. Tradition does not mean habit. At any rate, it is not because we no longer dress as one did under Louis XIV or in 1900 that we have no style. We have things to say, and we say them according to the means forged by our epoch. Raphael today wouldn't paint as he did.

DEGAND A current obsession is *wanting* a French art, as if French art was not necessarily the product of French artists.

MATISSE Obviously. Moderation is the characteristic of French art. It is found everywhere in France. In places that seem the most cosmopolitan one finds France. Someone said to me not long ago when I was abroad: 'How lucky you are to return to Paris where everything is so beautiful and so fine.' I responded: 'In returning to my home I am going to pass by the avenue de l'Opéra; I don't see what it can have that is particularly French; it seems to me that this character of the street is everywhere.' He insisted: 'Don't fool yourself; you will only notice it by leaving here.' This foreigner was right. In this avenue which appeared to have grown up a little haphazardly, all was well-placed. The shop signs were not too large and flashy and I could breathe an air of tranquillity there with which I was quite satisfied.

But the French are not aware of their surroundings, for the same reason that you don't think about the jacket you're wearing when it gives you ease of movement.

DEGAND What do you think of the 'human element' which so completely occupies certain of our contemporaries?

MATISSE These preoccupations are foreign to painting. When I had students I told them: you must begin by cutting off your tongue, for, starting today, you should express yourself only through plastic means. You must be what you are, and cultivate this. Don't wait for inspiration. It comes while one is working.

The human element, what is it, after all? It is the faculty that certain beings have to identify with their setting, with the people around them, the flowers that they see, the landscapes in which they live. The colours of a picture, like the phrases of a symphony, don't need anecdote to give the spectator or the listener the feeling that the artist is a sensitive or generous being . . .

DEGAND People have still not given up reproaching your art for being highly decorative, meaning that in the pejorative sense of *superficial*.

MATISSE Delacroix said: We are not understood, we are acknowledged. The decorative for a work of art is an extremely precious thing. It is an essential quality. It does not detract to say that the paintings of an artist are decorative. All the French primitives are decorative.

The characteristic of modern art is to participate in our life. A painting in an interior spreads joy around it by the colours, which calms us. The colours obviously are not assembled haphazardly, but in an expressive way. A painting on a wall should be like a bouqet of flowers in an interior. These flowers are an expression, tender or passionate. Or, the pleasure simply comes to us from a yellow or red surface, which accounts for the more tender expression of the flowers, like roses, violets, daisies, compared with the bright and purely decorative orange of marigolds.

DEGAND There is a Matissian atmosphere which emanates from the man as well as the work, an atmosphere of fine and sensual intellectuality, serene and grave, devoid however of vain austerity. There is nothing profane or irrelevant.

26

Black is a Colour, 1946[1]

On the occasion of an exhibition at the Gallery Maeght in December 1946, the title of which was 'Black is a Colour', Matisse made remarks on this theme which were recorded by M. Maeght. Matisse's use of black as a colour is particularly interesting, since in one way or another it is to be found throughout his paintings, even in the late cut gouaches, where it finds full expression in such late compositions as *Tristesse du roi*. Matisse's musical allusion is not uncommon in his writings and surely not unexpected from a painter who, like Ingres, was a dedicated violinist.

BLACK IS A COLOUR

Before, when I didn't know what colour to put down, I put down black. Black is a force: I depend on black to simplify the construction. Now I've given up blacks.[2]

The use of black as a colour in the same way as the other colours—yellow, blue or red— is not a new thing.

The Orientals made use of black as a colour, notably the Japanese in their prints. Closer to us, I recall a painting by Manet in which the velvet jacket of a young man with a straw hat is painted in a blunt and lucid black.[3]

In the potrait of Zacharie Astruc by Manet,[4] a new velvet jacket is also expressed by

a blunt luminous black. Doesn't my painting of the *Marocains*[5] use a grand black which is as luminous as the other colours in the painting?

Like all evolution, that of black in painting has been made in jumps. But since the Impressionists it seems to have made continuous progress, taking a more and more important part in colour orchestration, comparable to that of the double-bass as a solo instrument.

27

How I made my Books, 1946[1]

'How I made my Books' is a specialized essay contributed to an anthology of statements by artist-illustrators. It is a literal account of Matisse's method of working, descriptive rather than theoretical,[2] with the notable exception of the parallel drawn between making a painting and making a book. This procedure from the broad conception to detail, and then through a process of distillation and reduction to essentials, seems to run throughout Matisse's writings. See Frontispiece and p. 108 for two of the works discussed.

HOW I MADE MY BOOKS

To start with my first book—the poems of Mallarmé.[3]

Etchings, done in an even, very thin line, without hatching, so that the printed page is left almost as white as it was before printing.

The design fills the entire page so that the page stays light, because the design is not massed towards the centre, as usual, but bleeds over the whole page.

The right-hand pages carrying the full-page illustrations were facing left-hand pages which carry the text in 20-point Garamond italic. The problem was then to balance the two pages—one white, with the etching, the other comparatively black, with the type.

I obtained my result by modifying my arabesque in such a way that the spectator should be interested as much by the white page as by his expectation of reading the text.

I can compare my two pages to two objects taken up by a juggler. His white ball and black ball are like my two pages, the light one and the dark one; so different, yet face to face. In spite of the differences between the two objects, the art of the juggler makes a harmonious whole in the eyes of the spectator.

My second book: *Pasiphaé* by Montherlant.[4]

Linoleum cuts. A simple white line upon an absolutely black background. A simple line, without shading.

òrs, dormeuse aux longs cils, hiron-
delle, hirondelle...

Un dernier baiser, un dernier, à la bague de
ton orteil.

Je serai ton vêtement dans le silence de la nuit.

Je prendrai tes doigts endormis.

Je les poserai en rêvant sur mon cou, sous
mes aisselles...

Les doigts de ceux qu'on aime sont des gouttes
de pluie.

Minuit. Au ciel les signes errent comme des
voiles.

34

... L'angoisse qui s'amasse en frappant sous ta gorge...

Double-page spread from Montherlant: 'Pasiphäé'. 1944. Linoleum cuts

Here the problem is the same as that of the 'Mallarmé', except the two elements are
reversed. How can I balance the black illustrating page against the comparatively white
page of type? By composing with the arabesque of my drawing, but also by bringing the
engraved page and the facing type page together so that they form a unit. Thus the
engraved part and the printed part will strike the eye of the beholder at the same moment.
A wide margin running all the way around both pages masses them together.

At this stage of the composition I had a definite feeling of the rather grim character
of this black and white book. Books, however, generally seem that way. But in this case
the wide, almost entirely black page seemed a bit funereal. Then I thought of red initial
letters. That pursuit caused me a lot of work; for after starting out with capitals that were
pictorial, whimsical, the invention of a painter, I had to settle for a more severe and clas-
sical conception, more in accord with the elements already settled—the typography and
engraving.

So then: Black, White, Red—Not so bad . . .

Now for the cover. A blue came to my mind, a primary blue, a canvas blue, but with a
white line engraved on it. As the cover has to remain in the slipcase or the binding, I had
to retain its 'paper' character. I lightened the blue, without making it less blue, but
through a woven effect—which came from the linoleum. Unknown to me an attempt was
made whereby the paper, saturated with blue ink, looked like leather. I rejected it im-
mediately because it had lost the 'paper' character I wanted it to have.

This book, because of the numerous difficulties in its design, took me ten months of
effort, working all day and often at night.

The other books, notably *Visages*, the *Poésies de Ronsard*, the *Lettres portugaises*,[5]

those in the process of publication, which are waiting their turn at press, though they differ in appearance, were all done according to the same principles, which are:

1. Rapport with the literary character of the work.
2. Composition conditioned by the elements employed as well as their decorative values: black, white, colour, style of engraving, typography. These elements are determined by the demands of harmony for the book as a whole and arise during the actual progress of the work. They are never decided upon before the work is undertaken, but develop coincidentally as inspiration and the direction of my experiments indicate.

I do not distinguish between the construction of a book and that of a painting, and I always proceed from the simple to the complex, yet am always ready to reconceive in simplicity. Composing at first with two elements, I add a third insofar as it is needed to unite the first two in an enriched harmony—I almost wrote 'musical' harmony.

I reveal my method of working without claiming that there are no others, but mine developed naturally, progressively.

I want to say a few words about lino-cuts.

Linoleum shouldn't be chosen just as a cheap substitute for wood, for it gives the print a particular character, very different from that of wood, and for which it should be singled out.[6]

I have often thought that this simple medium is comparable to the violin with its bow: a surface, a gouge—four taut strings and a swatch of hair.

The gouge, like the violin bow, is in direct rapport with the feelings of the engraver. And it is so true that the slightest distraction in the tracing of a line causes a slight involuntary pressure of the fingers on the gouge and has an adverse effect on the line. Likewise, a change in the pressure of the fingers which hold the bow of a violin is sufficient to change the character of the sound from soft to loud.

Lino-cutting is a true medium predestined to be used by the painter-illustrator.

I have forgotten a valuable precept: put your work back on the block twenty times over and then, in the present case, begin over again until you are satisfied.

28

Oceania, 1946[1]

This fragment of text in which Matisse describes his own Oceania tapestry (Figure 42) offers a nice insight into his version of the creation of forms from experience 'recollected in tranquillity'.

OCEANIA

This panel, printed on linen—white for the motifs and beige for the background—forms, together with a second panel, a wall tapestry composed during reveries which came fifteen years after a voyage to Oceania.²

From the first, the enchantments of the sky there, the sea, the fish, and the coral in the lagoons, plunged me into the inaction of total ecstasy. The local tones of things hadn't changed, but their effect in the light of the Pacific gave me the same feeling as I had when I looked into a large golden chalice.

With my eyes wide open I absorbed everything as a sponge absorbs liquid.

It is only now that these wonders have returned to me, with tenderness and clarity, and have permitted me, with protracted pleasure, to execute these two panels.

29

Jazz, 1947¹

Matisse began the cut and pasted designs for *Jazz* some time around 1943 and the book was published in September 1947, as a folio of almost one hundred and fifty pages.² The book consists of some twenty plates of varying subject matter taken largely from folklore, mythology, and the circus—a departure from Matisse's usual subject matter—with an accompanying text reproduced in Matisse's own large, sprawling handwriting (see Figure 43).³ In the introduction to the text Matisse notes that the holograph text is meant to 'serve only as an accompaniment to my colours. . . . *Thus their role is purely visual.*' With typical modesty Matisse states that he can only offer some remarks, made in the course of his lifetime as a painter: 'I ask of those who have the patience to read them, that indulgence which is generally accorded to the writings of painters.' The introduction, then, serves as a modest and indirect way for the painter to introduce his desire to make some observations about the nature of art and about life itself. The device of saying that the writing is unimportant gives him freedom to ramble in the text and to be metaphorical, in contrast to the usually methodical explanation of his ideas.

Although most writers have accepted the lack of relationship between plates and text,⁴ it seems that a subtle relationship does exist. The illustrations themselves seem to have two major kinds of subject: the isolated figures (the Clown, Icarus, Swimmer, etc.) which seem to be metaphors for the artist; and the double figures (Knife Thrower, Cowboy, Heart, etc.) which suggest a dialogue, in the manner of 'artist and model'. Thus the underlying theme of the *Jazz* plates seems obliquely to be concerned with art and artifice. Further, despite their vivid colours and circus themes, few of the compositions are cheerful; several are among

Matisse's most ominous images. There are also some wry juxtapositions, such as the place-
ment of 'Icarus' at the end of the 'Aeroplane' section. Not only is the subject matter of *Jazz*
unusual, then, but so is the feeling conveyed. It is quite likely that Matisse in *Jazz* was striving
after the kind of meaningful cacophony found in Erik Satie's *Parade* of 1917.

The subject matter is very close, and there are also striking parallels between some of
Matisse's *Jazz* plates and Picasso's costumes for *Parade*.[5] Further, *Jazz* suggests some
striking parallels with the descriptions of the first performance of *Parade* (18 May 1917),[6]
which Matisse very likely attended.[7] When Matisse began work on *Jazz* in 1943 the title was
evidently going to be 'Circus',[8] since most the the compositions had to do with the circus. It is
possible that the change of title to *Jazz* was the result of the connection in his mind between
jazz music and *Parade*.[9]

The twenty plates and rambling text of *Jazz*, full of subtlety and innuendo, at once bold
and gay and tragic (Satie had said of jazz that 'it shouts its sorrows'), form one of Matisse's
most interesting statements about his art.

JAZZ

Notes

Why, after having written, 'he who wants to dedicate himself to painting should start
by cutting out his tongue', do I need to resort to a medium other than my own? Because
now I wish to display colour plates in the most favourable conditions possible. To do so,
I need to separate them by intervals of a different character. I decided that a handwritten
text was most suitable for this purpose. The unusual size of the writing seems to me to
provide the necessary decorative rapport with the character of the colour plates. Thus these
pages serve only as an accompaniment to my colours, as asters add to the composition of a
bouquet of more important flowers. *Thus their role is purely visual.*

What can I write? I certainly cannot fill these pages with the fables of La Fontaine,
as I did when I was a solicitor's clerk, for 'engrossed conclusions' that no one, not even
the judge, ever reads; and which only serve to use up a quantity of official paper pro-
portionate to the importance of the case.

I only offer some remarks, notes made in the course of my lifetime as a painter. I ask
that one read them in the indulgent spirit generally accorded the writings of a painter.

The Bouquet

When I take a walk in the garden I pick flower after flower, gathering them as I go,
one after the other into the crook of my arm. Then I go into the house with the intention of
painting them. After I have rearranged them in my own way, what a disappointment:
all their charm is lost in this arrangement. What has happened? The unconscious grouping
made when my taste led me from flower to flower, has been replaced by a conscious
arrangement, the result of remembered bouquets long since dead, which have left in my
memory the bygone charm with which I have burdened this new bouquet.

Renoir told me: 'When I have arranged a bouquet in order to paint it, I go round to the
side I have not looked at.'

The Aeroplane

A simple voyage by plane from London to Paris gives us a revelation of the world which
our imagination cannot anticipate. At the same time that the feeling of our new situation

delights us, it confuses us with the memory of the cares and annoyances with which we let ourselves be troubled on that same earth that we catch sight of below us as we cross over holes in the plain of clouds that we are overlooking from an enchanted world which was there all the time. And when we are returned to our modest condition of walking, we will no longer feel the weight of the grey sky upon us because we will remember that beyond this wall of clouds, so easily crossed, there exists the splendour of the sun; the perception of limitless space, in which we felt for a moment so free.

Shouldn't one have young people who have finished their studies make a long journey by plane.

The character of a face in a drawing depends not upon its various proportions but upon a spiritual light which it reflects—so much so, that two drawings of the same face may represent the same character though drawn in different proportions. No leaf of a fig tree is identical to any other, each has a form of its own, but each one cries out: Fig tree![10]

If I have confidence in my hand that draws, it is because as I was training it to serve me, I never allowed it to dominate my feeling. I very quickly sense, when it is paraphrasing something, if there is any disaccord between us: between my hand and the 'je ne sais quoi' in myself which seems submissive to it.

The hand is only an extension of sensibility and intelligence. The more supple it is, the more obedient. The servant must not become the mistress.

Drawing with Scissors

Cutting directly into colour reminds me of a sculptor's carving into stone. This book was conceived in that spirit.

My Curves are not Mad

The plumb line, in determining the vertical, forms, with its opposite, the horizontal, the draughtsman's points of the compass. Ingres used a plumb line.[11] You see in his studies of standing figures this unerased line, which passes through the sternum and the inner ankle bone of the leg which bears the weight.

Around this fictive line the 'arabesque' develops. I have derived constant benefit from my use of the plumb line. The vertical is in my mind. It helps me give my lines a precise direction and in my quick drawings I never indicate a curve—for example, that of a branch in a landscape—without a consciousness of its relationship to the vertical.

My curves are not mad.

A new picture must be a unique thing, a birth bringing to the human spirit a new figure in the representation of the world. The artist must summon all his energy, his sincerity, and the greatest modesty, to shatter the old clichés that come so easily to hand while working, which can suffocate the little flower that does not come, ever, in the way one expects.

A Musician Has Said:

In art, truth and reality begin when you no longer understand anything you do or know and there remains in you an energy, that much stronger for being balanced by opposition, compressed, condensed. Then you must present it with the greatest humility, completely white, pure, candid, your brain seeming empty in the spiritual state of a communicant approaching the Lord's Table.

You clearly must have all your accomplishments behind you, and have known how to keep your Instinct fresh.

Do I Believe in God?

Yes, when I work. When I am submissive and modest, I sense myself helped immensely by someone who makes me do things by which I surpass myself. Still, I feel no gratitude

toward *Him* because it is as if I were watching a conjurer whose tricks I cannot see through. I then find myself thwarted of the profit of the experience that should be the reward for my effort. I am ungrateful without remorse.

Young painters, painters misunderstood or only lately understood—no hatred! Hatred is a parasite that devours all. 'One doesn't build upon hatred, but upon love. Emulation is necessary, but hatred . . .

'Love, on the contrary, sustains the artist.

'Love is an important thing, the greatest good, which alone renders light that which weighs heavy, and bears with an equal spirit that which is unequal. For it carries weights which without it would be a burden, and makes sweet and pleasant all that is bitter . . .

'Love wants to rise, not to be held down by anything base . . .

'Nothing is more gentle than love, nothing stronger, nothing higher, nothing larger, nothing more pleasant, nothing more complete, nothing better—in heaven or on earth—because love is born of God and cannot rest other than in God, above all living beings. He who loves, flies, runs, and rejoices; he is free and nothing holds him back.[12]

Happiness

Derive happiness from yourself, from a good day's work, from the clearing that it makes in the fog that surrounds us. Think that all those who have *succeeded*, as they look back on the difficulties of their start in life, exclaim with conviction, 'Those were the good old days!' For most of them success = Prison, and the artist must never be a *prisoner*. Prisoner? An artist must never be a prisoner of himself, prisoner of a style, prisoner of a reputation, prisoner of success, etc. Did not the Goncourt brothers write that Japanese artists of the great period changed their names several times during their lives? This pleases me: they wanted to protect their freedom.

Lagoons: wouldn't you be one of the seven wonders of the Paradise of painters?[13]

Happy are those who sing with all their hearts, in the forthrightness of their hearts.

Find Joy in the sky, in the trees, in the flowers. There are flowers everywhere for those who want to see them.

Future Life

Wouldn't it be consoling and satisfying if all those who gave their lives to the development of their natural talents, for the profit of all, were to enjoy after their deaths a life of satisfaction in accord with their desires, while those who live in narrow-minded selfishness . . .[14]

Jazz

These images, in vivid and violent tones, have resulted from crystallizations of memories of the circus, popular tales, or travel. I have written these pages to calm the simultaneous oppositions of my chromatic and rhythmic improvisations, to provide a kind of 'resonant background' which carries them, surrounds them and thus protects their distinctiveness.

I pay my respects to Angèle Lamotte and Tériade—their perseverance has sustained me in the creation of this book.[15]

30

André Marchand: *The Eye*, 1947[1]

Like the interviews of Montherlant and Bouvier, André Marchand's recollection of his conversation with Matisse gives a charming insight into Matisse's candid views on painting. Matisse was evidently quite fond of anecdotes like that of the Corsican painter. Clearly, he also enjoyed interesting verbal juxtapositions and transcriptions of different levels of awareness of reality.

THE EYE

I arrive at the villa 'Le Rêve'. 'You know,' says Matisse, 'I didn't invite you to come and see me the other day because I am often bothered by people who drop in unexpectedly. But I have the greatest delight in chatting, and that's why I called you this morning.' I reply that I wouldn't want to disturb his peace and quiet for anything in the world. Then the conversation turns to the country: he asks if I find it beautiful. I tell him it is downright ugly, that all the buildings are dreadful, that the ruin of the countryside is the fault of the architects. Henri Matisse smiles, says to me: 'But at Versailles, you can't paint, whereas here, in this disorder, it is the painter who must find order.'

Some photos had just arrived from Paris. They are of landscapes, one of which Matisse painted forty years ago. 'I was very young, you see, I thought it was no good, a bad job, not constructed, an unimportant sketch. Well, look at it in miniature there in the photo; everything is there, it has balance, the tree leaning slightly toward the right; look, here is an enlargement. Basically, after that, I only developed this idea further. You know, you have only one idea, you are born with it and all your life you develop your fixed idea, you make it breathe. I believe that in drawing I have been able to say something, I have worked a lot with that problem. Cézanne constructed his paintings, but the magic of colour still remained to be found after him. Cézanne's paintings have a peculiar structure; reversed, looked at in a mirror for example, they often lose their balance.'

Henri Matisse tells me he used to go to the Louvre. Chardin attracted him when he was young, but he realized that he couldn't paint like Chardin, that basically he had to harmonize yellow, blue and red, and by this apparently abridged means, he had to express himself completely. Everything had to be redone in order to attain life, and then there was the problem of black.

Matisse quotes Pissarro on the subject of Manet; Pissarro said to him one day, 'Manet is stronger than us all, he made light with black' (this went against all the Impressionist theories of the time). While Henri Matisse speaks, outside the daylight is fading and the evening sky is turning pale green.

Matisse says to me: 'Here is a country where light plays the leading role, colour comes second; it's with colour that you put down this light of course,[2] but above all you must feel this light, have it within yourself; you can get there by means which seem completely paradoxical, but who cares? It's the result alone that counts. I went to Corsica one year,[3]

and it was by going to that marvellous country that I learned to know the Mediterranean. I was quite dazed by it all; everything shines, everything is colour and light.

'I met a Corsican painter one day who told me his country was abominable and seeing my work said: "How strange what you're doing is; what is it of?" I told him it was a certain house and described it to him. "Ah!" he said, "I know the place well, I will go and see it tomorrow." The next day he came to the place I was working, stood in surprise in front of my canvas, looking at the subject, understanding nothing at all, and said: "I like what you're doing there, but I can't find it anywhere in the subject".'

Matisse continues: 'There is a young girl who draws who comes to see me fairly often. I tell her: basically when you look at a subject you have only to copy it, right'—Matisse smiled as he watched me. 'Yes, it's not that you have only to copy it, but in the course of working whether you are before a landscape, a person, a bunch of flowers—anything at all—along comes the struggle, the revolt, and it's at that moment that you exactly set down the chosen subject according to your own temperament; painters with nothing to say copy quite stupidly; they are boring and useless.'

Adjusting a navy-blue cap on his head, Matisse adds: 'Ah! what a fascinating occupation, it's strange how short life is: now I can see what I have to do, I would like to start over again, but a painter's life is never long enough, you leave your work in the middle; the essential thing is to say well what you have to say.' Then suddenly he says:

'Do you know that a man has only one eye which sees and registers everything, this eye, like a superb camera which takes minute pictures, very sharp, tiny (Matisse shows me the size between his fingers, about three millimetres across) and with that picture man tells himself: "This time I know the reality of things", and he is calm for a moment, then slowly superimposing itself on the picture another eye makes its appearance, invisibly, which makes an entirely different picture for him.

'Then our man no longer sees clearly, a struggle begins between the first and the second eye, the fight is fierce, finally the second eye has the upper hand, takes over and that's the end of it. Now it has command of the situation, the second eye can then continue its work alone and elaborate its own picture according to the laws of interior vision. This very special eye is found here', says Matisse, pointing to his brain.

31

The Path of Colour, 1947[1]

'The Path of Colour' is Matisse's account of how he came to the realization that 'colour exists in itself, possessing its own beauty', and notes the positive effect of having one's efforts confirmed by a tradition, especially a long-lived one. Although the allusion here is to the Fauve period, the same idea was seen to be a moving force behind Matisse's disavowal of the style of the Nice period. Here Matisse sums up an important aspect of his use of colour: the way in

which light is suggested through colour, the musical effect that can be created with colour which obeys the needs of the painting (rather than mere description of objects), and the simplicity of his use of colour. Matisse used a fairly limited palette through which he was able to achieve broad colour effects.[2]

Instead of elaborately detailed means for the rendering of light, atmosphere, and the use of different colours, Matisse notes again that 'it is enough to invent signs. When you have a real feeling for nature you can create signs which are equivalents to both the artist and the spectator.' In this way Matisse reaffirms the importance of the artist's personality in contact with nature as a source of image-making.

The use of expressive colours is felt to be one of the basic elements of the modern mentality, an historical necessity, beyond choice. This sense of the inevitable seems to run through a great deal of Matisse's thought, as in his reminiscence of the time when he started to paint and realized that there was no turning back.[3] Just as there is often no turning back for the individual so there is sometimes no turning back for a whole tradition, and it seems that Matisse was possessed of an acute awareness of this.

This statement parallels in many ways the ideas in 'Role and Modalities of Colour', Text 23, above.

THE PATH OF COLOUR

Colour exists in itself, has its own beauty. We were made to realize this by the Japanese *crépons* we bought for a few centimes on the rue de Seine.[4] Then I understood that one could work with expressive colours which are not necessarily descriptive colours. Of course, the originals were no doubt disappointing. But isn't eloquence even more powerful, more direct when the means are vulgar? Van Gogh was also crazy about Japanese *crépons*.

Once my eye was unclogged, cleansed by the Japanese *crépons*, I was capable of really absorbing the colours because of their emotive power. If I instinctively admired the Primitives in the Louvre and then Oriental art, in particular at the extraordinary exhibition at Munich,[5] it's because I found in them new confirmation. Persian miniatures, for example, showed me all the possibilities of my sensations. I could find again in nature what they should be. By its properties this art suggests a larger and truly plastic space. That helped me to get away from intimate painting.

Thus my revelation came from the Orient. It was later, before the icons in Moscow, that this art touched me and I understood Byzantine painting. You surrender yourself that much better when you see your efforts confirmed by such an ancient tradition. It helps you jump the ditch.

I had to get away from imitation, even of light. One can provoke light by the invention of flats, as with the harmonies of music. I used colour as a means of expressing my emotion and not as a transcription of nature. I use the simplest colours. I don't transform them myself, it is the relationships which take charge of them. It is only a matter of enhancing the differences, of revealing them. Nothing prevents composition with a few colours, like music which is built on only seven notes.

It is enough to invent signs. When you have a real feeling for nature, you can create signs which are equivalents to both the artist and the spectator.

In the early Russian ballets, Bakst threw in colours by the bucketful. It was magnificent but without expression. It is not quantity which counts, but choice and organization. The only advantage which comes out of it is that colour henceforth has universal freedom even in the department stores.

We have made this choice in spite of ourselves. It was an inescapable fate. That is why it so profoundly represents the spirit of a period. But there is no need to confine oneself to that; today one must continue and go beyond.

32

Exactitude is not Truth, 1947[1]

In 1948 The Philadelphia Museum of Art held a large retrospective show of Matisse's work, organized by Henry Clifford. For the catalogue of that exhibition Matisse wrote two short essays; the first is 'Exactitude is not Truth'. In this essay Matisse makes some very cogent statements about his art. He notes that in painting and drawing, even in portraiture, conviction does not depend on 'the exact copying of natural forms, nor on the patient assembling of exact details, but on the profound feeling of the artist before the objects which he has chosen, on which his attention is focussed and the spirit of which he has penetrated'. He reiterates the image of the fig tree that he used in *Jazz*, and extends the image to other growing things, even people, concluding that everything has an inherent truth which must be distinguished from its surface appearance; and that this is the only truth that matters. He notes that it is the essential truth of an object which makes a drawing or painting successful. This describes the process by which the painter arrives at 'signs' for objects.

EXACTITUDE IS NOT TRUTH

Among these drawings, which I have chosen with the greatest of care for this exhibition, there are four—portraits perhaps—done from my face as seen in a mirror. I should particularly like to call them to the visitor's attention. [See page 118.]

These drawings seem to me to sum up observations that I have been making for many years on the characteristics of a drawing, characteristics that do not depend on the exact copying of natural forms, nor on the patient assembling of exact details, but on the profound feeling of the artist before the objects which he has chosen, on which his attention is focussed, and the spirit of which he has penetrated.

My convictions on these matters crystallized after I had verified the fact that, for example, in the leaves of a tree—of a fig tree particularly—the great difference of form that exists among them does not keep them from being united by a common quality. Fig leaves, whatever fantastic shapes they assume, are always unmistakeably fig leaves. I have made the same observation about other growing things: fruit, vegetables, etc.

Thus there is an inherent truth which must be disengaged from the outward appearance of the object to be represented. This is the only truth that matters.

Four self-portrait drawings, 1939

The four drawings in questions are of the same subject, yet the calligraphy of each one of them shows a seeming liberty of line, of contour, and of the volume expressed.

Indeed, no one of these drawings can be superimposed on another, for all have completely different outlines.

In these drawings the upper part of the face is the same, but the lower is completely different. In no. 158 [top, left], it is square and massive; in no. 159 [top, right], it is elongated in comparison with the upper portion; in no. 160 [bottom, left], it terminates in a point and in no. 161 [bottom, right], it bears no resemblance to any of the others.

Nevertheless the different elements which go to make up these four drawings give in the same measure the organic makeup of the subject. These elements, if they are not always indicated in the same way, are still always wedded in each drawing with the same feeling—the way in which the nose is rooted in the face—the ear screwed into the skull—the lower jaw hung—the way in which the glasses are placed on the nose and ears—the tension of the gaze and its uniform density in all the drawings—even though the shade of expression varies in each one.

It is quite clear that this sum total of elements describes the same man, as to his character and his personality, his way of looking at things and his reaction to life, and as to the reserve with which he faces it and which keeps him from an uncontrolled surrender to it. It is indeed the same man, one who always remains an attentive spectator of life and of himself.

It is thus evident that the anatomical, organic inexactitude in these drawings has not harmed the expression of the intimate character and inherent truth of the personality, but on the contrary has helped to clarify it.

Are these drawings portraits or not?

What is a portrait?

Is it not an interpretation of the human sensibility of the person represented?

The only saying of Rembrandt's that we know is this: 'I have never painted anything but portraits.'

Is the portrait in the Louvre, painted by Raphael and showing Joan of Aragon in a red velvet dress, really what is meant by a portrait?

These drawings are so little the result of chance, that in each one it can be seen how, as the truth of the character is expressed, the same light bathes them all, and that the plastic quality of their different parts—face, background, transparent quality of the spectacles, as well as the feeling of material weight—all impossible to put into words, but easy to do by dividing a piece of paper into spaces by a simple line of almost even breadth—all these things remain the same.

Each of these drawings, as I see it, has its own individual invention which comes from the artist's penetration of his subject, going so far that he identifies himself with it, so that its essential truth makes the drawing. It is not changed by the different conditions under which the drawing is made; on the contrary, the expression of this truth by the elasticity of its line and by its freedom lends itself to the demands of the composition; it takes on light and shade and even life, by the turn of spirit of the artist whose expression it is.

L'exactitude n'est pas la vérité.

33

Letter to Henry Clifford, 1948[1]

Matisse considered himself a continuation of the tradition of painting that came before him and was very conscious of the influence that his predecessors had upon him. Especially in the later years of his life, he was also concerned about his own influence upon young painters. In the 'Letter to Henry Clifford', written upon the occasion of the 1948 Philadelphia Exhibition, he expresses this concern and makes some observations about the relationship of his own paintings to the young painters of the day.

His comment that if drawing is of the Spirit, colour is of the Senses, is one of his most definitive comparisons of colour and drawing.

Although Matisse states, 'I do not claim to teach', it is obvious that this letter is prompted by the desire to make his ideas known to young artists and that he feels that only training like his own, or at least that of his own tradition, based upon careful observation of nature and diligent hard work, will allow the painter to achieve true mastery of his art. He also states, going back to his belief in the capacities of the individual, that the young artist must be gifted and that this gift cannot be taught, only amplified, by appropriate study. This reiteration of the importance of study and of nurturing one's own spirit, and pedagogical concern, are common in his later writings.

LETTER TO HENRY CLIFFORD

Vence, 14 February 1948

Dear Mr. Clifford:

I hope that my exhibition may be worthy of all the work it is making for you; your efforts touch me deeply.

However, in view of the great reverberations it may have, seeing how much preparation has gone into it, I wonder whether its scope will not have a more or less unfortunate influence on young painters. How are they going to interpret the impression of apparent facility that they will get from a rapid, even superficial, overall view of my paintings and drawings?

I have always tried to hide my own efforts and wanted my work to have the lightness and joyousness of a springtime which never lets anyone suspect the labours it has cost. So I am afraid that the young, seeing in my work only the apparent facility and negligence in the drawing, will use this as an excuse for dispensing with certain efforts which I believe necessary.

The few exhibitions that I have had the opportunity of seeing during these last years make me fear that young painters may avoid the slow and painful preparation which is necessary for the training of any contemporary painter who claims to construct with colour alone.

This slow and painful work is indispensable. Indeed, if gardens were not dug over at the proper time, they would soon be good for nothing. Do we not first have to clear and then to cultivate the soil in season?

The preparatory work of initiation, of renewing, is what I call 'cultivating the soil'.

When an artist has not known how to prepare for his time of flowering, by work which bears little resemblance to the final result, he has a short future before him; or when an artist who has 'arrived' no longer feels the necessity of getting back to the soil from time to time, he ends up going around in circles, repeating himself until, by this very repetition, his curiosity is extinguished.[2]

An artist must possess Nature. He must identify himself with her rhythm, by efforts that prepare for the mastery by which he will later be able to express himself in his own language.[3]

The future painter must be able to forsee what is useful to his development—drawing or even sculpture—everything that will let him become one with Nature, identify himself with her, by penetrating the things—which is what I call Nature—that arouse his feelings. I believe study by means of drawing to be essential. If drawing belongs to the realm of the Spirit and colour to that of the Senses, you must draw first to cultivate the Spirit and to be able to lead colour through the paths of the Spirit. That is what I want to cry aloud, when I see the work of young people for whom painting is not an adventure, and whose only goal is their impending first exhibition which is to start them on the road to fame.

It is only after years of preparation that the young artist should touch colour—not colour as description, that is, but as a means of personal expression. Then he can hope that all the images, even the very symbols which he uses, will be the reflection of his love for things, a reflection in which he may have confidence if he has been able to carry out his education with purity, and without lying to himself. Then he will employ colour with discernment. He will place it in accordance with a natural, unformulated and completely concealed design that will spring directly from his feelings; this is what allowed Toulouse-Lautrec, at the end of his life, to exclaim, 'At last, I no longer know how to draw.'

The painter who is just beginning thinks that he is painting from the heart. The artist who has completed his development also thinks that he is painting from the heart. Only the latter is right, because his training and his discipline allow him to accept impulses from within, which he can in part control.

I do not claim to teach; I only want my exhibition not to suggest false interpretations to those who have their own way to make. I should like people to know that they cannot approach colour as though it held open house, that one must go through a strict preparation to be worthy of it. But first of all it is clear that one must have a gift for colour, as a singer must have a voice. Without this gift one can get nowhere, and not everyone can declare like Correggio, 'I too am a painter'.[4] A colourist makes his presence known even in a simple charcoal drawing.

My dear Mr. Clifford, here my letter ends. I started it to let you know that I am aware of the trouble you are taking over me at the moment. I see that, obeying an inner necessity, I have made it an expression of what I feel about drawing, colour, and the importance of discipline in the education of an artist. If you think that all these reflections of mine can be of any use to anyone, do whatever you think best with this letter. You may add it, if there is still time, to the explanatory part of your catalogue.

Please accept, Mr. Clifford, the expression of my feelings of deepest gratitude.

Henri Matisse

34

Interview with R. W. Howe, 1949
¹

In 1949 Matisse gave a brief interview to Russell Warren Howe which, despite the chattiness of Howe's reportage, is of interest. The statement that 'to draw is to make an idea precise', for example, reinforces the impression that one gets from Matisse's paintings, that the idea is embedded in the drawing and the emotional or sensory impulse is carried for the most part by colour. This comment is also consonant with Matisse's statement in the letter to Henry Clifford that drawing is of the spirit and colour of the senses.

Of especial interest is Matisse's (expected) criticism of the doctrinaire aspect of Cubism, so foreign to his own intuitive approach, and his disavowal of the influence of Gauguin, to whom he was so often compared because of the superficial similarity between their works.

Matisse's equivocal response to 'non-objective' painting is worth noting; only a few years later, his answers to André Verdet's questions on the subject will be quite specific and outspoken.

INTERVIEW WITH R. W. HOWE

Caravaggio, Velazquez, Turner, Van Gogh and many other artists have taught us to expect a physical link between a painter and his canvases, but Henri-Matisse in no way resembles his art. With his careful dress and manner and his neat apartment in the Boulevard Montparnasse, he is in magnificent contrast to his startling North African orientalism, to his fantasy-arabesques of figure and decoration, to the drenching reds and poster emerald-greens he found in the French Midi, or to the other myriad pure-tints which were on his palette when he returned from the South Seas. At seventy-nine, he is a discreet and simplicity-loving grandfather.

But the popular picture of Matisse, scientific craftsman, is inaccurate. M. René Huyghes [*sic*], curator of paintings at the Louvre, attributes to him an 'exquisite and refined impassibility'. When I told Matisse this, he nodded characteristically and said, 'Look at the walls around you. You will see that what he says is not altogether true.'

The walls he indicated were covered by large Indian ink drawings on figure-and-decoration themes, typified by a power of simplicity and gentle French lucidity, by an orchestration of line and arabesque which suggested at one and the same time concision and intensity, and which, transformed into colour, would become an art of independent harmonies, each supporting the other. The essential lesson of each was personal emotion, instinctiveness.

'How can one make art without passion?' asked Matisse. 'Without passion, there is no art. The artist to a greater or lesser degree dominates himself, but it is passion which motivates his work.'

Some critics have fixed Matisse's aim as the solidity which Cézanne spoke of. Others propose a classic dignity. When I asked him which was correct, he just said, 'Look at what I'm doing now,' and if the bold Matisse line of his latest work suggested Cézanne

and solidity, the group of recent female head-portraits on one of his bedroom walls re-called equally the classic dignity of David (the current exhibition of whose works Matisse had just visited) and the more fluid dignity of Utamaro and Kuniyoshi.

The lasting quality of Matisse rests to a great extent in the drawing. 'To draw is to make an idea precise. Drawing is the precision of thought. By it the feelings and the soul of the painter travel without difficulty into the spirit of he who looks on. A work without drawing is a house without a frame', he told me.

Of his method, Matisse speaks freely. For his figure-pieces, his favourite work, he does not always work from studio drawings. He often draws directly from model to canvas.

When I asked him if he believed in a methodical life, he gave a great wink of agreement, for that is one of his strongest principles. 'One must work at set hours every day. One must work like a workman. Anyone who has done anything worthwhile has done that.' Later he said, 'All my life, I have worked all my waking day.'

The master of colour chuckles when you mention the conception of Paul Signac's theory that there were a fixed number of complementary tones, and ask him if this conception is absolute. 'Assuredly not! Complementaries? There are some which have no name. One can create associations which are not red, not green, not blue. We do not need laws, we just assimilate each new discovery.'

Too doctrinaire also is the mind-over-feeling attitude of many Cubists. For Matisse, the mind effort is only partly dominant, and it is the instinct which creates. 'For me, it is the sensation first, then the idea. I see a bouquet of flowers, it pleases me, I do something. If the Cubist conceives an idea and then asks himself "what sensation does that give me?"—well, I just don't understand that.'

The art of Matisse was a courageous individualism, but he modestly describes it in another way—'I owe my art to all painters. When I was young, I worked in the Louvre, copying the old masters, learning their thought, their technique. In modern art, it is indubitably to Cézanne that I owe the most.'

The architectural solidity and virility of Matisse is far from the colour-shapes of the Impressionist-born art of Gauguin, to whom the textbooks ascribe Matisse's chief inspiration. He says strongly, 'The basis of Gauguin's work and mine is not the same.' For that reason, Matisse can do no more than 'esteem' the Impressionistic and Gauguinesque art of his old friend Pierre Bonnard.

His most iconoclastic opinion is on Delacroix, whose *Journal* is now the most-read book among French painters: perhaps because Matisse, in line with French tradition, finds a mysticism like Delacroix's too philosophical, too intellectual—too 'literary', as French critics say—he thinks all this interest completely unjustified.[2]

I asked him: 'What do you think of the abstract—do you believe that one should deduce one's abstractions from the forms of nature, or that one should create the form, outside of nature?'

Matisse replied, 'There is always a measure of reality. The rest, I agree, is imagination. But there are no laws until the work is finished. One cannot make programmes. Painting is a grave art: we have not yet all its spirit, all its reason; nor have we liberty, and that is what is needed most.'

On the new painting, Matisse is non-committal. 'I am not rightly placed to speak of the art of younger painters. I know better—I was falsely judged myself when I was a young man.'[3] And at the mention of Surrealism, Matisse puts his chin out sharply—a gesture which is all a Frenchman needs to make in order to say, 'That's a different kettle of fish.' For the aesthetics which his genius does not span do not much interest him; he is a specialist. 'I have no opinion on Surrealism. It is difficult, so difficult to judge the young. We all do that of which we are capable.'

I asked him what he would do if he were a young painter in this day and age. 'I should be very thankful!' he smiled, adding, 'but seriously, my life tells you what I should do. I should do what I have done. Now I am almost at the end of the journey, and I cannot know precisely what I would do if I were at the beginning. I am not exactly youthful, and one must have youth to see into the future. If I were young, I would do something, and when I had done it I should know then on what researches I should spend my life.

'To-day, everything is expensive for the painter—colours, materials, life itself. If I were a young painter, I should take a job with a salary, and then I would be independent and paint freely.

'My art would not suffer. If I did bad painting, if I decorated Christmas crackers, that would harm my art, but bank-clerking or loading a goods-train would be fine.

'Nietzsche said, "All artists should learn a trade in order to be free." One need only work three or four hours a day. Then one's painting can be sincere, and one need not worry about the tastes of others. Sometimes, I know, one must work as one can', he says, and then recalls the time when he and Marquet painted laurel leaves all over Jambon's theatre in Paris for one-and-a-half francs an hour.

Unlike Vlaminck, Matisse is undismayed at the modern scene, and to the feelings of the new generation he says, 'Anxiety? It is no worse to-day than it was for the Romantics. One must dominate all that. One must be calm; and art should not be worrying or disturbing—it should be balanced, pure, tranquil, restful.'

Matisse, in his simplicity, is yet too complex a character to capture in half-an-hour's conversation. I found him in bed after the ritual afternoon nap, dictated by feeble health. He was reading a book on architecture, and by his hand lay the Bible. His assistant was tracing some of his inkline drawings, in connection with his experiments, and the walls were lined with his work. He has a look of intense intelligence, and his rare smile is warm and candid. In his simplicity, he is strangely like his master, Cézanne. He is often wisely non-committal. He is specialized to his art, which is primarily instinctive, and he is no example of Baudelaire's theory that literature, music and painting were interrelated. The only scientific side of his nature seems to be his sure knowledge of anatomy, which lends itself to the discovery of new values, some structural, some less easy to define. He is conscious of his assured place in the history of art, but conscious too that he is of a different period to that of the new painting, and selflessly indifferent to a future that will probably see others going on ahead.

Henri-Matisse has brought all the great traditions of French painting onto a new path, where for many bitter, impoverished years he walked alone, ill and in debt and doubting himself; on that path he now rests, contented.

He has often been called the painter of luxury. One has only to think of the lives of the great Spanish masters to see that few things are more artistic than luxury. He is perhaps a fraction less aptly called the painter of exoticism, for there is little evidence in him of that element which is half of exoticism—fear that the world is destined to become uniform. But at all costs he has in him the other half—the desire for escape, a feeling for broad spaces: one of his parting remarks was, 'If I were young, I'd make a tour of the world in a plane. I find that an extraordinary achievement. Why in a matter of hours, one can be in India, China, South Africa. Miraculous!'

35

Henri Matisse Speaks to You, 1950[1]

In March 1950, Matisse wrote a short essay for *Traits*, a small *avant-garde* periodical addressed largely to art students. Matisse's article, in keeping with the tenor both of the periodical and of his own pedagogical concerns, is addressed to the aspiring artist. He once again encourages study of the art of the past while cautioning against the dangers of superficial imitation. This short statement is a good example of Matisse's acute awareness of the historical context within which every artist works, and of his own use of the past as a 'library' of possibilities of perception.

HENRI MATISSE SPEAKS TO YOU

For forty years, I lived with a large plaster cast of the Argive statue 'Cleobis'.[2]

This larger-than-lifesize figure with its rigid forms, and parallel limbs, in which one sees an Egyptian influence—how alive it is! with a life more condensed and more profound than that of Egyptian sculpture, and also more human. It marks the beginning of Greek feeling, from which we are descended.

For ten years, I walked around it in my garden. Placed in a corner of the lawn and surrounded by tree trunks, it looked beautiful.

When its head and shoulders had become partially disintegrated by the rains of many winters, I brought it into the studio so as not to lose it completely, and finally here we are now in Nice.

We have rarely been separated for more than forty years, and the great interest I have had in it has only increased.

Recently, during a night of insomnia, I caught myself unconsciously contemplating it from the hollow of my armchair. The perfect silence of the hour certainly helped our coming together. With each involuntary pause I made before this plaster statue, this revealer of so many treasures, its exceptional qualities once again impressed me. It did not reveal new beauties to me, but old discoveries asserted themselves with greater intensity and with more profundity than in our previous encounters.

Happy with this renewal of interest, I solemnly promised myself to commune with it again, charcoal in hand, not doubting the benefit that it would be able to give me in future revelations.

I understood then the great benefit that the artist's sensibility can draw from an encounter with an ancient, especially very ancient work, with which he feels affinities.

Didn't Cézanne encounter Poussin?

I remembered studies that I made before other ancient sculptures. These studies didn't produce pleasant drawings, but drawings revealing intense efforts; they were not final results, it's true, but were afterwards recognized as profitable.

I just had a visit from Le Corbusier, that distinguished and inventive mind, who has successfully realized his great architectural and decorative daring.

As we stopped before my Argive Adonis, he said to me, 'Let me look at this marvel, I drew it a great deal ten years ago.' [3]

Isn't this a little surprising, this confession of an artist who would seem to be only self-motivated?

All that I am relating has no other intent than to be read by some artist in formation (isn't one in formation all one's life?) who is searching for new sources of inspiration in which he would be able to feel confident because his personality could draw freely upon those sources.

May I add that it is perilous to fall under the influence of the masters of my own epoch, because the language is too close to ours, and one risks taking the letter for the spirit. The masters of ancient civilizations had a language which was very full for them, but so different from ours that it prevents us from making too literal an imitation. Influenced by them, we are obliged to create a new language, for theirs refuses us a full development of ideas and very quickly closes its door on us.

Cézanne said: 'Defy the influential master.'

Cézanne did not need to fear the influence of Poussin, for he was sure not to adopt the externals of Poussin; whereas when he was touched by Courbet, as were the painters of his period, his technique was too strongly affected by Courbet, and Cézanne found his expression limited by Courbet's technique. Also, after that period, all this group of painters went to the other extreme: Courbet worked with black paint, and the Impressionists, at first his imitators, used all the colours of the rainbow.

WHEN ONE IMITATES A MASTER, THE TECHNIQUE OF THE MASTER STRANGLES THE IMITATOR AND FORMS ABOUT HIM A BARRIER WHICH PARALYSES HIM. I COULD NOT REPEAT THIS TOO OFTEN.

36

The Text, 1951[1]
[Preface to the Tokyo Exhibition]

In 1951 Matisse had a large retrospective exhibition in Tokyo, for which he wrote a preface to the catalogue. As in the letter to Henry Clifford, Matisse states his concern that the students who will see the exhibition should be able to see that 'the principal interest of my works comes from careful observation and respect for nature'. Matisse then goes on to reiterate the advice to young artists that he expressed in the letter to Henry Clifford, stating that without sincerity and the study of nature the artist can do nothing but float from one influence to another. Thus in the last years of his life, while his own works—especially the late cut gouaches—were becoming more and more abstract, Matisse felt impelled to advise the younger generation, who were producing painting that he admittedly did not understand, to study nature in order that they might realize that the source of his imagery was not in mere stylization, but in a conviction of sincerity before nature.

THE TEXT [Preface to the Tokyo Exhibition]

After I had decided that my exhibition at the Maison de la Pensée Française in Paris[2] would be my last show of this kind, I nevertheless agreed to this important exhibition in Japan—Mr. Hazama had so clearly explained the interest it would have for the art students of his country.

Given the place that Japanese artists have accorded me until now, I thought it my duty to accept his proposition and so I collected for this exhibition paintings and drawings which show my activity retrospectively.

I hope that the students who see this show will perceive that the principal interest of my works comes from attentive and respectful observation of Nature as well as from the quality of feeling which Nature has inspired in me, rather than from a certain virtuosity which almost always comes from honest and constant work.

I cannot stress enough the absolute necessity for an artist to have perfect sincerity in his work, which alone can give him the great courage he needs in order to accept it in all modesty and humility.

Without this sincerity, for which I am making a great case, the artist can only drift from one influence to another, forgetting to find the ground from which he must take his own individual characteristics.

Let the young artist not forget that the attraction of this ground is directed to his heart and rarely fits in with the problems of existence.

He must nevertheless manage to reconcile the two without impairing his scope.

37

The Chapel of the Rosary, 1951[1]

Upon completion of the Chapel of the Rosary at Vence, Matisse wrote an introduction to the picture book of the Chapel. His comments, which are quite general, barely touch on the Chapel itself. Instead he stresses the importance of the Chapel as a summing up of his career, as a unique contribution to posterity and as a major synthesis of the traditions of which he is a part. He calls particular attention to his reaction against the Beaux-Arts teaching and to his study of the expressive qualities of form and colour: in short to the respect for 'the purity of the means' which he saw as perhaps his most important contribution to the plastic tradition, and which he felt to be so powerfully realized in the Chapel.

THE CHAPEL OF THE ROSARY

All my life I have been influenced by the opinion current at the time I first began to paint, when it was permissible only to render observations made from nature, when all that derived from the imagination or memory was called bogus and worthless for the construction of a plastic work. The teachers at the Beaux-Arts used to say to their pupils, 'Copy nature stupidly'.

Throughout my career I have reacted against this attitude to which I could not submit; and this struggle has been the source of the different stages along my route, in the course of which I have searched for means of expression beyond the literal copy—such as Divisionism and Fauvism.

These rebellions led me to study separately each element of construction: drawing, colour, values, composition; to explore how these elements could be combined into a synthesis without diminishing the eloquence of any one of them by the presence of the others, and to make constructions from these elements with their intrinsic qualities undiminished in combination; in other words, to respect the purity of the means.

Each generation of artists views the production of the previous generation differently. The paintings of the Impressionists, constructed with pure colours, made the next generation see that these colours, if they can be used to describe objects or natural phenomena, contain within them, independently of the objects that they serve to express, the power to affect the feelings of those who look at them.

Thus simple colours can act upon the inner feelings with more force, the simpler they are. A blue, for example, accompanied by the brilliance of its complementaries, acts upon the feelings like a sharp blow on a gong. The same with red and yellow; and the artist must be able to sound them when he needs to.

In the Chapel my chief aim was to balance a surface of light and colour against a solid wall with black drawing on a white background.

This Chapel is for me the culmination of a life of work, and the coming into flower of an enormous, sincere and difficult effort.

This is not a work that I chose, but rather a work for which I was chosen by fate, towards the end of the course that I am still continuing according to my researches; the Chapel has afforded me the possibility of realizing them by uniting them.[2]

I forsee that this work will not be in vain and that it may remain the expression of a period in art, perhaps now left behind, though I do not believe so. It is impossible to be sure about this today, before the new movements have been fully realized.

Whatever weaknesses this expression of human feeling may contain will fall away of their own accord, but there will remain a living part which will unite the past with the future of the plastic tradition.

I hope that this part, which I call my revelation, is expressed with sufficient power to be fertilizing and to return to its source.

38

The Chapel of the Rosary, 1951[1]
[On the Murals and Windows]

Late in 1951 Matisse wrote a short statement on the Vence Chapel (Figure 45) for the Christmas issue of *France Illustration*. In this essay Matisse elaborates on the composition of the main visual elements of the Chapel: the three ceramic tile panels (St. Dominic, the Virgin and Child, The Stations of the Cross), and the stained-glass windows. This essay, which is descriptive in a manner reminiscent of 'How I made my Books' (Text 27), provides one of Matisse's most detailed discussions of a single work.

THE CHAPEL OF THE ROSARY
[On the Murals and Windows]

This chapel is for me the culmination of a lifetime of labour.
The ceramics of the Chapel of the Rosary at Vence have produced reactions of such astonishment that I would like to try to dispel them.

These ceramic panels are composed of large squares of glazed white tile bearing drawings in black outline which decorate them while still leaving them very light. The result is an ensemble of black on white in which the white dominates, and whose density forms a balance with the surface of the opposite wall, which is composed of stained glass windows which run from the floor to the ceiling, and which express, through their adjacent forms, an idea of foliage which is always of the same origin, coming from a characteristic tree of the region: the cactus with large oval spine-covered stalks, which bear yellow and red flowers.

These stained-glass windows are composed of three carefully chosen colours of glass, which are: an ultramarine blue, a bottle green, and a lemon yellow, used together in each part of the stained-glass window. These colours are of quite ordinary quality; they exist as an artistic reality only with regard to their quantity, which magnifies and spiritualizes them.

To the simplicity of these three constructive colours is added a differentiation of the surface of some of the pieces of glass. The yellow is roughened and so becomes translucent only while the blue and the green remain transparent, and thus completely clear. This lack of transparency in the yellow arrests the spirit of the spectator and keeps it in the interior of the chapel, thus forming the foreground of a space which begins in the chapel and then passes through the blue and green to lose itself in the surrounding gardens. Thus when someone inside can see through the glass a person coming and going in the garden, only a metre away from the window, he seems to belong to a completely separate world from that of the chapel.

I write of these windows—the spiritual expression of their colour to me is indisputable —simply to establish the difference between the two long sides of the chapel, which, decorated differently, sustain themselves by their mutual opposition. From a space of bright shadowless sunlight which envelops our spirit on the left, we find, passing to the right, the tile walls. They are the visual equivalent of a large open book where the white pages carry the signs explaining the musical part composed by the stained-glass windows.

In sum, the ceramic tiles are the spiritual essential and explain the meaning of the monument. Thus they become, despite their apparent simplicity, the focal point which should underline the peaceful contemplation that we should experience; and I believe this is a point that should be stressed.

In their execution the artist is revealed with complete freedom. Thus, having from the first foreseen these panels as illustrations of these large surfaces, during the execution he gave a different feeling to one of these three: that of the Stations of the Cross.

The panel of Saint Dominic and that of the Virgin and the Christ Child are on the same level of the decorative spirit, and their serenity has a character of tranquil contemplation which is proper to them, while that of the Stations of the Cross is animated by a different spirit. It is tempestuous. This marks the encounter of the artist with the great tragedy of Christ, which makes the impassioned spirit of the artist flow out over the chapel. Initially, having conceived it in the same spirit as that of the first two panels, he made it a procession of succeeding scenes.[2] But, finding himself gripped by the pathos of so profound a tragedy, he upset the order of his composition. The artist quite naturally became its principal actor; instead of reflecting the tragedy, he has experienced it and this is how he has expressed it. He is quite conscious of the agitation of the spirit which this passage from the serene to the dramatic arouses in the spectator.[3] But isn't the Passion of Christ the most moving of these three subjects?

I would like to add to this text that I have included the black and white habits of the Sisters as one of the elements of the composition of the chapel; and, for the music, I preferred to the strident tones—however enjoyable, too explosive—of the organ, the sweetness of the voices of women which with their Gregorian chant can become a part of the quivering coloured light of the stained-glass windows.

39

Matisse Speaks, 1951[1]

'Matisse Speaks' is a transcription by Tériade of a statement made by Matisse in July 1951. The context of the statement is autobiographical, and Matisse refers here to several incidents (Bouguereau's studio, Moreau, the Louvre, his own class, etc.) which, judging from his frequent reference to them, he evidently felt to be significant incidents in his life.

This document is also of especial interest because Matisse refers to specific events and works which were important enough to him to be mentioned many years later in this outline of his career.

MATISSE SPEAKS

Beginnings, 1890–92

I was an attorney's clerk, studying to be a lawyer, at St.-Quentin. Convalescing after an illness, I met somebody who copied chromos—sort of Swiss landscapes which in those days were sold in albums of reproductions. I bought a box of colors and began to copy them, too. Afterwards, every morning from seven to eight, before going to my studies, I used to go to the École Quentin Latour where I worked under draftsmen who designed textiles.[2] Once bitten by the demon of painting, I never wanted to give up. I begged my parents for, and finally got, permission to go to Paris to study painting seriously.

The only painter in St.-Quentin was a man named Paul Louis Couturier,[3] a painter of hens and poultry-yards. He had studied with Picot—one of Bouguereau's disciples—which he mentioned, and with Gustave Moreau, which he never mentioned. So I came to Paris with recommendations from Couturier to Bouguereau.

I showed some of my first pictures to Bouguereau who told me that I didn't know perspective. He was in his studio, re-doing for the third time his successful Salon picture, *The Wasp's Nest* (it was a young woman pursued by lovers). The original Salon picture was nearby; next to it was a finished copy, and on the easel was a bare canvas on which he was drawing a copy of the copy. Two friends were with him: Truphème,[4] one of the prize-winners of the Artistes Français group and director of the Municipal School of Drawing on the Boulevard Montparnasse, and a man named Guignon, another of the Artistes Français painters—he only painted olive trees at Menton. Bouguereau was literally re-making his picture for the third time. And his friends exclaimed: 'Oh, Monsieur Bouguereau! What a conscientious man you are; what a worker!' 'Ah, yes!' responded Bouguereau, 'I am a worker, but art is hard.'

I saw the unconsciousness (unconscious because they were sincere) of these men who were stamped by official art and the Institute, and soon understood that I could get nothing from them.

I went to the Académie Julian and signed up for the Prix de Rome competition at the École des Beaux-Arts. One of my friends persuaded me that there was nothing to learn at the École de Rome and I began to work from my own experiences.[5] I was enormously helped in this by meeting Gustave Moreau, in whose studio I entered and where I met Dufy and Rouault. Moreau took an interest in my work. He was a cultivated man who stimulated his pupils to see all kinds of painting, while the other teachers were preoccupied with one period only, one style—of contemporary academicism—that is to say their own, the leftovers of all conventions.

Copies at the Louvre, 1894–96

We used to make copies at the Louvre, somewhat to study the masters and live with them, somewhat because the Government bought copies. But they had to be executed with minute exactitude, according to the letter and not the spirit of the work. Thus the works most successful with the purchasing commission were those done by the mothers, wives and daughters of the museum guards. Our copies were only accepted out of charity, or sometimes when Roger-Marx pleaded our cause.[6] I would have liked to be literal, like the mothers, wives and daughters of the guards, but couldn't.

What is believed to be boldness was only awkwardness. So liberty is really the impossibility of following the path which everyone usually takes and following the one which your talents make you take.

Among the pictures I copied at that time, I remember the *Portrait of Baldassare Castiglione* by Raphael, Poussin's *Narcissus*, Annibale Caracci's *The Hunt*, the *Dead Christ* of

Philippe de Champagne. As for the *Still-life* by David de Heem, I began it again, some years later, with the methods of modern construction.[7]

Around 1896 I was at the École des Beaux-Arts and roomed on the Quai St.-Michel. Next door was the painter Véry who was influenced by the Impressionists, especially Sisley. One summer we went to Brittany together, to Belle-Île-en-Mer. Working next to him I noticed that he could get more luminosity from his primary colors than I could with my old-master palette. This was the first stage in my evolution, and I came back to Paris free of the Louvre's influence and heading towards color.

The search for color did not come to me from studying paintings, but from the outside —that is from the revelation of light in nature.

Divisionism, 1904

At St.-Tropez I met Signac and Cross, theoreticians of Divisionism. In their company I worked on my picture *The Terrace at St.-Tropez*[8]—really the boathouse at Signac's house, which was called La Hune. I also painted the big composition, *Luxe, Calme et Volupté* [Figure **13**]—it is still in the Signac collection—a picture made of pure rainbow colors. All the paintings of this school [Divisionism] had the same effect: a little pink, a little blue, a little green; a very limited palette with which I didn't feel very comfortable. Cross told me that I wouldn't stick to this theory, but without telling me why. Later I understood. My dominant colors, which were supposed to be supported by contrasts, were eaten away by these contrasts, which I made as important as the dominants. This led me to painting with flat tones: it was Fauvism.

Fauvism, 1905–10

Fauvism at first was a brief time when we thought it was necessary to exalt all colors together, sacrificing none of them. Later we went back to nuances, which gave us more supple elements than the flat, even tones.

The Impressionists' aesthetic seemed just as insufficient to us as the technique of the Louvre, and we wanted to go directly to our needs for expression. The artist, encumbered with all the techniques of the past and present, asked himself: 'What do I want?' This was the dominating anxiety of Fauvism. If he starts from within himself, and makes just three spots of color, he finds the beginning of a release from such constraints.

This period lasted for some time, even some years. Once you have reached the point where you take cognizance of the quality of your desire, you begin to consider the object which you are making, and you need to modify your methods in order to become more intelligible to others, and to organize all the possibilities that you have recognized within yourself.

The man who has meditated on himself for a certain length of time comes back to life sensing the position he can occupy. Then he can act effectively.

My master, Gustave Moreau, used to say that the mannerisms of a style turn against it after a while, and then the picture's qualities must be strong enough to prevent failure. This alerted me against all apparently extraordinary techniques.

The epithet 'Fauve' was never accepted by the Fauve painters; it was always considered just a tag issued by the critics. Vauxcelles invented the word. We were showing at the Salon d'Automne; Derain, Manguin, Marquet, Puy and some of the others were exhibiting together in one of the big galleries. The sculptor Marque showed an Italianate bust of a child in the center of this hall. Vauxcelles came in the room and said: 'Well, Donatello among the wild beasts!' ['*Tiens, Donatello au milieu des fauves.*']

A whole group worked along these lines: Vlaminck, Derain, Dufy, Friesz, Braque. Later, each member denied that part of Fauvism he felt to be excessive, each according to his personality, in order to find his own path.

Morocco

The voyages to Morocco helped me accomplish this transition, and make contact with nature again better than did the application of a lively but somewhat limiting theory, Fauvism. I found the landscapes of Morocco just as they had been described in the paintings of Delacroix and in Pierre Loti's novels. One morning in Tangiers I was riding in a meadow; the flowers came up to the horse's muzzle. I wondered where I had already had a similar experience—it was in reading one of Loti's descriptions in his book *Au Maroc.*

*The Moroccans*⁹—I find it difficult to describe this painting of mine with words. It is the beginning of my expression with color, with blacks and their contrasts. They are reclining figures of Moroccans, on a terrace, with their watermelons and gourds.

The Academy, 1908

This is what they called my 'academy'. Around 1908, some younger painters wanted help. At that time there was some empty space at the Couvent des Oiseaux; we rented it for a studio where one could get together and work. I used to come by in the evenings, from time to time, to see what they were doing. I quickly realized that I had my own work to do, and was wasting too much of my energy. After each criticism I found myself faced with lambs, and I had to build them up constantly, every week, to make them into lions. So I wondered whether I was a painter or a teacher; I decided I was a painter and quickly abandoned the school. Purrmann (member of the Academy in Berlin and a professor there), Grunwald (professor at Stockholm), and the Scandinavian Sorenson were among my pupils.

The Collectors

Among the collectors who were interested in my work from the beginning, I must mention two Russians, Stchoukine and Morosoff. Stchoukine, a Moscow importer of Eastern textiles, was about fifty years old, a vegetarian, extremely sober. He spent four months of each year in Europe, traveling just about everywhere. He loved the profound and tranquil pleasures. In Paris his favorite pastime was visiting the Egyptian antiquities in the Louvre, where he discovered parallels to Cézanne's peasants. He thought the lions of Mycenae were the incontestable masterpieces of all art. One day he dropped by at the Quai St.-Michel to see my pictures. He noticed a still-life hanging on the wall and said: 'I buy it [*sic*], but I'll have to keep it at home for several days, and if I can bear it, and keep interested in it, I'll keep it.' I was lucky enough that he was able to bear this first ordeal easily, and that my still-life didn't fatigue him too much. So he came back and commissioned a series of large paintings to decorate the living room of his Moscow house—the old palace of the Troubetzkoy princes, built during the reign of Catherine II. After this he asked me to do two decorations for the palace staircase, and it was then I painted *Music* and *The Dance* [Figures 22 and 21].

Morosoff, a Russian colossus, twenty years younger than Stchoukine, owned a factory employing three thousand workers and was married to a dancer. He had commissioned decorations for his music room from Maurice Denis, who painted *The Loves of Psyche*. In the same room were six big Maillol sculptures. From me he bought, among other pictures, *Window at Tangiers, The Moroccans on the Terrace* and *The Gate of the Casbah*.¹⁰ The paintings of both these collectors now belong to the Museum of Western Art in Moscow.

When Morosoff went to Ambroise Vollard, he'd say: 'I want to see a very beautiful Cézanne.' Stchoukine, on the other hand, would ask to see all the Cézannes available and make his choice among them.

Cubism

Braque had come back from the Midi with a landscape of a village by the seashore, seen from above. Thus there was a large background of sea and sky into which he had continued the village roofs, giving them the colors of the sky and water. I saw the picture in the studio of Picasso who discussed it with his friends. Back in Paris, Braque did a portrait of a woman on a chaise-longue in which the drawing and values were decomposed. Cubism is the descendant of Cézanne who used to say that everything is either cylindrical or cubical.[11] In those days we didn't feel imprisoned in uniforms, and a bit of boldness, found in a friend's picture, belonged to everybody.

Cubism had a function in fighting against the deliquescence of Impressionism.

The Cubists' investigation of the plane depended upon reality. In a lyric painter, it depends upon the imagination. It is the imagination that gives depth and space to a picture. The Cubists forced on the spectator's imagination a rigorously defined space between each object. From another viewpoint, Cubism is a kind of descriptive realism.

Negro art

I often visited Gertrude Stein in the Rue de Fleurus. On the way was a little antique shop. One day I noticed in its window a small Negro head carved in wood which reminded me of the huge red porphry[*sic*] heads in the Egyptian galleries of the Louvre. I felt that the methods of writing form were the same in the two civilizations, no matter how foreign they may be to each other in every other way. So I bought the head for a few francs and took it along to Gertrude Stein's. There I found Picasso, who was astonished by it. We discussed it at length, and that was the beginning of the interest we all have taken in Negro art—and we have shown it, to greater or lesser degrees, in our pictures.

It was a time of new acquisitions. Not knowing ourselves too well yet, we felt no need to protect ourselves from foreign influences, for they could only enrich us, and make us more demanding of our own means of expression.

Fauvism, the exaltation of color; precision of drawing from Cubism; trips to the Louvre and exotic influences from the ethnographical museum at the old Trocadéro,[12] all shaped the landscape in which we were living, through which we were travelling, and out of which we all came. It was a time of artistic cosmogony.

The War, 1914–18

Despite pressure from certain conventional quarters, the war did not influence the subject matter of painting, for we were no longer merely painting subjects. For those who could still work there was only a restriction of means, while for those who couldn't work there was only a gathering of desires which they were able to gratify when peace returned. From this period date two of my large works, the *Young Girls by the River* and *The Piano Lesson* [Figure 27].[13]

Nice

I left L'Estaque because of the wind, and I had caught bronchitis there. I came to Nice to cure it, and it rained for a month. Finally I decided to leave. The next day the mistral chased the clouds away and it was beautiful. I decided not to leave Nice, and have stayed there practically the rest of my life.

At first, in 1918, I lived at the Hôtel Beau-Rivage. Back the following winter, I went to the Hôtel de la Méditerranée where I spent every winter, from October to May, for five years. Then I took an apartment at 1 Place Charles Félix, on the top floor overlooking the market-place and the sea.

I worked at Nice as I would have worked anywhere.

Windows have always interested me because they are a passageway between the exterior and the interior. As for odalisques, I had seen them in Morocco, and so was able to put them in my pictures back in France without playing make-believe.

Some thoughts on painting

A work of art has a different significance for each period in which it is examined. Should we stay in our own period and consider the work of art with the brand-new sensibility of today, or should we study the epoch in which it was made, put it back in its time and see it with the same means and in a context of parallel creations (literature, music) of its period in order to understand what it meant at its birth and what it brought to its contemporaries? Obviously some of the pleasure of its present existence and of its modern action will be lost when it is examined from the point of view of its birth. In each period, a work of art brings to man the pleasure that comes from communion between the work and the man looking at it. If the spectator renounces his own quality in order to identify himself with the spiritual quality of those who lived when the work of art was created, he impoverishes himself and disturbs the fullness of his pleasure—a bit like the man who searches, with retrospective jealousy, the past of the woman he loves.

This is why artists have always felt the need of dressing their themes—picked from any and all periods—in the attributes and appearances of their own time. The Renaissance painters did this; Rembrandt's biblical scenes are full of anachronisms, but he preserved the gravity and the humanity of the Bible, while James Tissot,[14] who actually went to live in the holy places and found his inspiration from old documents, could only make anecdotal pictures, without sweep or evocative power.

[Tériade here refers to Matisse's 1936 statement on Fauvism.]

Travels

I am too anti-picturesque for traveling to have given me much. I went quickly through Italy. I went to Spain. I even spent a winter in Seville. I went to Moscow at Stchoukine's invitation around 1910; it seemed to me like a huge Asian village. I went to Tahiti in 1930.

In Tahiti I could appreciate the light, light as pure matter, and the coral earth. It was both superb and boring. There are no worries in that land, and from our tenderest years we have our worries; they probably help keep us alive. There the weather is beautiful at sunrise and it does not change until night. Such immutable happiness is tiring.

Coming back from Tahiti, I went through America. The first time I saw New York, at seven in the evening, its mass of black and gold was reflected in the water, and I was completely ravished. Near me someone on the boat was saying 'it's a spangled dress,' and this helped me to arrive at my own image: to me New York seemed like a gold nugget.

40

Testimonial, 1951[1]

In 1952 Maria Luz published a series of remarks by Matisse, recalled from a 1951 interview, the text approved by Matisse.

In this statement Matisse makes one of his clearest expositions about the nature of his space, his objects, and his conception of drawing in relation to colour, and he is more specific about these features than in most of his earlier writings. Just as his art at this time was more severe distilled, and abstract, so it seems that this essay presents ideas which have been presented before, but in a clearer, more distilled and more abstract way.

TESTIMONIAL

I can say nothing of my feeling about space which is not already expressed in my paintings. Nothing could be clearer than what you can see on this wall: this young woman whom I painted thirty years ago . . . this 'bouquet of flowers' . . . this 'sleeping woman' [Figure 40][2] which date from these last few years, and behind you, this definitive plan of a stained-glass window made of coloured paper cut-outs.[3]

From *Bonheur de Vivre*—I was thirty-five then—to this cut-out—I am eighty-two—I have not changed; not in the way my friends mean who want to compliment me, no matter what, on my good health, but because all this time I have looked for the same things, which I have perhaps realized by different means.

I had no other ambition when I made the Chapel. In a very restricted space, the breadth is five metres, I wanted to inscribe, as I had done so far in paintings of fifty centimetres or one metre, a spiritual space; that is, a space whose dimensions are not limited even by the existence of the objects represented.

You must not say that I recreated space starting from the object when I 'discovered' the latter: I never left the object. The object is not interesting in itself. It's the environment which creates the object. Thus I have worked all my life before the same objects which continued to give me the force of reality by engaging my spirit towards everything that these objects had gone through for me and with me. A glass of water with a flower is different from a glass of water and a lemon. The object is an actor: a good actor can have a part in ten different plays; an object can play a different role in ten different pictures. The object is not taken alone, it evokes an ensemble of elements. You reminded me of the table I painted isolated in a garden?[4] . . . Well, it was representative of a whole open-air atmosphere in which I had lived.

The object must act powerfully on the imagination; the artist's feeling expressing itself through the object must make the object worthy of interest: it says only what it is made to say.

On a painted surface I render space to the sense of sight: I make of it a colour limited by a drawing. When I use paint, I have a feeling of quantity—surface of colour which is

26 *Madame Matisse* 1913.

27 *La leçon de piano* 1916.

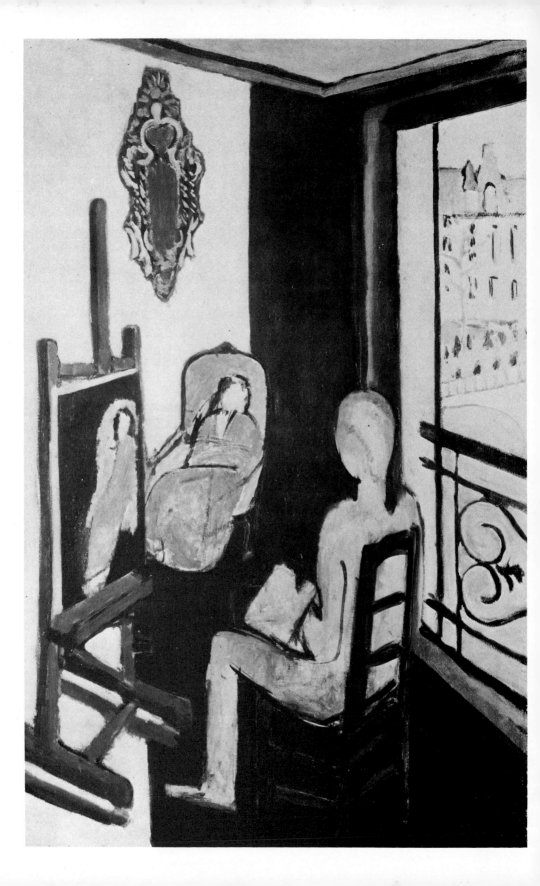

28 *L'artiste et son modèle* 1916.

29 *L'atelier du quai Saint-Michel* 1916.

30 *L'artiste et son modèle* 1919.

31 *Intérieur au violon* 1917–18.

32 *Intérieur à Nice* 1921.

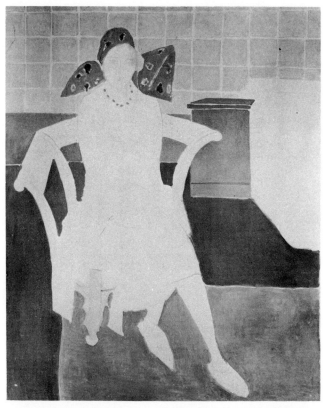

33 *Femme au turban* 1929–30.

34 *Jeune fille en jaune* 1929–31.

35 *Jeunes filles au paravent mauresque* 1921.

36 *La danse, II* 1932–33.

37 *Le dos, IV* 1929–30. ▶

38 *Nu rose* final stage 1935.

Stage 1, 3 May 1935.

Stage 11, 20 June 1935.
Stage 18, 15 September 1935.

39 *Grande robe bleue, fond noir* 1937.

40 *Le rêve* 1940.

41 *Nature morte rouge au magnolia* 1941.

42 *Océanie—la mer* 1947.

43 *Icarus (Jazz)* 1947.

46 *Nu bleu: la chevelure* 1952.

47 *Nu bleu, III* 1952.

44 *Grand intérieur rouge* 1948.

◀ 45 Chapel of the
Dominicans at Vence,
interior 1951.

48 *L'escargot* 1953.

49 Matisse at work on the Crucifix for the Chapel at Vence 1951.

necessary to me, and I modify its contour in order to determine my feeling clearly in a definitive way. (Let's call the first action 'to paint' and the second 'to draw'.) In my case, to paint and to draw are one. I choose my quantity of coloured surface and I make it conform to my feeling of the drawing, like the sculptor moulds clay by modifying the ball which he first made and afterwards elicits his feeling from it.

Look at this stained-glass window again: here is a dugong—an easily recognizable fish, it is in the Larousse[5]—and, above, a sea animal in the form of algae. Around are begonias.

This Chinese soldier on the mantelpiece is expressed by a colour whose shape determines its degree of effectiveness.

This fellow (*the artist turns it between his fingers*)—who is turquoise and aubergine as no soldier has ever been, would be destroyed if he were dressed in colours taken from material reality. To invented colours whose 'drawing' determines the contours, is added the artist's feeling to perfect the object's meaning. Everything here is necessary. This brown spot, which represents the ground on which one imagines the figure, gives the turquoise and aubergine an atmospheric existence which their intensity could make them lose.[6]

The painter chooses his colour in the intensity and depth which suit him, as the musician chooses the timbre and intensity of his instruments. Colour does not command drawing, it harmonizes with it.

'Vermilion doesn't do everything . . .' said Othon F[riesz][7] with bitterness. Neither must colour simply 'clothe' the form: it must constitute it.

You ask me if my cut-outs are an end of my researches? . . . My researches don't seem to me to be limited yet. The cut-out is what I have now found the simplest and most direct way to express myself. One must study an object a long time to know what its sign is. Yet in a composition the object becomes a new sign which helps to maintain the force of the whole. In a word, each work of art is a collection of signs invented during the picture's execution to suit the needs of their position. Taken out of the composition for which they were created, these signs have no further use.

This is why I have never tried to play chess although it was suggested to me by friends who thought they knew me well. I told them: 'I can't play with signs that never change. This Bishop, this King, this Queen, this Castle, mean nothing to me. But if you were to put little figures which look like so-and-so or such a one, people whose life we know, then I could play; but still inventing a meaning for each Pawn in the course of each game.'

Thus the sign for which I forge an image has no value if it doesn't harmonize with other signs which I must determine in the course of my invention and which are completely peculiar to it. The sign is determined at the moment I use it and for the object of which it must form a part. For this reason I cannot determine in advance signs which never change, and which would be like writing: that would paralyse the freedom of my invention.

There is no separation between my old pictures and my cut-outs, except that with greater completeness and abstraction, I have attained a form filtered to its essentials and of the object which I used to present in the complexity of its space, I have preserved the sign which suffices and which is necessary to make the object exist in its own form and in the totality for which I conceived it.[8]

I have always sought to be understood and, while I was taken to task by critics or colleagues, I thought they were right, assuming I had not been clear enough to be understood. This assumption allowed me to work my whole life without hatred and even without bitterness toward criticism, regardless of its source. I counted solely on the clarity of expression of my work to gain my ends. Hatred, rancour and the spirit of vengeance are useless baggage to the artist. His road is difficult enough for him to cleanse his soul of everything which could make it more so.

Interview with Charbonnier, 1951[1]

Georges Charbonnier's interview with Matisse, which covers a broad range of subjects in some depth, gives some interesting insights into Matisse's conscious and subconscious processes of synthesis. His discussions of the dance theme and of the Chapel at Vence are especially detailed, and in speaking of the spiritual value of his own painting he shows how far he was from thinking of his own art as mere decoration.

INTERVIEW WITH CHARBONNIER

GEORGES CHARBONNIER. Henri Matisse, you have made a number of mural compositions and, in them, you have used the theme of the dance several times. How did you compose these mural paintings?

HENRI MATISSE. I like dance very much. Dance is an extraordinary thing: life and rhythm. It is easy for me to live with dance. When I had to compose a dance for Moscow,[2] I had just gone to the Moulin de la Galette on Sunday afternoon. And I watched the dancing. I especially watched the farandole. Often, in the middle or at the end of a session there was a farandole. This farandole was very gay. The dancers hold each other by the hand, they run across the room, and they wind around the people who are standing around . . . it is all extremely gay. And all that to a bouncing tune. An atmosphere I knew very well. When I had a composition to do, I returned to the Moulin de la Galette to see the farandole again. Back at home I composed my dance on a canvas of four metres, singing the same tune I had heard at the Moulin de la Galette, so that the entire composition and all the dancers are in harmony and dance to the same rhythm.[3]

G.C. Did the idea of using the theme of the dance exist before the mural painting, or is it rather the surface and form of the wall which suggested the theme to you?

H.M. No, it's not the wall, but because I particularly like dance; it's because I saw more in dance: expressive movements, rhythmic movements, music that I like. This dance was in me, I did not need to warm myself up: I proceeded with elements that were already alive.

G.C. Did you think from the beginning that movement would be used effectively in mural painting? It is said that the static characterizes easel painting whereas movement . . .

H.M. There are two ways of looking at things. You can conceive a dance in a static way. Is this dance only in the mind or in your body? Do you understand it by dancing with your limbs? The static is not an obstacle to the feeling of movement. It is a movement set at a level which does not carry along the bodies of the spectators, but simply their minds.[4]

G.C. In the United States, you did another mural composition for the American, Barnes, using the theme of the dance.

H.M. I did a ceiling there with the same composition, but I adapted it to the circum-

stances. For example, there were what architects call 'lunettes' in a vaulted ceiling. And then I made my figures larger than life-size, larger than the surfaces could contain. Thus there is half a body coming down from above. Another is half-length. Over an area which was not very wide, only thirteen metres, I permitted the observer to see a much larger dance, because I used fragments.[5]

G.C. Didn't any special difficulty arise from the fact that this wall painting is placed against the light?

H.M. This wall painting is indeed against the light, but in the end I profited from the situation. The mural is above three big doors, each five metres high, which give onto a garden. They are glass. The spaces between the doors are about two metres wide. I made use of the contrast created by these spaces; I used them to create correspondences with the forms in the ceiling. I put blacks in the ceiling much darker than the grey of the spaces between the doors. Thus I displaced the contrast. Instead of making it between the bright doors and the spaces in between, I put it up in the ceiling so that my very strong contrast united the whole panel, doors and spaces.

G.C. I think you were led to use colours which were not violent because the very lively greens of the garden upset the composition of the painting?

H.M. The main point to observe was that this decoration was placed in an enormous room in which there were the finest Renoirs, the finest Cézannes, and remarkable Seurats. I could not, did not claim to, nor ought to I have fought with these paintings. Being up above I had to use a range of sort of aerial colours, and I also had to avoid some colours, like green, it's true; but at the same time, I made big black contrasts corresponding to the spaces between the doors, and pink compartments, blue compartments, compartments of various colours so as to create a music of colours which was not very singular really, although my feeling was in harmony with the dance.[6]

G.C. The dance theme—I am returning again to this point—wasn't it suggested to you by the form of the ceiling, more exactly by the necessity of using the whole surface of the ceiling, which led to representing some figures standing and others crouching?

H.M. Above all I had to give the impression of vastness in a limited space. That's why I used figures which are not always whole, so half of them is outside . . . If for example, I filled a space three metres high, I have the figures a total height which, if fully represented, would have been six metres. I use a fragment and I lead the spectator by the rhythm, I lead him to follow the movement from the fragment he sees so that he has a feeling of the totality.

The good thing is certainly—as in painting generally—to give the idea of immensity within a very limited surface.

That's what I did in the Chapel at Vence. It's a convent chapel, and in spite of everything, it seems to me that I created the idea of vastness which touches the soul and even the senses. The role of painting, I think, the role of all decorative painting, is to enlarge surfaces, to work so that one no longer feels the dimensions of the wall.

G.C. Why did you decorate the Chapel at Vence?

H.M. Because, for a very long time, I wanted to synthesize my contribution. Then this opportunity came along. I was able, at the same time, to do architecture, stained-glass, large mural drawings on tile and to unite all these elements, to fuse them into one perfect unity. I even designed for the Chapel a spire more than 12 metres high. And this spire—in wrought iron—which is more than 12 metres, doesn't crush the Chapel but, on the contrary, gives it height. Because I made the spire—like a pencil drawing on a sheet of paper—in the air . . . When you see a cottage with smoke coming from the chimney at the end of the day, and watch the smoke that rises and rises, you get the impression that it never stops at all. That is something of the feeling I created with my spire.[7]

The same for the interior, for the altar: an officiant stands in front of the public.

It was thus necessary to decorate the altar in a light manner so that the officiant could see his flock and the faithful could see the officiant. There is thus, in the elements, a lightness which meets this need. This lightness arouses feelings of release, of obstacles cleared, so that my chapel is not 'Brothers, we must die.' It is rather 'Brothers, we must live!'[8]

G.C. Do you think—I know that I am putting this clumsily—that there is such a thing as religious art?

H.M. All art worthy of the name is religious. Be it a creation of lines, or colours: if it is not religious, it doesn't exist. If it is not religious, it is only a matter of documentary art, anecdotal art . . . which is no longer art. Which has nothing to do with art. Which comes at a certain period in civilization to explain and demonstrate to people without any artistic upbringing the things that they could have noticed anyway without there being any need to tell them. The public is spiritually lazy. One must put a story-picture in front of their eyes which remains in their minds and even leads them a little farther . . . But that's art which we no longer need. That art is out-dated.

G.C. When you do a chapel, when you decorate it, you know that people are going to come in who will see the paintings, the decorations, who will find themselves in a certain environment and who will adopt a certain attitude. What do you seek to communicate to them? Do you feel a duty towards them? This duty, do you think you have it equally when you show only an easel painting stripped of religious ends, a mural painting which has only a decorative end?

H.M. I want the chapel visitors to experience a lightening of the spirit. So that, even without being believers, they sense a milieu of spiritual elevation, where thought is clarified, where feeling itself is lightened. The benefit of the visit will come into being easily without any need for it to be hammered home.

G.C. This benefit, don't you dream of providing it equally for someone looking at a canvas?

H.M. That is obvious. A picture which wouldn't give rise to that feeling wouldn't exist. A picture by Rembrandt, Fra Angelico, a picture by a good artist always inspires this feeling of escape and spiritual elevation. The fact that the picture is an easel painting won't let it escape this necessity. An easel painting, what is an 'easel painting'? It's a painting you hold in your hand, if you like. But this painting must nevertheless take the spectator's spirit much farther than a set-piece. I don't conceive of a painting without this quality. Otherwise, it's a reproduction. Today, thanks to photography, one can make such lovely reproductions, even in colour, that the duty of the artist, the painter, is to provide more; what photography cannot give.

G.C. The painting of Rembrandt whom you have just mentioned, for example doesn't always communicate serenity. El Greco often communicates anxiety. Whereas, you have said, you have written—the passage has been quoted a hundred times—'I don't wish to disturb'.

H.M. Yes indeed. I believe my role is to provide calm. Because I myself have need of peace.

Rembrandt's painting is obviously painting in depth. It is the painting of the North, of Holland, Flanders, which doesn't have the same atmosphere as ours in France or on the Mediterranean . . . the Mediterranean is quite close to Paris, after all.

El Greco is a tormented soul who exteriorizes his torment and puts it on canvas. This torment is certainly communicated to the spectator. But one could conceive that had El Greco dominated his torment and anxiety, he would have expressed it as Beethoven did in his last symphony.[9]

G.C. Let's change the subject. You are a painter, but you are also a sculptor and, personally, there's a question I am always asking myself. Are the means of expression equivalent? Do certain things express themselves by choice in music, others in painting?

Can you say certain things in painting and others in sculpture? And conversely, in painting and sculpture, can you say the same thing? Suppose one morning, a man begins to paint and not to sculpt—or vice-versa—it is probable that this choice cannot be put down to chance.

H.M. I myself have done sculpture as the complement of my studies. I did sculpture when I was tired of painting. For a change of medium. But I sculpted as a painter. I did not sculpt like a sculptor. Sculpture does not say what painting says. Painting does not say what music says. They are parallel ways, but you can't confuse them.[10]

G.C. But is their course the same?

H.M. The horizon line is vast. It is made of innumerable points. As you go on walking, you go towards the horizon, but you go towards quite different points. In any case, art is the expression of man's soul. He uses what means he can: music, sculpture, painting . . . It's a personal affair, an affair of natural dispositions and talents.

G.C. Let us restrict ourselves to the field of forms and colours. Can you oppose painting and drawing? Alain has said that painting expresses the moment and drawing the instant . . . does that seem valid to you?[11]

H.M. Personally, I think painting and drawing say the same thing. A drawing is a painting made with reduced means. On a white surface, a sheet of paper, with pen and ink, you can, by creating certain contrasts, create volumes; by changing the quality of the paper you can give supple surfaces, bright surfaces, hard surfaces, without, however, using either shading or highlights . . . For me, drawing is a painting made with reduced means, which can be totally absorbing, which can very well release the feelings of the artist just as much as the painter. But painting is obviously a thing which has more to it, which acts more strongly on the spirit.

G.C. Like all artists of real importance, you have thus done painting, drawing, sculpture, but you have also made illustrations. What sort of problem does illustration present? What is involved in illustrating a text?

H.M. Illustrating a text is not completing a text. If a writer needs an artist to explain what he has said it's because the writer is inadequate. I have found writers to whom there was nothing to add: they had said everything.

The illustration of a book can also be an embellishment, an enrichment of the book by arabesques, in conformity with the writer's point of view. You can also produce illustrations by decorative means: fine paper, and so on. Illustration has its usefulness, but it doesn't add much to the essential literature. Writers have no need of painters to explain what they want to say. They should have enough resources of their own to express themselves.

G.C. One last question, positively the last: how is it that in the work of a fairly large number of contemporary painters, the human face is becoming anonymous?

H.M. Are you saying that for my benefit? Because I don't put in eyes sometimes, or a mouth for my figures. But that's because the face is anonymous. Because the expression is carried by the whole picture. Arms, legs, all the lines act like parts of an orchestra, a register, movements, different pitches. If you put in eyes, nose, mouth, it doesn't serve for much; on the contrary, doing so paralyses the imagination of the spectator and obliges him to see a specific person, a certain resemblance, and so on, whereas if you paint lines, values, forces, the spectator's soul becomes involved in the maze of these multiple elements . . . and so, his imagination is freed from all limits.

42

Interview with Verdet, 1952[1]

In April and May 1952, André Verdet interviewed Matisse at Cimiez. This extended interview, ranging over many subjects, is one of the most important interviews with Matisse. Verdet's questions are well chosen, and Matisse's answers clarify and extend many of his previous ideas with great eloquence, such as the personal motivation behind his desire for balance and equilibrium, his choice of subject matter, and the process of creation.

Matisse also has a good deal to say about drawing, especially the arabesque, which he declares to be the most synthetic means of linear expression, and speaking of colour, he emphasizes its relative nature, noting that the relationship between painting and drawing is that of the modification of colour areas through drawing. As in the statement to Maria Luz, he notes that the sensation of space is separate from the size of the actual area, be it a small canvas or the Chapel at Vence, that his works are projections of his sensations enlarged in a spiritual space. Matisse also elaborates upon the projection of imagery which he believes to be a synthesis of the self in relation to nature and states that his drawings and paintings are parts of himself: 'Together they constitute Henri Matisse'.

Matisse's feelings about the relationship between the abstractness of art and the importance of inspiration from nature are quite fully stated here. Current developments in America and Europe perplexed and disturbed him. This interview provides valuable insight into Matisse's understanding of abstraction; he himself at the time of this interview had created several works which might be called non-objective, such as *L'escargot* (Figure **48**). But his description of how he arrived at the final metaphor in such works shows the great importance to him of the experience of the actual object in the formulation of the image; the final image is an equivalence of the object, however abstract or metaphorical. Whereas in the earlier paintings he abstracted directly from what he *saw*, in the cut-outs he abstracted more from what he *knew*: the same process of recollection that he described in relation to his Oceania tapestry.

Matisse's antipathy to non-figurative art is not so much an objection to its theoretical basis (equivalence through non-figurative form) but a dislike of what he obviously felt to be a loss of contact with nature. This of course is very closely related to his concern about young painters, as expressed in the letter to Henry Clifford and in the preface to the 1951 Tokyo Exhibition catalogue.

INTERVIEW WITH VERDET

Why are you in love with the arabesque?
Because it's the most synthetic way to express oneself in all one's aspects. You find it in the general outline of certain cave drawings. It is the impassioned impulse which swells these drawings.[2]

How do you find the arabesque?
Look at these blue women,[3] this parakeet, these fruits and leaves. These are paper cut-outs and this is the arabesque. The arabesque is musically organized. It has its own timbre.

Can the arabesque have an important function as a mural decoration?
It has a real function. There again it translates the totality of things with a sign. It makes all the phrases into a single phrase. And there again, it is the proportion of things which is the chief expression.

Does easel painting still have a future?
I think that one day easel painting will no longer exist because of changing customs. There will be mural painting.
 Colours win you over more and more. A certain blue enters your soul. A certain red has an effect on your blood-pressure. A certain colour tones you up. It's the concentration of timbres. A new era is opening.

Shouldn't a painting, based on the arabesque, be placed on the wall, without a frame?
The arabesque is effective only when contained by the four sides of the picture. With this support, it has strength. When the four sides are part of the music, the work can be placed on the wall without a frame.

Are there many elements of oriental art in the art of the 10th, 11th, and 12th centuries, that is, Romanesque art?
Yes, there were many. These elements came through Constantinople and Venice as did all imports from the East at the time. These elements were a good contribution. Such contributions, in general, are always good. The bad is very quickly rejected. The contributions transform, rejuvenate and enrich. They open up new avenues and also form links.

Do you agree with Cézanne that there is a green blue and a yellow blue?
I would simply say that colour exists only through relationships, and that the painting calls forth the emotional relationship of colour to drawing.[4]

Is the choice of the painted object determined in the first place by a sociological necessity or by a subconscious necessity of the artist?
First of all by a subconscious necessity. But then the sociological necessity intervenes and becomes operative.

A critic has claimed that the work of art is always made in advance. Do you think so?
A work of art is never made in advance, contrary to the ideas of Puvis de Chavannes, who claimed that one could not ever visualize the picture one wanted to paint too completely before starting. There is no separation between the thought and the creative act. They are completely one and the same.

Does the necessity to create the work of art begin to germinate when the individual realizes that something is missing?
It begins when the individual realizes his boredom or his solitude and has need of action to recover his equilibrium.

Does the work reflect the artist?
The work is the emanation, the projection of self. My drawings and my canvases are pieces of myself. Their totality constitutes Henri Matisse. The work represents, expresses, perpetuates. I could also say that my drawings and my canvases are my real children.

When the artist dies he is cut in two. There are lives of artists which are short. Raphael, Van Gogh, Gauguin, Seurat, for example. But these people expressed themselves completely. They died *represented*. And they haven't finished living.[5]

An artist must therefore force himself to express himself totally from the beginning. Thus, he will not grow old: if he is sincere, human and constructive, he will always find an echo in following generations.

Do you have faith, for the future, in the collective work of art?
Yes, I believe in the collective work of art for certain given subjects, certain functions, and on the condition of a discipline. Let someone take the initiative. Others will follow, bringing their personal contribution, if they respect their guiding spirit. They will remain freely obedient to a direction while maintaining their own emotive powers.

Do the paper cut-outs represent your need for surprise?
No. It's rather the paper material which remains to be disciplined, to be given life, to be augmented. For me, it's a need for knowledge. Scissors can acquire more feeling for line than pencil or charcoal.

Observe this big composition: foliage, fruit, scissors; a garden. The white intermediary is determined by the arabesque of the cut-out coloured paper which gives this *white-atmosphere* a rare and impalpable quality. This quality is that of contrast. Each particular group of colours has a particular atmosphere. It is what I will call the *expressive atmosphere*.[6]

With the completion of the Chapel of Vence, it was said you were reconciled with Catholicism?
Much has been said and written. A lot of stories were circulated, in Europe and in America. The work of art was nothing more than a pretext for gossip.[7]

First of all, sacred art demands a good moral hygiene. My only religion is the love of the work to be created, the love of creation, and great sincerity. I did the Chapel with the sole intention of expressing myself *profoundly*. It gave me the opportunity to express myself in a totality of form and colour. The work was a learning process for me. I set a game of equivalences in play there. I created an equilibrium between rough and precious materials. These things were reconciled and harmonized by the law of contrasts. Multiplication of planes became unity of plane.

And it is intentional that I repeat yet again that it's not by copying the object that I will be able to make it come alive in the soul of the spectator, as I feel it, but rather by the single virtue of synthetic equivalence.

Let's return to Vence: red cannot be introduced into the Chapel ... However, this red exists and it exists by virtue of the contrast of the colours which are there. It exists by reaction in the mind of the observer.

I know you attach the greatest value to sincerity in a work of art ...
Art is not a trick of invention. Art must always be measured to the actual emotion of the man. Without sincerity there is no authentic work. When I am questioned and I answer, I always see myself doing the thing or having done it. I can't contradict myself. I am sincere and this sincerity is my equilibrium.

I also think of Courbet: 'A real masterpiece is something one must be able to begin again to prove one is not guided by whim or by chance.' That is part of sincerity. Like Rude said: 'That which goes beyond my compass is my personality.'

Abroad, notably in Scandinavia, people are very much amazed by the mediocrity of the
teaching at the École des Beaux-Arts, and that such a backward institution can still exist in
the 20th century . . .
Reactions are needed. Summer needs the winter. At the École des Beaux-Arts one learns
what not to do. It's an example of what to avoid. That's the way it is. The Ecole des
Beaux-Arts is an excuse for the Prix-de-Rome. It will die all alone.

Attendance at the École should be replaced by a long free stay at the zoological gardens.
There, by continual observation, students would learn the secrets of embryonic life, of
quiverings. Little by little, they would acquire this *fluid* that real artists eventually possess.[8]

You see: break with habit and the conformist routine. One day Toulouse-Lautrec
cried, 'At last I don't know how to draw.' That meant he had found his true line, his
true drawing, his own draughtsman's language. That also meant that he had left the
means used *to learn to draw.*

One must know how to maintain childhood's freshness upon contact with objects, to
preserve its naivety. One must be a child all one's life even while a man, take one's
strength from the existence of objects—and not have imagination cut off by the existence
of objects.[9]

Did your stay in Tahiti have a great influence on your work?
The stay in Tahiti was very profitable. I very much wanted to experience light on the
other side of the Equator, to have contact with its trees and to penetrate what is there.
Each light offers its own harmony. It's a different atmosphere. The light of the Pacific, of
the Islands, is a deep golden goblet into which you look.

I remember that first of all, on my arrival, it was disappointing. And then, little by
little, it was beautiful, beautiful, . . . it is beautiful! The leaves of the high coconut
palms, blown back by the trade winds, made a silky sound. This sound of the leaves
could be heard along with the orchestral roar of the sea waves, waves which broke over
the reefs surrounding the island.

I used to bathe in the lagoon. I swam around the brilliant corals emphasized by the
sharp black accents of holothurians.[10] I would plunge my head into the water, transparent
above the absinth bottom of the lagoon, my eyes wide open . . . and then suddenly I
would lift my head above the water and gaze at the luminous whole. The contrasts . . .

Tahiti . . . the Islands . . . But the tranquil desert island doesn't exist. Our European
worries accompany us there. Indeed there were no cares on this island. The Europeans
were bored. They were comfortably waiting to retire in a stuffy torpor and doing nothing
to get out of the torpor, nothing to interest themselves or to defeat their boredom; they
did not even think any more. Above them and all around them, there was this wonderful
light of the first day, all this splendour; but they didn't see how good it was any more.

They had closed the factories and the natives wallowed in animal pleasures. A beautiful
country, asleep in the bright heat of the sun.

No, the tranquil desert island, the solitary paradise doesn't exist. One would be quickly
bored there because one would have no problems. The memory even of Mozart would
seem strange to you.

I have often observed that even your canvases go beyond the limits of what is called easel
painting and that they contain the space of mural painting.
The size of a canvas is of little importance. What I always want is to give the feeling of
space, as much in the smallest canvas as in the Chapel at Vence. Everything we see passes
before the retina, is inscribed in a small chamber, then is amplified by imagination. One
must find the tone of the correct quantity and quality to make an impression on the eye,
the sense of smell, and the mind. To make someone fully enjoy a jasmine plant for example.

To find the quantity and quality of colours. Look at this composition: a garden. Well now, this garden is the recollection of my sensations experienced in nature which I project forward, which I expand in space.

I just interrupted you when you were going to talk about linear decisions . . .
Yes, the decision of line comes from the artist's profound conviction. That paper cut-out, the kind of volute acanthus that you can see on the wall up there, is a stylized snail. First of all I drew the snail from nature, holding it between two fingers; drew and redrew. I became aware of an unfolding, I formed in my mind a purified sign for a shell. Then I took the scissors. It was important that 'the end should always be contained in the beginning'. Further, I had to establish the connection between the object observed and its observer.

I had placed that snail in the big composition of the *Jardin*. But the musical movement of the whole combination was broken. So I removed the snail; I have put it on one side to wait for a different purpose.

I repeat once more: one must be sincere; the work of art only exists fully when it is charged with human emotion and is rendered with complete sincerity, and not by means of applying some pre-arranged programme. This is the way we can look at the pagan works of artists before the early Christian primitives without being disturbed. On the other hand we can find ourselves before certain works of the Renaissance made in rich, sumptuous, alluring materials, which make us disturbed to see that a feeling which has the characteristics of Christianity has so much that is ostentation and fabrication about it. Yes, that comes from the bottom of my soul: fabricated for the rich. The artist sinks to the level of his patron. In pagan art, the artist is frank with himself, carnal, natural; his emotion is sincere. There is no ambiguity. In the equivocal situation of the Renaissance, too often the patron's satisfaction guides the artist. The artist's spirit is thus limited.[11]

I believe you knew Vollard well?
He had come from Reunion.[12] I don't know how he managed to approach Renoir. He nosed about everywhere. From time to time, in the evening, he used to visit him. Often, in order to work, Renoir was obliged to throw him out. One day he told him: 'You should do something for Cézanne; believe me, he's a great artist.'

Cézanne's exhibition took place. Almost everyone was against it. No one could believe it. They thought it dreadful. The bourgeois who know they understand nothing of art— they not only passed up Cézanne but also Renoir, Bonnard and many others; the bourgeois claimed that Cézanne's painting did not conform to the Greek canon of beauty. Only one critic, Geoffroy [*sic*] wrote a good favourable article.[13]

But this Vollard was a cunning fellow, a gambler, and he had a flair . . . for business. He succeeded in setting up a gallery on rue Laffitte. Forain said of him then that he was the 'tripe-seller' of the rue Laffitte.

Vollard had acquired a considerable number of Cézannes. They were everywhere; the walls were covered with them; there were even piles of them on the floor, one right next to another, leaning up against the wall. He had managed to buy them at a low price. Cézanne, moreover, had judged him: 'Vollard is a "slave-trader".'

To show you what kind of fellow he was, here is a little story: Valtat was in the Midi and his works were beginning to be noticed by a few collectors.[14] Vollard, who was advised by Renoir, stopped at Antheor at Valtat's house and after having counted some canvases in a pile against the wall, said to Valtat without turning them around: 'That makes so much . . .' Of course Valtat accepted.

The exhibitions of young artists at the gallery on the rue Laffitte were no more than a pretext to bring in well-known buyers. On the day of a vernissage, without respect for the

artist's work, etchings by Cézanne, Renoir and others were soon brought out. Vollard had no consideration for the canvases of young artists.

To break even at the end of each month, he set out to visit all his clients at home with sumptuous books under his arms which he had published and which he sold at a discount. He ate like a pig, digested slowly, grew sullen and seemed to fall asleep. Around four o'clock, upsy daisy! the call of the evening papers woke him up and off he dashed, Take the Dreyfus affair, now! Vollard was violently anti-Dreyfus. He said all those fellows, Dreyfus and the Dreyfusards should be stuck away on an uninhabited island until they chewed each other up.

Poor Gauguin! Vollard brought him to the end of his tether . . . Gauguin used to send him canvases and Vollard sent him small consignments of colours, little tubes of colours. Yes, Vollard acted shamefully toward Gauguin.

More than ten years ago, I met Vollard for the last time at Vittel. I reminded him of one of the old anecdotes he liked to bring out about female logic. Afterwards he said: 'Monsieur Matisse is a very dangerous man because he has an excellent memory.'

Your book Jazz *caused a considerable stir. Many consider it one of the turning-points in your constant evolution. What gave you the idea for this book, which was so well done?*
By drawing with scissors on sheets of paper coloured in advance, one movement linking line with colour, contour with surface. It simply occurred to me to unite them and Tériade made a book out of it. Yes, *Jazz* did cause a considerable stir and I felt that I should continue, because until then the work was made useless by a lack of co-ordination between the different elements functioning as global sensations. Sometimes a difficulty arose: lines, volumes, colours and when I united them everything melted, one thing destroying another. I had to start over again, to look to music and dance, to find equilibrium and avoid the conventional. A new departure, new exercises, discoveries. I can tell you in confidence that it's from the book *Jazz*, from my paper cut-outs, that later my stained-glass windows were born.

It's not enough to place colours, however beautiful, one beside the other; colours must also react on one another. Otherwise, you have cacophony. Jazz is rhythm and meaning.

Nearly two years ago, the critic Charles Estienne published an anthology called Is Abstract Art Academic?[15] *Do you think that today's abstract art could lead to a dead-end?*
First of all, I will say that there is no one abstract art. All art is abstract in itself when it is the fundamental expression stripped of all anecdote. But let's not play on words . . . Non-figurative art, then . . .

All the same, one can say that today if there is no longer any need for painting to give explanations in its physical make-up, yet the artist who is expressing the object by a synthesis, while seeming to depart from it, must nonetheless be able to explain this object himself *to himself*. He must necessarily end by forgetting it but, I repeat, deep *within himself* he must have a real memory of the object and of the reactions it produces in his mind. One starts off with an object. Sensation follows. One doesn't start from a void. Nothing is gratuitous. As for the so-called abstract painters of today, it seems to me that too many of them depart from a void. They are gratuitous, they have no power, no inspiration, no feeling, they defend a *non-existent* point of view: they imitate abstraction.

One doesn't find any expression in what is supposed to be the relationship of their colours. If they can't create relationships they can use all the colours in vain.

Rapport is the affinity between things, the common language; rapport is love, yes love.

Without rapport, without this love, there is no longer any criterion of observation and thus there is no longer any work of art.

43

Looking at Life with the Eyes of a Child, 1953[1]

In this essay Matisse notes that creation begins with vision, which is itself a creative operation. Within Matisse's canon it is essential for the artist to look at everything as if he were seeing it for the first time, as though he were a child; for without this faculty it is impossible to express oneself in an original, personal way.

Matisse feels that this equivalence and transposition of objects from the chaos of actual visual reality to the order and structure of a picture is achieved by infusing the picture with the same power and beauty that is found in nature. He concludes once again with the observation that the act of creation is the equivalent of an act of metaphysical love, and that love is at the root of all creation.

LOOKING AT LIFE WITH THE EYES OF A CHILD

Creation is the artist's true function; where there is no creation there is no art. But it would be a mistake to ascribe this creative power to an inborn talent. In art, the genuine creator is not just a gifted being, but a man who has succeeded in arranging, for their appointed end, a complex of activities, of which the work of art is the outcome.

Thus, for the artist creation begins with vision. To see is itself a creative operation, requiring an effort. Everything that we see in our daily life is more or less distorted by acquired habits, and this is perhaps more evident in an age like ours when cinema posters and magazines present us every day with a flood of ready-made images which are to the eye what the prejudices are to the mind.

The effort needed to see things without distortion takes something very like courage; and this courage is essential to the artist, who has to look at everything as though he saw it for the first time: he has to look at life as he did when he was a child and, if he loses that faculty, he cannot express himself in an original, that is, a personal way.

To take an example. Nothing, I think, is more difficult for a true painter than to paint a rose because, before he can do so, he has first to forget all the roses that were ever painted. I have often asked visitors who came to see me at Vence whether they had noticed the thistles by the side of the road. Nobody had seen them; they would all have recognized the leaf of an acanthus on a Corinthian capital, but the memory of the capital prevented them from seeing the thistle in nature. The first step towards creation is to see everything as it really is, and that demands a constant effort. To create is to express what we have within ourselves. Every creative effort comes from within. We have also to nourish our feeling, and we can do so only with materials derived from the world about us. This is the process whereby the artist incorporates and gradually assimilates the external world within

himself, until the object of his drawing has become like a part of his being, until he has it within him and can project it onto the canvas as his own creation.

When I paint a portrait, I come back again and again to my sketch, and every time it is a new portrait that I am painting: not one that I am improving, but a quite different one that I am beginning over again; and every time I extract from the same person a different being.

In order to make my study more complete I have often had recourse to photographs of the same person at different ages; the final portrait may show that person younger or under a different aspect from that which he or she represents at the time of sitting, and the reason is that that is the aspect which seemed to me the truest, the one which revealed most of the sitter's real personality.

Thus a work of art is the climax of long work of preparation. The artist takes from his surroundings everything that can nourish his internal vision, either directly, when the object he is drawing is to appear in his composition, or by analogy. In this way he puts himself into a position where he can create. He enriches himself internally with all the forms he has mastered and which he will one day set to a new rhythm.

It is in the expression of this rhythm that the artist's work becomes really creative. To achieve it, he will have to sift rather than accumulate details, selecting for example, from all possible combinations, the line that expresses most and gives life to the drawing; he will have to seek the equivalent terms by which the facts of nature are transposed into art.

In my *Still Life with Magnolia* [Figure 41] I painted a green marble table red; in another place I had to use black to suggest the reflection of the sun on the sea;[2] all these transpositions were not in the least matters of chance or whim, but were the result of a series of investigations, following which these colours seemed to me to be necessary, because of their relation to the rest of the composition, in order to give the impression I wanted. Colours and lines are forces, and the secret of creation lies in the play and balance of those forces.

In the Chapel at Vence, which is the outcome of earlier researches of mine, I have tried to achieve that balance of forces; the blues, greens and yellows of the windows compose a light within the chapel, which is not strictly any of the colours used, but is the living product of their mutual blending; this light made up of colours is intended to play upon the white and black-stencilled surface of the wall facing the windows, on which the lines are purposely set wide apart. The contrast allows me to give the light its maximum vitalizing value, to make it the essential element, colouring, warming, and animating the whole structure, to which it is desired to give an impression of boundless space despite its small dimensions. Throughout the chapel every line and every detail contributes to that impression.

That is the sense, so it seems to me, in which art may be said to imitate nature, namely, by the life that the creative worker infuses into the work of art. The work will then appear as fertile and as possessed of the same power to thrill, the same resplendent beauty as we find in works of nature.

Great love is needed to achieve this effect, a love capable of inspiring and sustaining that patient striving towards truth, that glowing warmth and that analytic profundity that accompany the birth of any work of art. But is not love the origin of all creation?

44
Portraits, 1954[1]

For the folio *Portraits*, which consists of some ninety-three plates, Matisse wrote an introduction about portraiture, apparently at the request of Fernand Mourlot,[2] in which he makes general comments on portraiture and describes his own process of creating portraits.

In portraiture, as in the rest of his paintings, Matisse notes his fidelity to original sensation and avoidance of schematization. He notes that when painting a portrait a painter need not consciously inflect the work with his own style since it will bear his personal stamp anyway, once again stating his avoidance of both formula and exactitude in favour of personal expression.

He remarks that the process of producing a portrait requires a kind of rapport with the model in which the image is revealed gradually in progressive sittings until he finally arrives at an image which has a certain resonance to the model. This description of his working method for doing portraits applies, at least ideally, to the method of all of his painting. Matisse shrewdly observes that when a surgeon asked him how he did his rapid drawings he answered that they were like revelations which followed analysis, and that the surgeon replied that Matisse's method was very much like the method of medical diagnosis; thus underlining the value of informed intuition.

Matisse's discussion of portraiture and its application to his method of painting from life is curiously reminiscent of the statement in 'Notes of a Painter', that like Chardin, Cézanne, Rodin and Leonardo, Matisse felt that above all: 'I want to secure a likeness'.

PORTRAITS

The study of the portrait seems forgotten today. Yet it is an inexhaustible source of interest to anyone who has the gift or simply the curiosity.

One might think that the photographic portrait is adequate. For anthropometry, yes, but for an artist who seeks the true character of a face, it is otherwise: recording the model's features reveals feelings often unknown even to the very diviner who has brought them to light.[3] If need be, the analysis of a physiognomist would be almost indispensable to attempt an explanation of them in comprehensive terms, for they synthesize and contain many things that the painter himself does not at first suspect.

True portraits, that is to say those in which the features as well as the feelings seem to come from the model, are rather rare. When I was young, I often went to the Musée Lécuyer at Saint-Quentin. There were a hundred or so pastel drawings by Quentin-Latour, done before starting his large formal portraits. I was touched by those agreeable faces, and then realized that each one of them was quite personal. I was surprised, as I left the Museum, by the variety of individual smiles on each countenance; though natural and charming on the whole, they had made such an impression on me that my own face

was aching as if I had been smiling for hours. In the seventeenth century, Rembrandt, both with his brush and with his etching needle, made true portraits. My master Gustave Moreau said that before Rembrandt only grimaces had been painted, and Rembrandt himself declared that all of his work was nothing but portraits. I remembered this saying, as it appeared to me true and profound.

The human face has always greatly interested me. I have indeed a rather remarkable memory for faces, even for those that I have seen only once. In looking at them I do not perform any psychological interpretation, but I am struck by their individual and profound expression. I don't need to put into words the interest which they arouse in me; they probably retain my attention through their expressive individuality and through an interest that is entirely of a plastic nature.

The driving force which leads me throughout the execution of a portrait depends on the initial shock of contemplating a face.

I have studied the representation of the face a good deal through pure drawing and so as not to give the result of my efforts the characteristics of my own personal style—as a portrait by Raphael is before everything a Raphael—I endeavoured around 1900, to copy the face literally from photographs, which kept me within the limits of the visible features of a model. Since then I have sometimes taken up this way of working again. While following the impression produced on me by a face, I have tried not to stray from the anatomical structure.

I ended up discovering that the likeness of a portrait comes from the contrast which exists between the face of the model and other faces, in a word form its particular asymmetry. Each figure has its own rhythm and it is this rhythm which creates the likeness. In the West the most characteristic portraits are found in Germany: Holbein, Dürer, and Lucas Cranach. They play with asymmetry, the dissimilarities of faces, as opposed to the Southerners who usually tend to consolidate everything into a regular type, a symmetrical structure.

I believe, however, that the essential expression of a work depends almost entirely on the projection of the feeling of the artist in relation to his model rather than the organic accuracy of the model.

The revelation of the interest to be had in the study of portraits came to me when I was thinking of my mother. In a post office in Picardy, I was waiting for a telephone call. To pass the time I picked up a telegraph form lying on a table, and used the pen to draw on it a woman's head. I drew without thinking of what I was doing, my pen going by itself, and I was surprised to recognize my mother's face with all its subtleties. My mother had a face with generous features, the highly distinctive traits of French Flanders.

I was still a pupil occupied with 'traditional' drawing, anxious to believe in the rules of the School, remnants of the teaching of the masters who came before us: in a word, the dead part of tradition, in which all that was not actually observed in nature, all that derived from feeling or memory was scorned and condemned as bogus. I was struck by the revelations of my pen, and I saw that the mind which is composing should keep a sort of virginity for certain chosen elements, and reject what is offered by reasoning.

Before the revelation at the post office, I used to begin my study by a kind of schematic indication, coolly conscious, showing the sources of the interest which the model moved me to interpret. But after this experience, the preliminary tracing I have just mentioned was modified right from the very beginning. Having cleaned and emptied my mind of all preconceived ideas, I traced this preliminary outline with a hand completely given over to my unconscious sensations which sprang from the model. I was careful not to introduce into this representation any conscious observation, or any correction of physical error.

The almost unconscious transcription of the meaning of the model is the initial act of

every work of art, particularly of a portrait. Following this, reason takes charge, holds things in check and makes it possible to have new ideas using the initial drawing as a springboard.

The conclusion of all this is: the art of portraiture is one of the most remarkable. It demands especial gifts of the artist, and the possibility of an almost total identification of the painter with his model. The painter should come to his model with no preconceived ideas. Everything should come to him in the same way that in a landscape all the scents of the countryside come to him: the smell of the earth, the flowers linked with the play of clouds, the movement of trees, and the different sounds of the countryside.

I am able to speak only of my experiences; I find myself before a person who interests me and, pencil or charcoal in my hand, I set down his appearance on the paper, more or less freely. This, in the course of a banal conversation during which I speak myself or listen without any spirit of opposition, permits me to give free rein to my faculties of observation. At that moment, it wouldn't do to ask a specific question, even a banal one such as 'What time is it?' because my reverie, my meditation upon the model, would be broken, and the result of my effort would be seriously compromised.

After half-an-hour or an hour I am surprised to see a more or less precise image, which resembles the person with whom I am in contact, gradually appear on my paper.

This image is revealed to me as though each stroke of charcoal erased from the glass some of the mist which until then had prevented me from seeing it.

This generally is the meagre result of a first sitting. It seems wise to me then to let one or two days intervene between this and the second sitting.

During this interval there occurs a kind of unconscious mental fermentation process. And thanks to this fermentation, in conformity with the impressions I received from my subject during the first sitting, I mentally reorganize my drawing with more certainty than there was in the result of the first contact.

When I look at my first attempt again it appears weak, uncompromising; but beyond the haze of this uncertain image I can sense a structure of solid lines. This structure releases my imagination which works, at the next sitting, in accordance with the inspiration which comes both from the structure and directly from the model. The model is no more to me than a particular theme from which the forces of lines or values grow out which widen my limited horizon.

This second sitting is analogous to having a fresh encounter with a sympathetic person. The model ought to be relaxed, and feel more confident with his observer; the latter is concealed behind a conversation which is not concerned with particularly interesting things, but on the contrary, runs on unimportant details. It seems to set up a current between the two, independent of the increasingly commonplace words passing between them.

There generally appears, in accordance with the impressions of this sitting, a linear construction. The conclusions made during the first confrontation fade to reveal the most important features, the living substance of the work.

The sittings continue in the same spirit, probably without these two people becoming substantially more informed about each other than on the first day. Something has come into being, however, an interaction of feeling which makes each sense the warmth of the other's heart; the outcome of this can be the painted portrait, or the possibility of expressing in a series of quick drawings that which has come to me from the model.

I have gained a deep knowledge of my subject. After prolonged work in charcoal, made up of studies which more or less interrelate, flashes of insight arise, which while appearing more or less rough, are the expression of the intimate exchange between the artist and his model. Drawings containing all the subtle observations made during the work arise from a fermentation within, like bubbles in a pond.

These drawings spring forth in one piece constituted of elements without apparent

co-ordination to the analysis which has preceded them; the multiplicity of sensations expressed in each of them seems impossible to execute, so great is the speed with which they all combine. I am absolutely convinced that they represent the goal of my curiosity.

During a friendly visit, the surgeon L[eriche][4] said to me, 'I should like to know how you do your quick drawings'. I answered that they were like the revelations resulting from an analysis but made without first knowing what subject I was dealing with: a kind of meditation.[5] He said to me: 'That's exactly how I make my diagnoses. If someone asks why I say such and such, I answer: "I have no idea, but I'm sure of it, and I mean it".'

Notes

In the notes, references to certain basic works have been made throughout in the following shortened forms:

Barr = Alfred H. Barr, Jr., *Matisse: His Art and His Public* (New York, 1951).
Diehl = Gaston Diehl, *Henri Matisse* (Paris, 1954).
Escholier, 1937 = Raymond Escholier, *Henri Matisse* (Paris, 1937).
Escholier, 1956 = Raymond Escholier, *Matisse, ce vivant* (Paris, 1956).
Schneider = Pierre Schneider, *Henri Matisse exposition du centenaire* (Paris, 1970).

BIOGRAPHICAL NOTE

1 This brief account of Matisse's life is meant to help the reader put the documents and discussions that follow into context. For a detailed account of Matisse's life and work the reader is referred to the basic works above.

2 See Barr, pp. 44–5, for a translation of Roger Marx's essay.

3 Barr, p. 92.

4 See Barr, p. 116, n. 2.

5 Later Matisse was to recall, 'I went to Moscow . . . it seemed to me like a huge Asian village' (Text 39, below.) See also Alison Hilton, 'Matisse in Moscow', *Art Journal*, XXIX, 2, Winter 1969/70, pp. 166–73.

6 Clara T. MacChesney, 'A Talk with Matisse, Leader of Post-Impressionists', *New York Times Magazine*, 9 March 1913.

7 Escholier, 1956, p. 126.

8 Barr, p. 256. The letter is dated 1 September 1940.

9 Barr, p. 256.

INTRODUCTION

1 Matisse told Georges Charbonnier (Text 41, below): 'I myself have done sculpture as the complement of my studies. . . . For a change of medium. But I sculpted as a painter. . . . Sculpture does not say what painting says.' While Matisse wrote on painting, drawing, and book illustration, he wrote virtually nothing about his sculpture.

2 Matisse was conscious of this continuity: 'There is no separation between my old pictures and my cut-outs . . .' he told Maria Luz in 1951 (Text 40, below).

3 Quoted by Apollinaire (Text 1, below).

4 'Notes of a Painter' (Text 2, below).

5 Barr, p. 562.

6 'Notes of a Painter' preceded by a considerable amount of time published statements by Braque and Picasso. Although Braque's earliest interview (1908) was published in 1910 (Gelett Burgess, 'The Wild Men of Paris', *Architectural Record*, May 1910, pp. 400–14), his writings were not published until later ('Pensées et réflexions sur la peinture', *Nord-Sud*, December 1917, pp. 3–5). Picasso's first published theoretical statement ('Picasso Speaks', *The Arts*, May 1923, pp. 315–26) came even later. Further, while Braque's writings on art are aphoristic, and sometimes obscure, and Picasso's bombastic, Matisse usually uses the expository form, as in 'Notes of a Painter'. He also wrote statements on each of his major media, with the exception of sculpture.

7 At the turn of the century Matisse was considerably older than his fellow students, and while working at Carrière's atelier evidently took a somewhat pedagogical attitude toward his colleagues. Jean Puy, for example, recalls Matisse's discussion of the structure of Cézanne at this time (Michel Puy, *L'effort des peintres modernes*, Paris, 1933, p. 70).

8 In this way Matisse's writings differ quite sharply from the intense systematization and specificity of Kandinsky's *Concerning the Spiritual in Art*, or the writings of Paul Klee. Matisse was inclined to speak in general terms; he avoided complicated nomenclature or practical demonstration of ideas, and his writings are always more philosophic than technical; or, when

he is being pedagogical, more concerned with general principles than with conveying practical information.

9 Matisse's difficulties during the Experimental period are reflected in his correspondence. In April 1913 he wrote to Camoin, 'The truth is that Painting is very deceptive', expressing his dissatisfaction with the portrait of *Madame Matisse* (Figure 26). In an important letter of autumn 1914 he wrote to Camoin at some length discussing his evaluation of Seurat and Delacroix in relation to himself, also noting his own realizations to be more elusive than they had been ten years before. And on 2 May 1918, he wrote to Camoin: 'Contour gives grand style (as soon as one proceeds by half-tones one is closer to truth but less grand). Don't you find that that is seeing things a little superficially, and that one can use contour and a semblance of grand style, and half-tones and real grand style? Which is the grander style, that of Gauguin or of Corot? I believe that style comes from the order and the elevation of the mind of the artist. That order is acquired or developed or even completely intuitive, perhaps the consequence of order. But if it is the result of taking a position it never results in more than half-tone. This is said without pretension.'

10 José Ortega y Gasset, *The Dehumanization of Art and Other Writings on Art and Culture*, Garden City, N. Y., 1956, p. 23: 'The nineteenth century was remarkably cross-eyed ... its products ... may be said to mark a maximum aberration in the history of taste.'

11 Frédéric-Auguste-Antoine Goupil (*officier d'académie, élève d'Horace Vernet* . . .) was the author of several 'how-to-do-it' books on art and decoration. The book that Matisse used was *Manuel général de la peinture à l'huile précédé de considérations sur les peintures anciennes et modernes, restauration et conservation des tableaux, peinture à la cire, renaissance de la mosaïque en France*, Paris, 1877. The book was part of a series, most of which—including another work on painting, *Traité méthodique et raisonné de la peinture à l'huile*, Paris, 1867—were priced at one franc. The elaborate *Manuel général*, however, was priced at six francs and included historical and aesthetic, as well as practical advice and instruction.

12 This is discussed in detail by Frank Anderson Trapp in 'The paintings of Henri Matisse: origins and early development, 1890–1917', unpublished Ph.D. dissertation, Harvard University, 1952, pp. 237–43.

13 Goupil, *op. cit.* p. 6.

14 See for example Texts 33, 35, 36, below.

15 Goupil, *op. cit.* p. 6.

16 Goupil, *op. cit.* p. 7.

17 'Henri Matisse le Méditerranéen nous dit', *Comœdia*, 7 February 1942, p. 6.

18 Goupil, *op. cit.* p. 11; see Texts 10 and 44, below, for Matisse's use of photographs.

19 Goupil, *op cit.* p. 74.

20 Later, Matisse recounted his debut at Bouguereau's studio to Escholier and Guenne (see Text 7, below).

21 Barr, p. 563. The rest of the statement is worth quoting: 'Because it forces them into the same cliché: believe it or not they are being taught to do a head, a bust, hands and feet in a limited amount of time, a "monstrous procedure" for the study of art. . . .

'Because, manual dexterity alone counts.

'Because, deprived of their instinct, their curiosity, the poor artists are turned into chronic invalids at a period of their lives, between 15 and 25 years, which determines their future. . . .'

22 See the 'Letter to Henry Clifford' (Text 33, below, especially Note 2).

23 The general procedure for a student was to draw in the Cours Yvon, and hope to attract the favourable attention of one of the professors, who would then invite the student to work in his atelier. This, however, was not properly speaking entrance to the École des Beaux-Arts, for which an examination, comprised of five parts, was necessary: *un dessin d'anatomie (ostéologie), un dessin de perspective, un fragment de figure modelé d'après l'antique, une étude élémentaire d'architecture*, and *un examen sur les notions générales de l'histoire*. This competition was known as the *concours de places*. In the Matisse dossier at the École des Beaux-Arts archives is a note signed by Bouguereau (dated January 1892) presenting Matisse for the *concours de places*; thus Matisse probably competed in the February 1892 *concours*, although he may have waited until the summer. (The life drawing [Fig. 2] submitted for the *concours* is presently at the Musée Matisse at Le Cateau. It is inscribed 'Matisse H. élève de MM. Bouguereau et Ferrier'. In 1952 Matisse wrote a note on this drawing stating that it was the basis for his refusal.) Bouguereau's endorsement of Matisse's candidacy was standard procedure, Matisse having worked in his atelier (Matisse had been recommended to Bouguereau by the Saint-Quentin painter P.-L. Couturier who, like Bouguereau, had studied with Picot).

As Albert Boime (*The Academy and French Painting in the Nineteenth Century*, London, 1971, p. 23) points out, 'the rules governing inscriptions at the École required the formal recommendation of a master in favour of an applicant. Enrolment in a private atelier was thus in practice a condition for admission to the École.'

Matisse, in his own most elaborate recounting of this experience, neglects the entrance examination, but dwells instead on the inadequacy of Bouguereau and Ferrier as teachers (see Escholier, 1937, pp. 30–1).

24 When asked in 1942 'What do you remember of your teachers?' Matisse replied: 'One only among them counts for me: Gustave Moreau who turned out, among numerous students, some real artists. . . .' (See below, Text 20.)

Although Gaston Diehl (*Henri Matisse*, Paris, 1954, p. 7, n. 16) says that Matisse, at the request of Moreau, was admitted as a Beaux-Arts student by special exemption from the entry *concours*, the Matisse dossier at the École des Beaux-Arts reveals that Matisse was finally accepted to the École proper in the March 1895 judgement, after the February 1895 *concours*. Out of a possible 20 points in each of the five categories,

Matisse received 17 in life drawing, 3 in perspective, 4 in modelling, 0 in architecture, and 13 in history (see Note 23 above for the exact categories) for a total of 37 out of a possible 100. With this score he finished the *concours* in forty-second place (eighty-six pupils were accepted to the École at that time).

25 Moreau also introduced his students to the masters of the Louvre. Matisse later (1943) recalled the beneficial effect that this had on his early experience, since it shielded him from the prevailing state of mind at the École, which was centred on producing Salon entries and Prix-de-Rome candidates: 'It was almost a revolutionary attitude on Moreau's part to send us off to the Louvre at a time when official art, doomed to the vilest pastiches, and living art, given over to *plein-air* painting, seemed to have joined forces to keep us away.' (Diehl, p. 11).

26 Cited in Jean Guichard-Meili, *Matisse*, New York, 1967, p. 36.

27 Cited in Guichard-Meili, *op. cit.* p. 25.

28 For discussion and reproduction of some of these works, see Barr, pp. 33, 293.

29 The exhibition opened on 25 April 1896. On 9 June 1896 Matisse wrote to his cousin Lancelle saying that the exhibition had not given him only 'platonic satisfactions', since he had sold two paintings, one to the State, which had also commissioned two more copies: one of a Chardin for 1,000 francs, another of an Annibale Caracci for 1,200 francs. Matisse added, 'You see, my dear friend, that there is some painting which brings returns'. (Letter to Lancelle), *Arts*, 13 August 1952, p. 1.

30 For a discussion of landscape *études* and *esquisses*, see Boime, *op. cit.*, Note 23, above, p. 150 ff.

31 For Matisse's own description of this experience, See Escholier, 1937, pp. 77–8.

32 Goupil's 1877 treatise (p. 163), for example, briefly discusses the decorative arts, including the study of ornamental composition and arabesques with scrolls, and refers to his own *Manuel général de l'ornement décoratif* (Paris, 1862).

33 Diehl, p. 7.

34 'Matisse Speaks' (Text 39, below).

35 Henry Havard, *La décoration*, 2nd ed., Paris, 1892?. Havard is advertised on the title-page as '*Inspecteur général des Beaux-Arts*' and the book was published under the patronage of '*l'administration des Beaux-Arts couronné par l'Institut (Prix Bordin) et honoré des souscriptions du Ministère d'Instruction Publique, de la Ville de Paris, des Chambres du Commerce de Paris*'. I should like to thank Mr John Neff for calling this book to my attention.

36 Havard, *op. cit.* p. 4.

37 Havard, *op. cit.* p. 7.

38 Havard, *op. cit.* p. 8.

39 Havard, *op. cit.* p. 15.

40 Havard, *op. cit.* p. 19.

41 Havard, *op. cit.* p. 14.

42 Havard, *op. cit.* p. 20.

43 S. Tschudi Madsen, *Art Nouveau*, New York–Toronto, 1967, p. 15.

44 Frank Anderson Trapp, 'Art Nouveau Aspects of Early Matisse', *Art Journal*, XXVI, 1, Fall, 1966, pp. 2–8.

45 Trapp, *Art Journal*, pp. 6–8.

46 Madsen, *op. cit.* pp. 15–16.

47 Meyer Schapiro, 'Matisse and Impressionism', *Androcles*, 1, 1, February 1932, p. 23.

48 Guenne: Interview with Matisse (Text 7, below).

49 The Impressionists of course also relied on instinct, as did Matisse. It is likely that Matisse experienced his first physical boldness with a canvas and free instinctive rendering of the first impression during his Impressionistic phase. Monet, for example, had written to Sargent: 'Impressionism simply means the sensation of the moment. All great painters were more or less impressionists. It is really a question of instinct.' (Evan Charteris, *John Sargent*, New York, 1927, p. 129.) Monet also had stressed self-expression of a sort, saying that he 'has simply tried to be himself and not another'. (E. G. Holt, *From the Classicists to the Impressionists: A Documentary History of Art and Architecture*, New York, 1966, p. 381.) Although Matisse like Monet tried to preserve a certain naivety toward experience, it was in order to arrive at fresh 'signs' for objects, not in order to submerge objects into the optical effect. Monet emphasized the recording of pure optical sensation, almost the opposite of what Matisse was after in 1908. See for example Lilla Cabot Perry, 'Reminiscences of Claude Monet from 1889 to 1909', *The American Magazine of Art*, XVIII, March 1927, p. 120.

50 Barr, p. 38.

51 It should also be remembered that Matisse visited Renoir at Cagnes several times during 1917–18.

52 Schapiro, *art. cit.*, p. 29.

53 See Kurt Badt, *The Art of Cézanne*, Berkeley and Los Angeles, 1965, pp. 268–75, for a discussion of Cézanne and Symbolism. Some of Badt's comments also apply to Matisse, such as (p. 270): 'Cézanne "manufactured" nothing with his mind, he invented nothing, he painted merely what he perceived. But he perceived in an entirely individualistic way . . . Cézanne's formula was the medium of expression for the symbolic exposition of the real world as a sign . . . of the unshakeable objectiveness and unshakeable "existing together" of objects. It emerged in his art in various forms, without however changing at the core. What was novel about it was that it turned all external appearances of real things into a symbol of being, "which is eternal".'

54 The Matisse is reproduced in Guichard-Meili, *op. cit.*, Note 26, above, p. 45, the Cézanne, in Meyer Schapiro, *Paul Cézanne*, New York, 1952, p. 63.

55 The Matisse is reproduced in Barr, p. 311; the Cézanne in Schapiro, *Paul Cézanne*, p. 51.

56 Matisse was also aware of the painting's direct effect upon his early career. Speaking of the purchase of his Cézanne *Trois baigneuses*, to Gaston Diehl ('Avec Matisse le classique', *Comœdia*, no. 102, 12 June 1943, p. 1) he said: 'I remember that everything there had its place, that the hands, the trees ćounted in the same way as the sky. I had recognized in [Cézanne] this stability in the form, this song of the

arabesque in close union with the colour, that I myself wanted to obtain.

'What I always sought was to arrive at an ordered ensemble, using only the strict means of painting. At Collioure in 1905, before a landscape already exalted by him, I attempted to establish a vast composition with several of my drawings, to put them into a general arabesque and to find an accord with my colours brought to their maximum force and luminosity.'

57 See Jack D. Flam, 'Matisse's *Backs* and the Development of his Painting', *Art Journal*, xxx, 4, Summer 1971, pp. 352–61.

58 Camoin, who had known Cézanne since 1899, wrote in a letter to Matisse (2 December 1905): 'I found [Cézanne] squeezing some Veronese green onto his palette . . . "But there is only theory! My dear fellow, but Veronese, that's it! The theory." Ah! how we laughed . . . What a sensitive man, Cézanne, "also, you see, you must make *pictures*, compose the pictures as the masters did, not like the Impressionists who cut out a piece of nature by chance, put in personages. Look at [Claude] Lorrain." '

Cézanne's important letters to Emile Bernard were published in 1907: E. Bernard, 'Souvenirs sur Paul Cézanne et lettres inédites', *Mercure de France*, 1 and 15 October 1907. Matisse had doubtless read them, and possibly knew of others through Vollard.

59 See for example John Rewald, ed., *Paul Cézanne Correspondence*, Paris, 1937, pp. 289–91, for Cézanne's use of the words 'researches' (*recherches*) and 'studies' (*études*); and of 'means of expression' (pp. 262, 268, 273–5), another phrase used by Matisse in similar contexts.

60 Some aspects of this common heritage are discussed below. See also Carla Gottlieb, 'The Joy of Life: Matisse, Picasso, and Cézanne', *College Art Journal*, xviii, 2, Winter, 1959, pp. 106–16.

61 Lawrence Gowing, *Henri Matisse: 64 Paintings*, New York, 1966, p. 7.

62 Picasso, Statement to Marius de Zayas, 1923; cited in Alfred H. Barr, Jr., *Picasso: Fifty Years of his Art*, New York, 1946, pp. 270–1. The entire statement provides an interesting contrast to Matisse's ideas.

63 Roger Shattuck, *The Banquet Years*, revised ed., London, 1969, p. 327. See also Shattuck's chapter on the aesthetics of this period, pp. 325–52.

64 For a discussion of Matisse and Bergson see the Introduction to 'Notes of a Painter', below; also

Edward F. Fry, *Cubism*, New York–Toronto, 1966, pp. 37–40, for a brief but interesting discussion.

65 Braque spoke of finding behind the brilliance of Provençal light 'something deeper and more lasting'. (Cited in Fry, *op. cit.* p. 17.) See also Braque's interview with Gelett Burgess, 'The Wild Men of Paris', *Architectural Record*, May 1910, pp. 400–14, in which Braque emphasizes the role of art as an equivalence rather than an imitation of nature, thus producing what Matisse similarly calls a more lasting interpretation of nature.

66 See Fry, *op. cit.* pp. 39–40. Juan Gris made one of the most cogent statements of this in *L'Esprit nouveau*, 15 February 1921, pp. 533–4; translated in Fry, *op. cit.* pp. 162–3.

67 See Fry *op. cit.* p. 40; see also Albert Gleizes and Jean Metzinger, *Du Cubisme*, Paris, 1912; translated in Robert L. Herbert, *Modern Artists on Art*, New York, 1964.

68 The flow of Cubist ideas must have made an impression on Matisse, and very likely emboldened him in his own explorations of more expressive construction. Matisse, however, seems to have been even more affected by Eastern art at this time, especially after the large Islamic art exhibition in Munich in 1910, and his trips to Spain, Russia and Morocco the year after.

It is also possible that Matisse's wariness of the Cubists kept him back from any public statement about his art at this time, even though for a while in 1914 Matisse and Juan Gris talked 'relentlessly' about painting every day. See Douglas Cooper, *The Cubist Epoch*, London, 1970, p. 207.

69 In such works as *Tête blanche et rose* (Barr, p. 402), and the Schoenborn *Poissons rouges* (Barr, p. 169). In 1952, speaking of Cubism, *c.* 1914, he told Frank A. Trapp: 'I had my own work to do . . . After all, there is in Paris an atmosphere and one senses that atmosphere. In that respect there was perhaps a *concordance* between my work and theirs. But perhaps they themselves were trying to find me.' Frank Anderson Trapp, 'The Paintings of Henri Matisse: Origins and Early Development, 1890–1917', unpublished Ph.D. dissertation, Harvard University, 1952, p. 212.

70 Gowing, *op. cit.*, Note 61 above, pp. 11–12.

71 That Picasso was aware of this difference, too, can be seen from his conversations with Françoise Gilot in *Life with Picasso*, New York—Toronto—London, 1964, p. 271.

I APOLLINAIRE'S INTERVIEW

1 'Henri Matisse', *La Phalange*, II, 18; December 1907, pp. 481–5. Translation from *Matisse: his art and his Public* by Alfred H. Barr, Jr. © 1951 by the Museum of Modern Art, New York. All rights reserved. Reprinted by permission of The Museum of Modern Art. The original essay was illustrated by the following works by Matisse: *Portrait de l'artiste*, 1906 (Barr, p. 333); *La madras rouge*, 1907 (Barr, p. 350); *La coiffure*, 1907 (Barr, p. 339); *Le luxe, I*, 1907 (Barr, p.340).

2 Fernande Olivier, in *Picasso et ses amis*, Paris, 1933, p. 107, notes that whenever Matisse began to

talk about painting he chose his words deliberately. Leo Stein, in *Appreciation: Painting, Poetry and Prose*, New York, 1947, p. 152, speaking of this period recalls: 'Matisse was really intelligent. He was also witty, and capable of saying exactly what he meant when talking about art. This is a rare thing with painters. . . .' And George L. K. Morris, recalling a 1931 meeting with Matisse ('A Brief Encounter with Matisse', *Life*, LXIX, 9; 28 August 1970, p. 44), notes: 'As soon as Matisse speaks about art his voice becomes gentle and distinct, he talks very slowly'.

2 NOTES OF A PAINTER

1 Henri Matisse, 'Notes d'un peintre', *La Grande Revue*, LII, 24; 25 December 1908, pp. 731–45. Within a year of its original publication, 'Notes d'un peintre' was translated into Russian and German: *Toison d'Or* (*Zolotye Runo*), 6, 1909; *Kunst und Künstler*, VII, 1909, pp. 335–47.

Matisse's article was prefaced by Georges Desvallières who noted that Matisse wished to have certain of his works illustrated so that the public could compare what he said with what he did. The following works were illustrated: *La liseuse*, 1906 (Barr, p. 332); *Nu debout*, 1907 (Barr, p. 338); *Nu assis*, 1908 (Leningrad); *Greta Moll*, 1908 (Barr, p. 351); *Nu noir et or*, 1909 (Schneider, p. 165); *Joueurs de boules*, 1908 (Figure 19). The three nudes are very close in style and appear to have been done from the same model. *Joueurs de boules* is the most 'advanced' of the works represented and is the only 'imagined' and only multifigure scene. Desvallières' preface tries to 'explain' and prepare his essentially literary readership for Matisse's works, of which he says that although 'our personal good taste may sometimes be shocked by them . . . even then our artistic intelligence should not be indifferent to the discoveries made by this artist . . . he has liberated our eyes; he has enlarged our understanding of design. . . .' *La Grande Revue* indeed was a somewhat prestigious forum for Matisse's statement, recent issues having contained articles by such writers as André Gide, Raymond Poincaré, Léon Blum and Charles Martel.
2 By 1908 Matisse was beginning to lose his dominant position among the Paris *avant-garde* to Picasso and the Cubists. (See Barr, pp. 86–8.) He felt that Cubism was too systematic and theoretical, and was to recall later in life that it was only another form of descriptive realism (Text 39, below).
3 Though it now seems odd, Matisse's early Fauve works were themselves criticized for being applications of theory. André Gide ('Promenade au Salon d'Automne', *Gazette des Beaux-Arts*, XXXIV, December 1905, pp. 476–85) noted that *La femme au chapeau*, the scandal of the 1905 Salon, was not madness but 'the result of theories'. In Maurice Denis' review of the 1905 Salon (*L'Ermitage*, 15 November 1905; reprinted in Maurice Denis, *Théories, 1890–1910*, 4th ed., Paris, 1920, pp. 203–10) Denis criticizes Matisse for lack of individual emotion, and for painting a kind of excessively theoretic 'dialectic'. Leo Stein (*Appreciation: Painting, Poetry and Prose*, New York, 1947, p. 161) relates that Matisse rebuffed Denis in front of one of Matisse's own paintings.
4 Charles Edward Gauss, *The Aesthetic Theories of French Artists from Realism to Surrealism*, Baltimore, 1949, p. 63.
5 Clara T. MacChesney, 'A Talk with Matisse, Leader of Post-Impressionists', *New York Times Magazine*, 9 March 1913. (Text 6, below.)
6 Gauss, *op. cit.* p. 64.
7 Henri Bergson, *Creative Evolution*, New York, 1911, pp. 177–8.

8 As cited in Roger Shattuck, *The Banquet Years*, revised ed., London, 1969, p. 327.
9 See Kurt Badt, *The Art of Cézanne*, Berkeley and Los Angeles, 1965, pp. 195–228. Cézanne also pursued what Badt calls '*the One which is permanent in the changing world*' (p. 217). The whole problem of realization is based essentially on arriving at an intuition of truth (source), a tangible vehicle in which the goal might be realized (motif), and a vehicle for expressing the aim (articulation). The artist must penetrate apparent reality to arrive at Reality. The problem is complicated, in that while Reality is constant, or rather has a constant duration, its manifestations and the *means for perceiving them*, are not. Hence Pissarro's acute observation that Cézanne painted the same painting all his life. (See Barr, p. 38, where this is taken literally to mean his 'Bathers'.) In other words, Cézanne was striving for the same realization all his life. The *réalisation* of which Cézanne speaks is an articulation of the penetration into Reality. For this Cézanne depended upon the sensations he could receive from the Provençal landscape by which he might realize the structure behind the material manifestation and construct accordingly. The process of *réalisation*, then, moves, by intuition, from source to work to articulation: paintings are the material results, condensed, of perceptions of reality based on visual sensations modified by intuition. Matisse's process follows a similar path. The main difference between Cézanne and Matisse on this point is that Cézanne's sensations were received and articulated in detail, whereas Matisse sought a *Gestalt* perception. Whereas Cézanne worked toward the whole in parts, achieving realization by adjusting the parts to form a 'realized' totality, Matisse started with the whole and adjusted the parts until the totality was 'realized' by adjustment and balancing of parts. Thus the notion of being able 'to reconceive in simplicity'.
10 Cited in Shattuck, *op. cit.* p. 342.
11 In 1941 Matisse, speaking to Francis Carco, referred to his studio as the cinema of his sensibility (See Text 18, below.) This idea also seems quite Bergsonian: 'To reduce things to Ideas is therefore to resolve becoming into its principal moments, each of these being, moreover, by the hypothesis, screened from the laws of time and, as it were, plucked out of eternity. That is to say that we end in the philosophy of Ideas when we apply the cinematographical mechanism of the intellect to the analysis of the real.' (Henri Bergson, *Creative Evolution*, p. 315.)
12 Only recently Alison Hilton ('Matisse in Moscow,' *Art Journal*, XXIX, 2; Winter 1969–70, p. 166) has written of Matisse's position in 'Notes of a Painter': 'He believed in a purely decorative and hedonistic art. Accordingly, he stripped his paintings of all the disturbing or boring sides of life, and gave full play to what is festive, as in the early *Joy of Life*. A painting should contain nothing exciting or excessive, and, above all, no message.'
13 It is interesting in this context to note Greta

Moll's account of the portrait Matisse painted of her (1908) and which was illustrated in 'Notes of a Painter'. She noted, 'I found it very interesting to watch how always when he altered one color he felt forced to change the whole color scheme.' (Barr, p. 129.)

14 Cf. Cézanne (letter to Camoin, 28 January 1902): 'I have little to tell you; indeed one says more and perhaps better things about painting when facing the motif than when discussing purely speculative theories —in which as often as not one loses oneself.' (John Rewald, ed., *Paul Cézanne, Letters*, London, 1941, p. 218.)

15 Paul Signac (1863–1935); Georges Desvallières (1861–1951); Maurice Denis (1870–1943); Jacques-Emile Blanche (1861–1942); Charles Guérin (1875–1939); Emile Bernard (1868–1941). It is interesting that Matisse cites mostly his contemporaries and painters older than himself, rather than the younger painters such as Braque (1882–1963) and Derain (1880–1954), or Marquet (1875–1947) with whom he had in fact been more closely allied. The painters that Matisse names might be considered as the more 'respectable' element of the *avant-garde* at the time, and also represent a group of men who had some reputation as writers and theorists. (Bernard had in fact recently written on Cézanne in 'Souvenirs sur Paul Cézanne et lettres inédites', *Mercure de France*, 1 and 15 October 1907.)

16 The reference is most pointedly to Signac (see Note 3 above), although Matisse obviously did not want his criticism of the Impressionists or Rodin to be taken as a slur on their work.

17 Ironically, a criticism still made in 1970, see Note 12, above; see also Janet Flanner (as Genêt), *The New Yorker*, 30 May 1970, p. 86; also Denys Sutton, 'Matisse Magic Again', *Financial Times*, 3 June 1970, who describes Matisse as a painter 'who is so easy on the eye and who is in no way profound'.

18 Cf. Bergson, *Creative Evolution*, p. 145, where a similar idea is set out in more detail.

19 Matisse would return to this point several times. Speaking of the 1931–3 Barnes Murals, he told Escholier (1956, p. 129): 'Perhaps it would be important to indicate that the composition of the panel arose from a struggle between the artist and the fifty-two square metres of surface of which his spirit had to take possession, and not the modern procedure of the compositions' projection on the surface, multiplied to the size required and traced.

'A man looking for a plane with a searchlight does not explore the vastness of the sky in the same way as an aviator.

'If I have made myself clear, I think you will grasp the essential difference between the two conceptions.'

20 Cf. Cézanne (letter to Bernard, 12 May 1904): 'I am progressing very slowly, for nature reveals herself to me in very complex forms; and the progress needed is incessant. One must see one's model correctly and experience it in the right way; and furthermore express oneself forcibly and with distinction.' (Rewald, *Paul Cézanne, Letters*, p. 235.)

21 Cf. Matisse, 'A Cézanne is a moment of the artist while a Sisley is a moment of nature.' (Barr, p. 38.)

22 Cf. Braque, in 1908: 'I couldn't portray a woman in all her natural loveliness . . . I haven't the skill. No one has. I must, therefore, create a new sort of beauty, the beauty that appears to me in terms of volume, of line, of mass, of weight, and through that beauty interpret my subjective impression. Nature is a mere pretext for decorative composition, plus sentiment. It suggests emotion, and I translate that emotion into art. I want to expose the Absolute, and not merely the factitious woman.' (*The Architectural Record*, New York, May 1910, p. 405.)

23 Matisse here makes a fine distinction between various levels of reality. The movement captured by a snapshot, although it actually has happened, is so far away from absolute Reality (so superficial a moment), that it is without meaning, not 'seen', even though the image may have passed imperceptibly across the retina. 'Seen' (*ayons vu*) is meant here in the sense of 'perceived'.

24 Thus (in Bergsonian terms) the image can 'direct the consciousness to the precise point where there is an intuition to be seized'.

25 Cf. Bergson, *Creative Evolution*, pp. 156–7, and especially, 'the intellect is characterized by the unlimited power of decomposing according to any law and of recomposing into any system'.

26 Auguste Rodin (1840–1917).

27 An implicit rebuttal to Signac.

28 Matisse had just been to Italy in 1907.

29 A criterion that Matisse no doubt got, at least in part, from Cézanne.

30 Cf. Braque (1917): 'One must not imitate what one wishes to create.' (Cited in Edward F. Fry, *Cubism*, New York–Toronto, 1966, p. 147.) Also Picasso (1923): 'We all know that Art is not truth. Art is a lie that makes us realize truth. . . . The artist must know how to convince others of the truthfulness of his lies.' (Fry, *op. cit.* pp. 165–6.)

31 Mérodack Joséphin Péladan, novelist and critic, was the founder of a mystic order of Catholic Rosicrucians. In the 1890s he had invented his own symbolic system in relation to which he conceived of himself as a prophet who would renovate art through mystical aesthetic ideas based on Dante and Leonardo (hence Matisse's reference at the end of this essay). The article referred to is 'Le Salon d'Automne et ses Retrospectives—Greco et Monticelli', *La Revue Hébdomadaire*, 42; 17 October 1908, pp. 360–78. In this article Péladan (pp. 360–1) wrote: 'The created being, like the Creator, in His image . . . is not restricted to historical costume. A manner of dress results from a manner of thought. The form manifests its basis; it is born of incessant work, of a growth from within and without. . . . Each year it becomes more difficult to speak of these people who have called themselves *les fauves* in the press. They are curious to see beside their canvases. Correct, rather elegant, one would take them for department store floor-walkers. Ignorant and lazy, they try to offer the public colourlessness and

formlessness.' Péladan's review of the 1908 Salon d'Automne makes an interesting contrast with that of Georges Desvallières · ('L'art finlandais au Salon d'Automne', *La Grande Revue*, 25 November 1908, pp. 397 ff in which Desvallières speaks of the purely plastic means of the Fauves).
32 Péladan wrote under the name of 'Sar'.
33 Péladan (*Revue Hébdomadaire*, p. 373) had written: 'The public, insensible to the difficult effort toward

beauty, wants only antics. A clown makes the fortune of a circus, and thousands of artists imitate Chocolat; only it is the canvas that receives the kicks in the face in colour. Truth, the most despairing of the Muses, terrible Truth would say: "Suppose that M. Matisse painted honestly; wouldn't he be nearly unknown; he shows off as at the fair, and the public knows him". By honestly, I mean with respect to the ideal and the rules. . . .'

3 STATEMENT ON PHOTOGRAPHY

1 *Camera Work*, No. 24; New York, October 1908, p. 22.
2 Cf. Matisse's 1933 statement to Tériade, and his comments on the use of photographs in *Portraits* (Texts 10 and 44).

3 Cf. Gustave Moreau, 'Photographic truth is merely a source of information.' Ragnar von Holten, *L'Art fantastique de Gustave Moreau*, Paris, 1960, p. 3.

4 SARAH STEIN'S NOTES

1 The publishers are grateful to Professor John Dodds for permission to use his transcription of Sarah Stein's manuscript. The headings given here are those used by Barr, pp. 550–2. For a history of Matisse's school, see Barr, pp. 116–18. On the Steins and Matisse see *Four Americans in Paris: The Collection of Gertrude Stein and her Family*, New York, 1970, especially pp. 35–50. For other first-hand accounts of Matisse's school see: Hans Purrmann, 'Aus der Werkstatt Henri Matisses', *Kunst und Künstler*, xx, 5, February 1922, pp. 167–76; Isaac Grünewald, *Matisse och Expressionismen*, Stockholm, 1944; Leo Swane, *Henri Matisse*, Stockholm, 1944; Matisse also gave a brief account of the opening of the school to Raymond Escholier, (1937, pp. 92–7). Escholier, 1956, pp. 80–1, publishes Pierre Dubreuil's version of Matisse's teaching, close to that of Sarah Stein:
 'The human body is an architectural structure of forms which fit into one another and support one another, like a building in which every part is necessary to the whole: if one part is out of place, the whole collapses. . . . If you are not sure, take measurements, they are crutches to lean on before you can walk. Construct your figures so that they stand, always use your plumb-line. Think of the hard lines of the stretcher or the frame, they affect the lines of your subject. . . . All human shapes are convex, there are no concave lines. . . . Paint on the white canvas. If you place a tone on a surface already coloured, without reference to your subject you sound a discord from the start which will hinder you all the way. One tone is just a colour; two tones are a chord, which is life. A colour exists only in relation to its neighbour. . . . Determine your impression from the beginning, and hold to that impression. Feeling counts above everything.'
2 Hans Purrmann, cited in Barr, p. 118.
3 For example, the use of the plumb line. For some very interesting parallels see F. Goupil, *Manuel général de la peinture à l'huile*, Paris, 1877, pp. 158–66, with his ten procedural steps: perceive, be attentive,

compare, reason, retain, abstract, combine and order, analyse, generalize, imagine or invent.
4 Matisse's indirect way of getting this Beaux-Arts information across is interesting and amusing. He himself was not unaware of the irony of his position as a teacher. In 1925 he noted the irony of the situation in his interview with Jacques Guenne (Text 7, below).
5 The specific imagery here seems to be inspired by the structure of Cézanne, particularly the Cézanne *Trois baigneuses* that Matisse owned. Although the advice is figurative, Matisse himself often used such metaphorical structures as in the obviously tree-like structure of *La serpentine*, 1909 (Barr, p. 367), or the architectural structure of *Le dos, II* of 1913–14 (Schneider, p. 286), and *Mlle Yvonne Landsberg* of 1914 (Barr, p. 395).
6 Such subtle ambiguities of shape recur throughout Matisse's work. Sometimes, as in *L'italienne* of 1915 (Barr, p. 403), which is in the shape of an amphora, the main compositional motif of the work is such a compound image.
7 Note the complete, almost mystical, fusing of the impulses inherent in the model and those received by the painter.
8 This provides some clue to Matisse's concept of his sculpture in relation to his two-dimensional works. In many cases his sculptures seem to be the results of self-imposed disciplines that would force him to 'definitely express' formal constructions that are illusory in painting or drawing. See Jack D. Flam, 'Matisse's *Backs* and the Development of his Painting', *Art Journal*, xxx, 4, Summer 1971, pp. 352–61.
9 A vivid description of the linear substructure of Matisse's paintings between 1907 and 1917.
10 The correct reading should probably be: 'The leg fits into the foot at the ankle. . . .'
11 Matisse here, as in other places (Cf. Note 4, above), seems to want to convey useful Academic studio advice, without seeming didactic. Thus he states the principle in the spirit of advice, without making it a rule.

12 Also a common compositional feature in Matisse's painting of that period: *La liseuse*, 1906 (Barr, p. 332); both versions of *Le luxe*, 1907–08 (Barr, pp. 340–1); *Baigneuses à la tortue*, 1908 (Barr, p. 357). Though this feature persists in Matisse's paintings through about 1918, it is less common after that.
13 This is especially vivid in the four reliefs of *Le dos*.

5 ESTIENNE: INTERVIEW WITH MATISSE

1 Charles Estienne, 'Des tendances de la peinture moderne: Entretien avec M. Henri-Matisse', *Les Nouvelles;* 12 April 1909, p. 4. Starting with the catalogue of the 1904 Salon d'Automne Matisse began to use the hyphenated 'Henri-Matisse' employed here by Estienne in order to avoid confusion with the well-known marine painter Auguste Matisse. After the latter died in 1931 Matisse generally dropped the hyphen.
2 Some twenty-five years later Matisse, speaking of the same problem was to say: 'The great mass of people who seem to have been touched by painting in the Middle Ages were not interested in the plastic and graphic qualities of the paint and the painter's work. They were interested in the story he had to tell because there were not other available ways for them to learn the story. . . . Today, no one need look at a picture, unless he is interested in painting. . . .
'When a painting is finished, it's like a new born child, and the artist himself must have time for understanding. How, then, do you expect an amateur to understand that which the artist does not yet comprehend?' ('Matisse Speaks', *Art News*, xxxi, 36; 3 June 1933, p. 8.)
Some forty years later, Matisse, answering a questionnaire about art and the public, wrote:
'Art cannot be hampered by the dead weight of the public. But today there is no rupture between art and public. I experienced such a rupture in my youth. I resisted without compromising, and the public came to terms all the same. Does the rupture between art and public result from a severance between art and reality? I keep my feet on the ground, true enough, and the public can always find their way into my work. But when I began, there was no way in. When the artist is gifted, people come to him as to a living spring.' (*Transition Forty-Nine*, 5, 1949, p. 118.)
3 This passage is an almost exact repetition of a passage in 'Notes of a Painter' (Text 2, above).

4 This paragraph also repeats part of 'Notes of a Painter'.
5 A reference to the first version of *La danse* (1909), done as a design for a proposed commission.
6 The staircase referred to is that of Sergei Shchukin, the Russian collector who had just recently (31 March 1909) confirmed an order for two large panels (*La danse* and *La musique*) to decorate his stairway. The project, which had been in the air for several months, was understandably on Matisse's mind at the time. This commission represented not only the opportunity for two of his largest works, but also the considerable sum of 27,000 francs.
This interview suggests that the original commission from Sergei Shchukin was conceived in terms of three and not two panels. The third panel that Matisse here mentions very likely refers to *Baigneuses* (Barr, p. 408) which is the same size as the two Shchukin paintings. A watercolour sketch for this painting, in a style similar to that of *Danse* and *Musique*, is presently in Russia. (See *Matiss. Živopis, skul'ptura, grafika, pisma*, Leningrad, 1969.) Thus it seems that *Baigneuses* well may have been started as early as 1910 as Pierre Matisse has suggested (Barr, p. 190, n. 8), although it was finally completed (much transformed) considerably later.
Matisse's conception here is quite in keeping with the procedure for decorative arts as outlined by such writers as Henry Havard, *La décoration*, Paris, 1892?: he chooses subjects which avoid intense emotion and with clearly legible but non-illusionistic imagery, conceives of his pictures in terms of their ultimate destination, and thinks in terms of emblematic abstract ideas. (See Havard, pp. 2–35.)
7 In this passage, which again parallels 'Notes of a Painter', the reference to the armchair is omitted.

6 CLARA T. MacCHESNEY: A TALK WITH MATISSE

1 Clara T. MacChesney, 'A Talk with Matisse, Leader of post-Impressionists', *New York Times Magazine*, 9 March 1913; © 1913 by The New York Times Company. Reprinted by permission.
2 The Bernheim-Jeune Gallery.
3 Matisse's house at Issy-les-Moulineaux, a suburb of Paris.
4 Matisse was then working on *Les capucines à 'La danse'*, *I* and *II* (Barr, pp. 382–3).
5 Matisse's school had in fact closed in 1911.
6 Paul Albert Besnard (1849–1934) and Jean-François Raffaëlli (1850–1924), successful popular painters in the 'modern style' who combined the look of modernism with an essentially traditional outlook, probably would have represented to MacChesney 'acceptable modernity'. Degas once said of Besnard that he 'has stolen our wings'. (Albert Boime, *The Academy and French Painting in the Nineteenth Century*, London, 1971, p. 17), and Matisse in a 1942 radio interview was to say of Besnard: 'Albert Besnard? But he is a conventional painter who is hiding behind the palette of the Impressionists. The terrible Degas said: "Besnard? *Mais c'est un pompier qui prend feu*".' (Barr, p. 563.)
7 The statement is of course paraphrased from Matisse's own 'Notes of a Painter'.
8 MacChesney seems here to be confusing Matisse and Monet.

7 INTERVIEW WITH JACQUES GUENNE

1 Jacques Guenne, 'Entretien avec Henri Matisse', *L'Art vivant*, 18; 15 September 1925, pp. 1–6; *Portraits d'artistes*, Paris, 1925, pp. 205–19.
2 The villa at Issy-les-Moulineaux, which was at 42 (later 92) route de Clamart, a few miles southwest of Paris.
3 The acquaintance referred to here is Philbert-Léon Couturier, whom Matisse later characterized as a 'painter of hens and poultry-yards' (Text 39, below). Adolphe William Bouguereau (1825–1905) was one of the most popular and 'successful' nineteenth-century Academic painters. For an amusing account of Matisse's introduction to Bouguereau's studio, see 'Matisse Speaks', 1951 (Text 39, below).
4 Matisse told Escholier (1937, p. 30) a slightly different version of the story, noting that Bouguereau said to him: 'You are erasing your charcoal with your finger. That denotes a careless man; take a rag or a piece of amadou. Draw the plaster casts hanging on the studio walls. Show your work to an older student: he will advise you . . . You have to understand perspective . . . But first you must learn how to hold a pencil. You'll never know how to draw.'
5 Gabriel Ferrier (1847–1914) and Bouguereau alternately taught the class at the Académie Julian.
6 For Matisse's elaboration of this story, see Escholier (1937, pp. 30–1).
7 It was later recounted that he was encouraged to go on painting by Goya's *Jeune et Vieille* at the Lille Museum, of which he thought, '*Ca, je pourrais le faire.*' (Barr, p. 3, note to p. 15A.)
8 Gustave Moreau (1826–98) had at this time recently been appointed a professor at the École des Beaux-Arts. The 'Antiques' refers to the Cours Yvon at the École des Beaux-Arts where students drew from casts.
9 Giulio Romano (1499–1546), the Mannerist painter and follower of Raphael.
10 Painted in June 1890. Illustrated, *Cahiers d'Art*, no. 5–6 (1931), p. 230.
11 Albert Marquet (1875–1947) was Matisse's closest friend at the time. The Petit Casino was a cabaret on the Passage Jouffroy.
12 Delacroix's statement reported by Baudelaire was: 'If you are not skilful enough to sketch a man falling out of a window, during the time it takes him to get from the fifth storey to the ground, you will never be able to produce monumental work.' (Marius Vachon, *Pour devenir un artiste*, Paris, n.d., p. 134.) Marquet is supposed to have added the postscript: 'Yes, and make it a recognizable likeness, too!' (Barr, p. 38.)
13 But later Matisse informed Alfred Barr that he had seen the Impressionists at Durand-Ruel's and Vollard's before 1897. (Barr, p. 16, n. 4.) Caillebotte

bequeathed his collection of Impressionist paintings to the Luxembourg Museum.
14 The Matisse copy, which he worked on for several years (1894–1900), is in the Musée Matisse at Le Cateau. (Reproduced in Schneider, p. 131).
15 The landscape painter Emile Véry, or Wéry, (1868–1935), with whom Matisse went to Brittany in 1896.
16 *La desserte*, 1897 (Figure 5).
17 The Salon de la Société Nationale des Beaux-Arts of 1897. Matisse had been made an Associate in 1896, thus the painting had to be hung; but it was hung badly.
18 This story had evidently been told earlier to Georges Desvallières. (Barr, p. 35, n. 1.)
19 1898, when Matisse worked in Corsica, and at Fenouillet near Toulouse.
20 The reference is evidently to the Islamic art exhibition at the Pavilion de Marsan of the Louvre in 1903, although there is some confusion on the matter. (See Barr, p. 90, n. 5.)
21 See Texts 23 and 31, below.
22 See Text 14, below.
23 The school, partially financed by Michael Stein, opened in January 1908, at 56 rue de Sèvres, and was moved in the spring to the former Couvent du Sacré Cœur on the boulevard des Invalides. The class tapered off after Matisse left Paris in the spring of 1909, and was finally closed in the spring of 1911. (See Barr, pp. 116–17.)
24 Cf. Courbet, 'I maintain that art is completely individual, and is for each artist nothing but the talent issuing from his own inspiration and his own studies of tradition.' Pierre Courthion, ed., *Courbet raconté par lui-même et par ses amis*, Geneva, 1950, II, p. 205.
25 For the Exposition Universelle of 1900.
26 Père (Julien) Tanguy (1825–1894), the colour dealer who early helped and exhibited the Impressionists, and was painted by Van Gogh.
27 Antoine Druet (b. 1857), subsequent owner of the Galerie Druet.
28 Ambroise Vollard, the famous shrewd dealer, was the largest early dealer in Cézannes, and gave Matisse his first one-man show in June 1904.
29 It was Druet who instituted the practice of photographing the *œuvre* of painters, the so-called 'Druet Process'.
30 Berthe Weill, the courageous gallery owner, the first to show Picasso in Paris (in 1900), also first exhibited Matisse, with five other Moreau pupils, in February 1902. Matisse later told Escholier (1956, p. 55) that while Weill and Druet had been as useful as any dealer is to a beginner, that they could offer no security.

8 STATEMENTS TO TÉRIADE

1 E. Tériade, 'Visite à Henri Matisse', *L'Intransigeant*, 14 and 22 January 1929, partially reprinted as 'Propos de Henri Matisse à Tériade', *Verve*, IV, 13, December 1945, p. 56 [On Fauvism and Expression through Colour]; 'Entretien avec Tériade', *L'Intransigeant*, 20 and 27 October 1930 [On Travel]. Translated by permission of the author.

2 Matisse mentioned this need to be away from the city on other occasions—cf. Text 20, below.
3 Henri Edmond Cross (1856–1910). See also Texts 12 and 39, below.
4 The reference to Matisse's battle with the neo-Impressionists is obvious. Signac was so angry at Matisse for abandoning his camp that he picked a fight with him at the café where the exhibitors and jurors met after the opening of the 1906 Indépendants (Georges Duthuit, *The Fauvist Painters*, New York, 1950, p. 61). In this statement Matisse implies that Seurat is a great painter almost despite, rather than because of, his theories. The emphasis is once again on human values—just what Matisse had been accused of lacking in 1905–6. In autumn 1914, Matisse wrote a letter to Camoin, regarding Seurat: 'I know that Seurat is completely the opposite of a romantic, which I am; but with a good portion of the scientific, of the rationalist, which creates the struggle from which I sometimes emerge the victor, but exhausted.' In the same letter, Matisse goes on to say: 'Delacroix's composition is more entirely created, while that of Seurat employs matter organized scientifically, reproducing, presenting to our eyes objects constructed by scientific means rather than by signs coming from feeling. As a result there is in his works a positivism, a slightly inert stability coming from his composition which is not the result of a creation of the mind but of a juxtaposition of objects. It is necessary to cross this barrier to re-feel light, coloured and soft, and pure, the noblest pleasure. Delacroix's imagination, brought to bear on a subject, remains anecdotal, which is a shame; this relates to the quality of his mind, for Rembrandt in the same conditions is noble. A word that I never can say in front of a picture by Delacroix. . . . I am happy with my picture that returns me to the middle of all these movements of my mind.'
5 Perhaps an amusing reference to his relatives in Bohain and Le Cateau. (See Escholier, 1956, p. 98.)
6 Cf. Texts 9 and 42, below.
7 Although Matisse refers here to 'art politics', he also felt that there was no relationship between art and any kind of politics. 'I keep myself outside of politics as much as possible', he told Yves Bridault ('J'ai passé un

mauvais quart d'heure avec Matisse', *Arts*, 371, 7–13 August 1952, p. 1). 'The mission of the artist is important enough for him to preoccupy himself only with his art . . . I know. Delacroix did some pictures in 1848. Revolutions can sometimes serve a purpose, but it is necessary despite everything to remain outside of politics. One can have liberal ideas, but the artist hasn't the right to lose any of the precious time which he has for his self-expression.'
8 James Tissot (1836–1902), a painter of exotic Eastern scenes. Cf. Text 39, below.
9 Cf. Texts 20 and 39, below.
10 *Jeune fille en jaune* (Figure 34).
11 Cf. the 'Aeroplane' section of *Jazz* (Text 29, below).
12 In January 1931 Matisse met George L. K. Morris, a young American painter, on a French train. Morris ('A Brief Encounter with Matisse', *Life*, LXIX 9, 28 August 1970, p. 44) has recorded the following: 'I reply that I'm returning to New York in two months. "That's a very good idea", Matisse chimes in. "Artists should stay in their own countries.". . . . I start a defense of my European trip. . . . The gentleness that had characterized Matisse's voice is now gone abruptly. "Poussin and El Greco have been dead 300 years and you consider *them* in your procedure!" He ends up: "The only hope for American art is for the painters there to stay home; they have a new untried country with beautiful skies and beautiful women—what more do you need?" '
13 For other discussions of Matisse's voyage to Tahiti, see Texts 9, 28, 29, 39, 42, below.
14 Cf. Text 39, below.
15 The Collection of Albert C. Barnes, in Merion, Pennsylvania. Barnes, who owned several of Matisse's paintings, commissioned Matisse to do the famous Dance mural (see Texts 11 and 41, below) for the Barnes Foundation.
16 Matisse's earliest collectors and patrons had been Russians and Americans. See Barr, pp. 57–203.
17 This idea had great appeal to Matisse. See Text 25, below.
18 Matisse had himself won the Carnegie prize in 1927 (see p. 5, above).

9 COURTHION: MEETING WITH MATISSE

1 Pierre Courthion, 'Rencontre avec Matisse', *Les Nouvelles littéraires*, 27 June 1931, p. 1; translated by permission of the author.
2 Matisse had been able to see works by Goya and El Greco at Durand-Ruel's gallery during the 1890s, including the latter's *View of Toledo*.
3 From 'Notes of a Painter'.
4 Matisse had visited Tahiti in the spring of 1930.
5 (Figure 3.) Matisse also did a variation on this still-life between 1915 and 1917. (Barr, p. 170.)
6 By Chardin; copied 1894–1900. (Schneider, p. 131.)

7 Copying Cézanne is not meant literally, but in spirit. Cf. Cézanne's *Le golfe de Marseilles vu de l'Estaque*, c. 1885 (F. Novotny, *Cézanne*, London, 1961, p. 22) and Matisse's view of *Saint-Tropez*, 1904 (Jean Guichard-Meili, *Matisse*, New York, 1967, p. 45); or various still-lifes (Guichard-Meili, pp. 22–3). This influence, especially from Matisse's own Cézanne *Trois baigneuses*, may be seen in *Le dos IV*, 1929–30, and in the Barnes Murals.
8 Copied c. 1895. (Barr, p. 293.)
9 By Raphael, copied, c. 1894. (Guichard-Meili, *op. cit.*, p. 39.)

10 STATEMENT TO TÉRIADE [ON CREATIVITY]

1 E. Tériade, 'Propos de Henri Matisse', *Minotaure*, I, 3–4, 1933, p. 10. Reprinted *Verve*, IV, 13; December 1945, p. 20. Translated by permission of Albert Skira.

2 In 1943, Matisse told Aragon: 'To get away from the individuality of the artist who relegates to the second level the intimate character inherent in the thing in question like Raphael, Renoir, etc., who seem to have always painted from the same woman . . .

I copied . . . photographs, forcing myself to make the greatest resemblance possible; an image with as good a likeness as possible. I thus limited the field of possible evolutions from my imagination. It was still an error, but what a lot of things I learned from it!' Louis Aragon, 'Matisse-en-France', *Henri Matisse dessins: thèmes et variations*, Paris, 1943, p. 36.

3 The river that rises in the Alpes Maritimes and enters the sea at Nice.

11 LETTERS TO ALEXANDRE ROMM

1 The French originals have recently been published in *Matiss. Živopis, skul'ptura, grafika, pisma*, Leningrad, 1969, pp. 130–3. Two of the letters on the Barnes Murals were first published in *Iskusstvo*, 4, 1934, pp. 199–203.

2 Alexandre Romm, *Henri Matisse*, Moscow, 1935; an English translation was published in New York in 1947.

3 *Matiss* [*sic*], Leningrad, 1969, p. 134.

4 See for example: Dorothy Dudley, 'The Matisse fresco in Merion, Pennsylvania', *Hound and Horn*, VII, 2; January–March 1934, pp. 298–303; Escholier, 1937, pp. 138–41; Gaston Diehl, 'Matisse: A la recherche d'un art mural', Paris, *Les Arts et les lettres*, no. 20, 19 April 1946, pp. 1, 3; also Text 41, below.

5 The first version dates from 1931–2, the second

from 1932–3. For a detailed discussion of the project see Barr, pp. 241–4.

6 *Poésies de Stéphane Mallarmé*, Lausanne, 1932.

7 One of the two versions of *Nature morte, Séville* of 1911. (Schneider, cat. no. 104 and addendum to no. 104: pp. 77, 107 and Errata Addenda, n.p.)

8 For additional background and comments on these compositions see Barr, pp. 132–8.

9 Matisse had visited Renoir at Cagnes in 1917–18.

10 Shchukin, fearing a scandal, was uneasy about having such a large painting of nudes in his house, and had asked Matisse to paint out the boy flautist's sex, which Matisse refused to do (Barr, p. 134). Shchukin then had it done when the painting was delivered. Matisse's request to Romm evidently went unheeded, since in autumn 1970 the painting still had a spot of red over the boy's sex.

12 ON MODERNISM AND TRADITION

1 Henri Matisse, 'On Modernism and Tradition', *The Studio*, IX, 50; May 1935, pp. 236–9.

2 Henri Matisse, 'Confrontations', *Formes*, I, 11 January 1930, p. 11.

3 Cf. Cézanne (letter to Roger-Marx, 23 January 1905): 'To my mind one should not substitute oneself for the past, one has merely to add a new link.' (John Rewald, *Paul Cézanne, Letters*, London, 1941, p. 248.)

4 Roger Fry, 'Henri Matisse', *Cahiers d'Art*, VI, 5–6, 1931, p. 63.

5 Cf. Cézanne (letter to Émile Bernard, 1905): 'The Louvre is the book in which we learn to read.' (Rewald, *op. cit.* p. 250.) 'Go to the Louvre. But after having seen the great masters who repose there, we must hasten out and by contact with nature revive in us the instincts and sensations of art that dwell within us.'

(Cézanne to Camoin, 13 September 1903, in Rewald, *op. cit.* p. 230.)

6 André Derain (1880–1954), whom Matisse had met at Carrière's studio in 1901. It was at Collioure in the summer of 1905 that Matisse and Derain painted their first purely Fauve canvases.

7 Henri-Édmond Cross (1856–1910) with whom Matisse worked in the summer of 1904 at St. Tropez.

8 An allusion, perhaps, to Picasso's Symbolic Cubism of this period.

9 The incident seems to have taken place at the 1906 Salon des Indépendants (Georges Duthuit, *The Fauvist Painters*, New York, 1950, p. 35). Vauxcelles himself credited Matisse with helping to coin the term. (See Barr, p. 56).

13 STATEMENT TO TÉRIADE [THE PURITY OF THE MEANS]

1 E. Tériade, 'Constance du fauvisme', *Minotaure*, II, 9; 15 October 1936, p. 3. Translated by permission of Albert Skira.

2 As in such paintings as *Grande robe bleue, fond noir* of 1937 (Figure **39**).

3 The same statement is published by Escholier (1937, p. 168; 1956, pp. 134–5) with some slight

changes in wording and with the addition here of: 'A kilogramme of green is greener than half a kilo. Gauguin attributes this saying to Cézanne in a visitor's book at the house of Marie Gloanec at Pont-Aven.'

4 Escholier, 1937, has this paragraph end with: 'It all depends on the feeling you're after.'

5 This sentence is omitted from the Escholier version.

14 ON CÉZANNE'S 'TROIS BAIGNEUSES'

1 Escholier, 1937, p. 17; *idem*, 1956, p. 50.

2 For an account of Matisse's purchase of the painting, see Barr, pp. 38–40.

15 DIVAGATIONS

1 Henri Matisse, 'Divagations', *Verve*, I, 1; December 1937, pp. 80–4.
2 See Barr, pp. 222–3.
3 The American painter Stuart Purser, for example, recalls that when he visited Matisse in 1938, Matisse was pleased when Purser expressed not only his own enthusiasm for Matisse's drawings, but that of his students and colleagues. Purser has noted that Matisse seemed to feel at this time that his drawing had the widest appeal of all his work.
4 See interview with Jacques Guenne (Text 7, above) for Matisse's account of his own experience as a teacher.
5 The reference is to the well-known passage in Leonardo's notebooks. See for example Elizabeth G. Holt, *A Documentary History of Art*, Garden City, N.Y., 1957, vol. I, p. 283.
6 Matisse had brought Rodin some drawings in 1900, and was apparently rebuffed by the master. Maurice Denis relates that Rodin told Matisse: 'Fuss over it, fuss over it. When you have fussed over it two weeks more, come back and show it to me again.' (André Gide, *Journal*, New York, 1947, I, p. 174.) Matisse gave Escholier (1956, pp. 161–2) his own version of the story as follows: 'I was taken to Rodin's studio in the rue de l'Université, by one of his pupils

who wanted to show my drawings to his master. Rodin, who received me kindly, was only moderately interested. He told me I had facility of hand, which wasn't true. He advised me to do "fussy" drawings and to show them to him. I never went back. In order to understand my direction, I figured I had need of someone's help to arrive at the right kind of detailed drawings. For, proceeding from the simple to the complex (but it's the simple which is difficult to explain), when I had mastered the details, I would have finished my work: that of understanding myself.
'My work-discipline was already the reverse of Rodin's. But I did not realize it then, for I was quite modest, and each day brought its revelation.
'I could not understand how Rodin could work on his Saint John, cutting off the hand and holding it on a peg; he worked on the details holding it in his left hand, it seems, anyhow keeping it detached from the whole, then replacing it on the end of the arm; then he tried to find its direction in accord with his general movement.
'Already, for myself I could only envisage the general architecture, replacing explanatory details by a living and suggestive synthesis.'
7 Michel Bréal (1832–1915), a well-known philologist and semantic scholar.

16 MONTHERLANT: LISTENING TO MATISSE

1 Henry de Montherlant, 'En écoutant Matisse', *L'Art et les Artistes*, XXXIII, 189; July 1938, pp. 336–9. Translated by permission of Henry de Montherlant's Executor.
2 Though Matisse refused to illustrate both of these books he later did illustrate a limited edition of *Pasiphäe* for Fabiani, published in 1944. He was to repeat his ideas on the role of illustration in his interview with Georges Charbonnier in 1950 (see Text 41, below).
3 The novelist Maurice Barrès (1862–1923), who described Hugo's magnificent funeral in a chapter of *Les déracinés* (1897).
4 Louis Lyautey (1854–1934), General, later Maré-

chal de France and writer, served in the colonies in Indochina and Madagascar with General Joseph Galliéni (1849–1916).
5 Matisse, on the other hand, was to note that from the time he chose a career as an artist he was pushed on 'by I do not know what, a force that I see today is quite alien to my normal life as a man'. (Escholier, 1956, p. 18.)
6 Matisse had also just expressed this idea in 'Divagations'. He was doubtless aware that an artist's writings and statements could be quite relevant to other artists. As has been noted, Matisse was himself keenly aware of the effect of statements by other artists (Cézanne, etc.) on his own thought.

17 NOTES OF A PAINTER ON HIS DRAWING

1 Henri Matisse, 'Notes d'un peintre sur son dessin', *Le Point* no. 21, July 1939, pp. 104–10.
2 When Matisse was compared to the famous juggler, Rastelli, around 1930, he replied: 'No, rather I am an acrobat'. (Escholier, 1956, p. 145.) Matisse later did compare himself to a juggler ('How I Made My Books', Text 27, below).

3 In 1943, Matisse told Aragon: 'I do not paint things, I paint only the difference between things. . . . Consider, . . . in the same series of drawings, the dress or the fabric . . . you will find that in each drawing they have the same quality as in the whole series. And thus with other elements. There is, then, in these series, a descriptive part of the objects which remains

unchanged from one drawing to the next. . . . Even if I feel like adding a few little embellishments to it! Only the expression of the model has changed.' Louis Aragon, 'Matisse-en-France', *Henri Matisse dessins: thèmes et variations*, Paris, 1943, p. 37.

4 The jewels and arabesques here referred to are those which Matisse often used in his prints and drawings. Cf. William S. Lieberman, *Matisse: 50 Years of His Graphic Art*, New York, 1956, pp. 114–17.

5 Cf. Matisse: 'Isn't a drawing a synthesis, the culmination of a series of sensations retained and reassembled by the brain and let loose by one last feeling, so that I execute the drawing almost with the irresponsibility of a medium?' (Aragon, *op. cit.* p. 34.)

6 The 'someone' here and directly below refers to Gertrude Stein, by whose descriptions of Mme Matisse (*The Autobiography of Alice B. Toklas*, first published 1933; New York, 1955, pp. 35ff) Matisse had been incensed enough to write a rebuttal for *Testimony Against Gertrude Stein*, The Hague, 1935, pp. 3–5.

7 This was a recurring idea in Matisse's discussion of drawing. See for example Gaston Diehl, 'Henri Matisse le méditerranéen nous dit', *Comœdia*, 7 February 1942, p. 1: 'The drawing should generate light. . . . To modify the diverse parts of the white paper, it suffices to play the neighbouring areas against each other.'

18 CARCO: CONVERSATION WITH MATISSE

1 Francis Carco, 'Conversation avec Matisse', *L'ami des peintres*, Paris, 1953, pp. 219–38 (originally published in *Die Kunst-Zeitung*, Zurich, 8, August 1943); interview dates from 1941. © Editions Gallimard 1953 translated by permission.

2 In 1900 Matisse and Marquet had taken jobs at the theatrical scenery atelier of Jambon, near the Butte-Chaumont.

3 Fernande Olivier, Picasso's mistress, and author of *Picasso et ses amis*, Paris, 1933.

4 Cf. *Autobiography of Alice B. Toklas* (first published 1933; New York, 1955, p. 36). Matisse actually had studied law, not pharmacy. This was one of many parts of Gertrude Stein's account that Matisse refuted in *Testimony Against Gertrude Stein*, The Hague, 1935.

5 Max Jacob and Picasso at that time lived at 13 rue de Ravignan in the building known as 'Le Bateau-Lavoir'. Frédé, the proprietor of the 'Lapin Agile' cabaret, was a well-known local character.

6 Cf. *Autobiography of Alice B. Toklas*, p. 37: 'She was a very straight dark woman with a long face and a firm loosely hung mouth like a horse'.

7 *La femme au chapeau* was of course painted in 1905. The reference here is possibly to the portrait of Mme Matisse, *Le Madras rouge*, 1907, Barr, p. 350. Matisse did not move to Issy, however, until 1909, and there may be some confusion here with *Mme Matisse* of 1913, Barr, p. 392.

8 The Cézanne *Trois baigneuses* which Matisse had bought from Vollard in 1899. Despite his poverty at the time, he held on to the painting, which he gave to the Musée du Petit Palais in 1936. (See Text 14, above.)

9 In 1947 Matisse, speaking of abstract painting, remarked to Escholier: 'Starting as I do from direct contact with nature, I have never wanted to be confined inside a doctrine whose laws would prevent me from getting health and strength through contact with the earth; like Antaeus.' (Escholier, 1956, p. 95.) Matisse discussed this relationship with Gaston Diehl ('Les nourritures terrestres de Matisse', *XXᵉ Siècle*, 2, 18 October 1945, p. 1): 'If it were only a matter of arranging some flowers, for example, in a vase, in order to make a motif for drawing or painting, art would be quite an easy thing. In reality there is a much

more important question to resolve. This spectacle creates a shock in my mind. It is that which I have to represent, that which comes forth from myself.

'I turn to nature to find the essence of each thing. The means we use are beautiful in themselves, it is quite useless to add to them, and nature is herself beauty and richness. It is a question of choice. But it is always necessary to choose and to compose in order to express oneself. In that way one moulds the brain of the spectator.'

10 A street festival in Nice.

11 A popular music hall in Montmartre.

12 Kees Van Dongen (1877–1934), one of the original Fauve group.

13 A French dance.

14 The Barnes collection is actually in Merion, Pennsylvania. The reference here may not be to the Barnes *Danse* of 1931–3, but to the 1909 *Danse* which in 1941 was in the collection of Walter P. Chrysler (cf. Text 41, below).

15 Georges Louis Leclerc Buffon (1707–1778), a famous naturalist, director of the Jardin du Roi, who wrote extensive works on plants and animals. Matisse's memory of the incident is perhaps somewhat confused. The archives of the Musée National d'Histoire Naturelle reveal that the statue of Buffon in the Jardin des Plantes was executed by Jean-Marius-Siméon Carlus (1852–1930), a student of Falguière and Mercié. The Buffon statue was done for the 1907 bicentennial anniversary of Buffon's birth. In 1903 Carlus did a bust of the museum director, Edmund Perrier, which evidently led to the Buffon commission. It is therefore possibly the bust of Perrier that Matisse remembers being executed, not the statue of Buffon.

16 The painter Eugène Carrière (1849–1906).

17 Jean Puy (1876–1960), Pierre Laprade (1875–1932), Auguste-Elisée Chabaud (1882–1955).

18 The original is '*Attention! V'là l'dégel!*' Idiomatically, the phrase also connotes a loss of innocence. In this context, Matisse is chiding Laprade for acquiring a glib facility, which resembled that of Carrière's soft (melted) forms.

19 Jean-Louis Forain (1852–1931) was an Academic painter and a critic. The allusion is to the hazy forms in Carrière's painting.

20 Auguste Pegurier (1856–1936).
21 The painter Henri Lebasque (1865–1937) had left Paris in 1900 for reasons of health. Matisse later (1917–18) visited Renoir at Cagnes.
22 *Pintre*, a variant of *pinter*, 'to tipple', a pun on *peintre*, 'painter'.
23 *Annuaire Almanach du commerce et de l'industrie* (*Didot-Bottin*), the commercial directory found in French post offices and cafés.
24 Both painters did several pictures of these views. See Barr, pp. 68–9, 309.
25 Berthe Weill owned the first private gallery to exhibit Matisse (February 1902). Albert Sarraut (1872–1962), an acquaintance of several Paris School personages, was a well-known politician and connoisseur, and author of many pieces on modern art.
26 Frank Harris (1854–1931), the novelist, dramatist, biographer, and bon vivant.
27 *Autobiography of Alice B. Toklas*, p. 37. Matisse denied this statement in *Testimony Against Gertrude Stein*, p. 4.
28 Louis Mæterlinck (1846–1926), painter and art historian; also director of the Musée de Grand.
29 Probably *Nature morte rouge au magnolia* (Figure 41).
30 Eugène Fromentin (1820–1876), painter, novelist, and author of a classic treatise on seventeenth-century Dutch and Flemish painting.
31 Leopold Zborowski (1889–1932).
32 Françoise Gilot (*Life with Picasso*, New York–Toronto–London, 1964, pp. 99–100) notes their lasting rivalry, as well as their mutual respect (pp. 261–4).
33 A reference to Balzac's short story 'Le chef-d'œuvre inconnu', in which the painter Frenhofer

secretly labours to produce a perfect painting; after ten years of work on the canvas, he shows it to two young painters who find it incomprehensible. Kurt Badt (*The Art of Cézanne*, Berkeley and Los Angeles, 1965, pp. 202–05) relates the story to the whole problem of 'realization' that has confronted modern painting since the nineteenth century. Although Carco's comparison seems unfair, Matisse during the early 1940s was in fact having very great problems with the 'realization' of his works. The nature and intensity of his feelings at this time are well described in a letter to Pierre Bonnard (13 January 1940): 'Your letter has found me knocked out this morning, completely discouraged. . . . For I am paralysed by something conventional which keeps me from expressing myself in painting as I would like. My drawing and my painting are separated.

'My drawing suits me, for it renders my particular feelings. But I have a painting, bridled by new conventions of flatness through which I should express myself entirely, exclusively in local tones, without shading, without modelling, which should react with one another to suggest light, spiritual space. This hardly goes with my spontaneity which makes me balance a large work in a minute because I reconceive my picture several times in the course of its execution without knowing where I am going, relying on my instinct. I have found a drawing which, after the preliminary work, has the spontaneity which empties me entirely of what I feel, but this means is exclusively for me, artist and spectator. But a drawing by a colourist is not a painting. He must produce an equivalent in colour. It is this which I do not achieve.' ('Correspondence Matisse-Bonnard, 1925–46', *La Nouvelle Revue Française*, XVIII, 211, 1 July 1970, p. 92.)

19 ON TRANSFORMATIONS

1 *First Papers on Surrealism*, New York, 1942, not paginated. The letter is dated 7 June 1942.

20 MATISSE'S RADIO INTERVIEW: FIRST BROADCAST

1 This text is translated from a French transcript very kindly made available to me by M. Pierre Schneider.
2 Excerpts from both broadcasts are published in Barr, pp. 562–3. The first broadcast probably dates to mid-January 1942 (the 13 March transcript says it appeared 'about two months ago').
3 In 1918 Matisse had written in a letter to Camoin (23 May 1918): 'What a lovely place Nice is! What light, soft and tender despite its brilliance.' And in 1943, he told Aragon: 'Nice . . . why Nice? In my art I have tried to create a crystalline state for the mind: this necessary limpidity I have found in several places in the world, in New York, in Oceania, in Nice.

If I had painted in the north as thirty years ago, my painting would have been different: there would have been mists, greys, gradations of colour through perspective. In New York the painters say, 'we can't paint here, with this sky made of zinc!' In fact, it is admirable. Everything becomes clear-cut, crystalline, precise, limpid. Nice, in this way, had helped me. You must understand that what I paint are objects thought of in plastic terms: if I close my eyes, I see the objects better than with my eyes open, free of accidental detail; that is what I paint. . . .' (Louis Aragon, 'Matisse-en-France', *Henri Matisse dessins: thèmes et variations*, Paris, 1943, p. 32.)

21 CONVERSATION WITH ARAGON [ON SIGNS]

1 Louis Aragon, 'Matisse-en-France', in *Henri Matisse dessins: thèmes et variations*, Paris, 1943; reprinted in Louis Aragon, *Henri Matisse* (translated by Jean Stewart), London—New York, 1972. Translation © Collins and Harcourt Brace Jovanovich.

22 HENRI-MATISSE AT HOME

1 Marguette Bouvier, 'Henri-Matisse chez lui', *Labyrinthe*, I, 15 October 1944, pp. 1–3. Translated by permission of Albert Skira.
2 A Moorish carved and inlaid screen.
3 These paintings (*Femme endormie; Annélies, tulipes, anémones*, etc.) are illustrated in Bouvier's article; cf Barr, p. 492.

4 The girl Annélies appears in a photograph with Matisse on p. 2 of Bouvier's article.
5 Cf. Aragon, Text 21, above, on the rendering of trees.

23 THE ROLE AND MODALITIES OF COLOUR

1 Henri Matisse, 'Rôle et modalités de la couleur', in Gaston Diehl, *Problèmes de la peinture*, Lyons, 1945, pp. 237–40.
2 Escholier, 1956, p. 97, notes that the young Victor Hugo first connected Chinese art with Ingres in *Conversation Littéraire*, 1819, while speaking of the Ingres *Odalisque*.
3 *Crépons:* Brightly coloured Japanese prints on crêpe paper. In a letter to A. Rouveyre (15 February 1942) Matisse made an interesting observation on these *crépons*: 'I knew and profited from the Japanese through reproductions, the poor prints bought on the rue de Seine in the boxes carried by the print mer-

chants. Bonnard told me the same thing, and added that when he had seen the originals he found them a bit disappointing. That is explained by the patina and the discolouration of the old prints. Perhaps if we had only had the originals to look at, we would not have been as impressed as by the reprints.' (Cited in Schneider, p. 117.)
4 Léon Bakst had done the settings for Diaghilev's *Scheherazade*. For more on Bakst's designs see Deborah Howard, 'A Sumptuous Revival: Bakst's Designs for Diaghilev's Sleeping Princess', *Apollo*, XCI, 98; April 1970, pp. 301–08.

24 OBSERVATIONS ON PAINTING

1 Henri Matisse (Observations on Painting, untitled), *Verve*, IV, 13; December 1945, pp. 9–10; translated as 'Observations on Painting', by Douglas Cooper, *Horizon*, XIII, 75; March 1946, pp. 185–7. Retranslated here using Cooper's title.
2 Probably *Nature morte, bouteille de menthe*. (Meyer Schapiro, *Paul Cézanne*, New York, 1952, p. 97.)
3 Matisse clarifies this with his comparison of Ingres and Delacroix, below.

4 Cf. Matisse, *Portraits*, Text 44, below.
5 See Note 2 to Text 23, above.
6 Cf. Cézanne (letter to Camoin, 9 December 1904): 'Whoever the master is whom you prefer, this must only be a directive for you. Otherwise you will never be anything but an imitator.' (John Rewald, ed., *Paul Cézanne, Letters*, London, 1941, p. 241.)

25 INTERVIEW WITH DEGAND

1 Léon Degand, 'Matisse à Paris', *Les Lettres françaises*, 6 October 1945, p. 7. Translated by permission of *Les Lettres françaises*.
2 The panel was commissioned by an Argentine

diplomat in Paris. Although begun in 1944, it was not finished until 1947. (See Barr, pp. 269–70, 493.) At the time of Degand's visit, the panel was provisionally 'finished'.

26 BLACK IS A COLOUR

1 Henri Matisse, 'Témoignages de peintres: Le noir est une couleur', *Derrière le miroir*, Paris: Maeght, December 1946, pp. 2, 6, 7.
2 Matisse does not mean that he had given up the use of black, but that he no longer used it merely for linear construction as in his earlier works. Actually at this time Matisse was making great use of black as a

colour instead of as an element of linear construction.
3 *Déjeuner à l'atelier*, 1868. The man in the black coat is Léon Koëlla. (Illustrated: Georges Bataille, *Manet*, New York, 1955, p. 79.)
4 *Zacharie Astruc*, 1864 (Bataille, *op. cit.*, p. 21).
5 *Les Marocains*, 1916; Barr, p. 172.

27 HOW I MADE MY BOOKS

1 Henri Matisse, 'Comment j'ai fait mes livres', in *Anthologie du livre illustré par les peintres et sculpteurs de l'école de Paris*, Geneva, 1946, pp. 21–4. For an informative discussion of Matisse's illustrated books see Barr, pp. 270–5.

2 Matisse discussed his outlook on book illustration with Escholier (1956, p. 153): 'I agree with your distinction between the illustrated and the decorated book. A book should not need completion by an imitative illustration. Painter and writer should work together, without confusion, on parallel lines. The drawing should be a plastic equivalent of the poem. I wouldn't say first violin and second violin, but a concerted whole.'

3 Matisse's first book, *Poésies de Stéphane Mallarmé*, Lausanne, 1932. It is interesting to note that Matisse does not consider books illustrated by drawings not specifically done for them (such as Reverdy's *Les Jockeys camouflés* of 1918) or even designs not related to the text (such as Joyce's *Ulysses* of 1935), as his 'Illustrated books', but confines the term to books which were the result of close collaboration between him and the publisher. The history of the Mallarmé book is given by Barr, pp. 244–6.

4 Henry de Montherlant, *Pasiphäé: Chant de Minos (Les Crétois)*, Paris, 1944. Matisse spoke of this book to Gaston Diehl, 'Matisse, illustrateur et maître d'œuvre', *Comœdia*, 132, 22 January 1944, p. 1: 'The

important thing is to create its substance. One lives with it in order to understand its demands, its possibilities. Little by little one ventures forward, one perfects the rapports. These, in their turn, will permit me to colour my blacks like my whites, to animate my surfaces and therefore to give the image the interior rhythm which corresponds to the expression of the author.'

5 Pierre Reverdy, *Visages*, Paris, 1946; *Florilège des Amours de Ronsard*, Paris, 1948; Marianna Alcaforado, *Les Lettres portugaises*, Paris, 1946. For a full list of Matisse's illustrated books, see Barr, pp. 559–60. Matisse also gave an interesting account of the Ronsard illustrations to Marguette Bouvier, 'Henri Matisse illustre Ronsard', *Comœdia*, 80, 9 January 1943, pp. 1, 6.

6 Speaking of these linoleum cuts, Matisse told Gaston Diehl ('Avec Matisse le classique', *Comœdia*, 102, 12 June 1943, p. 6): 'Three elements are in play: the linoleum, the gouge, and the *bonhomme*. It suffices to arrive at an accord between them, that is to express oneself according to the materials, to live with them. Gustave Moreau loved to repeat "The more imperfect the means, the more the sensibility manifests itself". And didn't Cézanne also say: "It is necessary to work with coarse means"? Here, to do things with such simple means, but at the same time in a very delicate manner, it is necessary to feel deeply, the sensation must burst forth definitively and totally.'

28 OCEANIA

1 Henri Matisse, 'Océanie, tenture murale', *Labyrinthe*, II, 3, pp. 22–3, December 1946. The compositions are reproduced along with the text.

2 The Tahiti trip of 1930. The tapestries were produced by Ascher and Company, London, in a limited edition of thirty.

29 JAZZ

1 Henri Matisse, *Jazz*, Paris, 1947.

2 The book was published on 30 September 1947. The plates were executed by Edmond Vaivel after the *découpages* of Matisse, using the same colours. The cover and manuscript pages were printed by Draeger Frères. The edition consisted of 250 numbered copies (and twenty copies, numbered I–XX, *hors commerce*) on vellum. All were signed by the artist. In addition 100 albums of plates only were printed.

Matisse had done *papiers découpés* for *Verve*, I, 1; December 1937, and in June 1943 a *Fall of Icarus* for *Verve*, IV, 13; December 1945, which is an early version of the *Jazz* plate 'Icarus'. Although Matisse had earlier used cut paper for the Barnes Murals and other works, these were his first uses of the cut-out as a medium in itself.

3 The text to *Jazz* is divided into sixteen sections. Some sections are introduced by a title, others by an underlined opening phrase.

4 See Barr, pp. 274–5.

5 For example, compare Matisse's 'Clown' (Frontispiece to *Jazz*) with the 1917 photograph of Nicolas Zverew as the Acrobat in *Parade* (Douglas Cooper, *Picasso théâtre*, Paris, 1967, fig. 78). For other striking parallels, see the *Parade* costumes of the Chinese Conjurer (Cooper, figs. 83–4), the French and American Managers (Cooper, figs. 85–7), and the Horse (Cooper, fig. 89), as well as the scenery (Cooper, figs. 99–100).

6 For a detailed description of the *Parade* performance, see Cooper, *op. cit.* pp. 13–34; also Roger Shattuck, *The Banquet Years*, revised ed., London, 1969, pp. 156–8. (Shattuck, *loc. cit.*).

7 In 1916 Picasso and Matisse had sponsored a Granados–Satie concert. Matisse returned to Paris from his first season in Nice in the late spring of 1917. (Barr, p. 183.) On 16 August 1917 Satie, in a letter to Jean Cocteau, wrote: 'If you see Matisse give him my

best and fondest regards [*dites lui mille choses de ma part, et combien je l'aime*].' (Cooper, p. 342.)

8 In an interview with Matisse, Gaston Diehl ('La leçon de Matisse', *Comœdia*, 146–7, 29 April 1944, p. 4) notes that Matisse was working 'on a series of cut and pasted paper compositions which will form an album entitled "Circus" or perhaps "Jazz" ', and notes that several of the compositions were 'already composed'.

9 Jazz music came to Paris in 1918 when an American Negro orchestra played at the Casino de Paris. Satie's use of jazz was its first concert treatment in French music. (See Shattuck, *op. cit.* p. 155.)

10 This section is a condensation of two of the themes of 'Exactitude is Not Truth', Text 32, below.

11 So did Matisse; he also passed this advice on to his students in 1908 (See 'Sarah Stein's Notes', Text 4).

12 This section ends with the parenthetical note '(*Tm. de JC*)'. The reference to Jesus is of course a general paraphrase on love. See, for example, I John 4; Luke 10: 27.

13 Cf. Matisse's recollection of the lagoons in Tahiti in 'Oceania', Text 28, above: and 'Interview with Verdet', Text 42, below. Three of the plates in *Jazz* (XVII–XIX) are entitled 'Lagoon'.

14 Cf. Matisse to Aragon (Text 21, above): 'Perhaps after all, without knowing it, I believe in a life to come, in some paradise where I shall paint frescoes . . .'

15 Angèle Lamotte, Tériade's collaborator on *Verve*, had died early in 1945.

30 ANDRÉ MARCHAND: THE EYE

1 André Marchand, 'L'Œil', in Jacques Kober, ed., *Henri Matisse*, Paris: Pierre à Feu (Maeght), 1947, pp. 51–3. Translation by permission of the publisher Marchand, a somewhat eclectic painter, was active in Paris after World War II.

2 Cf. Cézanne (letter to Emile Bernard, 23 December 1904): 'An optical impression is produced on our organs of sight which makes us classify as *light*, half-tone or quarter-tone the surfaces represented by colour sensations. (So that light does not exist for the painter.)' John Rewald, *Paul Cézanne, Letters*, London, 1941, p. 243.

3 Matisse was in Corsica in 1898.

31 THE PATH OF COLOUR

1 Henri Matisse, 'Le chemin de la couleur', *Art Présent*, 2, 1947, p. 23.

2 See C. R. Morse, 'Matisse's Palette', *Art Digest*, VII, 15 February 1933, p. 26.

3 Upon the opening of the Le Cateau Museum in 1952, Matisse recalled when he first realized his vocation as a painter: 'I was constantly aware of my decision, and despite the certitude that I had found my true vocation, one in which I was in my own element and not hemmed in as in my earlier life, still I was frightened, realizing that there was no turning back. So I plunged headlong into the work at hand, following the principle that I had had drummed into me all my life, which was "Hurry up!" Just like my parents, I got on with my work as quickly as possible, driven on by something, I do not know what, by a force which I see today as something alien to my normal life as a man.' (Escholier, 1956, p. 18.)

4 Brightly coloured Japanese prints on crêpe paper. See 'Role and Modalities of Colour', Text 23, above.

5 There were two important exhibitions of Islamic art that Matisse seems later to have confused. (Barr, p. 90, n. 5.) The first was in Paris in 1903, the second in Munich in 1910. Although the 1903 exhibition seems to be the one referred to here, Matisse could well be actually referring to the later exhibition, since that period in his art was as revolutionary as the developments of 1903, especially in terms of spatial conception.

32 EXACTITUDE IS NOT TRUTH

1 Henri Matisse, 'Exactitude is not Truth', in Philadelphia Museum of Art, *Henri Matisse: Retrospective*, Philadelphia, 1948, pp. 33–4. Translation by Esther Rowland Clifford, reprinted by permission of the Philadelphia Museum of Art. The text was written in May 1947. The title phrase comes from a saying of Delacroix.

33 LETTER TO HENRY CLIFFORD

1 Henri Matisse, 'Letter from Matisse to Henry Clifford', in Philadelphia Museum of Art, *Henri Matisse: Retrospective*, Philadelphia, 1948, pp. 15–16. The present text is translated from a copy of the original letter, which was very kindly sent me by Mr. Henry Clifford. The French version of the letter published in *Henri Matisse: Les grandes gouaches découpées* (Paris, 1961), is not a true copy, but rather a translation into French of the English version published in the Philadelphia catalogue. It is interesting

to note that, contrary to edited versions of the letter, Matisse actually suggested that the letter be published in 'the explanatory part' of the Philadelphia catalogue.
2 There is a striking similarity between certain parts of Matisse's letter and some of Bouguereau's remarks in an address to the Institut de France in 1885, in which he stresses the importance of studying to acquire technical skill, for ' . . . can greater misery be conceived than that experienced by the artist who feels the fulfilment of his dream compromised by the impotence of his execution?' (Linda Nochlin, ed., *Realism and Tradition in Art, 1848–1900*, Englewood Cliffs, 1966, p. 10.)
3 Cf. Cézanne (letter to Emile Bernard, 25 July 1904): 'To achieve progress nature alone counts, and the eye is trained through contact with her.' (John Rewald, *Paul Cézanne, Letters*, London, 1941, p. 239.)
4 Correggio's statement, '*Anch'io son pittore*', is supposed to have been uttered by the artist before the Raphael *St. Cecilia* at Bologna.

34 INTERVIEW WITH R. W. HOWE

1 Russell Warren Howe, 'Half-an-Hour With Matisse', *Apollo*, XLIX, February 1949, p. 29.
2 Matisse nevertheless had a great deal of regard for Delacroix, especially as a draftsman. (But see also Text 8, note 4.)
3 A gracious way of implying that he disapproves. Matisse reportedly enlarged on this in a conversation with Picasso around this time. Having received some catalogues with reproductions of American Abstract Expressionist Paintings, he noted: 'I have the impression that I'm incapable of judging painting like that for the simple reason that one is always unable to judge fairly what follows one's own work. One can judge what has happened before and what comes along at the same time. And even among those who follow, when a painter hasn't completely forgotten me, I understand him a little bit, even though he goes beyond me. But when he gets to the point where he no longer makes any reference to what for me is painting, I can no longer understand him. I can't judge him either. It's completely over my head.' Matisse then went on to say that Renoir had felt the same way about him. (Françoise Gilot, *Life with Picasso*, New York–Toronto–London, 1964, pp. 268–9.)

35 HENRI MATISSE SPEAKS TO YOU

1 'Henri Matisse vous parle', *Traits*, 8, March 1950, p. 5.
2. The plaster cast, presently at the Musée Matisse in Nice-Cimiez, is of an Argive Greek kouros. The original, which is identified as Cleobis by an inscription, is in the Museum at Delphi.
3 One of Le Corbusier's drawings of the statue is reproduced in *Traits* on the page facing Matisse's article.

36 THE TEXT [PREFACE TO THE TOKYO EXHIBITION]

1 Henri Matisse, 'Le Texte', in Tokyo National Museum, *Henri Matisse*, Tokyo, 1951, p.[2].
2 In 1950, at which the maquettes for the Vence Chapel and several of his sculptures had been shown for the first time.

37 THE CHAPEL OF THE ROSARY

1 Henri Matisse, 'La Chapelle du Rosaire', in *Chapelle du Rosaire des Dominicaines de Vence*, Vence, 1951.
2 In his letter to Bishop Rémond for the consecration of the Chapel, Matisse said of it: 'This work has taken me four years of exclusive and assiduous labour and it represents the result of my entire active life. I consider it despite its imperfections, to be my masterpiece . . . an effort which issues from a life consecrated to the search for truth.' (*L'Art sacré*, 11–12, 1951, pp. [2–3].) Interestingly, Matisse scrupulously avoids religious references in both these texts.

38 THE CHAPEL OF THE ROSARY [ON THE MURALS AND WINDOWS]

1 Henri Matisse, 'Chapelle du rosaire des Dominicaines de Vence', *France Illustration*, 320, 1 December 1951, pp. [561–70]; reprinted as 'La Chapelle de Vence, aboutissement d'une vie', *XXᵉ Siècle*, special number, 'Hommage à Henri Matisse' (1970), pp. 71–73.
2 The early studies for the Stations of the Cross were also more literally descriptive than the final, expressive ones. See Barr, pp. 520–1.
3 The Stations of the Cross panel is in fact one of Matisse's most violent departures from the art 'devoid of troubling or depressing subject matter', that he had stated as his goal in 'Notes of a Painter', and throughout his career.

39 MATISSE SPEAKS

1 E. Tériade, 'Matisse Speaks', *Art News Annual*, 21, 1952, pp. 40–71, reproduced by permission of *Art News*.
2 At St. Quentin Matisse had worked under a Professor Croisé at the École Quentin-Latour, primarily a school for textile and tapestry designers.
3 Actually Philbert-Léon Couturier (1823–1901), a student of the history and genre painter François Picot (1786–1868).
4 Auguste Joseph Truphème (1836–1898).
5 See Escholier (1937, pp. 30–1) for an elaboration.
6 The critic Roger Marx (1859–1913) had defended the Louvre copies of Matisse and other Moreau students and pleaded their case before the Purchase Committee. Marx later (winter 1901–02) introduced Matisse to Berthe Weill.

7 Matisse refers here to the 1915–17 variation of his 1893–5 copy of the De Heem painting. (See Barr, pp. 170–1.)
8 Barr, p. 315.
9 Of 1916. (Barr, p. 172.)
10 The so-called 'Moroccan Triptych' of 1912 (Barr, pp. 386–7).
11 In fact, Cézanne mentioned only spheres, cylinders, and cones.
12 Now the Musée de l'Homme.
13 *Les baigneuses* (Barr, p. 408) and the *Leçon de piano* are two of Matisse's largest and most austere early works.
14 James Tissot (1836–1902), a painter of exotic Eastern scenes.

40 TESTIMONIAL

1 Maria Luz, 'Témoignages: Henri Matisse', *XXᵉ Siècle*, n.s. 2; January 1952, pp. 55–7. Translated by permission of *XXᵉ Siècle*.
2 This 1940 picture, which had been repainted several times, seems to have been a favourite of Matisse.
3 The work referred to is *Poissons chinois*, 1951. (Pierre Reverdy and Georges Duthuit, *The Last Works of Henri Matisse*, New York, 1958, p. 31.)
4 *Table de marbre rose*, 1917. (Barr, p. 407.)
5 The dugong is, of course, a sea-dwelling mammal; there is a line drawing of it in the *Nouveau Larousse illustré*, the popular French encyclopaedia.

6 The figure referred to is not part of one of Matisse's compositions, but one of the several Chinese ceramic figures he owned.
7. The painter Othon Friesz (1879–1949), of whom Matisse had a low opinion. In 1935 he had written to Camoin describing a Friesz exhibition, which he called 'shabby'. (Escholier, 1956, p. 237.)
8. An excellent description of an essential difference between the conception of things in even his latest paintings and the cut-outs.

41 INTERVIEW WITH CHARBONNIER

1 Georges Charbonnier, 'Entretien avec Henri Matisse', *Le Monologue du peintre*, vol. II, Paris, 1960, pp. 7–16 © Editions Julliard 1960. This interview was recorded on tape in August 1950 and broadcast in January 1951.
2 The Shchukin painting (Figure 21).
3 This is an expansion of the same story that Matisse told Carco in 1941 (see Text 18) Georges Duthuit and Edward Steichen, however, have suggested folk origins for the dance theme. (See Barr, p. 135.)
4 Cf. 'Notes of a Painter', above, where Matisse also discusses repose and movement in works of art.
5 See Matisse's letter to Romm (14 February 1934), Text 11, above.
6 In 1946, Matisse told Gaston Diehl (*Les Arts et les lettres*, 19 April 1946): 'I had conceived this *Danse* long before, and had put it in the *Bonheur de vivre*, then in my first big dance composition. This time, however, when I wanted to make sketches on three canvases of one metre, I couldn't get it. Finally, I took three canvases of five metres, the very dimensions of the panels, and one day, armed with charcoal on the end of a bamboo stick, I set out to draw the whole thing at one

go. It was in me like a rhythm which carried me along. I had the surface in my head. But once the drawing was finished, when I came to colour it, I had to change all the pre-arranged forms. I had to fill the whole thing, and give a whole that would remain architectural. On the other hand, I had to stay in strict conjunction with the masonry, so that the lines would hold their own against the enormous, projecting blocks of the down-curving arches, and even more important, that the lines would follow across them with sufficient vitality to harmonize with each other. To compose with all that and to obtain something alive and singing, I could only proceed by groping my way and continually modifying my compartments of colours and blacks.'
7 Matisse spent a lot of effort on the design of this spire. In 1950 he told D. W. Buchanan that the spire was being changed because it looked 'too fragile', and would harmonize better with a heavier base. See Donald W. Buchanan, 'Interview in Montparnasse', *Canadian Art*, VIII, 2, 1950–1, pp. 61–5.
8 Barr (p. 281) recounts that when the poet Louis Aragon, a Communist, visited Matisse shortly after the first model of the Chapel had been constructed, Aragon

said of the model: 'Very pretty—very gay—in fact, when we take over we'll turn it into a dance hall.' Matisse replied: 'Oh no, you won't. I've already taken precautions. I have a formal agreement with the town of Vence that if the nuns are expropriated the Chapel will become a museum, a *monument historique!*'

9 Or, it is implied, like late Matisse. Matisse always kept his torment veiled from the outside world, and this reference to El Greco is an interesting statement of his evident belief that one's 'torment' could be sublimated and produce imagery like his own.

10 Matisse told Pierre Courthion: 'I took up sculpture because what interested me in painting was a clarifica-

tion of my ideas. I changed my method, and worked in clay in order to have a rest from painting where I had done absolutely all that I could for the time being. That is to say that it was done for the purpose of organization, to put order into my feelings and to find a style to suit me. When I found it in sculpture, it helped me in my painting. It was always in view of a complete possession of my mind, a sort of hierarchy of all my sensations that I kept working in the hope of finding an ultimate method.' (Jean Guichard-Meili, *Matisse*, New York, 1967, p. 168.)

11 Alain was the nom de plume of the French philosopher Emile-Auguste Chartier (1868–1951).

42 INTERVIEW WITH VERDET

1 André Verdet, 'Entretiens avec Henri Matisse,' in *Prestiges de Matisse* (Paris, 1952), pp. 37–76.

2 'Elle est l'élan passionnel qui gonfle ses dessins.' Pun on *élan* which means 'moose' or 'elk' as well as 'impulse' or 'enthusiasm'. Cf. Gustave Moreau (*Cahier IV*, p. 23, as cited in Ragnar van Holten, *Gustave Moreau*, Paris, 1960): 'Art is dead when, in composition, the reasonable combination of the mind and good sense come to replace, in the artist, the almost purely plastic imaginative conception—in a word, the love of the arabesque.'

3 The reference is to the series of blue cut-out female figures Matisse was then working on (see Figure 46).

4 A revealing example of Matisse's concern with *Gestalt* impressions, as opposed to Cézanne's concern with detailed analysis of visual sensations.

5 Cf. Matisse (in a radio interview, 1942, Text 20, above): 'An artist has no greater enemies than his bad paintings.'

6 The reference is probably to *Les légumes*, 1951 (signed 1952). Pierre Reverdy and Georges Duthuit, *The Last Works of Henri Matisse*, New York, 1958, p. 20.

7 Matisse's Chapel had indeed roused a good deal of speculation about his return to Catholicism. On 25 June 1951, the day of the consecration of the Vence Chapel, a Reuters dispatch stated untruthfully that Matisse had 'sent a message to the Bishop declaring that building the chapel had renewed his faith in God', and that Matisse had told the Bishop 'I started this work four years ago, and as a result I know now I believe in God.' (Barr, p. 287.) The 15 July issue of *La Vie catholique illustrée* published the story of the chapel under the headline ' "EVERY TIME I WORK I BELIEVE IN GOD" ', a misleading transposition of Matisse's somewhat less than religious statement in *Jazz* (Text 29, above). The attempt to align Matisse with the Church is also reflected in a curious little book composed of a few short quotations from Matisse (*Propos de Matisse: propos notés par le père Couturier*,

1956, unpaginated, printed in an edition limited to 35 copies) in which Matisse is quoted as having said: 'I told Picasso: yes, I pray, and you too, and you know it very well: when all goes badly, we throw ourselves into prayer to refind the climate of our first communion. And you do it, you too. Don't say no' (March 1949); 'One is led, one doesn't lead. I am only a servant.' 'Death is not at all final, it is a door which opens' (March 1952).

8 The École des Beaux-Arts was for Matisse a symbol of a certain kind of stupidity. In 1942 Matisse devoted most of a radio broadcast to the subject. In that interview he asked 'couldn't one give "travelling scholarships" to artists . . . so that they could go in freedom to study abroad, or in our Colonies or even in France, anywhere they feel that there is a possibility to develop and enrich themselves?' (Barr, p. 563.)

9 A recurrent theme in Matisse's later statements.

10 Trepang, or sea cucumber.

11 Matisse, recalling his 1907 visit to Italy, told Escholier, around the same time as the Verdet interview: 'In front of the primitives of Sienna, I thought "Here I am in Italy, the Italy of the primitives which I loved. When, in Venice, I came to the great Titian, Veronese, those wrongly termed Renaissance masters, I saw in them superb fabrics created for the rich, by those great sensuous artists of more physical than spiritual value." ' (Escholier, 1956, p. 86.)

12 La Réunion (Reunion Island), east of Madagascar.

13 Gustave Geffroy defended Cézanne in *Le Journal*, 16 November 1895. He also sat for an excellent portrait by Cézanne. His review of Matisse's *Femme au chapeau* in the 1905 Salon d'Automne had been unfavourable. In Matisse's 1913 interview with Clara MacChesney, Matisse had himself met this bourgeois misunderstanding of both modern and Antique art (see Text 6).

14 Louis Valtat (1869–1952).

15 Charles Estienne, *L'Art abstrait, est-il un académisme?*, Paris, 1950.

43 LOOKING AT LIFE WITH THE EYES OF A CHILD

1 Henri Matisse, 'Looking at Life with the Eyes of a Child', *Art News and Review*, London, 6 February 1954, p. 3. Vence is misprinted as 'Venice' twice in this article, and it is corrected in the version given here.

2 This occurs in some works of the Nice period, such as *Fenêtre ouverte*, 1921. (Schneider, p. 226.)

44 PORTRAITS

1 Henri Matisse, *Portraits*, Monte Carlo, 1954.
2 See Escholier, 1956, p. 193.
3 Though Matisse had remarked (Text 20, above) that ordinary portrait painters were being outdone by good photographers.
4 René Leriche, author of *Philosophie de la Chirurgie*, who operated on Matisse in 1941, and to whom Matisse in gratitude wrote, 'I owe you these few years, since they are a bonus. . . .' (Escholier, 1956, p. 207.)

5 Regarding this decisiveness, Matisse had told Aragon in 1943: 'When you slap someone, you obviously don't do it with softness and uncertainty. No, there is an impulse. And this impulse is not decision, it is conviction. You slap someone with conviction . . .' (Louis Aragon, 'Matisse-en-France', *Henri Matisse dessins: thèmes et variations*, Paris, 1943, p. 13.)

Bibliography

For works on Matisse up to 1951 the reader is referred to the excellent bibliography in Alfred H. Barr, Jr., *Matisse: his Art and his Public*, New York, 1951, and to Giovanni Scheiwiller, *Henri Matisse*, 5th edition, Milan, 1947, pp. 14–32.

General References

ACEVEDO, C. DE *Dibutade; ou, La représentation picturale des formes*. Paris, 1951.

ARNASON, H. H. *History of Modern Art*. Englewood Cliffs, 1968.

ASHTON, DORE *A Reading of Modern Art*. Cleveland and London, 1969.

BADT, KURT *The Art of Cézanne*. Berkeley and Los Angeles, 1965.

Baltimore Museum of Art *Paintings, Sculpture and Drawings in the Cone Collection*. Baltimore, 1967.

BARR, ALFRED H., JR. *Picasso: Fifty Years of his Art*. New York, 1946.

BARR, ALFRED H., JR. *Masters of Modern Art*. New York, 1954.

BARRY, JOSEPH A. *Left Bank, Right Bank: Paris and Parisians*. New York, n.d. (1951).

BAUDELAIRE, CHARLES *La Vie et l'œuvre d'Eugène Delacroix*. Paris, 1928.

BERGSON, HENRI *Creative Evolution*. New York, 1911.

BERNARD, EMIL 'Souvenirs sur Paul Cézanne et lettres inédites', *Mercure de France*, 1 and 15 October 1907.

BOIME, ALBERT *The Academy and French Painting in the Nineteenth Century*. London, 1971.

BRAQUE, GEORGES 'Pensées et reflections sur la peinture', *Nord-Sud*, December 1917, pp. 3–5.

BROCKWAY, WALLACE *Renoir to Matisse: The Albert D. Lasker Collection*. New York, 1957.

BURGESS, GELETT 'The Wild Men of Paris', *Architectural Record*, May 1910, pp. 400–14.

CARTIER-BRESSON, HENRI *The Decisive Moment*. New York, 1952. (Cover by Matisse. French edition Paris: Verve.)

CHARMET, RAYMOND *La Peinture française dans les musées russes*. Geneva, 1970.

CHARTERIS, EVAN *John Sargent*. New York, 1927.

CHIPP, HERSCHEL B., 'A Method for Studying the Documents of Modern Art', *Art Journal*, XXVI, 4, Summer 1967, pp. 369–73.

CHIPP, HERSCHEL B. *Theories of Modern Art*. Berkeley and Los Angeles, 1968.

COOPER, DOUGLAS *Picasso théâtre*. Paris, 1967.

COOPER, DOUGLAS *The Cubist Epoch*. London, 1970.

COURTHION, PIERRE *Courbet raconté par lui-même et par ses amis*. Geneva, 1950.

CRESPELLE, JEAN PAUL *The Fauves*. London, 1962.

DENIS, MAURICE *Théories, 1890–1910*, 4th ed. Paris, 1920.

DUTHUIT, GEORGES *The Fauvist Painters*, New York, 1950.

FLANNER, JANET 'King of the Wild Beasts', in *Men and Monuments*. New York, 1957.

FRY, EDWARD F. *Cubism*. New York–Toronto, 1966.

FRY, ROGER 'Henri Matisse', *Cahiers d'Art*, VI, 5–6, 1931, pp. 63–70.

GAUSS, CHARLES EDWARD *The Aesthetic Theories of French Artists from Realism to Surrealism.* Baltimore, 1949.

GENÊT [JANET FLANNER], [Letter from Paris], *The New Yorker,* 30 May 1970, p. 86.

GIDE, ANDRÉ *Journal,* 1. New York, 1947.

GIEURE, MAURICE 'Constantes esthétiques de Cézanne, Picasso, Matisse et Braque', in *Initiation à l'œuvre de Picasso.* Paris, 1951.

GILOT, FRANÇOISE *Life with Picasso.* New York–Toronto–London, 1964.

GOLDWATER, ROBERT, and TREVES, MARCO, eds. *Artists on Art.* New York, 1945.

GOUPIL, F. *Manuel complet et simplifié de la peinture à l'huile.* Paris, 1858.

GOUPIL, F. *Traité méthodique et raisonné de la peinture à l'huile.* Paris, 1867.

GOUPIL, F. *Manuel général de la peinture à l'huile.* Paris, 1877.

GUERRISI, MICHELE 'L'arabesco di Matisse', in *L'errore di Cézanne.* Pisa, 1954.

HAFTMANN, WERNER *Painting in the Twentieth Century,* 2 vols. New York, 1960.

HAMILTON, GEORGE HEARD *Painting and Sculpture in Europe, 1880 to 1940.* Baltimore, 1967.

HAVARD, HENRY *La décoration,* 2nd ed. Paris, 1892?

HERBERT, ROBERT L. *Modern Artists on Art.* New York, 1964.

HERON, PATRICK *The Changing Forms of Art.* London, 1955.

HOLT, ELIZABETH G. *A Documentary History of Art,* 1. Garden City, N.Y., 1957.

HOLT, ELIZABETH G. *From the Classicists to the Impressionists: A Documentary History of Art and Architecture.* New York, 1966.

HOLTEN, RAGNAR VON. *L'Art fantastique de Gustave Moreau.* Paris, 1960.

IZERGINA, A. N. *The Ermitage, Leningrad: French 20th-Century Masters.* Prague, 1970.

KIDD, STEVEN R. *The Abby Aldrich Rockefeller Memorial Window.* Pocantico Hills, 1956.

KOHN, HEINZ *Neuer Meister aus dem Museum Folkwang zu Essen.* Cologne, 1952.

LIBERMAN, ALEXANDER *The Artist in his Studio.* New York, 1960.

MAN, FELIX H., ed. *Eight European Artists.* London, 1954.

MAYWALD, WILHELM *Portrait-Atelier.* Zurich, 1958.

MORSE, C. R. 'Matisse's Palette', *Art Digest,* VII, 15 February, 1933, p. 26.

MOURLOT, FERNAND *Les affiches originales des maîtres de l'École de Paris.* Monte Carlo, 1959.

MULLER, JOSEPH EMILE *Fauvism.* New York, 1967.

Museum of Modern Art *The School of Paris: Paintings from the Florene May Schoenborn and Samuel A. Marx Collection.* New York, 1965.

NOCHLIN, LINDA, ed. *Realism and Tradition in Art, 1848–1900.* Englewood Cliffs, 1966.

NOVOTNY, F. *Cézanne.* London, 1961.

OLIVIER, FERNANDE *Picasso et ses amis.* Paris, 1933.

ORTEGA Y GASSET, JOSE *The Dehumanization of Art and Other Writings on Art and Culture.* Garden City, N.Y., 1956.

PÉLADAN, M. J. 'Le Salon d'Automne et ses Retrospectives—Greco et Monticelli', *La Revue Hébdomadaire,* 42, 17 October 1908, pp. 360–78.

PERRY, LILLA CABOT 'Reminiscences of Claude Monet from 1889 to 1909', *The American Magazine of Art,* XVIII, March 1927, pp. 120 ff.

PICASSO, PABLO 'Picasso Speaks', *The Arts,* May 1923, pp. 315–26.

POLLACK, BARBARA *The Collectors: Dr. Claribel and Miss Etta Cone.* Indianapolis, 1962.

POTTER, MARGARET, et al. *Four Americans in Paris, The Collection of Gertrude Stein and Her Family.* New York, 1970.

PUY, MICHEL *L'effort des peintres modernes.* Paris, 1933.

REWALD, JOHN, ed. *Paul Cézanne, Correspondance.* Paris, 1937.

REWALD, JOHN, ed. *Paul Cézanne, Letters.* London, 1941.

ROSENBLUM, ROBERT *Cubism and Twentieth Century Art*. New York, 1960.

SCHAPIRO, MEYER 'Matisse and Impressionism', *Androcles*, I, 1, February 1932, pp. 21–36.

SCHAPIRO, MEYER *Paul Cézanne*. New York, 1952.

SHACK, WILLIAM *Art and Argyrol: The Life and Career of Dr. Albert C. Barnes*. New York and London, 1960.

SHATTUCK, ROGER *The Banquet Years*, revised ed. London, 1969.

SIGNAC, PAUL *D'Eugène Delacroix au néo-impressionisme*, new edition. Paris, 1911.

SOBY, JAMES THRALL *Modern Art and the New Past*. Norman, Oklahoma, 1957.

STEIN, GERTRUDE *The Autobiography of Alice B. Toklas*. New York, 1955.

STEIN, LEO *Appreciation: Painting, Poetry, and Prose*. New York, 1947.

TSCHUDI MADSEN, S. *Art Nouveau*. New York–Toronto, 1967.

UNTERMEYER, LOUIS *Makers of the Modern World*. New York, 1955.

WARNOD, ANDRÉ *Les peintres, mes amis*. Paris, 1965.

Matisse Writings, Statements, Quotations, Interviews, and Letters
(Arranged in Chronological Order)

APOLLINAIRE, GUILLAUME 'Henri Matisse', *La Phalange*, II, 18, December 1907, pp. 481–5. (Text 1, above.)

MATISSE, HENRI 'Notes d'un peintre', *La Grande Revue*, LII, 24, 25 December 1908, pp. 731–45. (Text 2, above.)

MATISSE, HENRI [Statement on Photography] *Camera Work*, 24, October 1908, p. 22. (Text 3, above.)

ESTIENNE, CHARLES 'Des tendances de la peinture moderne: entretien avec M. Henri-Matisse', *Les Nouvelles*, 12 April 1909, p. 4. (Text 5, above.)

MACCHESNEY, CLARA T. 'A Talk with Matisse, Leader of post-Impressionists', *New York Times Magazine*, 9 March 1913. (Text 6, above.)

GUENNE, JACQUES 'Entretien avec Henri Matisse', *L'Art vivant*, 18, 15 September 1925, pp. 1–6; also in *Portraits d'artistes*, Paris, 1925, pp. 123–7. (Text 7, above.)

TÉRIADE, E. 'Visite à Henri Matisse', *L'Intransigeant*, XXII, 14 January 1929; partially reprinted as 'Propos de Henri Matisse à Tériade', *Verve*, IV, 13, December 1945, p. 56. (Text 8, above.)

TÉRIADE, E. 'Entretien avec Tériade', *L'Intransigeant*, 20 and 27 October 1930. (Text 8, above.)

MATISSE, HENRI 'Confrontations', *Formes*, 1, January 1930, p. 11. (Partial reprint of 1907–29 statements.)

HOPPE, RAGNAR 'På visit hos Matisse (1920)', in *Städter och Konstnarer: resebrev och essaer om konst*. Stockholm, 1931, pp. 193–9. (Quotes Matisse.)

FLINT, RALPH 'Matisse Gives an Interview on Eve of Sailing', *Art News*, XXIX, 3 January 1931, p. 3. (Brief quotations of Matisse.)

COURTHION, PIERRE 'Rencontre avec Matisse', *Les nouvelles littéraires*, 27 June 1931, p. 1. (Text 9, above.)

JEDLICKA, GOTTHARD 'Begegnungen mit Henri Matisse', in *Begegnungen: Künstlernovellen*. Basle, 1933, pp. 102–26. (Quotations of Matisse.)

'Matisse Speaks', *Art News*, XXXI, 36, 3 June 1933, p. 8. (Quotes Matisse on art and the public; see Text 5, n. 2, above.)

TÉRIADE, E. [Propos de Henri Matisse] *Minotaure*, I, 3–4, 1933, p. 10; reprinted *Verve*, IV, 13, December 1945, p. 20. (Text 10, above.)

COURTHION, PIERRE *Henri Matisse*. Paris, 1934. (Some quotations.)

DUDLEY, DOROTHY 'The Matisse Fresco in Merion, Pennsylvania', *Hound and Horn*, VII, 2, January–March 1934, pp. 298–303. (Quotations on Barnes Murals.)

MATISSE, HENRI 'Dva pisma [Two letters to A. Romm]', *Iskusstvo*, 4, 1934, pp. 199–203. (Text 11, above.)

MATISSE, HENRI *Testimony against Gertrude Stein*. The Hague, 1935 (supplement to *Transition* 23, 1934–5), pp. 3–8. (Rebuttal of Stein's statements concerning Matisse in *Autobiography of Alice B. Toklas*.)

MATISSE, HENRI 'On Modernism and Tradition', *The Studio*, IX, 50, May 1935, pp. 236–9. (Text 12, above.)

BREESKIN, ADELYN D. 'Swans by Matisse', *American Magazine of Art*, XXVIII, 10; 9 October 1935, pp. 622–9. (Quotation on the Mallarmé swan.)

TÉRIADE, E. 'Constance du fauvisme', *Minotaure*, II, 9, 15 October 1936, p. 3; partially reprinted in *Verve*, IV, 13, December 1945, p. 13. (Text 13, above.)

ESCHOLIER, RAYMOND *Henri Matisse*. Paris, 1937. (Recollections and statements, pp. 30–1, 77–8, 88, 91–2, 97, 138, 141, 168.)

HUPPERT, JANINE C. 'Montherlant vu par Matisse', *Beaux-Arts*, 243, 27 August 1937. (Quotations on book illustration.)

MATISSE, HENRI 'Divagations', *Verve*, I, 1, December 1937, pp. 80–4. (Text 15, above.)

MONTHERLANT, HENRY DE 'En écoutant Matisse', *L'Art et les Artistes*, XXXIII, 189, July 1938, pp. 336–9. (Text 16, above.)

PACH, WALTER *Queer Thing, Painting*. New York, 1938. (Some quotations.)

MATISSE, HENRI 'Notes d'un peintre sur son dessin', *Le Point*, 21, July 1939, pp. 104–10. (Text 17, above.)

MATISSE, HENRI 'In the Mail [extracts from 2 letters]', in *First Papers on Surrealism*. New York, 1942. (Partially quoted, Text 19, above.)

DIEHL, GASTON 'Henri Matisse le méditerranéen nous dit', *Comœdia*, 7, February 1942, p. 1. (Quotations on colour and light.)

ARAGON, LOUIS 'Matisse-en-France', in *Henri Matisse dessins: thèmes et variations*. Paris, 1943; reprinted in *Henri Matisse, roman*. Paris, 1971. (Text 21, above.)

BOUVIER, MARGUETTE 'Henri Matisse illustre Ronsard', *Comœdia*. 80, 9 January 1943, pp. 1, 6. (Quotations on Ronsard illustrations.)

GILLET, LOUIS 'Une visite à Henri Matisse', *Candide*, 24 February 1943. (Quotation on vision.)

DIEHL, GASTON 'Avec Matisse le classique', *Comœdia*, 102, 12 June 1943, pp. 1, 6. (Quotations on Cézanne's *Baigneuses*, book illustrations, and drawings.)

DIEHL, GASTON, ed. 'Témoignage de Matisse' in *Peintres d'aujourd'hui*. Collection Comœdia-Charpentier, June 1943. (Quotation on translation of emotion into formal means.)

CARCO, FRANCIS 'Souvenir d'atelier: conversation avec Matisse', *Die Kunst-Zeitung*, 8, August 1943; also in *L'ami des peintres*. Paris, 1953, pp. 219–38. (Text 18, above.)

DIEHL, GASTON 'Matisse, illustrateur et maître d'œuvre', *Comœdia*, 132, 22 January 1944, pp. 1, 6. (Quotations on *Pasiphaë* illustrations.)

DIEHL, GASTON 'La leçon de Matisse', *Comœdia*, 146–7, 29 April 1944, p. 1 ff. (Quotations on *Jazz*.)

BOUVIER, MARGUETTE 'Henri-Matisse chez lui', *Labyrinthe*, 1, 15 October 1944, pp. 1–3. (Text 22, above.)

DIEHL, GASTON 'Rôle et modalités de la couleur', in *Problèmes de la peinture*. Lyons, 1945, pp. 237–40. (Text 23, above.)

DIEHL, GASTON 'Les nourritures terrestres de Matisse', *XXᵉ Siècle*, 2, 18 October 1945, p. 1. (Quotations on art and nature.)

MATISSE, HENRI [Observations on Painting] *Verve*, IV, 13, December 1945, pp. 9–10. (Text 24, above.)

DEGAND, LÉON 'Matisse à Paris', *Les Lettres françaises*, 6 October 1945, p. 7 ff. (Text 25, above.)

DIEHL, GASTON 'A la recherche d'un art mural', *Paris, les arts, les lettres*, 20, 19 April 1946, pp. 1–3. (Quotations on Barnes Murals.)

PURRMAN, HANS 'Über Henri Matisse', *Werk*, XXXIII, 6, June 1946, pp. 185–92. (Quotations.)

MATISSE, HENRI 'Comment j'ai fait mes livres', *Anthologie du livre illustré par les peintres et sculpteurs de l'école de Paris*. Geneva, 1946, pp. xxi–xxiii. (Text 27, above.)

MATISSE, HENRI 'Témoignages de peintres; Le noir est une couleur', *Derrière le miroir*, December 1946, pp. 2, 6, 7. (Text 26, above.)

MATISSE, HENRI 'Océanie: tenture murale', *Labyrinthe*, II, 3, pp. 22–3, December 1946, (Text 28, above.)

MARCHAND, ANDRÉ 'L'Œil', in Jacques Kober, ed., *Henri Matisse*. Paris, 1947, pp. 51–3. (Text 30, above.)

MATISSE, HENRI *Jazz*. Paris, 1947. (Text 29, above.)

MATISSE, HENRI 'Le chemin de la couleur', *Art Présent*, 2, 1947, p. 23. (Text 31, above.)

MATISSE, HENRI 'Exactitude is Not Truth', in Philadelphia Museum of Art, *Henri Matisse*. Philadelphia, 1948, pp. 33–4. (Text 32, above.)

MATISSE, HENRI 'Letter from Matisse (to Henry Clifford)', in Philadelphia Museum of Art, *Henri Matisse*. Philadelphia, 1948, pp. 15–16. (Text 33, above.)

MATISSE, HENRI [Letter to Marc Vaux, 5 July 1948] *Carrefour des Arts*, 3, Summer 1948, p. 3. (Letter on 'la nuit de Montparnasse'.)

BARRY, JOSEPH A. 'Matisse Turns to Religious Art', *New York Times Magazine*, 26 December 1948, pp. 8, 24. (Brief quotations.)

BERNIER, ROSAMUND 'Matisse Designs a New Church', *Vogue*, 15 February 1949, pp. 76, 131–2. (Statements by Matisse on drawing, etc.)

HOWE, R. W. 'Half-an-hour with Matisse', *Apollo*, XLIX, February 1949, p. 29. (Text 34, above.)

MATISSE, HENRI [Statement on Art and the Public] *Transition Forty-Nine*, 5, 1949, p. 118. (Quoted in full, Text 5, n. 2, above.)

[MATISSE, HENRI] 'What I Want to Say; Work on the Dominican Chapel at Vence', *Time*, 24 October 1949, p. 70. (Brief quotations.)

BUCHANAN, D. W. 'Interview in Montparnasse', *Canadian Art*, VIII, 2, 1950, pp. 61–5. (Brief quotations; statement on Vence chapel.)

PERNOUD, RÉGINE 'Nous manquions d'un portrait de Charles d'Orléans . . . Henri Matisse vient d'en composer un', *Le Figaro Littéraire*, 14 October 1950. (Interview on illustrations for the poems of Charles d'Orléans.)

MATISSE, HENRI 'Henri Matisse vous parle', *Traits*, 8, March 1950, p. 5. (Text 35, above.)

BARR, ALFRED H., Jr. *Matisse: his Art and his Public*. New York, 1951. (Numerous quotations via questionnaires, correspondence, reminiscences, etc.)

STEIN, SARAH 'A Great Artist Speaks to His Students 1908', in Alfred H. Barr, Jr., *Matisse: his Art and his Public*. New York, 1951, pp. 550–2. (Text 4, above.)

'Matisse's Radio Interviews, Winter, 1942', in Alfred H. Barr, Jr., *Matisse: his Art and his Public*. New York, 1951, pp. 562–3. (See Text 20, above.)

MATISSE, HENRI 'Le Texte' in Tokyo National Museum, *Henri Matisse*. Tokyo, 1951, p. [2]. (Text 36, above.)

MATISSE, HENRI 'La Chapelle du Rosaire', in *Chapelle du Rosaire des Dominicaines de Vence*. Vence, 1951. (Text 37, above.)

MATISSE, HENRI [Letter to the Bishop of Nice] *L'Art Sacré*, 11–12, 1951, pp. 2–3. (Quoted Text 37, n. 2, above.)

LEJARD, ANDRÉ [Interview with Matisse] *Amis de l'Art*, n.s. 2, October 1951. (Statement on technique of late cut-outs.)

TÉRIADE, E. 'Matisse Speaks', *Art News*, L, 8, November 1951, pp. 40–71; *Art News Annual*, 21, 1952, pp. 40–71. (Text 39, above.)

MATISSE, HENRI 'La Chapelle du rosaire des Dominicaines de Vence', *France Illustration*, 320, 1 December 1951, pp. [561–70]; reprinted as 'La Chapelle de Vence, aboutissement d'une vie', *XXᵉ Siècle*, special number (1970), pp. 71–3. (Text 38, above.)

VERDET, ANDRÉ 'Entretiens avec Henri Matisse', in *Prestiges de Matisse*, Paris, 1952, pp. 37–76. (Text 42, above.)

LUZ, MARIA 'Témoignages: Henri Matisse', *XXᵉ Siècle*, n.s., January 1952, pp. 55–7. (Text 40, above.)

BRIDAULT, YVES 'J'ai passé un mauvais quart d'heure avec Matisse', *Arts*, 371, 7–13 August 1952, pp. 1, 8. (Includes statement on art and politics.)

MATISSE, HENRI [Letter to Lancelle, 9 June 1896] *Arts*, 371, 7–13 August 1952, p. 1. (Letter to Matisse's cousin concerning Salon de la Nationale, 1896.)

DIEHL, GASTON *Henri Matisse*. Paris, 1954. (Numerous unpublished quotations.)

MATISSE, HENRI *Portraits*. Monte Carlo, 1954. (Text 44, above.)

MATISSE, HENRI 'Looking at Life with the Eyes of a Child', *Art News and Review*. London, 6 February 1954, p. 3. (Text 43, above.)

PURRMANN, HANS, ed. *Farbe und Gleichnis. Gesammelte Schriften*. Zurich, 1955. (Reprints fourteen of Matisse's writings, with introduction—memoir by Purrmann.)

ESCHOLIER, RAYMOND *Matisse, ce vivant*. Paris, 1956. (Many unpublished quotes, letters, etc.)

MATISSE, HENRI *Propos de Matisse: propos notés par le père Couturier*. Paris, 1956. (Statements on faith; quoted Text 42, n. 7, above.)

ROUVEYRE, ANDRE 'Matisse évoqué', *La Revue des Arts*, VI, 2, June 1956. (Quotations of Matisse.)

MATISSE, HENRI [Letter on Leda panel, 6 March 1946] *Derrière le miroir*, 107–9, 1958, pp. 14, 18.

DAUBERVILLE, J. and H. 'Une visite à Matisse', in *Chefs-d'œuvre de Matisse*, Paris, 1958. (Some quotations.)

CHARBONNIER, GEORGES 'Entretien avec Henri Matisse', in *Le Monologue du peintre*, II, Paris, 1960, pp. 7–16. (Text 41, above.)

COUTURIER, MARIE-ALAIN *Se Garder Libre (Journal 1947–1954)* Paris, 1962. (Various quotations, many on faith and on the Vence Chapel.)

WARNOD, ANDRÉ *Les peintres, mes amis*. Paris, 1965. (Quotation on African sculpture and early career, pp. 42–7.)

BREZIANU, BARBU [Correspondence Matisse–Palady] *Secolul 20*, 6, 1965.

GUICHARD-MEILI, JEAN *Henri Matisse*. Paris, 1967. (Some unpublished quotations.)

MATISSE, HENRI [1934–5 Letters to A. Romm, et al.] *Matiss. Živopis, skul'ptura, grafika, pisma*. Leningrad, 1969. (Text 11, above.)

SCHNEIDER, PIERRE *Henri Matisse, exposition du centenaire*. Paris, 1970. (Quotations from unpublished letters.)

'Hommage à Henri Matisse', *XXᵉ Siècle* (special number), 1970. (Quotations recalled by Courthion, on the *Danse*, pp. 45–7, on Tahiti, pp. 56, 62; by Verdet, general remarks, pp. 113–15. Statement by Matisse on Vence Chapel, pp. 71–3.

CLAIR, JEAN, ed. 'Correspondance Matisse–Bonnard (1925/46)', *La Nouvelle Revue Française*, XVIII, July 1970, pp. 82–100; August 1970, pp. 53–70.

MORRIS, GEORGE, L. K. 'A Brief Encounter with Matisse', *Life*, 28 August 1970, pp. 44–47. (Brief quotations on training of the artist, etc.)

GIRAUDY, DANIÈLE, ed. 'Correspondance Henri Matisse–Charles Camoin', *Revue de l'Art*, 12, Summer 1971, pp. 7–34.

CACHIN-NORA, FRANÇOISE. 'Matisse et Signac (inédits annotés et commentés).' (To be published.)

Monographs since 1951

AHRENBERG, THEODOR *Göteborg Konstförening. Henri Matisse ur Theodor Ahrenbergs Samling.* Göteborg, 1960.

ALPATOV, MIKHAIL VLADIMIROVIČ *Matiss.* Moscow, 1969.

ARAGON, LOUIS *Henri Matisse, roman.* 2 vols. Paris. 1971. English edition: *Henri Matisse.* London–New York, 1972.

BARR, ALFRED H., Jr. *Matisse: his Art and his Public.* New York, 1951.

Bordeaux, Musée des Beaux-Arts *Hommage à Henri Matisse.* Bordeaux, 1970.

BOWNESS, ALAN *Matisse et le nu.* Paris–Lausanne, 1969.

BRILL, FREDERICK *Matisse.* London, 1967.

CASSOU, JEAN *Henri Matisse, Carnet de dessins.* Paris, 1955.

DIEHL, GASTON *Henri Matisse.* Paris, 1952.

DIEHL, GASTON *Henri Matisse.* Paris, 1954.

DIEHL, GASTON *Henri Matisse.* Paris, 1970.

DUTHUIT, GEORGES *Matisse: Période fauve.* Paris, 1956. English edition: *Matisse, Fauve Period.* New York, 1956.

ELSEN, ALBERT E. *The Sculpture of Henri Matisse.* New York, 1972.

ESCHOLIER, RAYMOND *Matisse, ce vivant.* Paris, 1956. English edition: *Matisse from the Life.* London, 1960.

FERRIER, JEAN-LOUIS *Matisse 1911–1930.* Paris, 1961.

FIALA, VLASTIMIL *Henri Matisse.* Prague, 1967.

Galerie Jacques Dubourg *Henri Matisse, aquarelles, dessins.* Paris, 1962.

GEORGE, WALDEMAR *Matisse.* Arcueil, 1955.

GOWING, LAWRENCE *Henri Matisse: 64 Paintings.* New York, 1966.

GREENBERG, CLEMENT *Henri Matisse.* New York, c. 1953.

GUICHARD-MEILI, JEAN *Henri Matisse, son œuvre, son univers.* Paris, 1967. English translation: *Matisse.* New York, 1967.

Hamburg, Kunstverein *Matisse und seine Freunde, les Fauves.* Hamburg, 1966.

HILDEBRANDT, HANS *Henri Matisse: Frauen, 32 Radierungen.* Leipzig, 1953.

'Hommage à Henri Matisse', *XXᵉ Siècle* (special number), 1970.

Includes articles by: Jean Cassou, Pierre Courthion, Jean-Louis Ferrier, Roger Fry, Jean Guichard-Meili, Gotthard Jedlicka, Jean Leymarie, Herbert Read, San Lazzaro, Yvon Taillandier, André Verdet and Pierre Volboudt.

HUMBERT, AGNÈS *Henri Matisse: Dessins.* Paris, 1956.

HUNTER, SAM *Henri Matisse, 1869–1954.* New York, 1956.

JEDLICKA, GOTTHARD *Die Matisse Kapelle in Vence; Rosenkranz Kapelle der Dominik-anerinnen.* Frankfurt, c. 1955.

JEDLICKA, GOTTHARD *Henri Matisse. La Coiffure.* Stuttgart, 1965.

KAMPIS, ANTAL *Matisse.* Budapest, 1959.

LAMBERT, SUSAN *Thirty-four Recently Acquired Lithographs and Aquatints by Henri Matisse.* London, 1968.

LAMBERT, SUSAN *Matisse lithographs.* London: Victoria and Albert Museum, 1972.

LASSAIGNE, JACQUES *Matisse.* Geneva, 1959.

LÉVÊQUE, JEAN-JACQUES *Matisse.* Paris, 1968.

LEYMARIE, JEAN *Matisse.* Paris, 1970.

LIEBERMAN, WILLIAM S. *Etchings by Matisse.* New York, 1955.
LIEBERMAN, WILLIAM S. *Matisse: 50 Years of His Graphic Art.* New York, 1956.
London, The Arts Council of Great Britain. *Matisse, 1869–1954.* London, 1968.
LUZI, MARIO *L'Opera di Matisse, dalla rivolta fauve all'intimismo (1904–1928).* Milan, 1971.
MARCHIORI, GUISEPPE *Matisse.* New York, n.d. [*c.* 1967].
MATISSE, HENRI *Henri Matisse, dessins et sculptures inédites.* Paris, 1958.
Matiss, Živopis, skul'ptura, grafika, pisma. Leningrad, 1969.
MOULIN, RAOUL-JEAN *Henri Matisse dessins.* Paris, 1968; English translation: *Henri Matisse, Drawings and Paper Cut-outs.* New York and London, 1969.
MOULIN, RAOUL-JEAN *Chatillon des Arts présente le jardin de Matisse.* Chatillon, 1970.
NEGRI, RENATA *Matisse e i Fauves.* Milan, 1969.
OKAMOTO, KENJIRO *Bonnard–Matisse.* Tokyo, 1968.
OKAMOTO, KENJIRO, and XANAHAIRA, ISAKU *Matisse–Rouault.* Tokyo, 1967.
ORIENTI, SANDRA *Henri Matisse.* Florence, 1971.
PACH, WALTER *Henri Matisse, a Gallery of Women: Portfolio of Sketches.* New York, *c.* 1954.
PERLS, FRANK *Frank Perls Art Dealer presents Six Sculptures by Henri Matisse.* Beverley Hills, 1968.
REVERDY, PIERRE, and DUTHUIT, GEORGES *The Last Works of Henri Matisse, 1950–1954.* New York, 1958. (English edition of *Verve*, 35–6.)
RUSSEL, JOHN, and the Editors of Time-Life Books *The World of Matisse, 1869–1954.* New York, 1969.
St.-Paul, Fondation Maeght *A la rencontre de Matisse.* St-Paul, n.d. [1969].
SCHNEIDER, PIERRE *Henri Matisse. Exposition du centenaire.* Paris, 1970.
SELZ, JEAN *Matisse.* New York, 1964.
TRAPP, FRANK ANDERSON 'The Paintings of Henri Matisse: Origins and Early Development, 1890–1917' (unpublished Ph.D. dissertation, Harvard University, 1952).
University of California, Los Angeles Art Council *Henri Matisse, Retrospective 1966.* Los Angeles, 1966.
VERDET, ANDRÉ *Prestiges de Matisse, précédé de visite à Matisse, entretiens avec Matisse.* Paris, 1952.
WHEELER, MONROE *The Last Works of Henri Matisse: Large Cut Gouaches.* New York, 1961.

Articles since 1951

ALAZARD, JEAN 'Deux peintres: Henri Matisse', *Revue Méditerrannée*, XV, 1955, pp. 405–409.
ARAGON, LOUIS 'Le second siècle de Matisse commence', *Les Lettres françaises*, 1330, 15–21 April 1970, pp. 3–9; 25–30.
ARNASON, H. H. 'Motherwell: the Window and the Wall', *Art News*, LXVIII, Summer 1969, p. 50.
AUBREY, P. 'Golberg et Matisse', *Gazette des Beaux-Arts*, sér. 6, LXVI, December 1965, pp. 343–4.
BALLOU, M. G. ' "Interior with Etruscan Vase" by Matisse', *Cleveland Museum Bulletin*, XXXIX, December 1952, pp. 239–40.
BAYNES, K. 'Art and Industry', *Architectural Review*, CXL, November 1966, p. 360.
BAZAINE, JEAN 'Clarté de Matisse', *Derrière le miroir*, 46–7, May 1952.
BELL, CLIVE 'Henri Matisse', *Apollo*, LX, December 1954, pp. 151–6.

BERNIER, R. 'Le Musée Matisse à Nice', *L'Œil*, 105, September 1963, pp. 20–9.

BLUNT, ANTHONY 'Matisse's Life and Work', *Burlington Magazine*, XCV, December 1953, pp. 399–400.

BOWNESS, A. 'Four Drawings by Modigliani and Matisse', *Connoisseur*, CL, June 1962, pp. 116–20.

BREESKIN, A. D. 'Matisse and Picasso as Book Illustrators', *Baltimore Museum News*, XIV, May 1951, pp. 1–3.

BREESKIN, A. D. 'Accolade to Henri Matisse', *Baltimore Museum News*, XV, May 1952, pp. 1–4.

BURGESS, G. 'The Wild Men of Paris' [first published 1910], *Architectural Record*, CXL, July 1966, p. 237.

BURR, J. 'Hymn of Hedonism: Arts Council's Retrospective', *Apollo*, n.s., LXXXVIII, July 1968, p. 62.

BURR, J. 'Lithographs and Aquatints at Lumley Cazalet Gallery', *Apollo*, n.s., LXXXVIII, August 1968, p. 138.

BURR, J. 'Exhibition in London', *Apollo*, n.s., XCI, May 1970, p. 394.

BUTLER, J. T. 'Matisse as a Draughtsman at the Baltimore Museum of Art', *Connoisseur*, 176, April 1971, p. 289.

CARLSON, E. G. 'Still Life with Statuette by Henri Matisse', *Yale University Art Gallery Bulletin*, XXXI, 2, Spring 1967, pp. 4–13.

CARLSON, V. 'Some Cubist Drawings by Matisse', *Arts*, 45, March 1971. pp. 37–9.

CASSOU, JEAN 'Henri Matisse, coin d'atelier', *Quadrum*, 5, 1958, pp. 68–9. (English summary, p. 90.)

CHAMPA, K. S. 'Paris: From Russia with Love', *Arts*, XXXIX, September 1965, p. 56.

CHANTELOU 'Les Matisse dispersés de 1951 à 1970', *Le Monde*, 4 November 1970.

'Chapelle de Vence', *L'Art sacré*, 11–12, July–August 1951. 32 pp., ill.

'Chapel of the Rosary, Vence', *Magazine of Art*, XLIV, November 1951, pp. 271–2.

CHASTEL, ANDRÉ 'Le visible et l'occulte, Matisse et Klee', *Médecine de France*, 61, 1955, pp. 41–2.

CHATELET, A. 'Musée des Beaux-Arts de Lille: quatre années d'acquisitions d'œuvres contemporaines', *Revue du Louvre*, XVIII, 6, 1968, p. 424.

CLAIR, JEAN 'La Tentation de l'Orient', *La Nouvelle Revue Française*, XVIII, 211, July 1970, pp. 65–72.

CLAIR, JEAN 'L'Influence de Matisse aux États-Unis', *XXe Siècle*, 35, December 1970, pp. 157–60.

COCTEAU, JEAN 'Matisse et Picasso', *Habitat*, 73, September 1963, pp. 58–60.

COGNIAT, RAYMOND 'Henri Matisse', *Goya*, II, Madrid, 1955–6, pp. 28–33.

'Coming Auctions', *Art News*, LXIX, October 1970, p. 74.

COMTESSE, ALFRED 'Le troisième grand livre d'Henri Matisse', *Stultifera Navis*, VII, 1955, pp. 87–90.

COOKE, H. L. 'Henri Matisse's Lorette Acquired by the National Gallery of Art, Washington, D.C.', *Burlington Magazine*, CVII, September 1965, p. 488.

COOPER, DOUGLAS 'Matisse Museum', *New Statesman and Nation*, LXV, February 1963, p. 162.

COSTESCO, ELEONORA 'Trois dessins de Matisse', *Art Rep. Pop. Roumaine*, XIV, 1957, pp. 67–70 (two variants of 'La blouse roumaine', Bucharest Museum).

'La Côte: Derain et Matisse', *L'Œil*, 1, January 1955, pp. 40–1.

COULONGES, HENRI 'Matisse et le paradis', *Connaissance des Arts*, 214, December 1969, pp. 114–21.

COULONGES, HENRI 'Les Premiers collectionneurs de Matisse', *Jardin des Arts*, 186, May 1970.

COURTHION, PIERRE 'Les grandes étapes de l'art contemporain, 1907–1917', *XXᵉ Siècle*, n.s., XXVIII, May 1966, p. 79 ff.

COURTHION, PIERRE 'Le papier collé du Cubisme à nos jours', and 'Les papiers découpés d'Henri Matisse', *XXᵉ Siècle*, n.s., 6, January 1956, pp. 3–60.

CUTLER, C. 'The House of Mourlot', *Art in America*, LIV, May 1966, p. 100.

'Dance and Drama in the Sale-room', *Apollo*, n.s., XC, October 1969, p. 359.

DANIEL-ROPS 'L'acte de foi de Matisse', *Jardin des Arts*, 17, 1956, pp. 257–61.

DAURIAC, J. P. 'Galerie Bernheim-Jeune. Paris: chefs-d'œuvre de Matisse à l'occasion de son centenaire', *Pantheon*, XXVIII, May 1970, p. 256.

DAVAL, J. L. 'Marlborough et Matisse conquièrent la Suisse', *Art International*, XV, October 1971, pp. 49–51.

DAVIS, F. 'The Elegant Pen of Matisse', *Country Life*, 150, 4 November 1971, pp. 120–6.

DE FORGES, M. T., and ALLEMAND, G. 'Orangerie des Tuileries: la collection Jean Walter —Paul-Guillaume', *Revue du Louvre*, XVI, 1, 1966, p. 57.

DEGAND, LÉON 'Pour une révision des valeurs; Matisse, un génie?', *Aujourd'hui et Architecture*, II, 10, November 1956, pp. 28–31.

DESCARGUES, P. 'Matisse parmi les expressionistes', *Connaissance des Arts*, 220, June 1970, pp. 100–07.

'Dessins récents dans l'exposition à la Galerie Maeght', *Cahiers d'Art*, XXVII, 1, 1952, pp. 55–66.

'Deux faux tableaux de Matisse', *Cahiers d'Art*, XXVII, 1, 1952, p. 94.

'Deux grandes rétrospectives à Paris: Fernand Léger et Henri Matisse', *XXᵉ Siècle*, n.s., 8, January 1957, p. 77.

DORIVAL, BERNARD 'Fauves: The Wild Beasts Tamed', *Arts News Annual*, 22, 1952, pp. 98–129.

DORIVAL, BERNARD 'Matisse', *Bull. Soc. Amis Musée de Dijon*, 1958–60, pp. 69–73.

DORIVAL, BERNARD 'Musée national d'art moderne: le legs Gourgaud', *Revue du Louvre*, XVII, 2, 1967, p. 95.

DUFY, RAOUL 'Hommages à Matisse', *Les Lettres françaises*, 2 December 1952.

DUNLOP, I. 'Lefevre Gallery, London', *Apollo*, n.s., XCII, December 1970, p. 480.

DU PLESSIX, F. 'The Albert D. Lasker Collection', *Art in America*, LVI, March 1968, p. 52 ff.

DUTHUIT, GEORGES 'Matisse and Courbet', *Ark*, 14, 1955, pp. 12–13.

DUTHUIT, GEORGES 'Material and Spiritual Worlds of Henri Matisse', *Art News*, LV, October 1956, pp. 22–5.

DUTHUIT, GEORGES 'Le Tailleur de lumière', *Verve*, 35–6, 1958.

ELDERFIELD, J. 'The Language of Pre-Abstract art; Three Good Museum Shows Illuminate the Problems of an Art on the Threshold of Abstraction', *Artforum*, 9, February 1971, p. 48.

ELLIOT, EUGENE C. 'Some Recent Conceptions of Color Theory', *Journal of Aesthetics and Art Criticism*, XVIII, June 1960, pp. 494–503.

ELSEN, ALBERT 'The Sculpture of Matisse, I: A New Expressiveness in Sculpture', *Artforum*, VII, September 1968, pp. 20–9; 'II: Old Problems and New Possibilities', October, pp. 21–33; 'III: Primitivism, Partial Figures and Portraits', November, pp. 26–35; 'IV: The Backs and Monumental Decorative Sculpture', December, pp. 24–32.

ESCHOLIER, RAYMOND 'Matisse et le Maroc', *Jardin des Arts*, 24, 1956, pp. 705–12.

ESTEBAN, CLAUDE 'Une limpidité nécessaire', *La Nouvelle revue française*, XVIII, 211, July 1970, pp. 72–7.

'Exhibition at La Boetie Gallery', *Art News*, LXIX, May 1970, p. 70.

'Exhibition at Loeb and Krugier Gallery', *Art News*, LXVI, January 1968, p. 15.

'Expósicion Matisse en la Galerie nacional de Praga', *Goya*, 94, January 1970, p. 263.

'February 23, 1957—Opening of the Cone Wing: Matisse Paintings and Drawings', *Baltimore Museum News*, xx, February 1957, pp. 1–3, 6–7, 12–13.

FERMIGIER, ANDRÉ 'Matisse et son double', *Revue de l'Art*, 12, 1971, pp. 100–7.

Le Figaro Littéraire, 1248, 20–26 April 1970. Articles by P. Mazars, A. Bosquet C. Roger-Marx, F. Mégret, pp. 26–32.

'Five Heads of Jeannette by Matisse', *Los Angeles Museum of Art Bulletin*, xix, 1, 1968–9, pp. 20–1.

FLAM, JACK D. 'Matisse's *Backs* and the Development of his Painting', *Art Journal*, xxx, 4, Summer 1971, pp. 352–61.

FLANNER, JANET 'King of the Wild Beasts', *New Yorker*, xxvii, 22 December 1951, pp. 30–2; 29 December 1951, pp. 26–8.

FORGE, ANDREW; HODGKIN, HOWARD; KING, PHILLIP 'The Relevance of Matisse', *Studio*, clxxvi, July 1968, pp. 9–17.

GÁLLEGO, J. 'Crónica de Paris: apoteosis de Matisse', *Goya*, 96, May 1970, pp. 360–2.

GASSER, MANUEL 'Exhibition Posters by Famous Artists', *Graphis*, xvi, March 1960, pp. 108–19.

GELDZAHLER, HENRY 'Two Early Matisse Drawings', *Gazette des Beaux-Arts*, sér. 6, 60, November 1962, pp. 497–505.

GIRY, M. 'Matisse et la naissance du fauvisme', *Gazette des Beaux-Arts*, sér. 6, 75, May 1970, pp. 331–44.

GORDON, A. 'Exhibitions in London', *Connoisseur*, clxvi, July 1967, p. 186.

GORDON, A. 'Hayward Gallery Opens with a Large Retrospective of Matisse', *Connoisseur*, clxviii, July 1968, pp. 186–8.

GORDON, D. E. 'Kirchner in Dresden', *Art Bulletin*, xlviii, Autumn 1966, p. 372.

GOTTLIEB, CARLA 'The Joy of Life: Matisse, Picasso, and Cézanne', *College Art Journal*, xviii, 2, Winter 1959, pp. 106–16.

GOTTLIEB, CARLA. 'The Role of the Window in the Art of Matisse', *Journal of Aesthetics and Art Criticism*, xxii, 4, Summer 1964, pp. 393–423.

GOUK, A. 'Apropos of Some Recent Exhibitions in London', *Studio*, clxxvi, October 1968, p. 125.

GOUK, A. 'An Essay on Painting', *Studio*, 180, October 1970, pp. 147–9.

GREENBERG, CLEMENT 'Matisse in 1966', *Bulletin of the Museum of Fine Arts, Boston*, lxiv, 1966, pp. 66–76.

HAHN, O. 'Paris', *Arts*, xlv, September 1970, p. 54.

HALL, D. 'Matisse's La leçon de peinture (Scottish National Gallery of Modern Art)', *Burlington Magazine*, cviii, May 1966, p. 261.

HAMILTON, G. H. 'The Alfred Stieglitz Collection', *Metropolitan Museum Journal*, iii, 1970, pp. 371 ff.

HAMMARÉN, CARL-ERIK 'Kapellet i Vence', *Paletten*, xvii, 2, 1956, p. 42.

HASEGAWA, S. 'Matisse through Japanese Eyes', *Art News*, liii, April 1954, pp. 27–9, 65, 66.

HENNING, E. B. 'Pablo Picasso: Fan, Salt Box, and Melon', *Cleveland Museum Bulletin*, lvi, October 1969, pp. 271–86.

'Henri Matisse', *Baltimore Museum News*, xviii, December 1954, pp. 6–7.

'Henri Matisse: A small Chapel in France and a Monumental Art Exhibition at the Museum of Modern Art (N.Y.)', *Life*, 26 November 1951, pp. 108–16.

HERZOGENBERG, J. 'Ans der Arbeit der Museen: CSSR; Matisse, Ausstellung', *Pantheon*, xxviii, May 1970, p. 247.

HESS, THOMAS B. 'The Most Beautiful Exhibition in the World: Matisse at the Grand Palais', *Art News*, lxix, Summer 1970, pp. 28–31.

HILTON, ALISON 'Matisse in Moscow', *Art Journal*, XXIX, 2, Winter 1969–70, pp. 166–173.

HOCTIN, LUCE 'Renaissance of Church Art in France', *Graphis*, XIII, May 1957, pp. 224–35.

HOLM, ARNE E. 'Matisse's Kapell i Vence', *Kunsten Idag* (Oslo), XX, 4, 1951, pp. 32–51. (Includes English translation.)

HOLM, ARNE E. 'Henri Matisse som Skulptor', *Kunsten Idag* (Oslo), XXXIII, 3, 1955, pp. 26–45.

'Hommage à Matisse: Grand Palais, Paris', *Connaissance des Arts*, 218, April 1970, p. 17 ff.

'Hommage à Matisse: Grand Palais; Bibliothèque Nationale; Galerie Dina Vierny', *Pantheon*, XXVIII, July 1970, pp. 335–6.

'Homage to Matisse', *Yale Literary Magazine*, Fall 1955. Includes writings by Alfred H. Barr, Jr., Marcel Duchamp, George Heard Hamilton, George Kirgo, Jacques Lipchitz, Leonid Massine, Darius Milhaud, Henri Peyre, Alice B. Toklas, and Frank Anderson Trapp.

'Homage to Matisse at Borgenicht Gallery', *Arts*, XLIII, Summer 1969, p. 68.

HONEYMAN, T. J. 'Les Fauves—Some Personal Reminiscences', *Scottish Art Review*, XII, 1, 1969, p. 17.

HÜTTINGER, EDUARD 'Henri Matisse Scultore', *Arte Figur. Ant. Mod.*, 4, 1959, pp. 40–4.

HUMBERT, AGNÈS 'Les Fauves et le Fauvisme', *Jardin des Arts*, 12, 1955, pp. 713–20.

ITALIAANDER, ROLF 'Henri Matisse baut eine Kirche', *Kunstwerk* (Baden-Baden), V, 1, 1951, pp. 52–3.

JOUFFROY, ALAIN 'Le Rayon vert de Matisse', *Opus International*, 33, March 1972.

KAPTEREVA, T. 'Crónica de Moscu', *Goya*, 93, November 1969, p. 175.

KRAMER, HILTON 'Matisse as a Sculptor', *Bulletin, Museum of Fine Arts, Boston*, LXIV, 1966, pp. 49–65.

LANGLAND, J. 'Henri Matisse' (poem), *Nation*, 180, 30 April 1955, p. 369.

LASSAIGNE, JACQUES 'Les grandes gouaches découpées de Matisse', *Les Lettres françaises*, 6 August 1959.

LEMASSIER 'Comment peignaient les grands peintres: Matisse', in *Peintures, Pigments, Vernis*. Paris, 1961.

LÉVÊQUE, JEAN-JACQUES 'Matisse', *Arti*, XVII, 7–8, 1967, pp. 12–30.

LEYMARIE, JEAN 'Le Jardin de Paris', *Quadrum*, 7, Brussels, 1959.

LEYMARIE, JEAN 'Les grandes gouaches découpées à la Kunsthalle de Berne', *Quadrum*, 7, Brussels, 1959, pp. 103–14, 192. (English summary, p. 192.)

LIEBERMAN, WILLIAM S. 'Henri Matisse, 1869–1954', *Print*, X, August 1956, pp. 17–28.

LIEBERMAN, WILLIAM S. 'Illustrations by Henri Matisse', *Magazine of Art*, XLIV, December 1951, pp. 308–14.

LUCIE-SMITH, E. 'Matisse Drawings at Victor Waddington', *Studio*, CLXXIII, May 1967, p. 252.

LYMAN, J. 'Matisse as a Teacher', *Studio*, CLXXVI, July 1968, pp. 2–3.

MARMER, NANCY 'Matisse and the Strategy of Decoration', *Artforum*, IV, March 1966, pp. 28–33.

'Matisse: A Rare Collection Record (Cone Collection)', *Vogue*, CXXV, March 1955, pp. 132–5.

'Matisse and His Masterpiece (Vence Chapel)', *American Society of Legion of Honor Magazine*, XXVIII, 1957, pp. 29–42.

'Matisse as a Draftsman, Baltimore Museum of Art; Exhibit', *Art News*, LXIX, January 1971, p. 8.

'Matisse at La Boetie Gallery', *Arts*, XLIV May 1970, p. 61.

'Ur Matisse Anteckningar', *Paletten*, XIX, 2, 1958, pp. 40–4.

'Matisse Chapel', *Architectural Forum*, XCVI, May 1952, pp. 148–53.

'Die Matisse Kapelle in Vence', *Werk*, XL, July 1953, pp. 200–04.

'The Matisse Retrospective Exhibition', *Calendar, Art Institute of Chicago*, LX, 2, 1966, pp. 1–4.

'Matisse Scultore al Kunsthaus', *Emporium*, 778, October 1959, pp. 176–7, 179.

'Matisse's Bathers with Turtle (City Art Museum, St. Louis)', *Burlington Magazine*, CVIII, February 1966, p. 90.

'Matisse's Last Mural, Installed in California: Tile Wall in the Brody Home, Los Angeles', *Art News*, LV, June 1956, pp. 30–1, 67.

MATTHAIS, LISA 'De Portugisiska Breven', *Ord ock Bild*, 1953, pp. 147–255.

MELLOW, JAMES R. 'New York Letter', *Art International*, XIII, Summer 1969, p. 48.

MELLOW, JAMES R. 'Matisse: A Celebration of Pleasure', *New York Times Magazine*, 28 December 1969, pp. 16–17, 30–4.

MELLOW, JAMES R. 'Exhibition Preview: Four Americans in Paris: The Collections of Gertrude Stein and her Family', *Art in America*, LVIII, November 1970, pp. 84–91.

MELVILLE, R. 'Matisse', *Architectural Review*, CXLIV, October 1968, pp. 292–4.

METKEN, G. 'Körper als Architektur von Formen: zu den plastischen Arbeiten von Henri Matisse', *Kunstwerk*, XXIII, December 1969, pp. 3–12.

'Minneapolis Institute Purchase: Boy with Butterfly Net', *Minneapolis Institute Bulletin*, XLII, 7 February 1953, pp. 26–9.

'Modern Art and Modern Taste: The Albert D. Lasker Collection', *Art News Annual*, 27, 1958, pp. 35–6.

MOFFETT, K. 'Matisse in Paris: the Master's Centenary is Royally Celebrated', *Artforum*, IX, October 1970, pp. 69–71.

MORLEY, GRACE L. MCCANN. 'The Matisse Exhibition' and 'Works by Henry Matisse in the San Francisco Region', *San Francisco Museum Quarterly*, 2nd ser., I, 1–2, 1952, pp. 13–20.

MULLALY, TERENCE 'The Fauves', *Apollo*, LXIV, December 1956, pp. 184–6.

MURCIA, M. 'Homage to Henri Matisse', *Marg*, VIII, 3, June 1955, pp. 91–4.

MURPHY, RICHARD W. 'Matisse's Final Flowering', *Horizon*, XII, I, 1970, pp. 26–41.

MYERS, BERNARD 'Matisse and the Fauves', *American Artist*, XV, 7, December 1951, pp. 70–2.

NEWBERRY, J. S. Jr. 'Matisse Drawing: "Still Life with Fruit and Flowers" ', *Detroit Institute Bulletin*, XXXI, I, 1951–2, pp. 21–3.

Les nouvelles littéraires, 23 April 1970. Articles by J. Cassou, G. Ganne; interview with Mme M. Matisse Duthuit.

La Nouvelle Revue Française, XVIII, July 1970. Articles by D. Vallier, J. Clair, C. Esteban, A. Terrasse, pp. 54–101.

PEPPIATT, M. 'South of France: Exhibitions', *Art International*, XIII, October 1969, p. 73 ff.

PERNOUD, RÉGINE 'The Chapel of the Rosary', *San Francisco Museum Quarterly*, 2nd ser., I, 1–2, 1952, pp. 13–20.

PITTALUGA, MARY 'Il Giudizio di Hans Purrmann sui Maestri Francesi', *Commentari*, IX, 1960, pp. 284–96.

PLEYNET, MARCELIN 'Le Système de Matisse', in *L'Enseignement de la peinture*, Paris, 1971.

PRÉAUD, TAMARA 'Pour mieux comprendre l'exposition Matisse', *Jardin des Arts*, 186, May 1970.

RAGON, MICHEL 'L'Anniversaire d'un grand Fauve: Henri Matisse, peintre de la joie de vivre', *Jardin des Arts*, 186, May 1970.

RAYMOND, MARIE 'Matisse contra de Abstracten', *Kroniek van Kunst en Kultur*, XIII, 10, Amsterdam, December 1953, pp. 227–9.

REICHARDT, J. 'Matisse and Subject Matter', *Studio*, CLXXII, July 1966, pp. 2–4.

REIFF, ROBERT F. 'Matisse and "The Red Studio" ', *Art Journal*, XXX, 2, Winter 1970–1, pp. 144–7.

ROBERTS, K. 'Exhibition at the New Hayward Gallery', *Burlington Magazine*, CX, August 1968, p. 476.

ROSENTHAL, G. 'Matisse's Reclining Figures: A Theme and Its Variations', *Baltimore Museum News*, XIX, February 1956, pp. 10–15.

ROSKILL, M. 'Looking Across to Literary Criticism', *Arts*, 45, Summer 1971, p. 17.

ROUVEYRE, A. 'Matisse Evoqué', *Revue des Arts*, June 1956, pp. 66–74.

RUSSELL, John 'London: Matisse Drawings', *Art News*, LXVI, Summer 1967, p. 60.

RUSSELL, JOHN 'Exhibition at the Hayward Gallery', *Art News*, LXVII, Summer, 1968, p. 21.

RUSSELL, JOHN 'Matisse-en-France', *L'Œil*, 184, April 1970, pp. 16–25.

RUSSELL, JOHN 'Paris: Unrolling the Red Carpet', *Art in America*, LVIII, May 1970, p. 114.

RALLES, GEORGES 'Visit to Matisse', *Art News Annual*, 21, 1952, pp. 37–9, 79–81.

SCHNEIDER, PIERRE 'Dans la lumière de Matisse', *L'Express*, 12 August 1968.

SCHNEIDER, PIERRE 'Galeries nationales du Grand Palais: Henri Matisse', *Revue du Louvre*, XX, 2, 1970, pp. 87–96.

SCHNIER, J. 'Matisse from a Psychoanalytic Point of View', *College Art Journal*, XII, 2, 1953, pp. 110–17.

SCHURR, G. 'Paris: A Tribute to Matisse at the Grand Palais', *Connoisseur*, CLXXIV, July 1970, p. 202.

SELDIS, HENRY J. 'Exhibition Preview: Matisse in Los Angeles', *Art in America*, LIII, December 1965, pp. 76–9.

SELDIS, HENRY J. 'The Magic of Matisse', *Apollo*, n.s., LXXXIII, April 1966, pp. 244–55.

SLIVKA, R. 'Matisse Chasubles Designed for the Vence Chapel', *Craft Horizon*, XVI, January 1956, pp. 22–5.

SMITH, ELAINE 'Matisse and Rouault Illustrate Baudelaire', *Baltimore Museum News*, XIX, October 1955, pp. 1–9.

SNODGRASS, W. D. 'Matisse: The Red Studio', *Portfolio and Art News Annual*, 3, 1960, pp. 90–1.

SOLMI, SERGIO 'Disegni di Matisse', *Sele Arte*, 1, 2, Florence, September–October 1952, pp. 54–7.

SOWERS, R. 'Matisse and Chagall as Craftsmen', *Craft Horizon*, XXII, January 1962, pp. 28–31.

SPAR, F. 'Grand Palais, Paris', *Connaissance des Arts*, 220, June 1970, p. 7 ff.

'Statements on Matisse by Apollinaire, Berenson, Kandinsky, Picasso, Fernande Olivier and Léger', *Art*, 1, London, 26 November 1954, p. 8.

SUTTON, DENYS 'Matisse Magic Again', *Financial Times*, 3 June 1970.

SUTTON, DENYS 'The Mozart of Painting', *Apollo*, XCII, 105, November 1970, pp. 358–365.

TAYLOR, M. 'Recent Acquisitions: the National Gallery Department of Prints and Drawings', *Arts Can.*, XXVI, February 1969, p. 20.

TÉRIADE, E. 'Matisse Speaks', *Art News Annual*, 21, 1952, pp. 40–77.

TERRASSE, ANTOINE 'La Force de l'instant', *La Nouvelle revue française*, XVIII, 211, July 1970, pp. 78–81.

THIRION, J. 'Musées de Nice: l'enrichissement des collections modernes de 1958 à 1964', *Revue du Louvre*, XVII, 1, 1967, pp. 55–61.

THOMAS, R. 'Graphics: Lumley Cazalet Gallery, London', *Arts and Artists*, V, June 1970, p. 70.

'Three Sculptures in the Cone Collection: "Reclining Nude", "Slave", "Venus in a Shell" ', *Baltimore Museum News*, XX, February 1957, pp. 10–11.

TRAPP, FRANK ANDERSON 'Art Nouveau Aspects of Early Matisse', *Art Journal*, XXVI, 1, Fall 1966, pp. 2–8.

TUCKER, WILLIAM 'Sculpture of Matisse', *Studio*, CLXXVIII, July 1969, pp. 25–7.

TUCKER, WILLIAM 'Four Sculptors, Part 3: Matisse', *Studio International*, CLXXX, September 1970, pp. 82–7.

VALLIER, DORA 'Matisse revu, Matisse à revoir', *La Nouvelle revue française*, XVIII, 211, July 1970, pp. 54–64.

'Vestments Designed by Matisse for the Vence Chapel', *Arts and Architecture*, LXXIII, May 1956, p. 35.

VIGNORELL, DON VALERIO 'La Lezione di Vence', *Arte Cristiana*, 1954, pp. 33–8.

VINCKENBOSCH, H. 'La "mise en condition" de l'amateur de livres illustrés. Commentaires irrespecteux sur les livres illustrés par Matisse', *Livre et Estampe*, 53–4, 1968, pp. 71–84.

WERNER, A. 'The Earthly Paradise of Henri Matisse', *Arts*, XL, January 1966, pp. 30–5.

WHITFIELD, S. 'Matisse and the Fauves at Hamburg', *Burlington Magazine*, CVIII, August 1966, p. 439.

WIND, EDGAR 'Traditional Religion and Modern Art', *Art News*, LII, May 1953, pp. 19–22.

WOIMANT, F. 'Bibliothèque Nationale: Matisse graveur et peintre du livre', *Revue du Louvre*, XX, 2, 1970, pp. 97–100.

WRIGHT, FREDERICK S. 'Matisse: Fabric vs. Flesh', *Art News*, LXIV, 9, September 1965, pp. 26–9, 64–5.

YOUNG, M. S. 'Letter from Columbus, Ohio; Ferdinand Howald: Art of the Collector', *Apollo*, n.s., XC, October 1969, p. 343.

YOUNG, M. S. 'Springtime in Paris: "Four Americans in Paris: the Collections of Gertrude Stein and her Family" at the Museum of Modern Art, New York', *Apollo*, n.s. 93, February 1971, pp. 135–40.

List of Illustrations

Except where otherwise stated, all works are oil on canvas

Index

PROPER NAMES

WORKS BY MATISSE